Our World Tour

Mario Dirks

Our World Tour

A Photographic Journey Around the World

rockynook

Mario Dirks (www.our-world-tour.com)

Editor: Joan Dixon
Project Editor: Jocelyn Howell
Copyeditor: Jocelyn Howell
Translator: David Schlesinger
Layout: Jan Martí, Command Z
Cover Design: Helmut Kraus, www.exclam.de
Printer: Friesens
Printed in Canada

ISBN 978-1-937538-36-1

1st Edition 2014
© 2014 by Mario Dirks

Rocky Nook Inc.
802 East Cota St., 3rd Floor
Santa Barbara, CA 93103

www.rockynook.com

Copyright © 2014 by dpunkt.verlag GmbH, Heidelberg, Germany.
Title of the German original: Our World Tour
ISBN 978-3-86490-073-0
Translation Copyright © 2014 by Rocky Nook. All rights reserved.

Library of Congress Cataloging-in-Publication Data

Dirks, Mario.
 [Photographs. Selections]
 Our world tour : a photographic journey around the Earth / by Mario Dirks.
 pages cm
 ISBN 978-1-937538-36-1 (paperback)
 1. Travel photography. 2. Dirks, Mario--Travel. I. Title.
 TR790.D57 2014
 779--dc23
 2013047614

Distributed by O'Reilly Media
1005 Gravenstein Highway North
Sebastopol, CA 95472

Foreword

December 2012

I'm sitting on a swaying ferry headed for Norderney, the island of my home. It's dark, stormy, and cold outside, and I begin to lose myself in my memories as I jot down the first lines to my book *Our World Tour*. Just three months ago I returned home to Germany after a yearlong tour that took me across nearly the entire globe. This book gives me the chance to relive my exceptional journey and to share with you, dear readers, my exciting photographic tour of the world.

How It All Began...

On a warm summer evening in June 2011, I was sitting on my balcony surfing the Internet. I had just returned from a long trip a few weeks earlier and I was already wistfully scanning travel brochures on the web. My wife and I had spent some time speculating about what it would be like to travel professionally as a photographer. I was replaying our conversations in my head when I stumbled across an unusual advertisement from the lens and camera manufacturer SIGMA:

> ### The Coolest Job in the World!
> *SIGMA Corporation is advertising for the best job in the world. Have you always wanted to travel to distant places, discover foreign lands and people, and be amazed by the world's most remarkable attractions? Then we have the perfect job for you. Living up to SIGMA's "Our World" motto, we're sending you on a world tour. As a SIGMA World Scout you will travel for 50 weeks, starting at the end of October 2011, on an organized tour around the entire world, visiting 50 of the world's most beautiful sites on six continents. Natural wonders, famous structures, and beloved locations are the destinations for the "Our World" Tour. Your main responsibility as a World Scout is to discover these breathtaking locations and to share your fascination with others. In addition to your travel costs, you will receive a fixed honorarium as well as the professional-grade mirror-reflex SIGMA SD1 camera with various lenses and accessories. In exchange, you will document your tour in photos and text for the public. Travelling the world for 50 weeks is an incredible experience in itself. But you will also be compensated. The remuneration package for the entire duration is 50,000 euro (~68,000 dollars). We will plan the itinerary, cover your hotel and travel expenses, and assemble the necessary photo equipment, including the SIGMA SD1.*

I couldn't believe my eyes; this was my dream job. But I wondered, in this day and age, was it actually a real job, or was it an advertising gimmick to gather as much contact information from entrants as possible? Part of me thought I should ignore the website and devote myself to more important matters. But my interest was hopelessly piqued and I called my wife Miriam, who was staying on Norderney at the time.

Miriam had just applied for a teaching job but had yet to receive an offer. I told her about the SIGMA job, and as soon as I mentioned that bringing a companion along for the journey was an option, she was gung ho. I quickly became as excited as her and submitted my online application. I had to submit an informative video in addition to the standard application forms and résumé. My friend Jens, a cameraman by trade, immediately declared his support for my new undertaking and offered to help me create a video. After collecting a few hours of footage along the beaches of Norderney, we had enough material to splice together an interesting film. I finalized my application materials and submitted them just as the deadline approached. And then I waited.

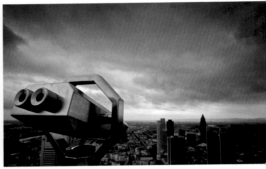

Winning pictures from the photography challenge in Frankfurt, representing three categories: creative (l), people (m), and city/landscape (r).

According to the Internet, more than 1,000 photographers applied for this remarkable job as a globetrotting photographer. SIGMA had to painstakingly evaluate each of these applications because, in the end, there could be only one World Scout. Days and weeks passed, and then finally news came that I had made the short list and had to prove my mettle against nine other applicants in a photography competition in Frankfurt!!

9.5.2011 Down to the 10 Best!!

It was 4:30 in the morning when my alarm clock abruptly woke me from sleep. I had been asleep for only three hours and I seriously considered whether I really wanted to deal with the stress of the day or just close my eyes and stay put. After a moment's consideration, sanity prevailed and I boarded a train headed for Frankfurt with a heavy bag of photo equipment and a serious case of sleep deprivation. I had a five-hour trip ahead of me and I used the time to read through a travel guide for the city that I had purchased the day before. Since I had never visited Frankfurt, I paid close attention to the map so that I would be able to orient myself at least a little bit. My train was delayed so I did not give the best first impression as I ended up being the last of the contestants to reach the twenty-first floor of the Innside Eurotheum Hotel. That's when the rubber hit the road. I had an hour and a half to explore Frankfurt and shoot three photos that fell within the categories of city, people, and creative. It was the most stressful 90 minutes of my life, and a little taste of what was to come over the next several months. I ran through the city in search of the most unusual subjects with a heavy pack on my back, an old Canon EOS 20D for wide-angle photos,

and my full-format Canon EOS 5D for portraits hanging around my neck. In the end, the effort and faith paid off. Some three hours later I was presented with an oversized travel voucher and a new camera as I grinned with joy and stared into various cameras and video cameras.

Preparations

Next came the need for quick action. The tour was scheduled to start in a scant month and a half and there were a million things to do. Visas needed to be procured, passports needed to be renewed. We needed to find an interim tenant for our apartment. We studied travel books and

Photo: SIGMA Germany Corp.

shopped for appropriate outdoor clothing. We cancelled our telephone and set up a mail-forwarding address. Worst of all was the gauntlet of immunizations we needed. In the following three weeks we each received countless shots. Everything was covered, from rabies to tetanus to yellow fever to tick-borne encephalitis to malaria to Japanese encephalitis, which I had never even heard of before.

11.01.2011 The Big Day
After all of the preparations were made and all of the hurdles were cleared, it was finally time to go.

Equipment
I had a ton of equipment from SIGMA in my baggage. It totaled nearly 65 pounds. Some of the gear, like tripods and such, could be checked in my luggage, but most of the valuable items came with me in my carry-on. Here's a list of all of the photo equipment:

› two SIGMA SD1 Merrill DSLR cameras
› lenses: SIGMA 70–200mm 2.8, SIGMA 24–70mm 2.8, SIGMA 17–50mm 2.8, SIGMA 85mm 1.4, SIGMA 105mm macro 2.8, SIGMA 10–20mm 3.5, SIGMA 8–16mm 2, SIGMA fisheye, SIGMA 2x converter, SIGMA 18–250mm travel lens
› two SIGMA flashes, SIGMA ring flash
› two carbon stands (one tripod, one monopod), Gorillapod
› ND filter 1000x, 2 Cokin ND linear gradient gray filters + mount, two SIGMA polarizing filters
› four CF cards, 13" Macbook Pro, three external hard drives
› Panasonic video camera
› two collapsible reflectors from California Sunbounce
› cable and remote release systems
› Sun Sniper camera belt

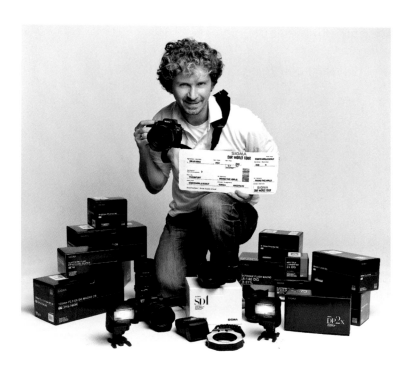

Photo: Tim Kreuer

Table of Contents

✈ The Americas

✈ Africa

The Americas

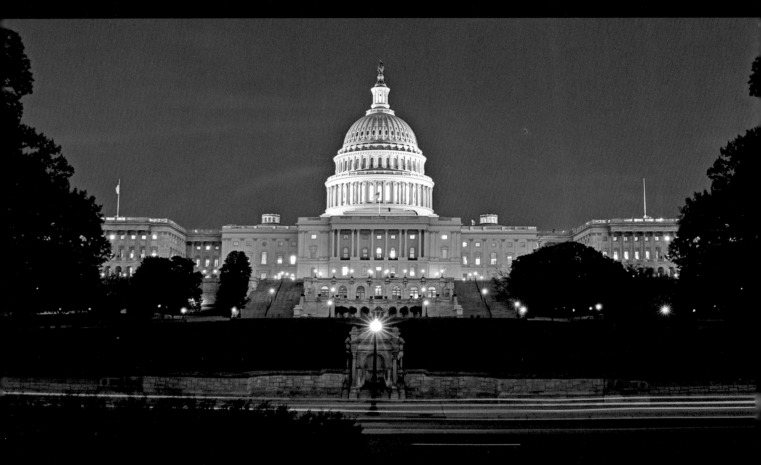

♠ *The United States Capitol in the blue hour · I wanted to shoot from a frontal perspective with the subject as central and symmetrical as possible. I used a cable release and turned on my camera's mirror-lock setting to avoid unnecessary vibrations. 28 mm · ISO 200 · f/18 · 8 sec*

USA Washington, DC

Jetlag! It's 5:30 in the morning and the five-hour time difference is making itself known. I can't sleep another minute for the life of me so I jump up and take a shower. At such an early hour, I decide on a piece of dry toast for breakfast while I prepare myself for the day with a travel guide and an iPad. Researching sights to visit, transit connections, weather, sun conditions, museums, and countless other things about the city are just as critical as making sure I have fully loaded camera batteries, empty memory cards, and a purposeful selection of lenses. The weather is fantastic: a blue sky with the sun shining and no indication of the forecasted snow chaos.

My first outing brings me to the White House. Wow, what an impressive building! Click, click—my first photos of the tour. I attach my polarizing filter to intensify the blue sky. A quick change of perspective…click, click…portrait, click…landscape, click, click. I'm also impressed that there are no other tourists around. Why is that? Finally, I realize that the building in front of me is the US Department of the Treasury. There's a certain similarity between the two buildings, but the actual White House is about 500 yards to the left. Embarrassing.

While I'm standing in front of the president's residence my every move is eyed suspiciously. To an outsider, my tripod could be mistaken for a weapon, so I remove it from its bag as slowly as possible before I assemble it. The fences and security presence prohibit me from approaching the White House too closely, so I use my telephoto lens and a tripod and try to capture photos that are as sharp as possible.

Tip: If you're using a lens with automatic image stabilization, you should disable this feature when your camera is attached to a tripod.

Arlington National Cemetery · A long focal length and a wide aperture enabled me to position the focal plane directly on the gravestone. The colorful flag immediately draws the viewer's attention. 147 mm · ISO 100 · f/2.8 · 1/800 sec ➔

Next I head to the Lincoln Memorial Reflecting Pool, which has been featured in many famous movies, including *Forrest Gump*. I already have an idea of the photo I want to take, but when I arrive at the landmark, it's empty due to construction. There goes more precious time down the drain. I promise myself that I'll research my plans more thoroughly going forward.

I pass on the Korean War Veterans Memorial to visit the Lincoln Memorial. Good old Abraham is sitting where he's supposed to be, but other tourists are constantly in my way. I don't actually want to feature them in my photo so I search for solutions. There are various options for dealing with this, but I opt for the simplest: cropping.

The Pentagon is off limits to me because photography is not permitted on site. Instead, I head over to the Arlington National Cemetery, which is an expansive graveyard with countless white gravestones. John F. Kennedy is buried here, but his gravestone is always surrounded by tourists, so I poke around for a different subject. I don't have to look for very long.

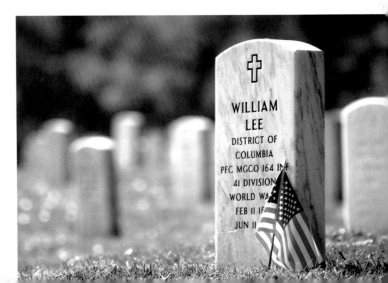

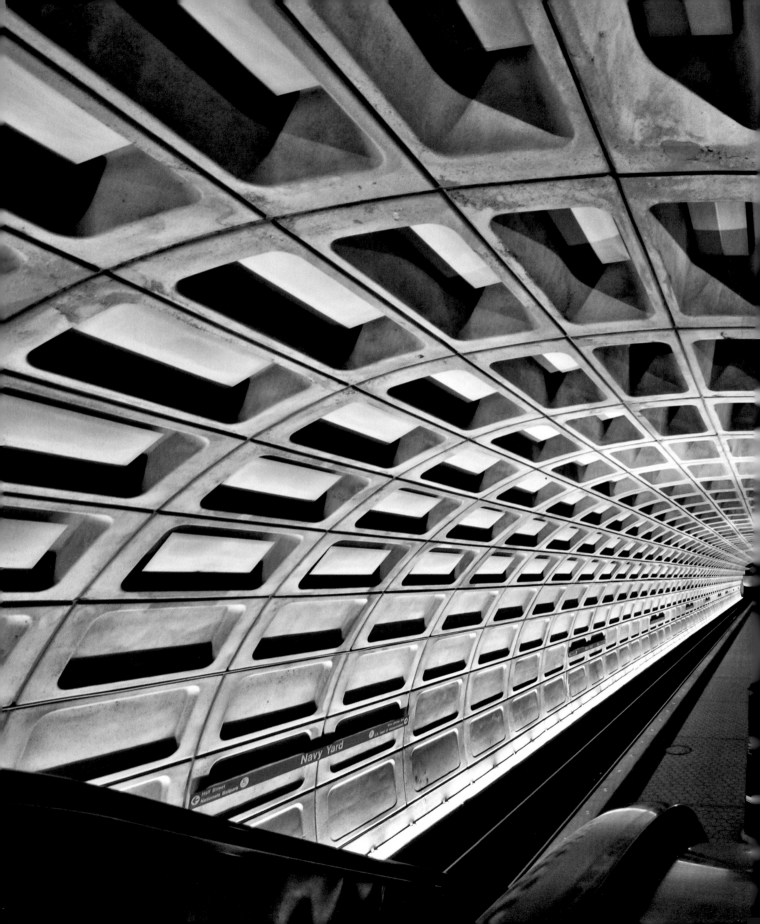

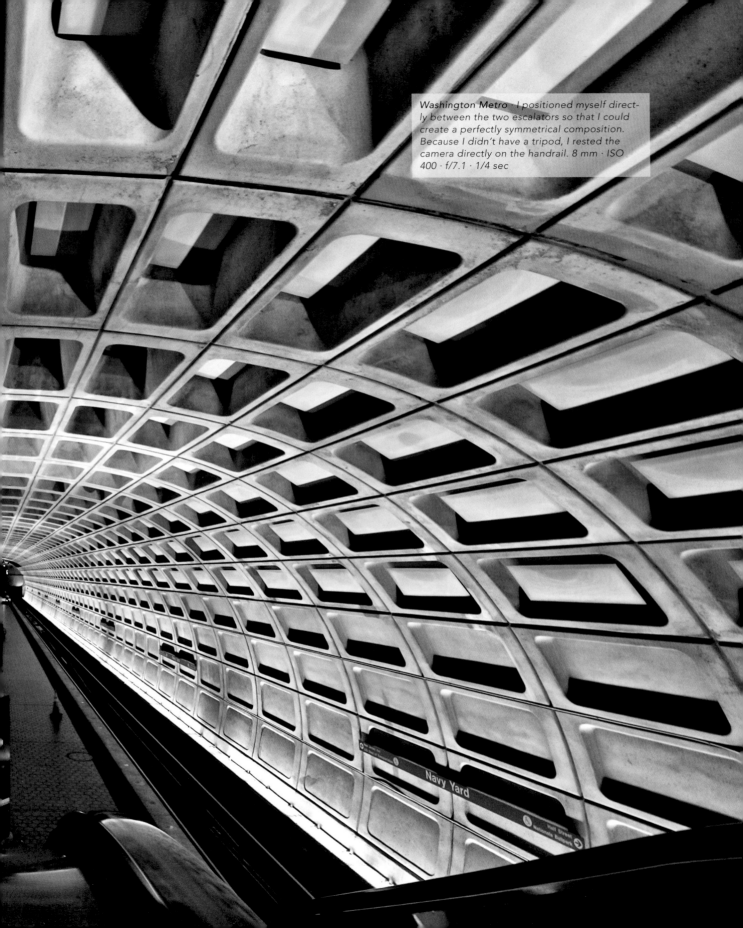

Washington Metro · I positioned myself direct-
ly between the two escalators so that I could
create a perfectly symmetrical composition.
Because I didn't have a tripod, I rested the
camera directly on the handrail. 8 mm · ISO
400 · f/7.1 · 1/4 sec

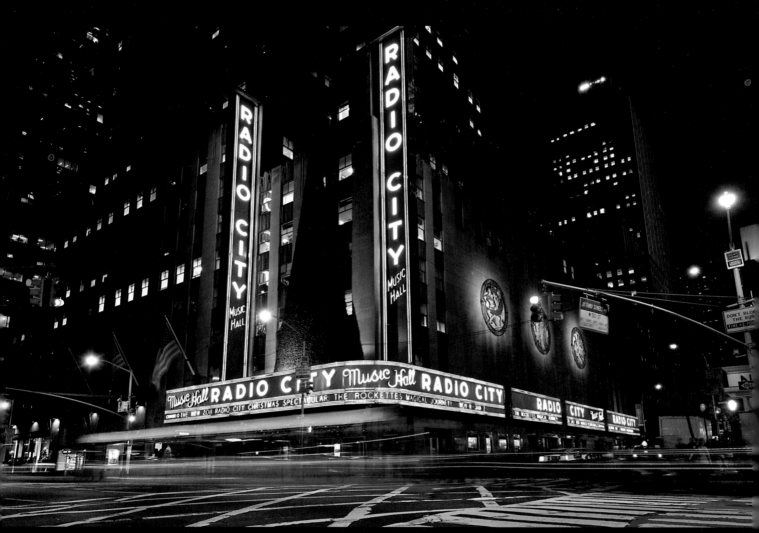

↟ *Radio City Music Hall · Manhattan offers striking subjects around the clock. Using a long exposure made the moving cars disappear from the photo. The remaining traces of light make for interesting accents. 16 mm · ISO 100 · f/9 · 2 sec*

USA New York

Bright lights, crowds of people, noise, sirens, honking taxis everywhere; my head is spinning, my eyes are bulging, and my feet are burning. I feel dizzy. Diagnosis? Overstimulation. New York is exactly as I imagined it—the city that never sleeps.

Sleep isn't on my personal agenda either. I've got two days to explore this metropolis. That's a short amount of time for a city that defies comprehension and has so much to offer. During the day I admired the Flatiron Building, the Statue of Liberty, Times Square, the Empire State Building, Rockefeller Center, and a number of other attractions. Now it's time for nighttime exploration. Armed with a heavy backpack and a tripod, I head off into the illuminated city. My eyes are on alert for the perfect subject. I'm hoping to find a vantage point from which I can document Manhattan's skyline. I feel a little uneasy as I walk through the dimly lit alleys. Statistically, someone is murdered every day in this city. I tighten my grip on my tripod with the hopes that I won't be separated from it. After what feels like hours, it's finally in front of me: the fantastically illuminated skyline of the city. It's the perfect time of day, with the blue hour just beginning. I quickly set up my tripod and choose my desired image area.

Tip: It's best to shoot evening skyline photos on weeknights because buildings will have more illuminated windows during those times.

I could spend hours taking in the view, but nightfall's chill forces me to pack my things and head home. Then, all of a sudden, I feel a sharp ache in my knee. I can't walk properly anymore and it becomes painfully clear to me that I'm not used to walking around so much with a heavy backpack. But how am I supposed to go on? In a panic, I limp to the nearest drug store. The sales clerk gives me a cream for my knee, adding, "We normally don't sell this without a prescription."

Only when brushing my teeth the following morning does it occur to me that the medication comes in a tube that is remarkably similar to my tube of toothpaste. With tears in my eyes and my mouth ablaze I try to rinse out my mouth and assuage the pain. (It took a good three days before I could taste anything again. On the plus side, however, I haven't had a toothache to this day.)

Early in the morning on my second day, as I am walking through the empty streets, I come across a crowd of excited people who are jumping and jostling outside of a shop window. I push my way to the front and am rewarded with no small surprise. I'm standing right next to heartthrob Leonardo di Caprio, who is pitching his latest film directly inside of this ground-level studio. The poor lighting and reflections on the windows rule out anything but a quick snapshot, but better that than nothing at all.

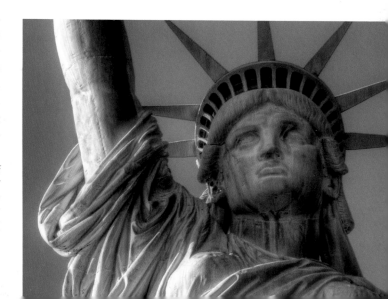

The Statue of Liberty · Instead of taking a picture of the entire statue, I decided to take a portrait of just her head. Because the contrast was especially stark, I used exposure bracketing to generate several images, which I later combined to create an HDR image.
400 mm · ISO 200 · f/5.6 · 1/320 sec ➔

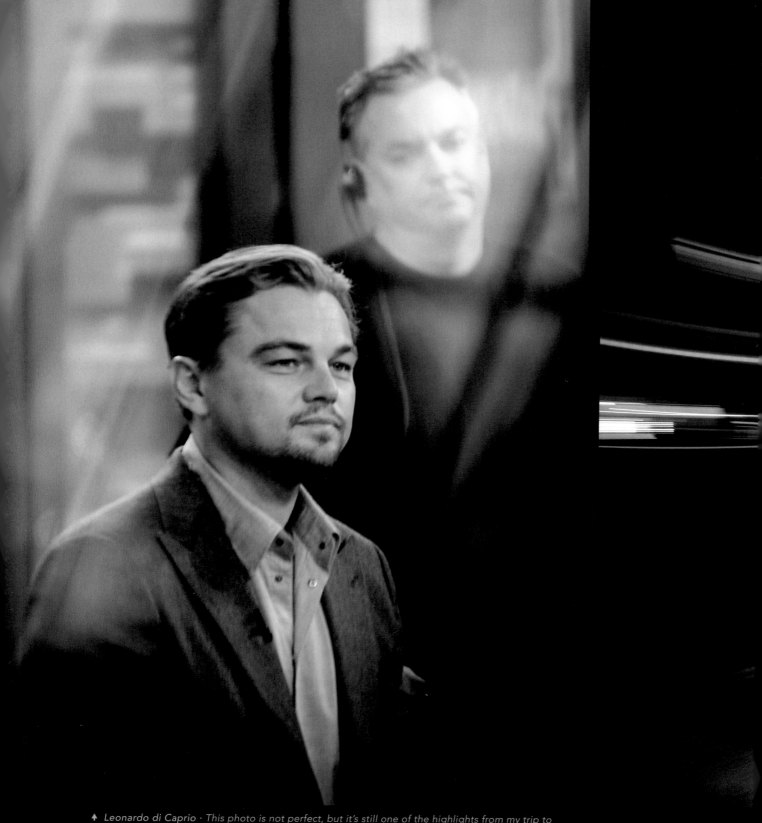

♠ *Leonardo di Caprio · This photo is not perfect, but it's still one of the highlights from my trip to New York. When else do you have the chance to get so close to a real Hollywood star? 200 mm · ISO 800 · f/2.8 · 1/100 sec*

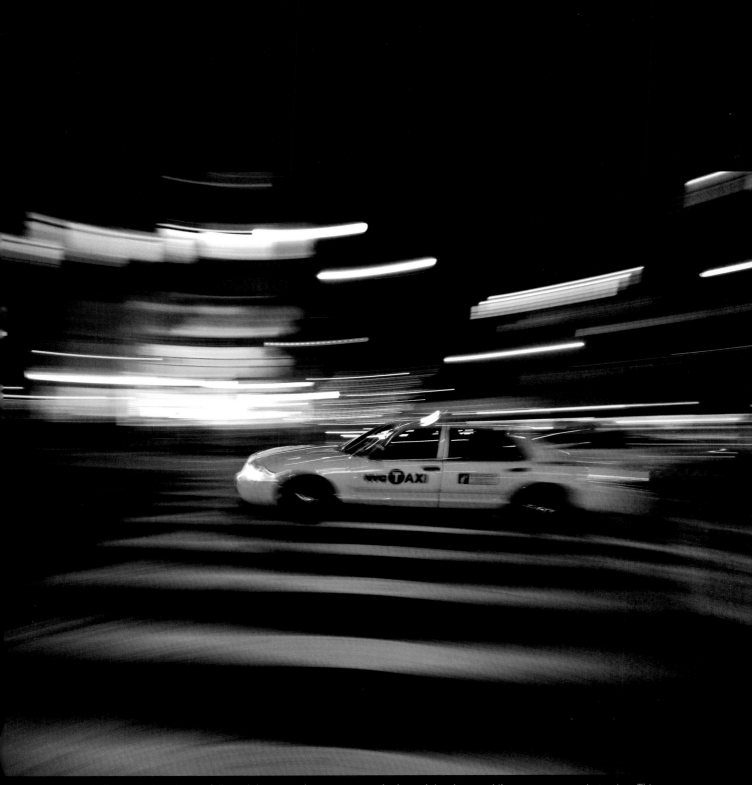

⬆ *Taxi · For this photo, I followed the taxi with my camera and released the shutter while my camera was in motion. This panning technique results in a sharp subject against a blurry background. It's best and easiest to use a wide-angle lens for this sort of photo. 8 mm · ISO 400 · f/5 · 1/6 sec*

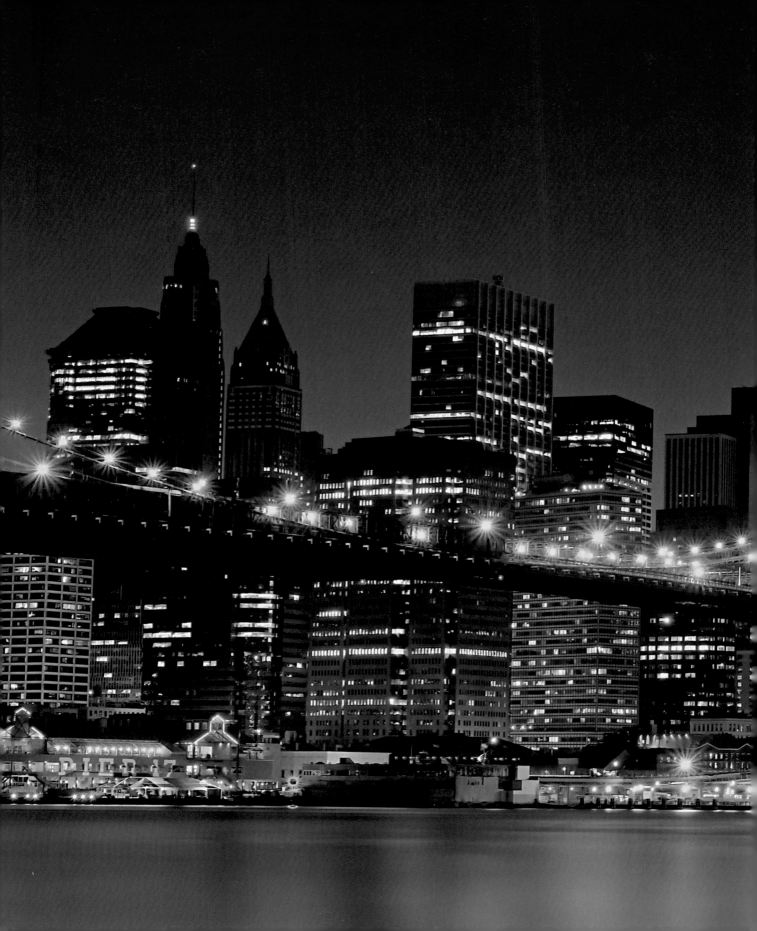

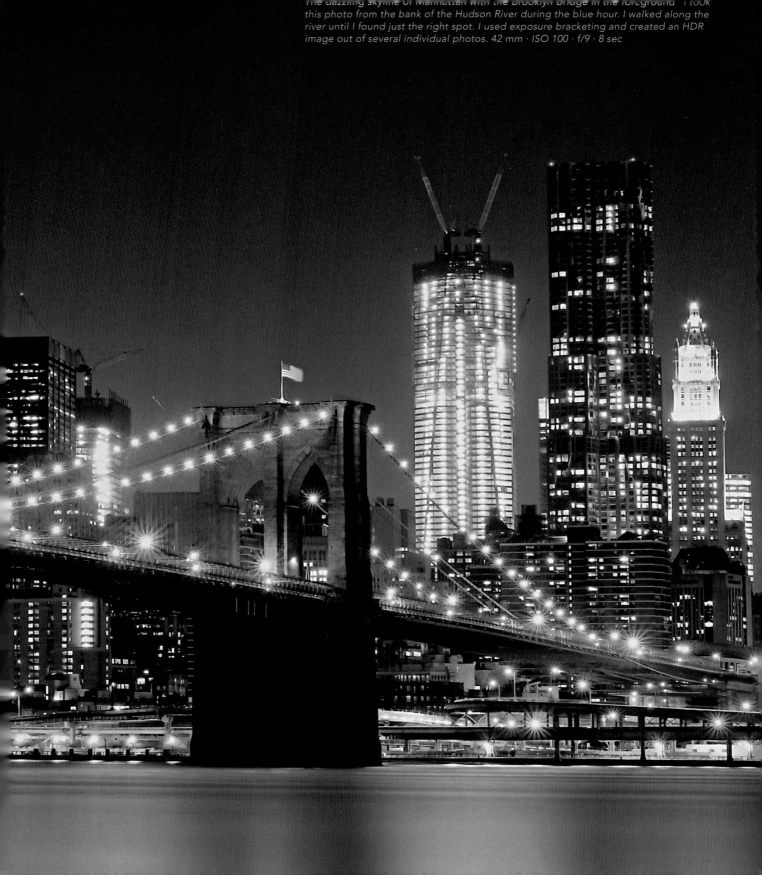

The dazzling skyline of Manhattan with the Brooklyn Bridge in the foreground. I took this photo from the bank of the Hudson River during the blue hour. I walked along the river until I found just the right spot. I used exposure bracketing and created an HDR image out of several individual photos. 42 mm · ISO 100 · f/9 · 8 sec

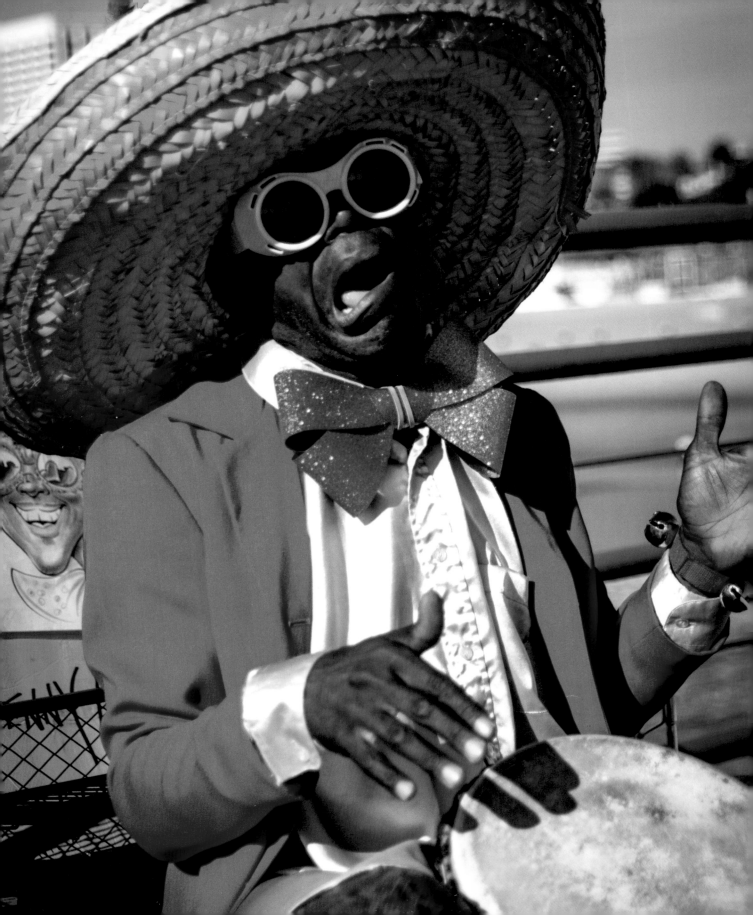

USA Los Angeles and Hollywood

My rental car was driven away by a chauffeur and my luggage was delivered to my room by a bellhop. I feel a little underdressed when I enter the magnificent lobby of my hotel. Lush carpets, lofted ceilings with stucco accents, and antique chandeliers—it's all very classy. I've arrived in Los Angeles, the city of the stars. And this time I have just one day to show myself around.

L.A. has nearly 4 million residents and is geographically huge, which means I need to limit my objectives to only the most essential. Off to Hollywood.

After I take in nearly every one of the 2,500 stars on the Walk of Fame, I want to visit the Hollywood sign. Unfortunately, it's not possible to do so on foot, so I sign up for a bus tour that hits all of the key highlights—Beverly Hills, Rodeo Drive, and so on—before finally arriving at my Hollywood sign.

The next morning I jaunt over to the Disney Concert Hall, a thoroughly marvelous architectural gem. After a quick detour to the beach in Santa Monica, it's time to resume my travels. I'm certain that my efforts in Tinseltown have put me solidly in the running for an Oscar of my own.

◄ *Santa Monica · I discovered this colorful, comical musician on a pier at the beach. The glaring sun produced harsh shadows, but that's not a problem for this sort of subject as the shadows only add to the photo's authenticity. 55 mm · ISO 200 · f/2.6 · 1/1600 sec*

▲ *Plastic golden Oscars · Replicas of the highly coveted trophies are sold on street corners all over L.A. Unlike the real thing, these ones are small and plastic. 34 mm · ISO 400 · f/2.8 · 1/80 sec*

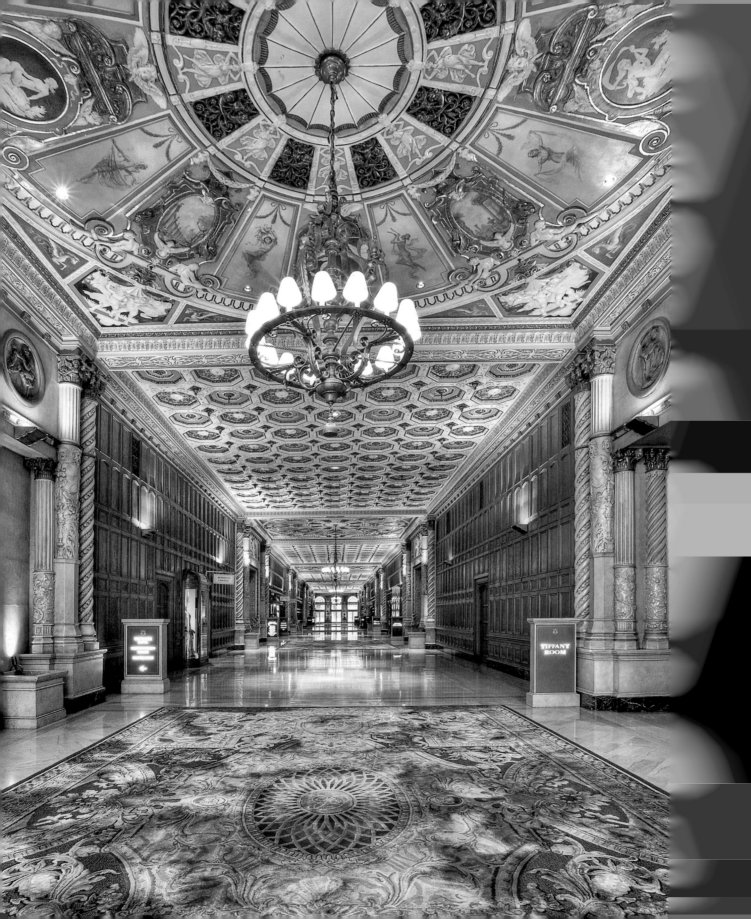

Walk of Fame · Here you find one celebrity after another. I picked out the star for the late king of pop, Michael Jackson, and tried to get a central perspective directly from above to accentuate it. 24 mm · ISO 200 · f/4.5 · 1/400 sec ➜

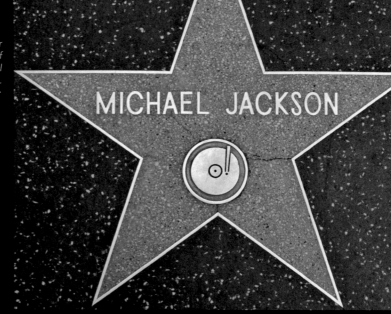

← *Los Angeles hotel lobby* · In a place like this, everyone feels like a star. The HDR editing (Photomatix Pro) gives this photo a slightly altered and somewhat surrealistic appearance. Seconds after taking this shot, hotel security stopped me from taking any other pictures. 10 mm · ISO 100 · f/13 · 4 sec

Walt Disney Concert Hall · This futuristic-looking building designed by architect Frank Gehry is one of the world's most famous concert halls, owing to its modern architecture and acoustics. I emphasized the shiny steel and the curved, sail-like roofs with light and shadow. 10 mm · ISO 200 · f/7.1 · 1/200 sec ↓

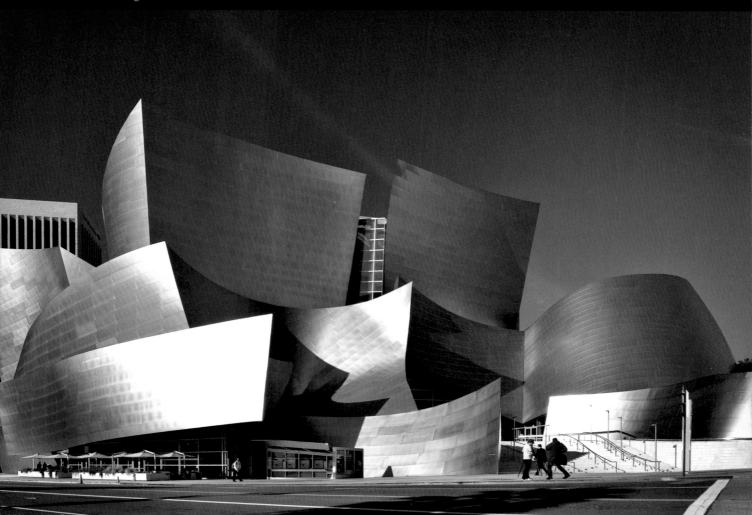

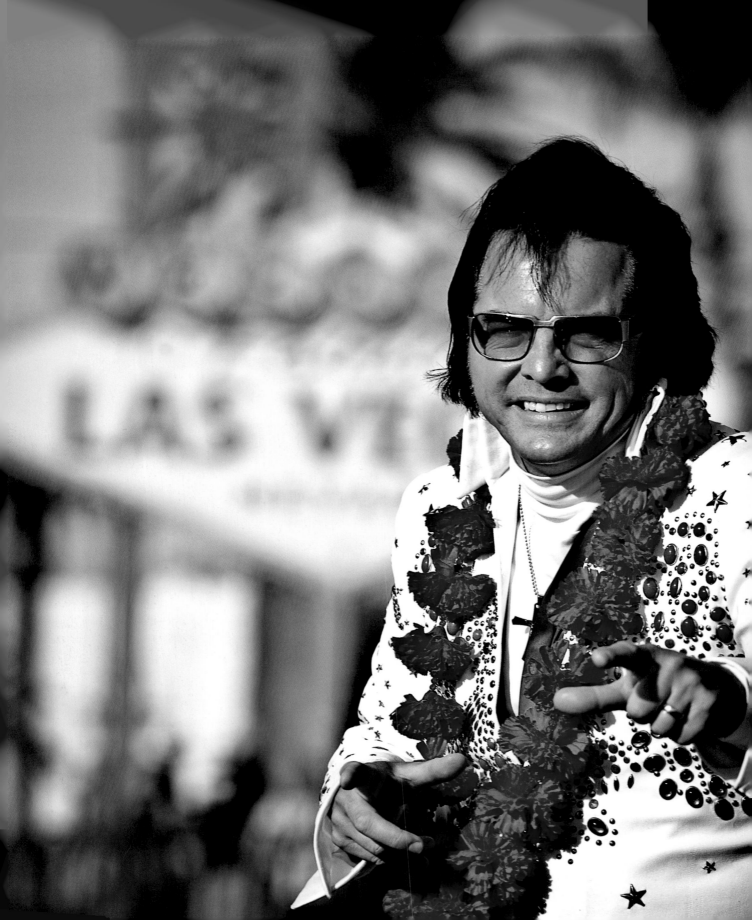

USA Las Vegas

A nerve-wracking, extremely loud, high-frequency alarm sounds. What now? Where am I? A quick glance at my alarm clock shows that it's 5:00 a.m. "Attention, please. Please evacuate the building," says a deafening voice coming from a speaker in my room. I get dressed in world-record time and frantically await something along the lines of a magnitude 6.0 earthquake. Oddly, when I arrive in the lobby I appear to be the only guest there. A kind hotel employee finally informs me that it was just a false alarm and I can go back to bed. Good joke!

Because I'm already wide awake, I take a quick walk through the casino. Today I'm in Las Vegas, the glitzy city of gambling and shows. It's hard to describe this city; you really have to experience it for yourself. Kitsch par excellence! You can find everything imaginable: fire-spewing volcanoes, huge fountains, lions, dolphins, and countless Elvis impersonators. The hotels are gigantic and it takes an eternity to walk through the casino and return to my room.

As soon as darkness falls, Las Vegas turns into a sea of colorful lights. It overwhelms the eyes. Here, you can find a number of world-famous cities in one—Venice, New York, Paris. Dead tired, I finally fall asleep late in the evening after walking what seems like 20 miles. The whole experience made my legs hurt and my head spin. But a little bit of pride washes over me: I managed to get through the day having gambled away only two dollars.

← Elvis impersonator · I decided to blur the background of this photo but leave the Las Vegas sign just legible enough to let viewers know where I ran into "Elvis."
200 mm · ISO 100 · f/4.5 · 1/640 sec

Several cities in one · Las Vegas gleams with thousands of lights day and night. I had an endless selection of shapes and colors to choose from while shooting during the blue hour.
55 mm · ISO 200 · f/2.8 · 1/80 sec →

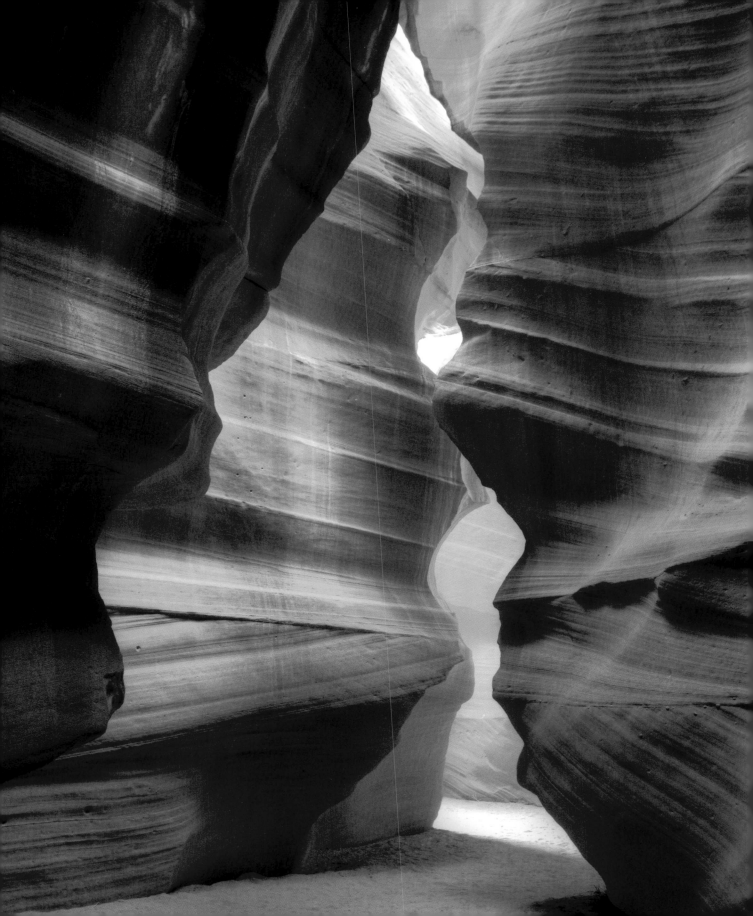

USA Grand Canyon and Vicinity

The first tentative rays of sunlight start to spill over the rocky horizon before they flood the canyon in a colorful spectacle of light. Warm gold and red tones compete with plays of shadow. In this case, waking up before sunrise makes all the sense in the world. I'm standing on the rim of the Grand Canyon and I'm truly overwhelmed. My fingers aren't working properly on account of the overnight freeze, but that doesn't keep me from shooting. Only after the sun has been up for a good hour have I earned my breakfast.

At a length of 277 miles and an average depth of 1 mile, the Grand Canyon is a proper wonder of the world. The best lighting for this magnificent river channel, which took millions of years to form, is early in the morning and right before sunset.

The surrounding area is also worth exploring, which is why I head out toward another attraction after breakfast. Antelope Canyon is about 150 miles away and is a beloved site for photographers. This so-called slot canyon features gentle contours that Antelope Creek has devotedly carved out of sedimentary rock. Because it's located on a Navajo reservation, you have to take a tour to access it. A dearth of light and a surplus of tourists make it difficult to photograph.

After the tour, I head over to the equally famous Horseshoe Bend, where you can get a spectacular view of a U-shaped gorge carved by the Colorado River. The day has ripened into late afternoon and the sun's light is tremendous. I take in a brief, mystical moment as I wonder at my surroundings. The site is a worthy conclusion to my two days of canyon touring. I would love to stay longer—there is so much more to discover—but my next destination is already calling.

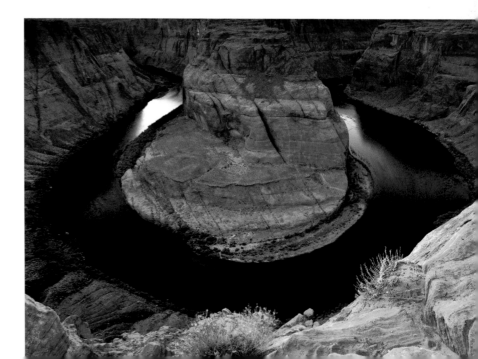

← *Antelope Canyon · This canyon, much beloved by photographers, is a two-hour drive from the Grand Canyon. The conditions on the guided tour weren't ideal; it was dark and the other tourists made it quite crowded. A slow shutter speed and a tripod were enough to "erase" the other people from my picture.*
16 mm · ISO 200 · f/5.6 · 2.4 sec

Horseshoe Bend · After about a ¾-mile hike from the parking lot to the observation point, I was rewarded with a stunning view. I used a powerful wide-angle lens to capture the entire horseshoe in my photo.
10 mm · ISO 100 · f/8 · 1 sec →

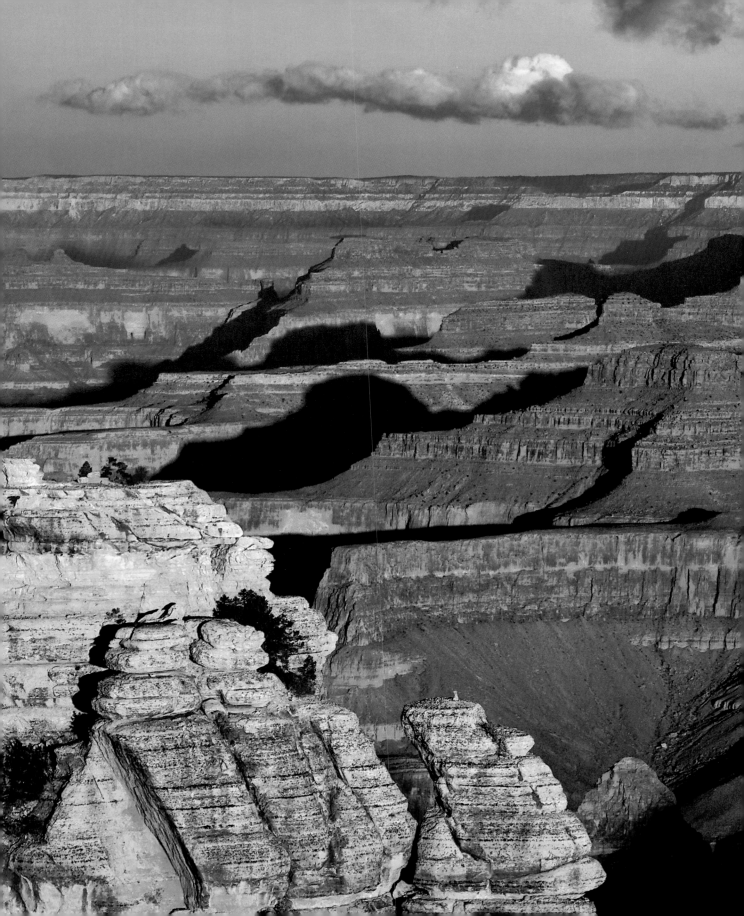

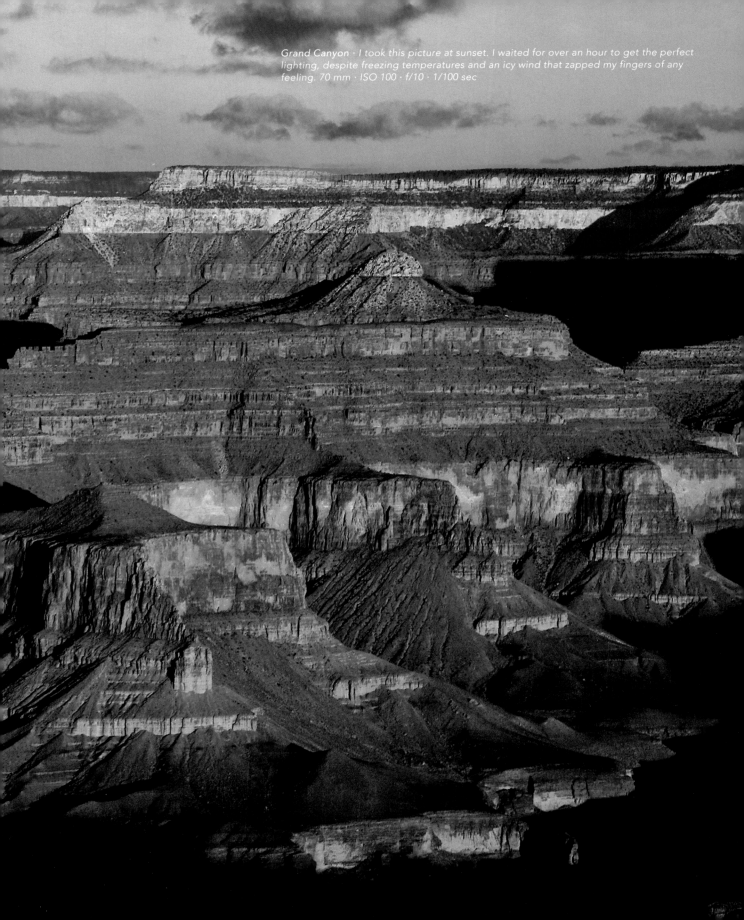

Grand Canyon · I took this picture at sunset. I waited for over an hour to get the perfect lighting, despite freezing temperatures and an icy wind that zapped my fingers of any feeling. 70 mm · ISO 100 · f/10 · 1/100 sec

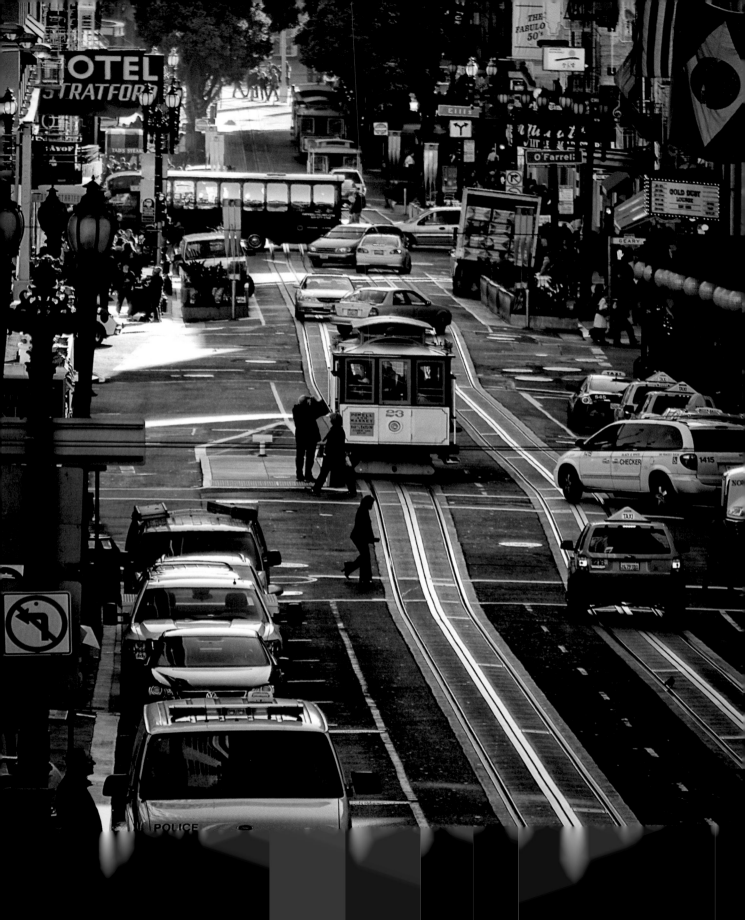

USA San Francisco

Between 8,000 and 10,000 homeless people live in San Francisco and there are a variety of reasons they are stranded here. I met a few outside my hotel and chatted with them for a bit. Matthew from Indiana, for example, has "journeyed" through the world for 35 years and hopes to become famous by writing a book about his experiences. Many other people have alcohol and drug addictions, which further complicate their plight. But enough about the unfortunate side of the city.

There are plenty of delightful parts of this city, too, including its famous cable cars. These early versions of a streetcar are pulled by a cable that runs for several miles under the street. Taking a trip on these primeval cars is a must for every visitor. I am grateful for the antiquated mode of transport because the streets of San Francisco are among the steepest in the world. But that's not what the city is most famous

for; that honor belongs to its fog. And it wreaks havoc on my nerves, shrouding everything in gray and sucking the beautiful colors out of the city.

Tip: In addition to the standard sights including the Golden Gate Bridge and the Painted Ladies, I also highly recommend a trip to Treasure Island. Standing on this small barrier island during evening twilight affords a stunning view of the Bay Bridge and the city's famous skyline.

← *Cable Cars · Steep streets and nostalgic cable cars are a typical sight in San Francisco. These subjects lend themselves well to black-and-white or sepia conversions. 219 mm · ISO 200 · f/5.6 · 1/320 sec*

Golden Gate Bridge · No trip to San Francisco is complete without checking out this famous bridge. I took this photo in the afternoon while standing on the beach. Using a gray filter allowed me to use a longer exposure time, which in turn made the bay appear calmer than it was. 70 mm · ISO 100 · f/16 · 10 sec →

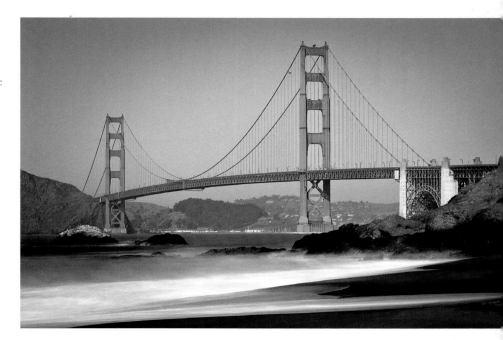

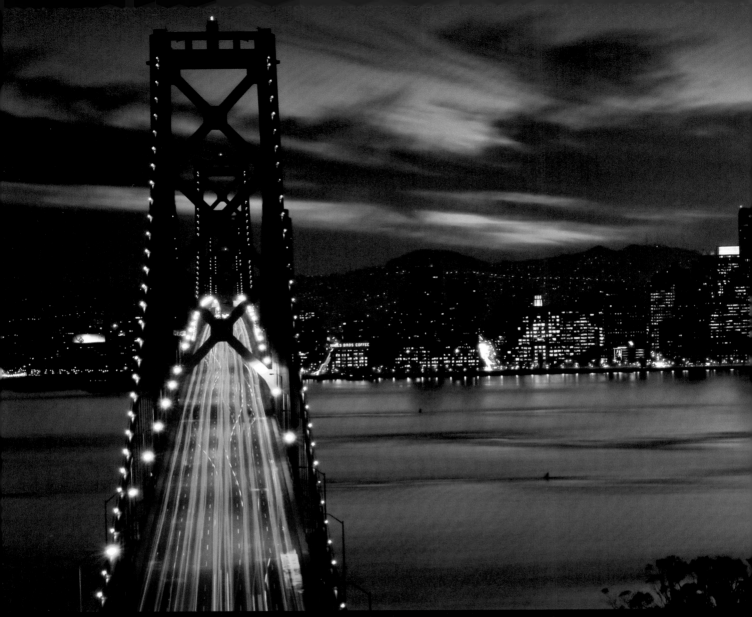

↑ *Illuminated Bay Bridge in the evening · I had to take a bus across the bridge to Treasure Island to get this photo. Once on the island, I hiked up a hill for an hour, fighting against some rough shrubs, until I finally had an unencumbered view of the illuminated bridge and city. The result was well worth the effort. 39 mm · ISO 100 · f/20 · 30 sec*

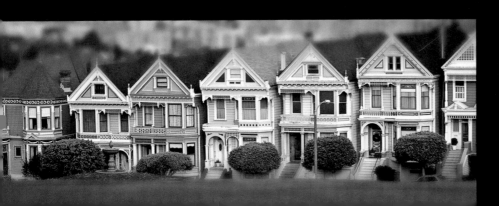

← *Painted Ladies · The well-known Painted Ladies look like small, colorful dollhouses because of the tilt-shift effect that I applied afterward with Photoshop.*
70 mm · ISO 100 · f/9 • 1/30 sec

Street man · One of many homeless people in San Francisco; here, using honesty to win over passersby.
112 mm · ISO 100 · f/2.8 · 1/1600 sec ➔

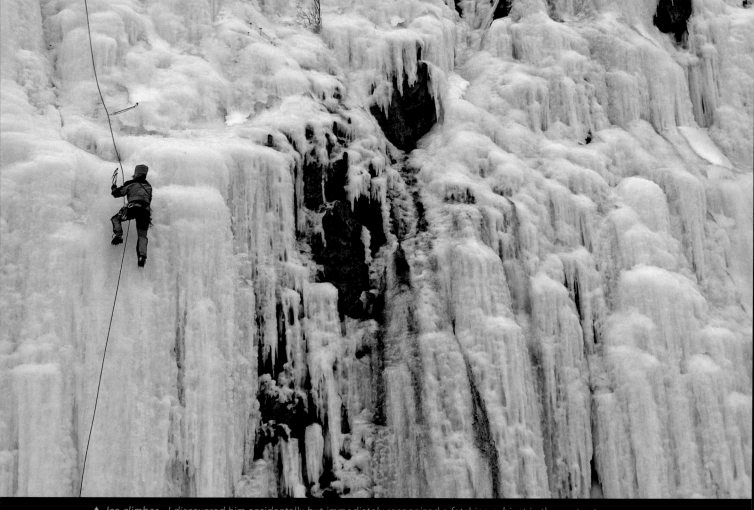

⬆ *Ice climber · I discovered him accidentally but immediately recognized a fetching subject in the contrast between his red clothing and the bluish wall of ice. 39 mm · ISO 200 · f/3.5 · 1/40 sec*

USA Anchorage

Sleet lashes my face and gusts of wind cause me to slip and slide over the frozen streets. Definitely not the best choice of footwear, I think to myself, as I do a delicate dance to keep my balance. Just don't fall; broken bones or shattered equipment is the last thing I need. Anchorage—the gateway to Alaska, founded in 1915—is somehow different from what I imagined. Where are all the Eskimos, igloos, sled dogs, and towering snowdrifts that I had associated with this wild state? Confounded, I turn into the next visitor center and inquire about guided tours, day-trips, and the like. I am met with a sympathetic shake of the head. "Wildlife?" I ask. The woman behind the counter looks mildly amused as she explains that it would require steely patience and ample luck to spot an animal at this time of year. The bears are hibernating and the whales are on their way to warmer waters. I should come back in spring or summer when Anchorage and the vicinity are a proper paradise for photographers. Saddened, I head for the door and resolve to trudge on by myself.

After taking a quick look at my travel guide I decided to visit the six-mile long Portage Glacier and the slightly smaller Exit Glacier. While I'm driving along the frozen Turnagain Arm, a sudden movement on an ice wall captures my eye. An ice climber with a pickaxe and crampons is pursuing his hobby at a dizzying height. At least I'm not the only one out here.

The closer I get to the glacier, the worse the weather becomes. The sleet falls harder and the stormy gusts shake my entire car. After passing several cars abandoned in drifts of snow or on the wrong side of the guardrail, I finally decide to give up on my intentions for safety's sake. Better to stop at a wildlife reservation on my way back, where I can at least take a few photos of some native species up close. But I don't get a true Alaskan experience until I'm on the airplane headed to my next destination. While I'm taking one last look through the window, the clouds part and what do I see? Alaska, as I imagined it.

Reindeer · On my Alaskan adventure I caught sight of this proud animal, although my intensive search for Santa Claus was in vain. 200 mm · ISO 200 · f/2.8 · 1/500 sec ➡

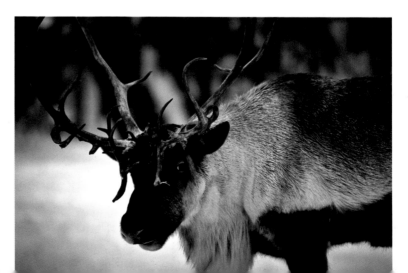

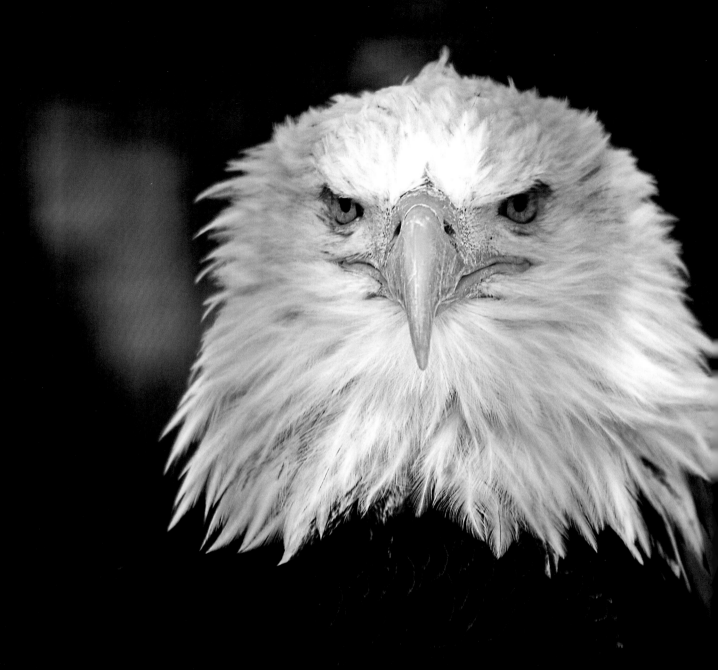

↟ *Bald eagle* · Thanks to my telephoto lens I was able to get a proper portrait of this imposing bird without causing it to fly away. It looks somehow displeased about it anyway. 200 mm · ISO 200 · f/2.8 · 1/125 sec

Alaska from above · I took this mountain panorama from the airplane as I was leaving the state. I needed a fast shutter speed to get as sharp an image as possible with the vibrations of the plane. 70 mm · ISO 200 · f/2.8 · 1/2500 sec ➜

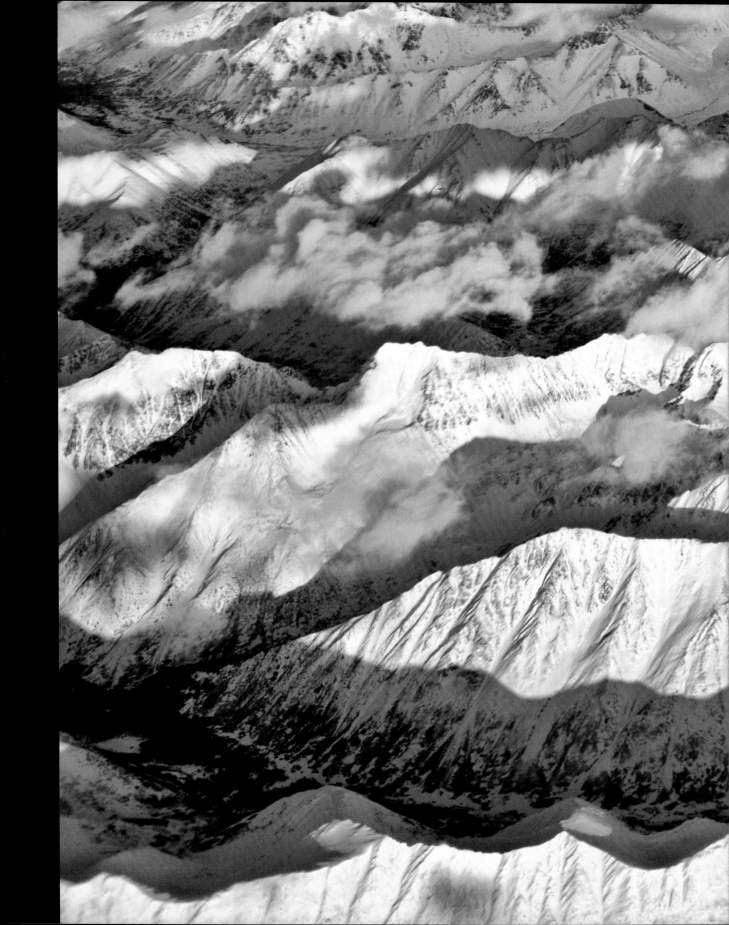

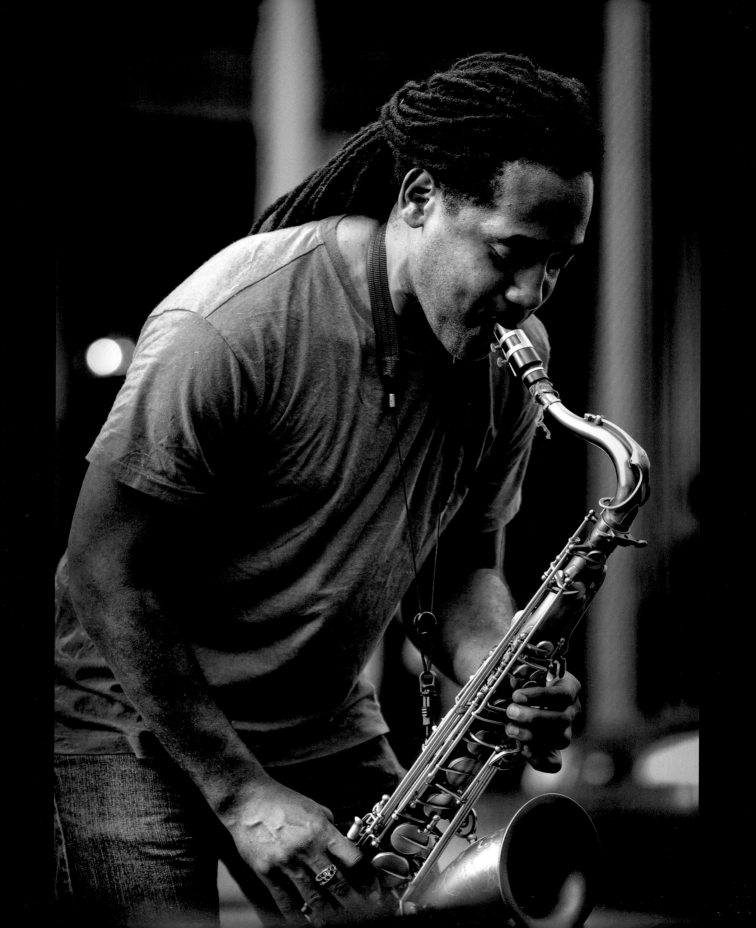

USA New Orleans

The baggage carousel comes to a stop as my anxiety comes to a head. Where the heck is my bag? It takes a while for someone from the airline to finally look into my missing luggage. A shrug of the shoulders is accompanied by the succinct answer, "I can't see it in our computer system." Annoyed, I fill out the appropriate form for lost baggage. This isn't how I imagined my introduction to New Orleans, the cradle of jazz.

After a restless night of sleep, I wake up and head over to the nearby French Quarter. The quiet sounds of saxophones and trumpets drift from side streets and I find myself humming along with them. Yep, music really is in the air in this city. I let myself wander away from their pull and end up in Jackson Square, where I find a gathering of painters, fortunetellers, artisans, horse-drawn carriages, and, of course, musicians. I love the scene here and I barely take my finger off of the shutter button; only once the battery indicator starts to blink do I stop. Beads of sweat start to form on my brow as I come to the painful realization that my battery charger is in my missing bag. I reach into my backpack and pull out my last, half-empty battery for the day. I feel as though I've gone back to the days of film photography, when every shot amounted to a significant expense. With so many enticing subjects surrounding me, I have a hard time limiting myself to only the most essential ones so that I can get the most from my remaining battery charge.

Exhausted from so much walking, I avail myself of the city's quaint, old streetcars. They are affectionately called Red Ladies, and they remind me a little of the cable cars in San Francisco. On my way back to the hotel I stop off at the well-known Bourbon Street for the evening. The street is a blur of hustle and bustle, and music combos can be heard everywhere. Unfortunately, my battery runs out of juice right in the middle of the commotion. I allow myself to enjoy the party atmosphere, though, and it doesn't take much time before I am in a better mood.

Back at the airport the following morning, no one can tell me exactly where my luggage has been for the past couple days, but it somehow appears shortly before my departing flight. I am sad to leave a city so rich with photographic opportunity and flair. I had to skip out on several things because of the ordeal with my missing bag and would have loved to stay longer. But I'll definitely be back!

← *Saxophone player · The man is playing in a crowded place in New Orleans, the birthplace of jazz. I come across musicians on every street corner as I walk through the streets delighted and elated.*
137 mm · ISO 200 · f/2.8 · 1/320 sec

Entrance to Musical Legends Park · I was hardly a few steps into the park before I was met by the spirit of the city in the form of plenty of live music.
ISO 200 · f/2.8 · 1/200 sec →

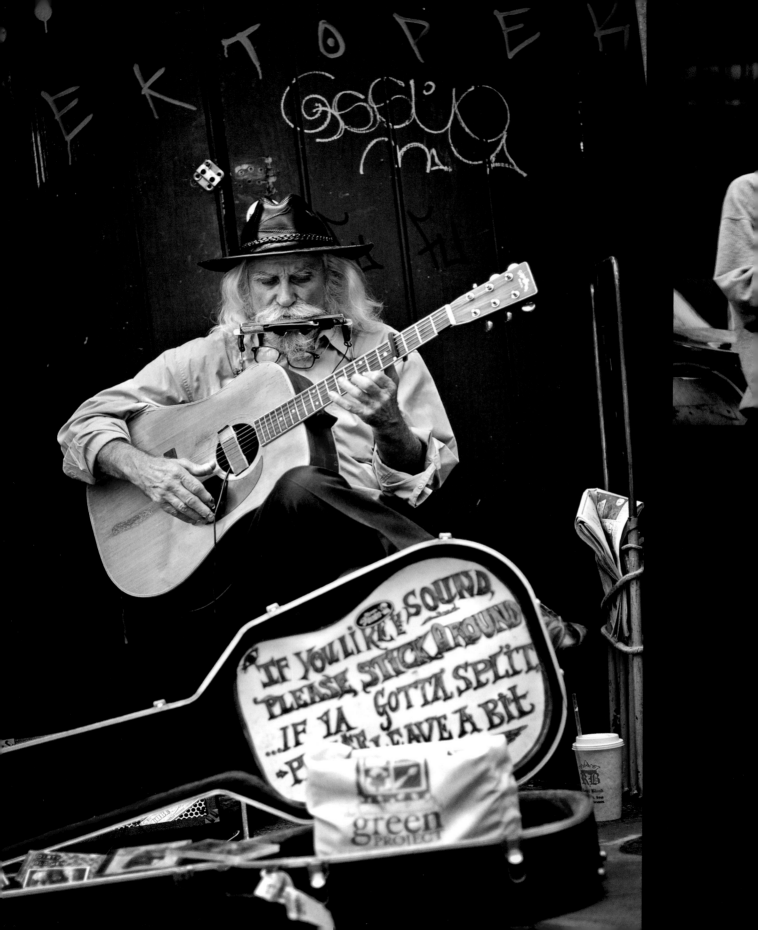

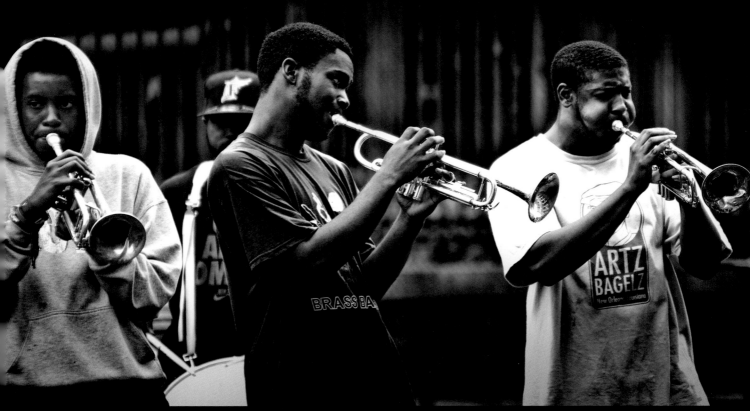

↟ **Brass trio** · Musicians are everywhere in New Orleans. Here, I opted for a black-and-white palate for a traditional, classic look and feel. 200 mm · ISO 200 · f/2.8 · 1/200 sec

← **Street musician** · Even this older gent has music in his blood. I shot him as a classic portrait using a slight telephoto focal length. 85 mm · ISO 200 · f/1.4 · 1/500 sec

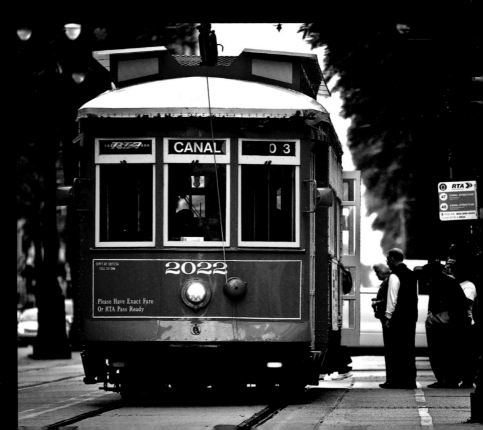

Red Lady · The quaint streetcars in New Orleans are called "Red Ladies," and they resemble the famous cable cars in San Francisco. 200 mm · ISO 200 · f/2.8 · 1/400 sec ➜

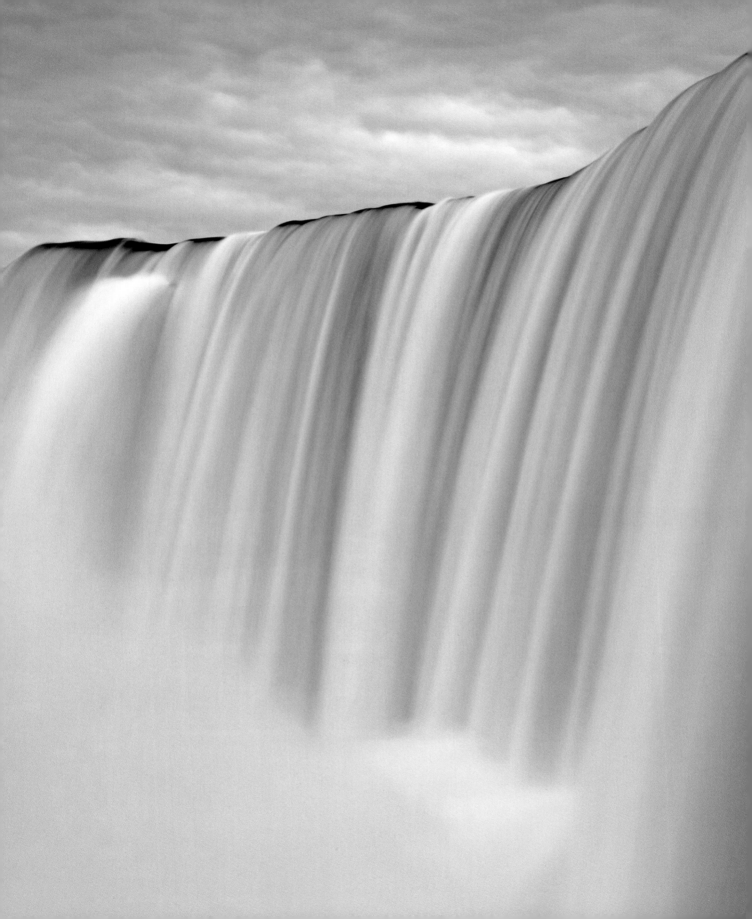

CANADA Toronto and Niagara Falls

I am surrounded by thunderous noise and a fine mist that coats my camera lens. Wipe the lens off, click; wipe it again, click; and so it goes for the next couple hours. I've arrived at Niagara Falls, an incredible spectacle of nature, where a huge volume of water drops 180 feet in some places. Unfortunately, the tour boat is out of service because the season is over, so I have to hike for a bit to document this imposing waterfall. The experience is fascinating and I capture it eagerly on my camera's memory card. To give my photos a painter's touch, I opt for slower shutter speeds.

The next morning, I take a ferry to the small and peaceful Toronto Island, where I find a stunning view of the skyline. It's the perfect place to shoot during the blue hour. Speaking of blue, that's the color my lips turn in the cold temperatures. But I I decide to stick it out until after the sunset, because all good things take time.

All thawed out the next morning, I take a sightseeing bus around the city. We pass by several worthy attractions and eventually arrive at the Royal Ontario Museum, whose architecture is so extraordinary that I return again in the evening to photograph it at twilight.

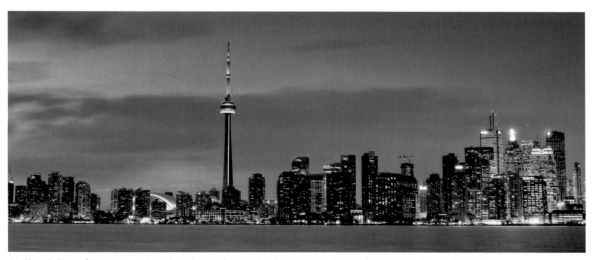

✦ *The skyline of Toronto · I shot this photo of Canada's largest city during the evening hour. The long exposure time smoothed out the surface of the water in the foreground. 37 mm · ISO 100 · f/8 · 30 sec*

✦ *Niagara Falls · For a smoother, painterly touch, I opted for a relatively slow shutter speed. I forgot my gray ND filter in the car, so I closed the aperture as far as possible and set the exposure for one second. 51 mm · ISO 100 · f/22 · 1 sec*

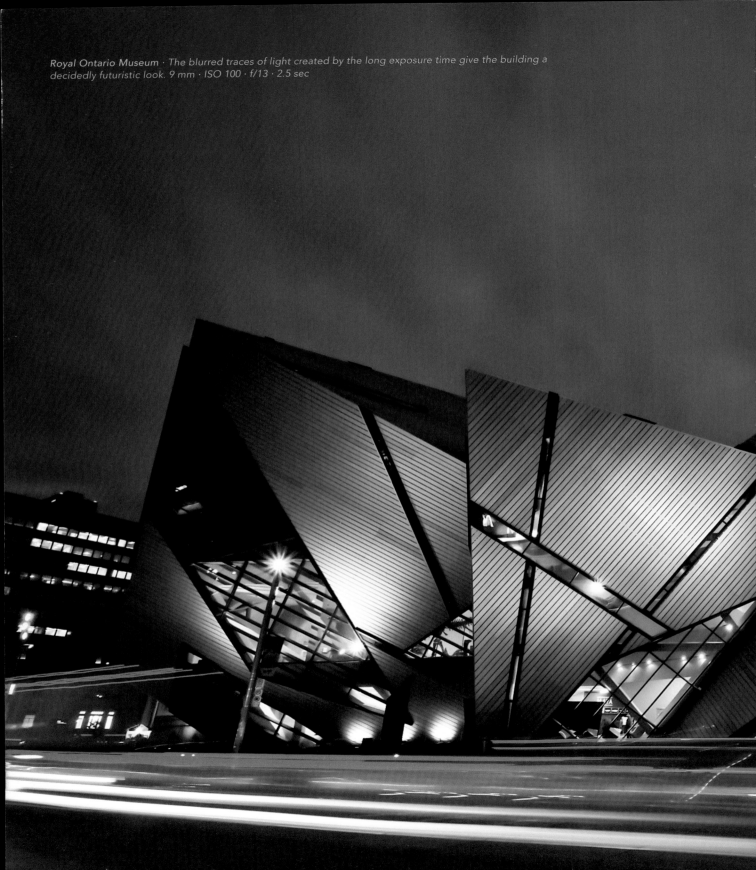

Royal Ontario Museum · The blurred traces of light created by the long exposure time give the building a decidedly futuristic look. 9 mm · ISO 100 · f/13 · 2.5 sec

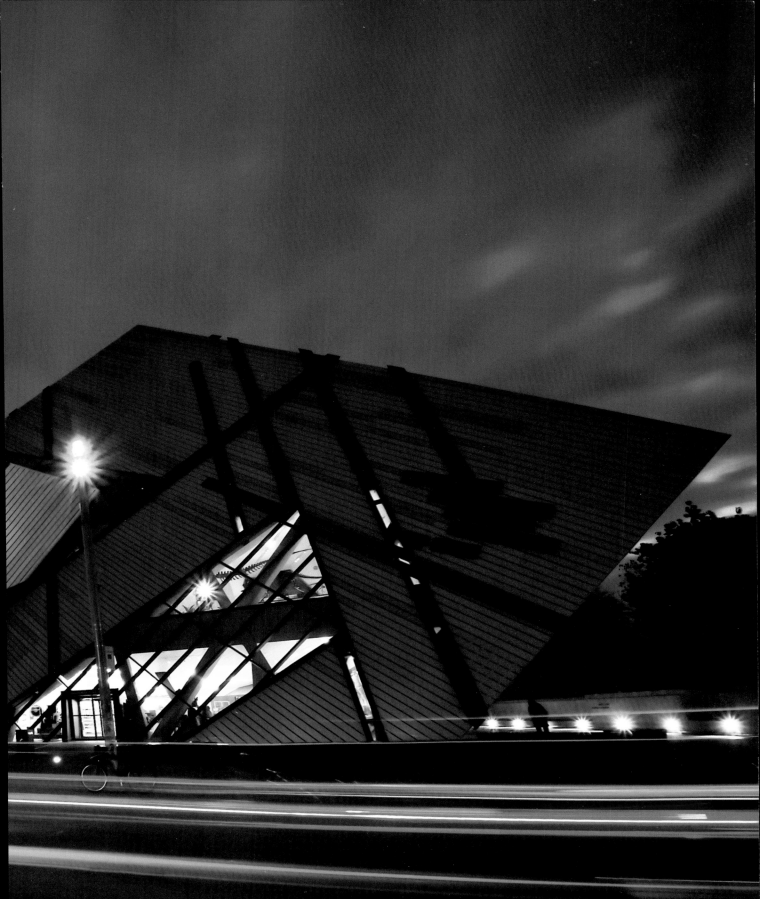

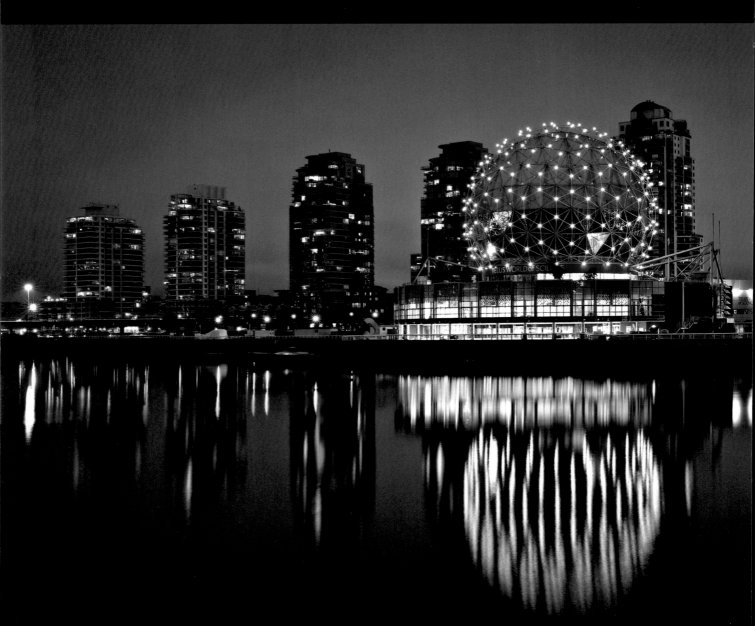

⬆ *Science World · Bad weather seemed to follow me for a great deal of my trip. A couple of days in Vancouver were rainy, which meant that during the day everything had a gray-on-gray look. Therefore, I waited for the evening to capture interesting photos. 28 mm · ISO 100 · f/11 · 30 sec*

CANADA Vancouver

The building that I am standing in front of looks like a giant ship with several sails. The sign says "Canada Place." I have made it to Vancouver. Many people told me I'd be able to see snow-covered mountaintops from here. I look in all directions but don't see any. It must be on account of the fog, which seems to be following me along my route. But I don't give up hope yet.

Further along the water, I pass the extinguished torches of the 2010 Winter Olympics. My own version of athletic achievement currently involves trekking about with my pack for miles on end. Because visibility is continuing to get worse and the damp cold is freezing my fingers, I put my hope in the evening, when the sky is supposed to clear up. Around 3:00 p.m. I make my way to Science World, which is a remnant of Expo '86. It's been turned into a museum and makes a great subject for photographs. It's particularly fetching at dusk when the lights turn on.

The sun still isn't shining the next morning, unfortunately. One of my targets for the day is Stanley Park, where I find several totem poles depicting and explaining the origins of Indian families. At dusk, I discover that the park is an ideal place to photograph the city's skyline. I decide to amble through downtown after taking a few satisfying shots of the city.

My eyes grow into saucers when I spy a gate with a large neon sign that says "German Christmas Market." The discovery spurs feelings of affection for home, so I decide to check it out. I find German bratwurst, liver loaf, mulled wine, brandy punch, and even traditional wood ornaments. Canadians love the idea of a traditional German Christmas market, and have held one here in Vancouver for a couple of years now. I'm more than content to spend the evening here. What a small world!

The extinguished Olympic Cauldron · I would have preferred to capture the torch in bright light, but even the most dedicated photographers have no influence over the weather. 24 mm · ISO 200 · f/2.8 · 1/200 sec ➜

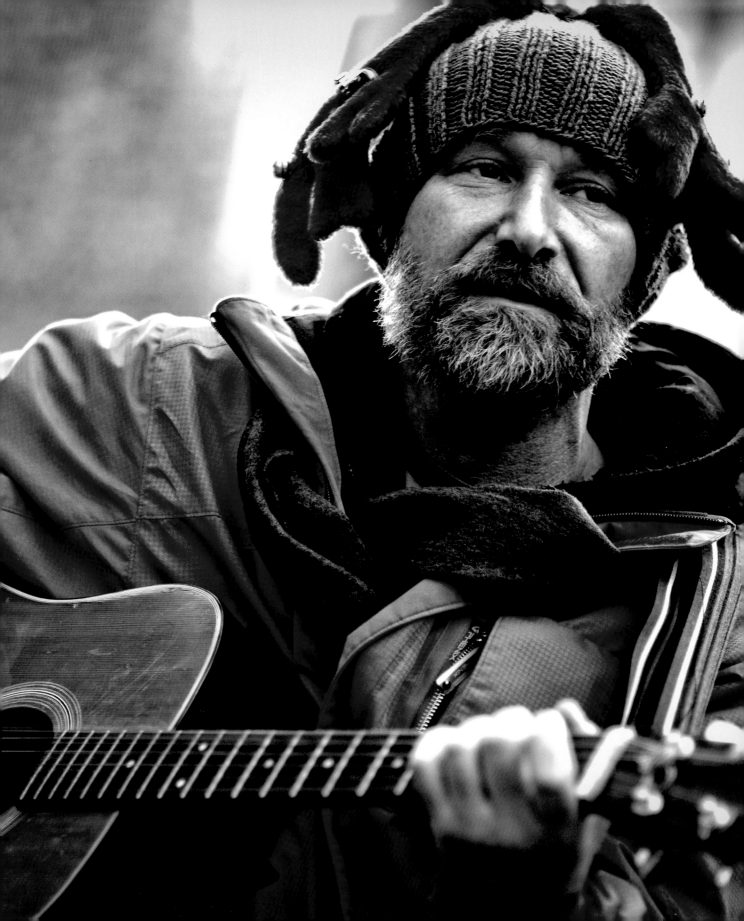

CANADA Vancouver Island

Cold wind stings my ears and my face freezes as I stand on the observation deck of a ferry. However, I quickly forget about the discomfort when I first catch sight of the island ahead. The view is unbelievable. My travels have brought me to Vancouver Island, which lies off the western coast of Canada and belongs to the province of British Columbia, according to seafarer George. At 290 miles long and up to 50 miles wide, the island is as large as Belgium. As I arrive in the capital, Victoria, I scratch my head and inspect my hotel brochure before peering up once more at the medieval-looking castle before me. The sign says "Fairmont Empress Hotel," which leaves no doubt as to my location, so this must indeed be where I am to reside for the next couple days.

Now in a pleasant mood, I head out into the evening to take in my surroundings and the port area. I meet Guy, who has a fantastic voice and is strumming a melancholy tune on his guitar in the Christmas spirit. He's from London, he tells me, but emigrated twenty years ago.

A car helps me get around the surrounding area the following morning. There are a ton of things to see on Vancouver Island: beautiful beaches, picturesque lakes, rain forests, and even the whales, bears, and pumas that inhabit them. I diligently review the instructions for what to do if I happen into a face-to-face meeting with a wild animal. This preventative measure comes in handy a short time later when I am concentrating on photographing a fern in the rain forest with my macro lens. Suddenly, I hear a loud crack come from the underbrush behind me and the hairs on the back of my neck stand up. If only I had invested a few dollars in anti-bear pepper spray. With my heart pounding I slowly turn to face the inevitable and I am standing eye-to-eye with an adorable adult deer. It takes a moment for me to recover from my shock before I have my camera at the ready. Changing the lens would take too much time, so I have to make do with the macro. Click, click, and then the animal is gone.

I'm a bit on edge for the rest of my adventures that day. I visit wonderful lakes that are still enough to reflect the mountains behind them. Once I finally recover from my confrontation with a deer, I muster some courage for a hike through the forest. I pass through dense growths of moss-covered trees and ferns until I come across a bubbling stream. All of it is very enchanting and reminds me of the *Lord of the Rings* movies. I take pictures until dusk starts to settle in. As soon as I have packed my equipment away in my backpack I hear a deep, rumbling bellow that isn't all that far away and is definitely not from a deer. I quickly abandon all of the lessons I've learned about encountering wild animals and sprint to the car in a panic. Time to get out of here.

← Guy, the street musician · He let me take his picture after a short conversation—establishing communication is the best way to get authentic portraits. I used the largest aperture I could so that any potential distractions from my main subject melted away into the blur of the background. 85 mm · ISO 200 · f/1.4 · 1/125 sec

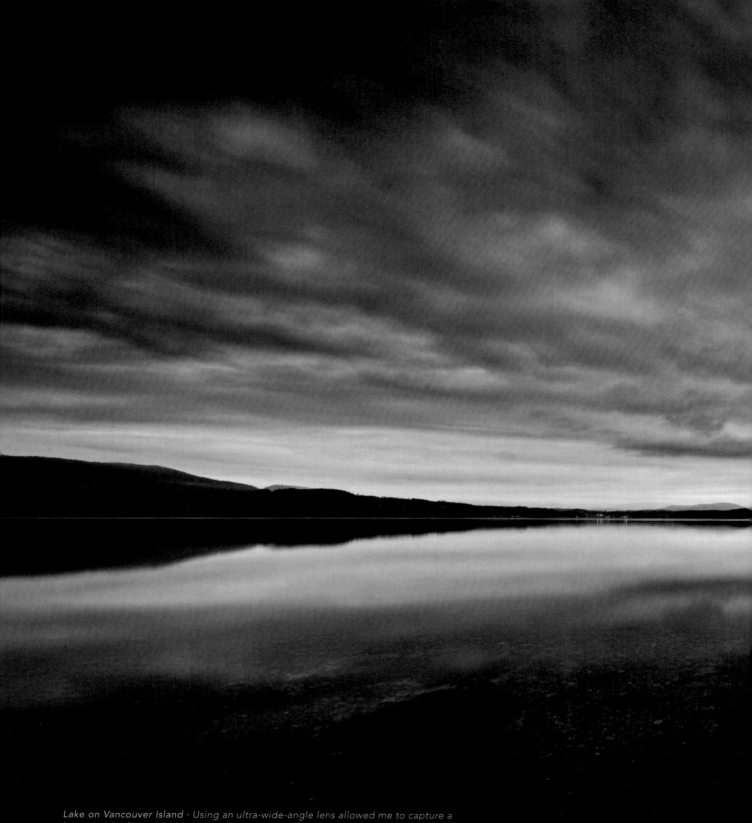

Lake on Vancouver Island · Using an ultra-wide-angle lens allowed me to capture a large swath of the dramatic sky in this picture. I also used a polarizer for this shot, making it possible for viewers to see the bottom of the lake. The finished image was converted into black-and-white. 8 mm · ISO 200 · f/11 · 6 sec

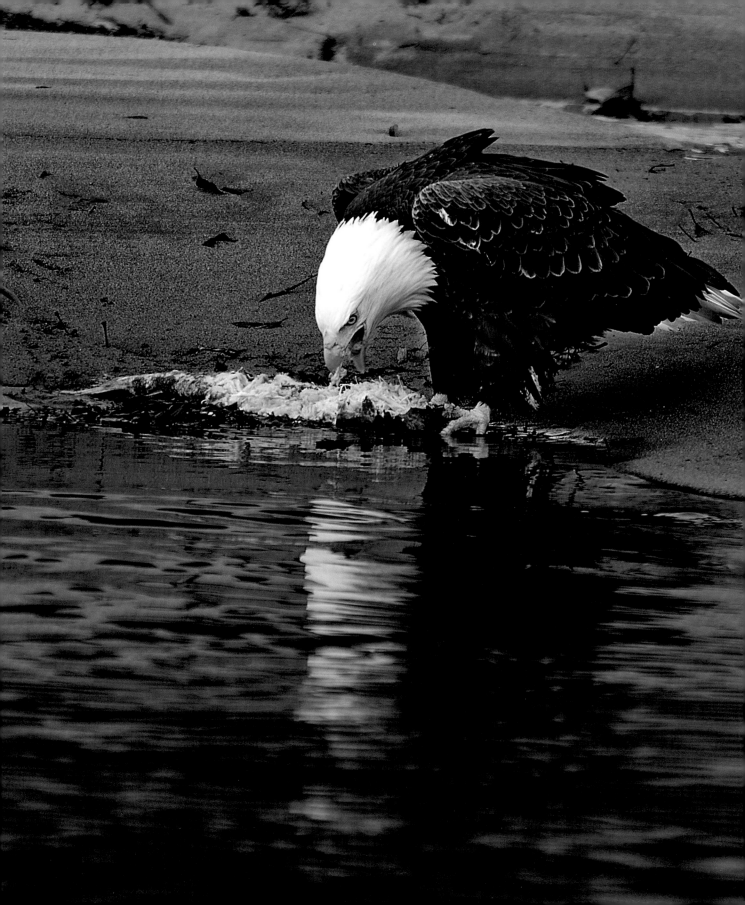

CANADA Whistler

"Today will be a great day," said the rental agent as he handed me my snowboard. A short time later, tears are filling my eyes and my nose is running as I speed down a mountain into a valley. I am in Whistler, one of the most beautiful ski resorts in the world. Athletes in the 2010 Winter Olympics competed here. I must say that a bit of an Olympic feeling washes over me as I shoot down the slopes. The feeling quickly disappears, however, when my board loses its grip on a patch of ice. It's a good thing I brought only my small, secondary camera with me today. Nothing's broken, so I hop up and head further down.

When I reach the peak again, the sun is smiling on me. I savor the heavenly tranquility and the view of the surrounding mountains. It's incredibly beautiful up here, just as it was on the way up to the mountain. The Sea to Sky Highway (Highway 99) offers continuous viewpoints from which you can see magnificent peaks and clear mountain lakes, and it's hard to keep from stopping every twenty feet to take it all in. Tired from all the exercise and fresh air, I fall asleep early in the evening.

I arise early the next morning so that I can be one of the first people on the slopes. My anticipation quickly wanes when I discover that fog has enveloped Whistler, limiting visibility to a maximum of about 30 yards. I explore my options and learn from the concierge about the community of Brackendale, where it's often possible to observe bald eagles in the wild. It sounds like a good alternative so I hop in the car, and an hour later, I'm there. After a bit of waiting, I hit pay dirt and spy one of these majestic birds snacking on a salmon for breakfast. Because the sky is overcast I have to shoot with a wide aperture. I'm extra cautious as I try to get close enough to the subject. These birds are quite imposing, sometimes having a wingspan of up to 90 inches. While I observe how the bird munches on his salmon, I realize that I, too, have grown hungry. I shoot a few more images and then head back to Whistler.

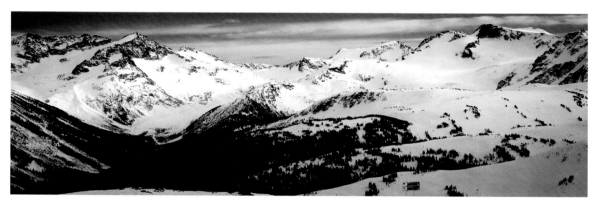

↑ *Whistler Ski Resort · Some of the Winter Olympic events took place here in 2010. When shooting landscapes with snow, the automatic exposure modes on most cameras tend to produce underexposed images. An exposure compensation of +1 is often a good way to go. 42 mm · ISO 200 · f/8 · 1/250 sec*

← *Bald eagle · Bald eagles are found often in the small community of Brackendale. I spied this proud bird of prey while it was eating its salmon breakfast. 200 mm · ISO 200 · f/2.8 · 1/250 sec*

♠ *Sea to Sky Highway (Highway 99) · Grand mountain landscapes alternate with clear mountain lakes along this highway. The small aperture turned the sun into a star, and I applied the tobacco filter while editing the picture later on. 24 mm · ISO 100 · f/11 · 1/800 sec*

CHILE Santiago de Chile and Puerto Varas

I use my first day in Santiago de Chile to get to know the city. I pass brightly painted houses on my way to my first destination: the television tower. According to what I've read, it includes an observation deck high above the city. I'm met by an energetic guard at the entrance who barks, "No publicity," and blocks me from going any further. Okay then, maybe not!

Instead I make my way over to Cerro San Christóbal. The top of the hill is about 1,000 feet above Santiago, and the view from up there is supposed to be spectacular. I am disappointed once I get to the top, however, because a thick haze of smog caused by exhaust hovers over the city. It's hard to see anything. I later learn that the air quality in Santiago ranks among the worst in the world, according to the World Health Organization. Because I'm already up here, though, I look around and discover the 72-foot tall statue of the Virgin Mary. She'll have to do as a substitute subject. A fellow tourist reverentially informs me that Pope John Paul II held mass here on the mountain in 1987. That's something!

The next day I take a plane to Puerto Montt. My guide meets me in the airport and introduces himself with perfect German: "Hallo, mein Name ist Gerd." Amazed, I ask him when he emigrated from Germany to Chile. When he tells me that he has only ever visited Germany for a couple weeks during his entire lifetime, I am confused. But my confusion is cleared up over the next couple hours as he leads me around. Gerd tells me about the German immi-

grants who came to this area and his forebears. I'm somewhat in shock when we arrive at the town of Frutillar, which looks like it could be in the Black Forest. The houses are made of wood and are covered with shingles. There are even German advertising signs that make me quickly forget that I'm thousands of miles from home.

While Gerd continues to tell me about the history of the area, we visit a cemetery where some of the original immigrants are buried. Our tour continues past beautiful landscapes and lakes. The absolute highlight for me is visiting the volcano Osorno, whose snow-capped peak is unusually visible. Last but not least, we visit a small fishing village. Low tide coincides with our arrival and the boats are dry—beautiful photographic subjects.

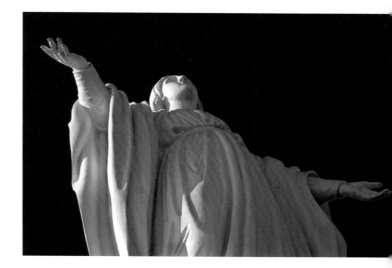

⊷ *Lake in Puerto Varas · The central position of the ship underscores the calm effect of the still water. 10 mm · ISO 100 · f/4 · 1/5 sec*

The Virgin Mary · She stands atop Cerro San Christóbal in Santiago de Chile. The city served as a starting point for my excursions into surrounding areas. 150 mm · ISO 100 · f/2.8 · 1/640 sec ⊹

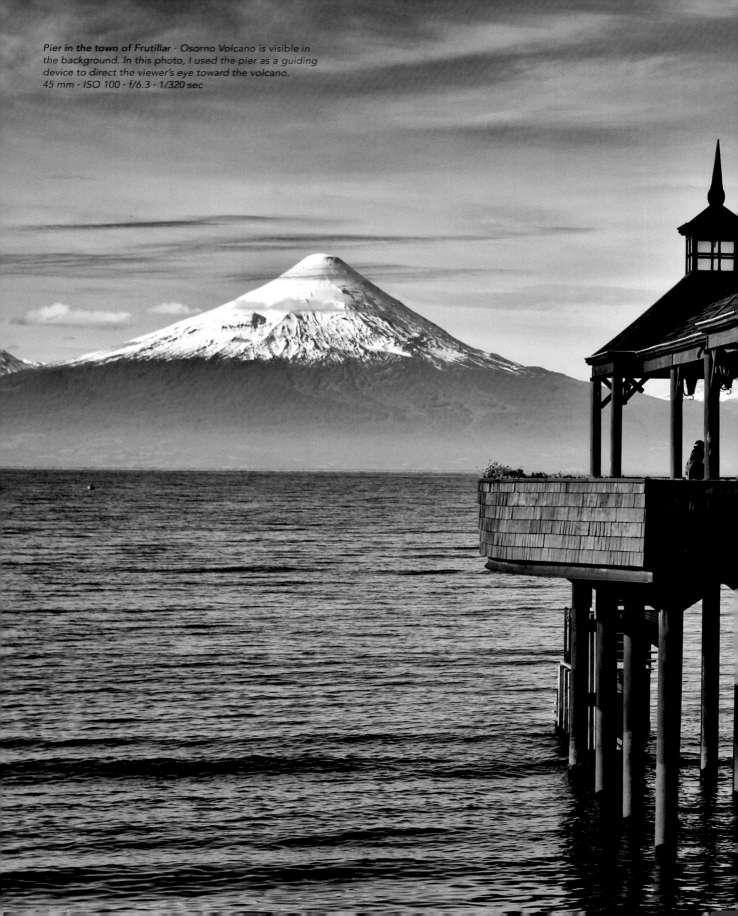

Pier in the town of Frutillar · Osorno Volcano is visible in the background. In this photo, I used the pier as a guiding device to direct the viewer's eye toward the volcano.
45 mm · ISO 100 · f/6.3 · 1/320 sec

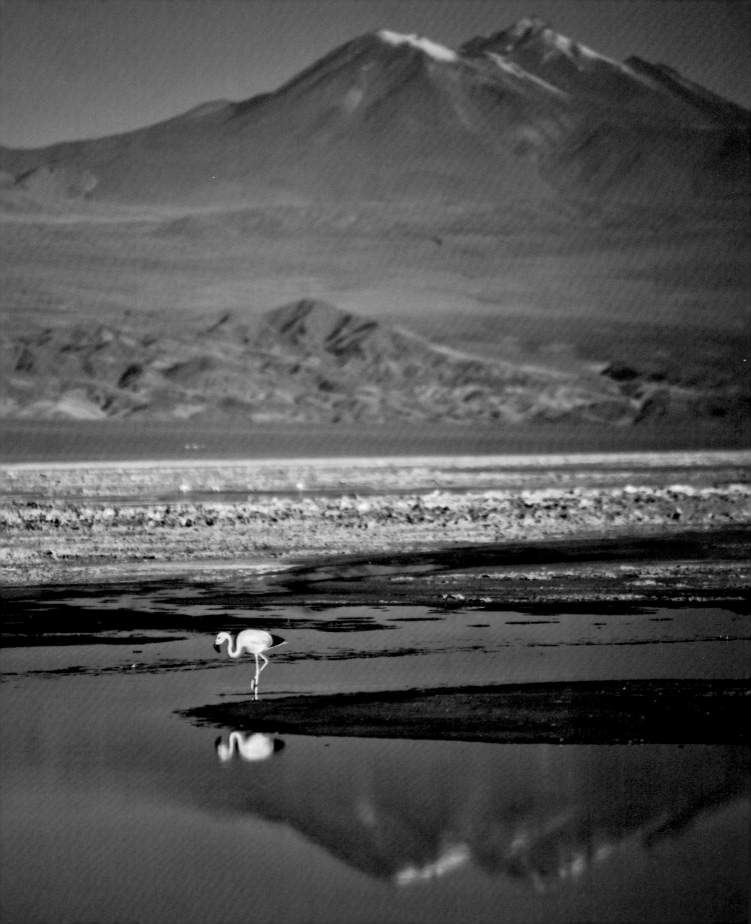

CHILE Atacama Desert

I hear a loud hiss. A fraction of a second is all it takes for my brain to process the noise: I've got a flat! "Take care and don't forget you're in a desert!" warned the rental agent when he handed over the mountain bike I'm riding. Now I'm standing with a flat tire in the middle of the Atacama Desert, the driest desert in the world. There's absolutely nothing around me except dry earth as far as the eye can see. It's the sort of situation that can make a man nervous. Thankfully the rental agent also sent me off with a spare inner tube. I anxiously change the tube because I want to avoid arriving at the same fate as the animals whose dry bones are strewn about the land around me. I pull myself together and ride as carefully as I can onward to the Valle de la Luna. The name says it all here—the area around me looks like a moonscape. The sun slowly sinks below the horizon and the landscape is bathed in a romantic light.

The next day I've got a less dangerous itinerary that involves a daytrip led by a guide. I've had enough of bicycling for now. Our bus first takes us to a typical desert village. All of the buildings here are small and simple with walls are made out of adobe. The large number of stray dogs is also conspicuous. One that I come across resembles a German shepherd—maybe he came over with German immigrants as well?

We travel on through the craggy and dry countryside, which every now and then is broken up by a green oasis of bushes and trees. Setting these in the foreground with volcanoes in the background makes for an enticing composition—later this would become one of my favorite subjects. Today's main attraction is the Salar de Atacama, the largest salt flat in Chile. If you're lucky you can see various types of flamingos here. There are some hanging out when we arrive, but they're so far away that even my telephoto lens doesn't bring me close enough. Oh well. The unmatched scenery and its striking subjects are thoroughly inspiring.

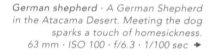

← Flamingo · One finds these proud animals often at the largest salt flat in Chile, the Salar de Atacama. 200 mm · ISO 100 · f/2.8 · 1/3200 sec

German shepherd · A German Shepherd in the Atacama Desert. Meeting the dog sparks a touch of homesickness. 63 mm · ISO 100 · f/6.3 · 1/100 sec ✦

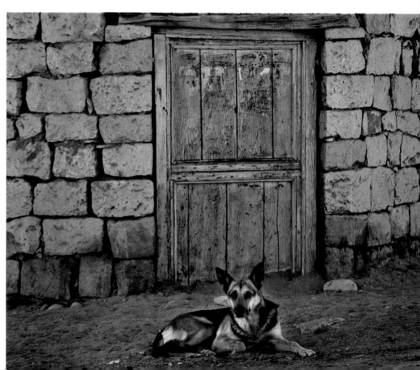

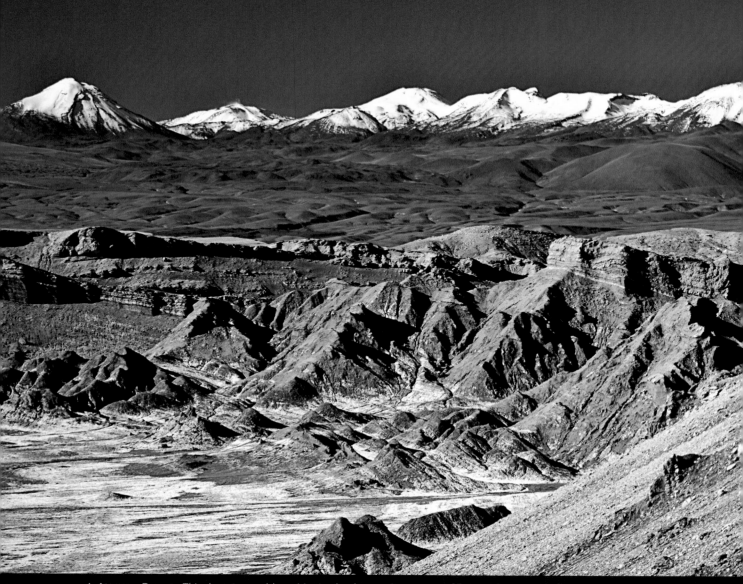

↟ *Atacama Desert* · This desert resembles a Martian landscape. As a matter of fact, NASA tested its Mars rovers here before they were sent on their distant missions. 70 mm · ISO 100 · f/4 · 1/400 sec

◂ *Sandy desert* · The Atacama Desert comprises more than just rubble; it also features sand hills. I went for a purist composition here. 70 mm · ISO 100 · f/4 · 1/250 sec

Atacama Desert at sunset · The red light bathed the large boulders in an attractive light. 24 mm · ISO 100 · f/7.1 · 3/5 sec ➜

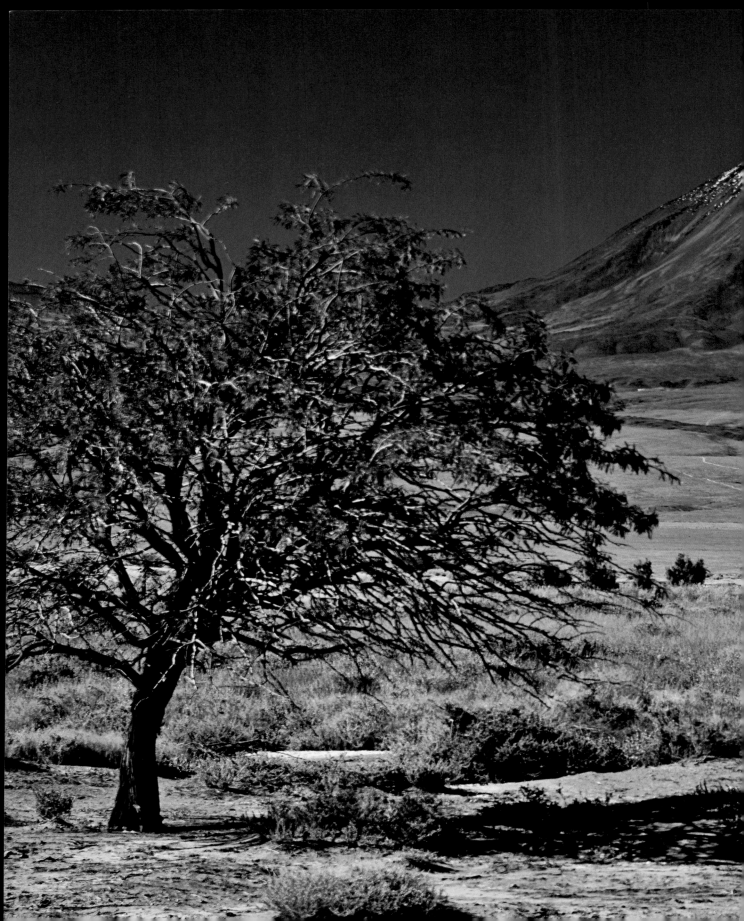

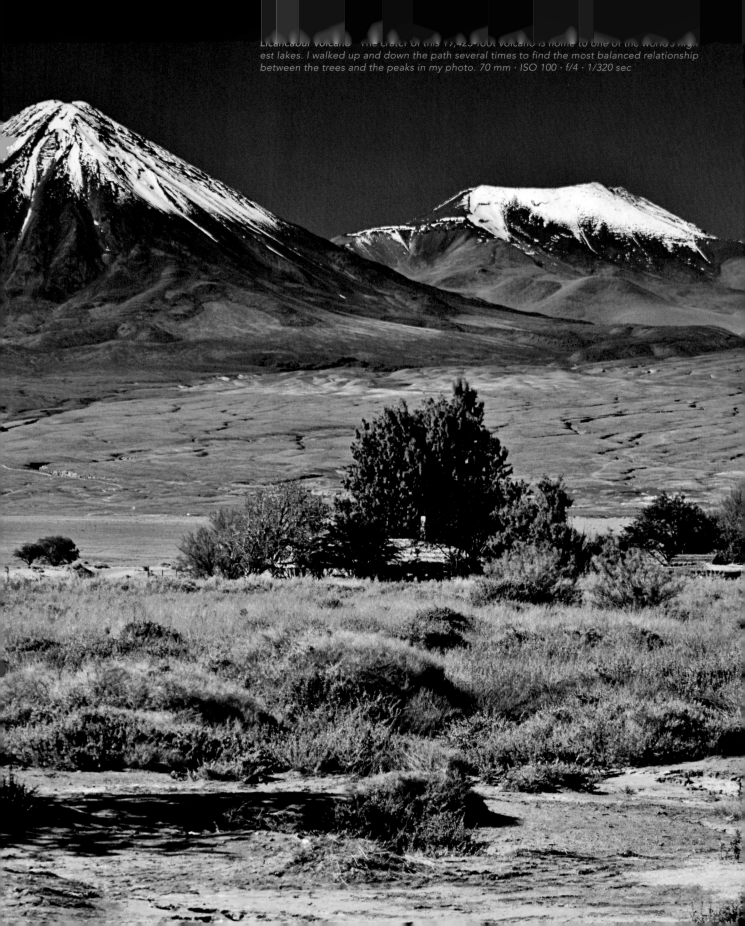

Licancabur Volcano · The crater of this 19,423-foot volcano is home to one of the world's highest lakes. I walked up and down the path several times to find the most balanced relationship between the trees and the peaks in my photo. 70 mm · ISO 100 · f/4 · 1/320 sec

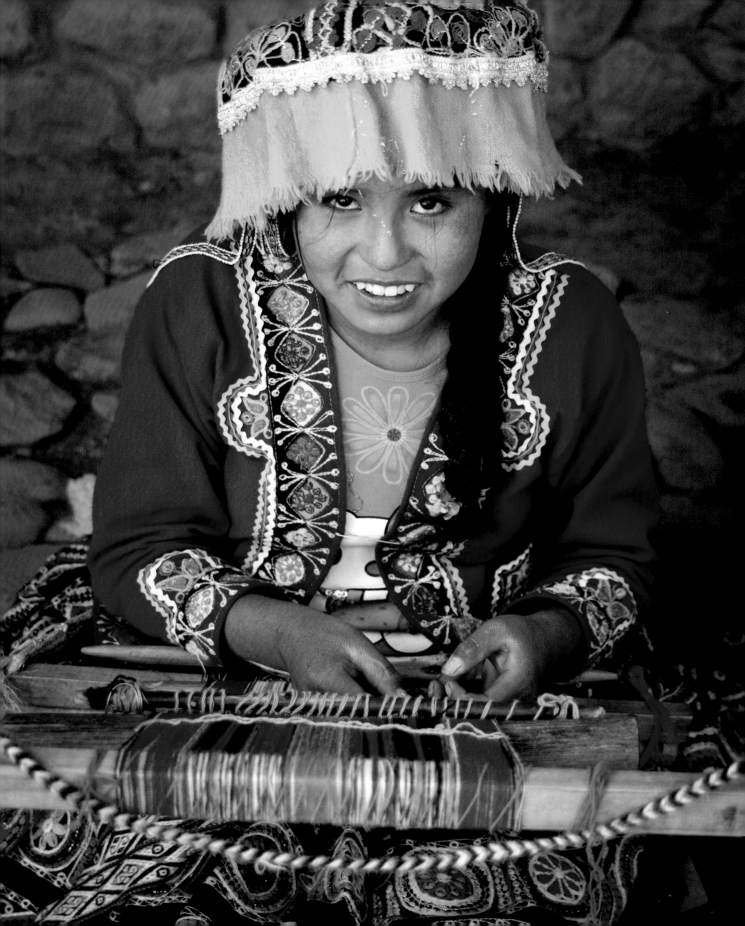

PERU Machu Picchu and Highlands

It's seven o'clock in the morning and a thick fog surrounds me. I'm a little disoriented, standing on a mountain at an elevation of 8,000 feet as I try to decide which direction to point my camera. All of a sudden a white llama appears next to me. It's probably just a hallucination induced by the coca leaves I've been chewing to help with altitude sickness. Nope, the llama is just as real as the city that slowly emerges in front of me as the rising sun dissipates the fog. A magic moment. Riveted, I watch as the city appears right in front of me: the lost city of the Incas, Machu Picchu. This moment is definitely the highlight of my brief travels in Peru.

My mountain bike tour through the Peruvian highlights with José, my guide, is also spectacular. At one point we climb up to 8,000 feet in elevation, where the air is pretty thin. Gasping for air, I do my best to capture the beauty surrounding me with my camera. Our break lasts for only a minute before we start our descent. "Keep your weight behind your saddle and keep your arms long and loose," are José's instructions. This easier said than done if you're also packing expensive camera equipment. With time I get more confident and brave, but I never forget that there's a steep precipice a couple of feet away, which could easily bring Our World Tour to a premature end. I'm relieved once I discover that the grade is flattening out. We pass some donkeys and farmers that make for perfect subjects. The final stretch takes us to the famous salt terraces in Maras, where salt is harvested in the traditional way from hundreds of ponds.

◆ *Traditional dress · The bright, colorful clothing of this young girl caught my attention. As soon as she smiled directly at the camera, I pressed the shutter button. 37 mm · ISO 200 · f/2.8 · 1/200 sec*

Alpaca wool · The increase in sharpness and the warm yellow of the yarn direct the viewer's attention to the round ball of wool. 51 mm · ISO 100 · f/3.2 · 1/125 sec ◆

On the agenda for the next day is a tour with Maria. She shows me an Inca temple and other constructions. The circular terraces of Moray are the most interesting to me. Some people believe that they were constructed with the help of extraterrestrials. The view into the life of a typical farmer is also a high point. I love finding out about the production and processing of alpaca wool.

Peru has a rich history and fantastic landscapes. It's easy to feel as though time stands still here. The people live in mostly simple conditions, but they seem satisfied and are very friendly. One thing I know for certain is that I'll be back!

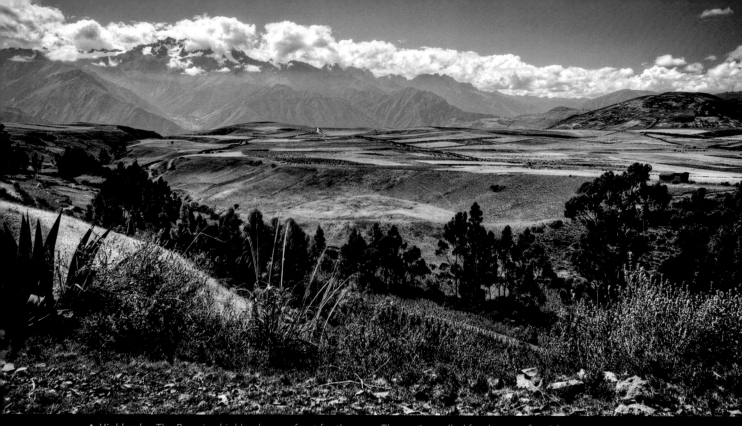

↟ **Highlands** · The Peruvian highlands are a feast for the eyes. The setting called for the use of a wide-angle lens and a polarizer to capture saturated colors. 20 mm · ISO 100 · f/5.6 · 1/200 sec

Farmer · The highland farmers are reserved but friendly. They don't own much, but they seemed thoroughly happy and enjoyed being photographed. 37 mm · ISO 100 · f/9 · 1/200 sec ↡

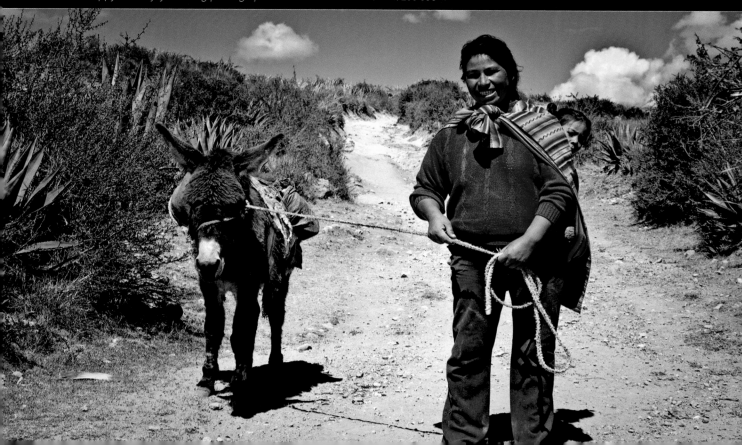

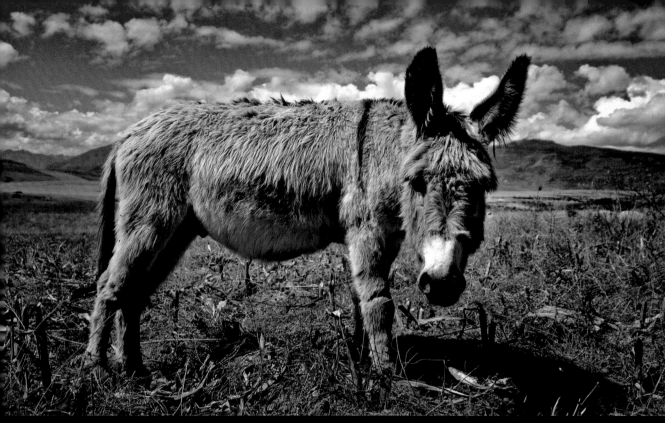

Animal encounter · Out of nowhere a cute, little donkey greeted me in the middle of a vast landscape.
24 mm · ISO 100 · f/5 · 1/500 sec

The famous Inca terraces of Moray · Some people believe these were created by extraterrestrials. Fittingly, I opt to take a photograph looking down at the terraces from above. 24 mm · ISO 100 · f/5 · 1/250 sec ✦

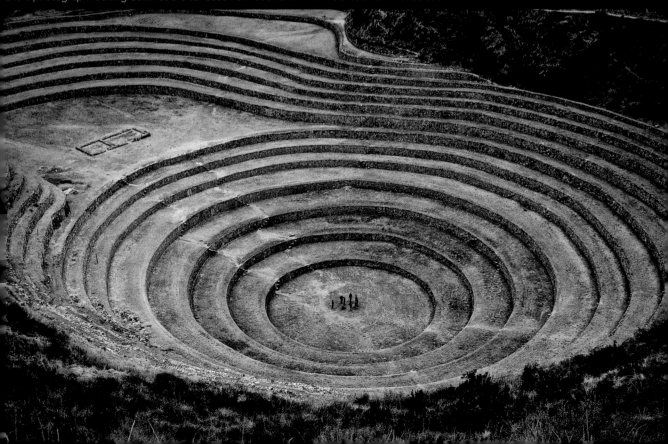

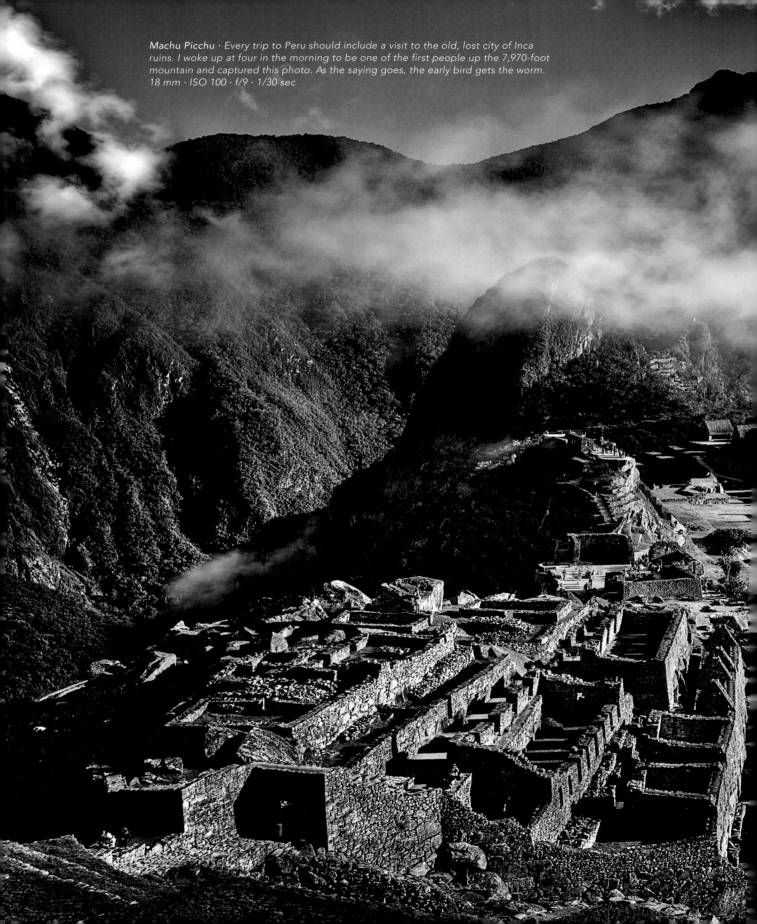

Machu Picchu · Every trip to Peru should include a visit to the old, lost city of Inca ruins. I woke up at four in the morning to be one of the first people up the 7,970-foot mountain and captured this photo. As the saying goes, the early bird gets the worm. 18 mm · ISO 100 · f/9 · 1/30 sec

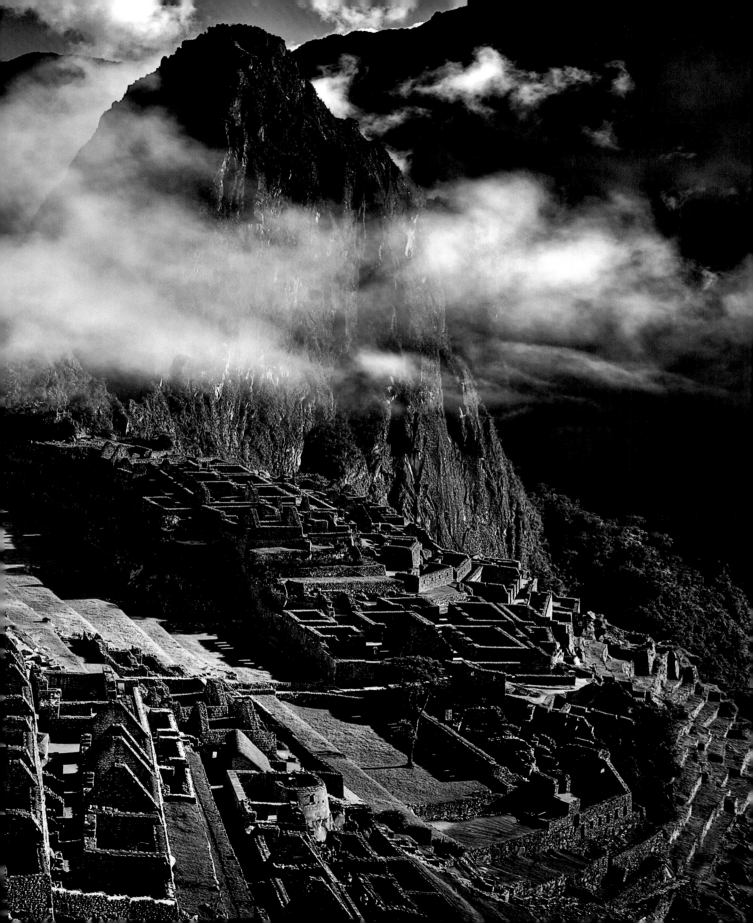

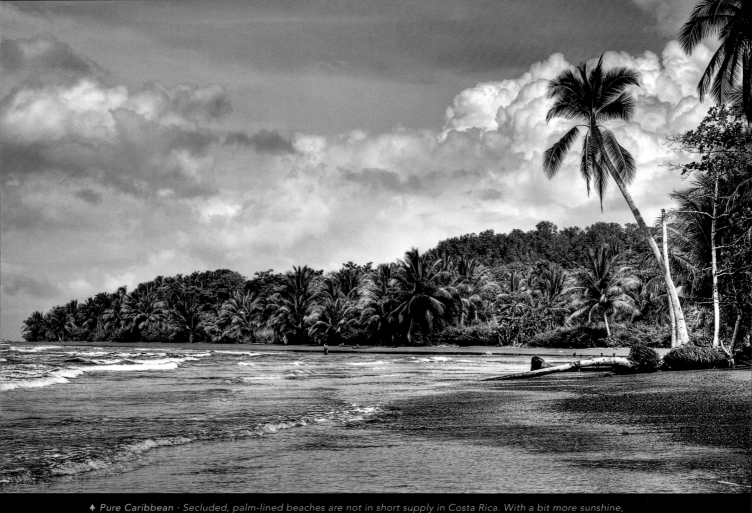

♠ *Pure Caribbean · Secluded, palm-lined beaches are not in short supply in Costa Rica. With a bit more sunshine, they make the perfect subject for a vacation advertisement. 12 mm · ISO 100 · f/3.5 · 1/250 sec*

COSTA RICA Costa Rica

I've hardly covered a few yards with my guide before it starts raining cats and dogs. In a matter of seconds I'm soaked through worse than I've ever been before. I'm in the Corcovado National Park in Costa Rica. Even the subsequent thunder and lightning don't prevent my guide from trudging on with his tour. Shaking like a leaf, I try to follow his gestures and explanations. "The advantage of the rain is that the animals won't hear us coming," he tells me optimistically. The disadvantages are a bit more serious for me: I can't see anything because of the steady downpour and I can't use my camera because it would be wrecked within moments. So I trot along for the three-and-a-half hours like a soaked poodle, listening to his descriptions about the diverse plants and animals present in the national park.

"This is what the rainy season is like—you'll just have to manage," said the unfazed guide. Before we head back on the boat, the rain finally lets up for a moment and I'm able to shoot some pictures. But the tropical rains follow me for the next couple days and continue to make my photography objectives difficult.

My multiday tour through the wild south of Costa Rica takes me from the capital San Jose through Cartago and into the mountains. I drive along the Pan-American Highway over the Cerro de la Muerte, which is the highest pass in Costa Rica at an elevation of 11,322 feet. Rain and fog alternate at this altitude, making the surrounding volcanoes impossible to see, but every now and then I catch a glimpse of the beautiful mountains. My journey continues on past typical houses and interesting churches. A long, green snake slithers across the road at one point and I encounter large iguanas all over.

Eventually I arrive at another national park, Manuel Antonio, where I have a little bit better luck with the weather and Costa Rica's famous flora and fauna. The poison dart frog is my favorite. This one-inch frog secretes a poison on its skin that indigenous Columbian tribes added to the tips of their arrows to further harm their prey.

Costa Rica is really a beautiful and varied country. The diversity of plants is gigantic and the beaches are too. But make sure you know when the rainy season is before planning a trip.

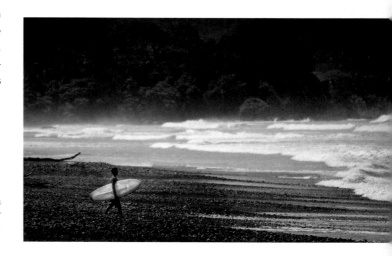

Costa Rica's Pacific coast · This surfer's paradise is known for its beautiful beaches. The sand here is darker than that of the beaches on the Caribbean coast. 200 mm · ISO 100 · f/2.8 · 1/1200 sec ➤

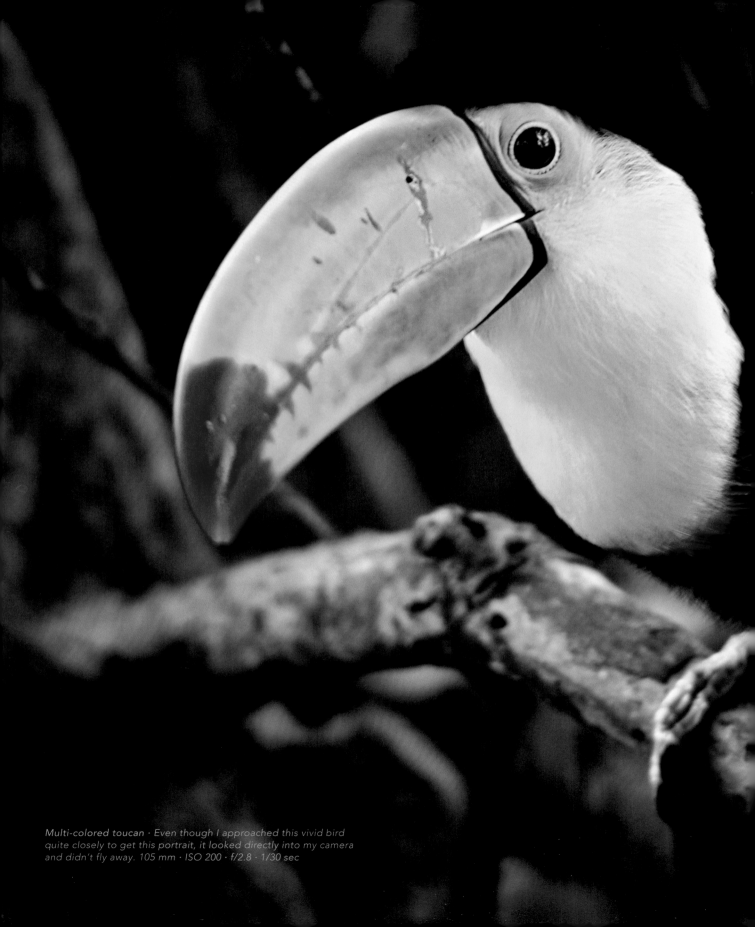

Multi-colored toucan · Even though I approached this vivid bird quite closely to get this portrait, it looked directly into my camera and didn't fly away. 105 mm · ISO 200 · f/2.8 · 1/30 sec

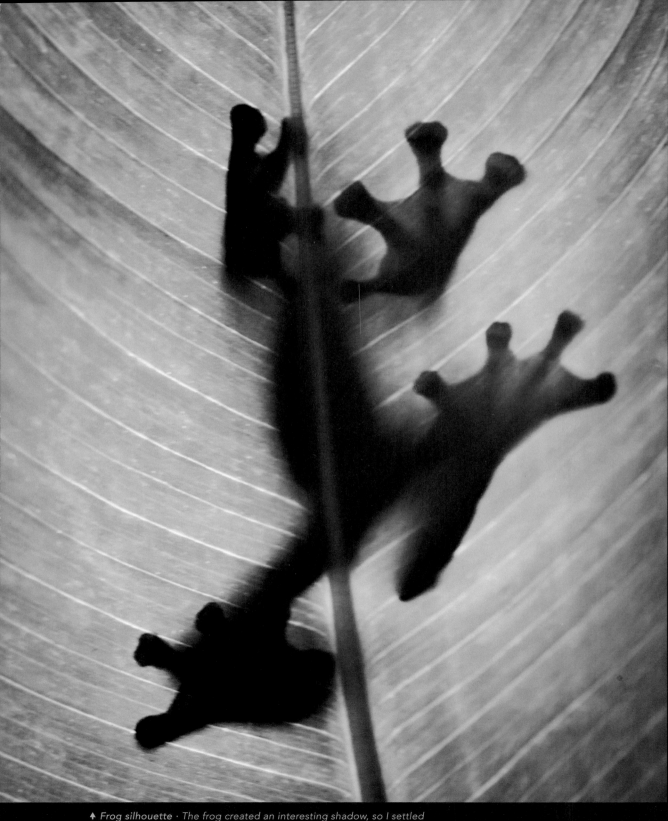

♠ **Frog silhouette** · *The frog created an interesting shadow, so I settled on this backlit exposure. 70 mm · ISO 200 · f/2.8 · 1/60 sec*

♠ **Wind and weather** · Costa Rica's landscape is worth seeing even during the rainy season. A wide-angle lens allowed me to include both the gloomy sky and the brilliant green landscape. 20 mm · ISO 100 · f/5.6 · 1/250 sec

Red-eyed tree frog · The frog's colors are fascinating, and because it was sitting so still, I had plenty of time to capture them. It was quite dark, so I had to use a really large aperture. Doing so allowed me to put emphasis on the frog's eyes. 70 mm · ISO 200 · f/2.8 · 1/125 sec ♥

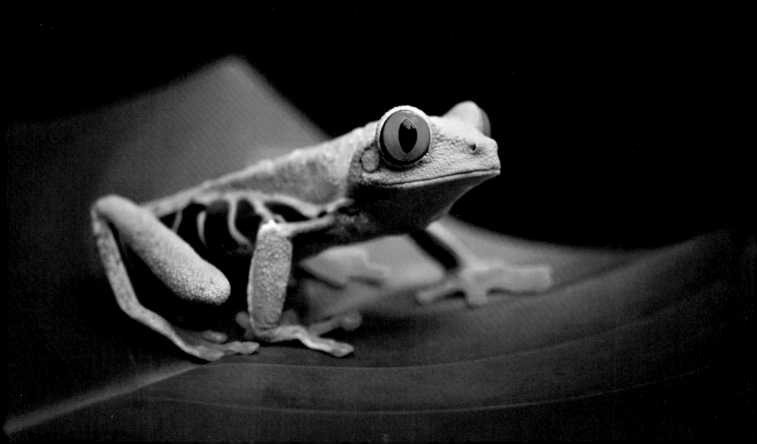

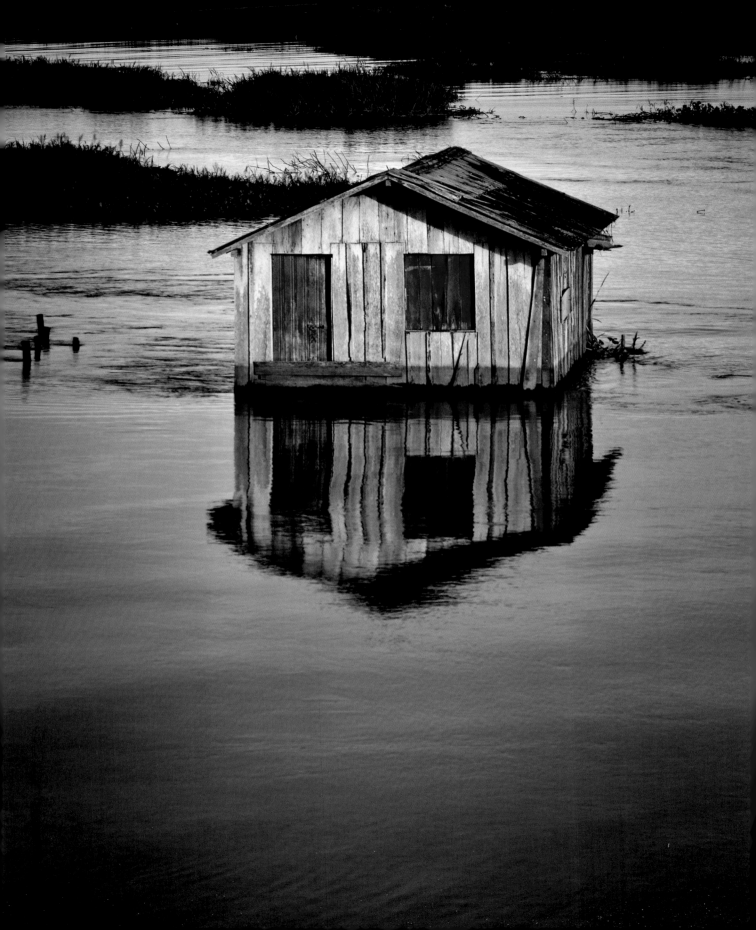

BRAZIL Manaus and the Amazon

The tour boat is only large enough for eight people plus the crew, and it definitely rocks when I first step onto it. I move into my cabin, which is a good 20-square-feet, and I can't help but feel like I've gone back to my childhood. The ropes are released and we cast off. I am en route up the Amazon, which is the largest river in the world in terms of volume of water flow, and at 4,000 miles, it's the second longest. We cruise past the city of Manaus. I'm totally confused after our first few miles when I see abandoned huts, half of which are submerged under water. Cats helplessly hang about on the roofs and are half starved to death. At a loss, I take some photos as the guide explains to me that the water level is currently at the highest level that has ever been recorded. In some cases, entire towns flooded and thousands of people are without homes. It is a devastating catastrophe that I had heard absolutely nothing about until now.

The next morning we wake up early and paddle up tributaries of the Amazon in a canoe. The light creates fetching reflections on the surface of the still water. We head into the jungle for a tour and visit a typical Amazonian family. As we visit, the women are peeling cassava tubers from which cassava flour is made.

The highlight of the day is a fishing tour. Normally this might not be all that exciting, but this time we use pieces of meat as bait because we're on the search for piranhas. It doesn't take long for me to catch a wriggling monster on my hook. In just a matter of minutes, a school of piranha can use razor-sharp teeth to devour an entire cow down to the bones in a feeding frenzy. This particular fish is in luck, though, because I returned it to freedom right after its photo shoot.

◄ Abandoned house · The view from the water of this entrapped house is simultaneously fascinating, surreal, and frightening. Water, water everywhere.
70 mm · ISO 200 · f/2.8 · 1/1250 sec

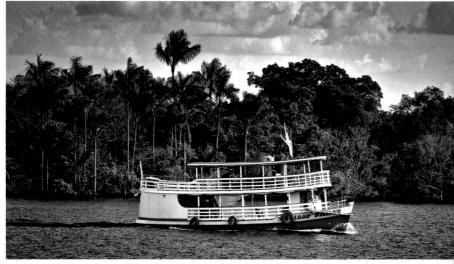

Clipper · I highly recommend a multiday trip on a so-called clipper up the Amazon. It is an incredibly remarkable experience.
200 mm · ISO 100 · f/2.8 · 1/1000 sec ➤

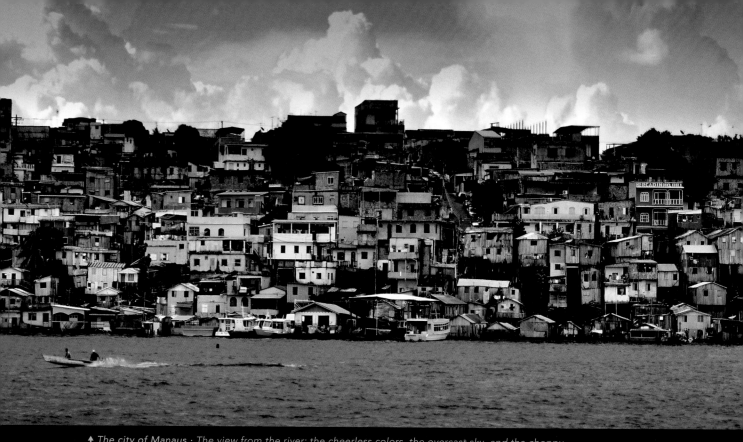

↟ *The city of Manaus · The view from the river: the cheerless colors, the overcast sky, and the choppy surface of the water make for a dramatic image. 24 mm · ISO 100 · f/3.5 · 1/500 sec*

Flood disaster · The Amazon was flooded to 50 feet above sea level in this area. The view was arresting. 200 mm · ISO 200 · f/2.8 · 1/800 sec ↡

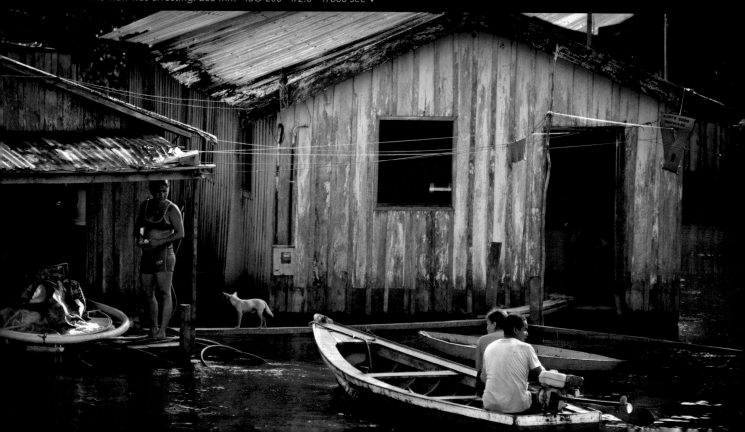

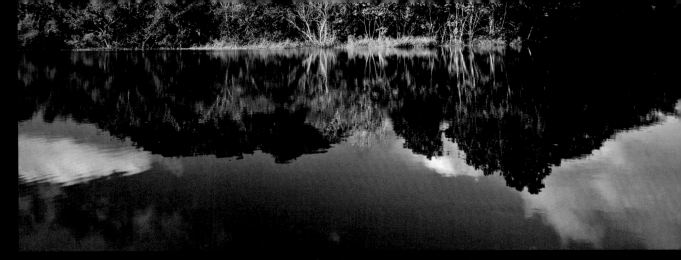

↟ *Rain forest · The dense brush on the banks of the Amazon offered countless photographic subjects. I decided to capture a reflection in the surface of the water. 20 mm · ISO 200 · f/3.5 · 1/400 sec*

Green iguana · My telephoto lens came in handy once again, allowing me to discover unusual creatures and photograph them without being noticed. 200 mm · ISO 200 · f/2.8 · 1/400 sec ↡

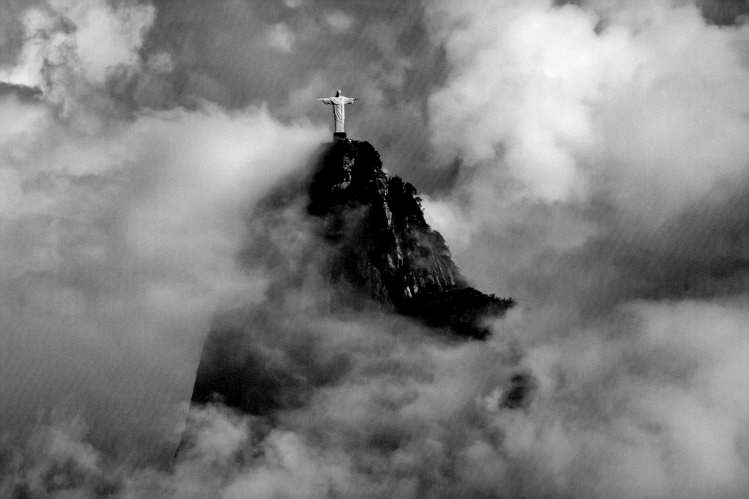

BRAZIL Rio de Janeiro

"Her name was Lola, she was a showgirl..." This old Barry Manilow song pops in to my head as I stare out at the dreamy Copacabana. I'm standing on Sugarloaf Mountain in Rio de Janeiro looking down into the valley. I took a tram up here an hour ago, and a feeling of Hollywood hovered in the gondola cars: James Bond and his nemesis Jaws were involved in a famous chase scene here in the 1979 movie *Moonraker*, starring Roger Moore. The clouds parted for a moment at a stopover on the way up the mountain and the statue of Christ and part of the 2,329-foot Corcovado came into view in the distance. The statue, like Sugarloaf, is a must for anyone who visits Rio. I was quite impressed by "Christo Redentor" (Christ the Redeemer), as locals call the statue.

Naturally, I make a trip to the top of Corcovado as well. A rack and pinion railcar makes for a leisurely trip up the hill, while a small music group treats travelers to the sounds of samba. Soon I arrive at the top and I'm surrounded by tourists who swarm around the statue like bees. Fortunately, the view of the statue and the surrounding landscape is fantastic. The clouds in the sky even create an interesting backdrop for my main subject.

In the afternoon I make the short walk from my hotel to Ipanema beach, which is a gathering spot not only for Rio's bathing beauties, but also for locals looking to surf the beautiful waves. I'd love to get a board and plunge into the waves, but that's obviously not possible with my camera gear.

As the sun slowly sinks in the sky it casts a warm glow on the beach. The last surfers climb out of the water and throw one final longing glance at the waves they've left behind. Now it's time to head back to the hotel because Rio isn't the safest of cities after dark.

Several locals warned me against walking around at night with my assortment of expensive camera equipment. But because the light this evening is so fantastic, I can't pass up the chance to shoot more. So I head up to the roof of my hotel, where I capture Copacabana beach with Sugarloaf in the background. One final pining glance, a quick "Ah, what a view," and then it's time to pack my bags.

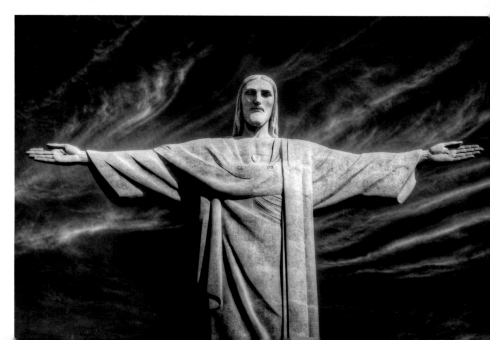

Christ statue · The HDR treatment makes the clouds in the background look striking. 35 mm · ISO 100 · f/7.1 · 1/100 sec ➔

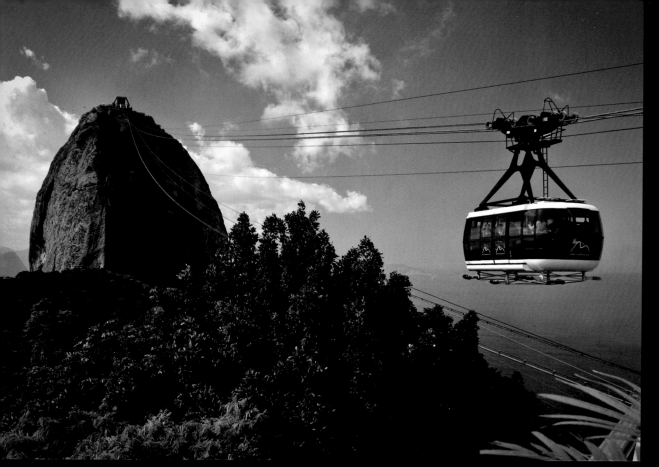

⬆ *The ride up to Sugarloaf · These gondola cars played a role in an old James Bond movie.*
17 mm · ISO 100 · f/5 · 1/125 sec

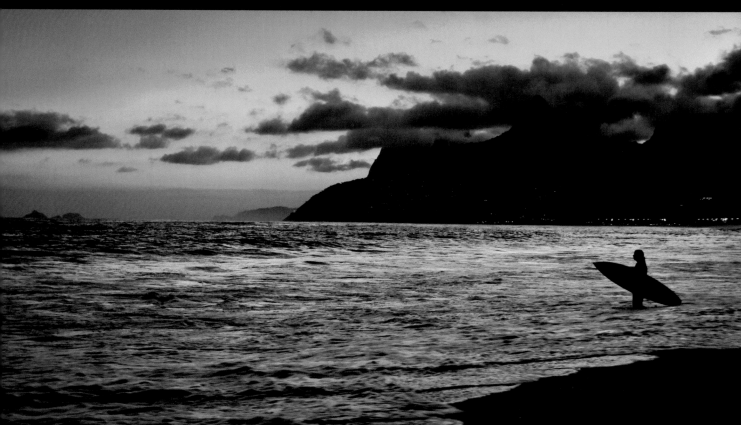

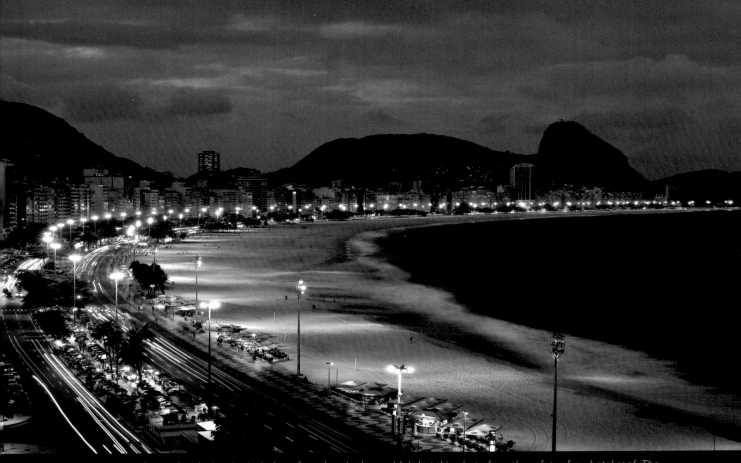

↑ *Copacabana* · Rio de Janeiro isn't the safest place in the world. I shot this photo from the safety of my hotel roof. The long exposure time resulted in interesting traces of light and velvety waves. *33 mm · ISO 100 · f/9 · 6 sec*

← *Beautiful sunset at Ipanema beach* · A surfer takes one final look out at the ocean. He is identifiable only by his silhouette—a striking effect. *30 mm · ISO 200 · f/2.8 · 1/40 sec*

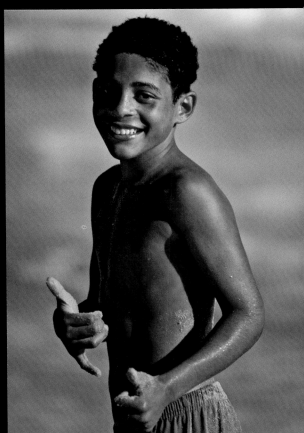

Brazilian boy · As soon as this youngster spotted me and my camera, he gave a big smile and flashed the universal surfer's hand signal: hang loose! Portraits like this one have a stronger effect when shot with a wide aperture. *200 mm · ISO 100 · f/2.8 · 1/1600 sec* →

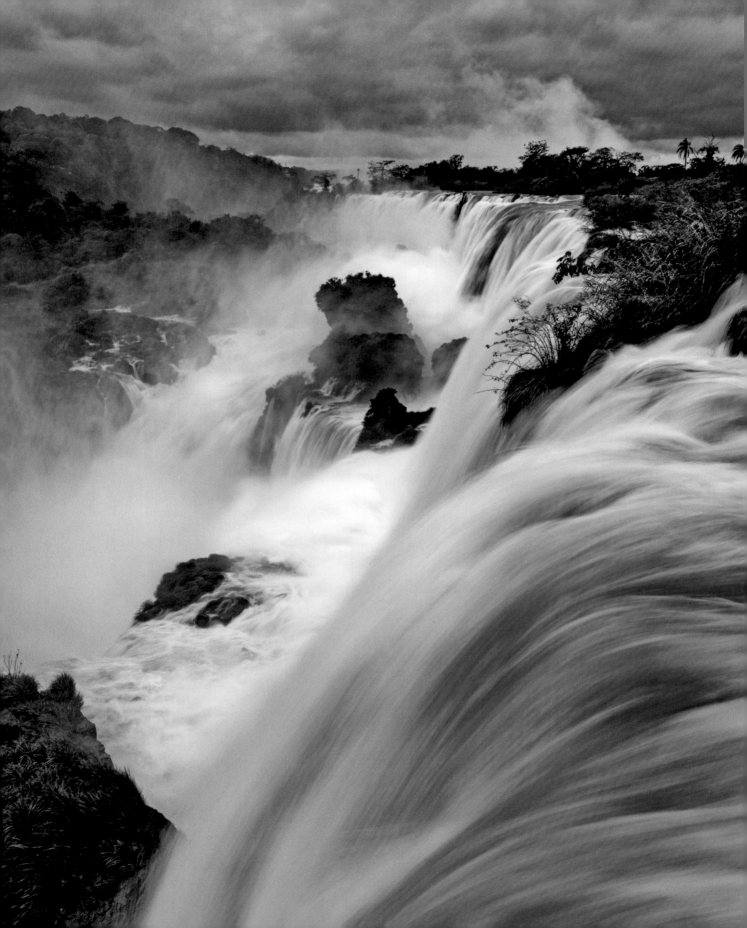

BRAZIL Iguazu Falls

Water rushes through the valley with an ear-splitting roar and a fine mist covers my skin and camera lens. Once again I'm standing with a slack jaw and bulging eyes in front of one of Earth's natural wonders, Iguazu Falls.

This spectacle of nature, which comprises 20 large falls and 255 smaller ones, is located between the Brazilian state Paraná and the Argentine province Misiones. The better part of the falls is about 210 feet tall, but some parts are as high as 269 feet. The volume of water that flows through the falls ranges from 1,500 to over 7,000 cubic meters per second, depending on precipitation. Today, some 5,000 cubic meters of water rush through the valley every second. With these striking numbers, it's no surprise that the waterfall is a UNESCO World Heritage site.

My hotel is located on the Brazilian side, from which you can generally get better panorama views. As a result of heavy rains and unfavorable winds, however, the spray from the falls is troublesome. The thick mist obscures my view and forces me to wipe off my lens to no end. I'm a little nervous about the situation because I have only this one day to take pictures.

I decide to try my luck on the Argentine side, where the panoramic view is lacking but the wind is now at my back and I'm a little closer to the falls. The gathering clouds steal some of my light, but the resulting lighting underscores the imposing power of the falls.

Tip: Photos can convey only a portion of the size and power of Iguazu Falls, which is taller than Niagara and broader than Victoria Falls. It is a spectacular attraction, and if you're ever in South America, it's one that you should definitely not pass up.

← *Spectacle of nature · The unbelievable quantity of water, the deafening roar, the whipping mist, the ominous clouds in the background—all in all, a scene of intensity! 16 mm · ISO 100 · f/22 · 1/5 sec*

Head-on · The frontal perspective shows a different, quieter side of the falls. 48 mm · ISO 100 · f/22 · 1/2 sec →

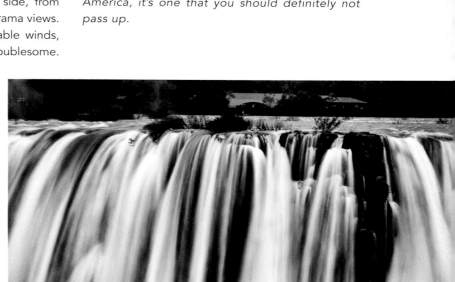

Africa

CAPE OF GOOD HOPE
THE MOST SOUTH-WESTERN POINT
OF THE AFRICAN CONTINENT

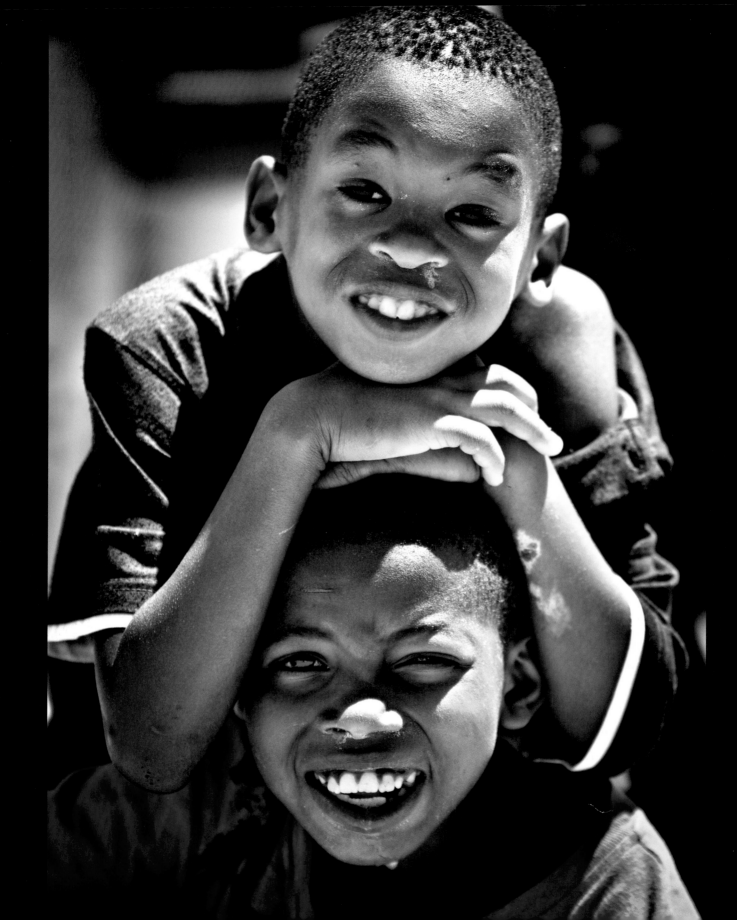

SOUTH AFRICA Cape Town

A loud crash is followed by a spray of water that hits my lens. The roaring waves provide a small glimpse into the violent forces present where the Atlantic and Indian Oceans meet. I am standing on the southernmost point of Africa—the Cape of Good Hope—taking in the view. And then it happens in the blink of an eye: a baboon jumps through my car window and tugs at my photo backpack. Thankfully, it's too heavy for him and he makes do with my can of provisions instead. I'd been warned of such occurrences, but I never imagined I'd have an encounter like this with a wild monkey. Nevertheless, Cape Town fascinates me. I didn't realize that I would come across such a diversity of wildlife. I come face to face with ostriches; penguins; antelope; tortoises; and cute, little rock dassies; but I also meet a snake that quickly slithers past me.

My tour leads me up to Table Mountain. The top of the mountain sports a fantastic overview of the city, but today the mountain is covered by the well-known "table cloth" of clouds and it's very cold and foggy at the top. Signal Hill, my next stop, also offers a sweeping view of the city that meanwhile has been bathed in evening's glow.

The next morning I head out on a historical excursion. The tour covers District Six, the history of apartheid, Nelson Mandela, and "Ubuntu," as my African guide explains with an open smile. We eventually arrive at the vast, outlying townships, where I observe what it really means to be poor. There are rickety shacks and tin huts, and many children whose toys are made out of old plastic bottles and car tires. But they're having fun and they laugh heartily when I show them the photos I've taken with my camera. Despite the impoverished circumstances, they seem to be carefree and happy. I decide to spend some money on school supplies and toys for the community, and I leave these poor settlements with mixed feelings.

I continue on to the colorful Bo-Kaap part of town, where the first freed slaves settled in 1834. I come across rows of colorful houses and beautiful architecture. Because South Africa, the Cape region in particular, is known for good wines, I take one more detour into the idyllic wine country. I round out my stay in the area by watching the sunset from the Bloubergstrand beach and casting one last look up at Table Mountain.

◄ *Kids playing in the townships · Communication is the simplest and best means for taking natural, relaxed portraits. These two struck this pose on their own. 137 mm · ISO 200 · f/2.8 · 1/1250 sec*

Arriving, finally, at the Cape of Good Hope · Simple signs make a useful subject for documentation. I opted for a head-on perspective to avoid distortions. 45 mm · ISO 100 · f/6.3 · 1/800 sec ➔

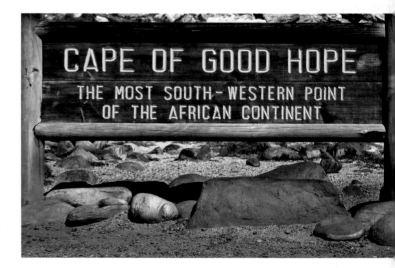

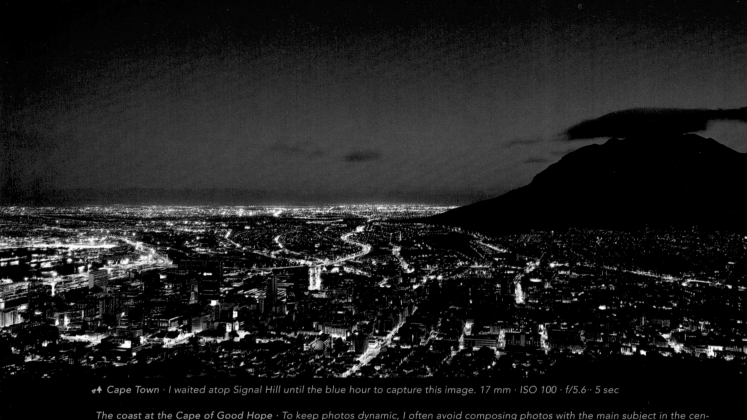

Cape Town · I waited atop Signal Hill until the blue hour to capture this image. 17 mm · ISO 100 · f/5.6 · 5 sec

The coast at the Cape of Good Hope · To keep photos dynamic, I often avoid composing photos with the main subject in the center of the image area, opting instead to shift the subject to the left or right of the picture. 200 mm · ISO 100 · f/7.1 · 1/1000 sec ♥

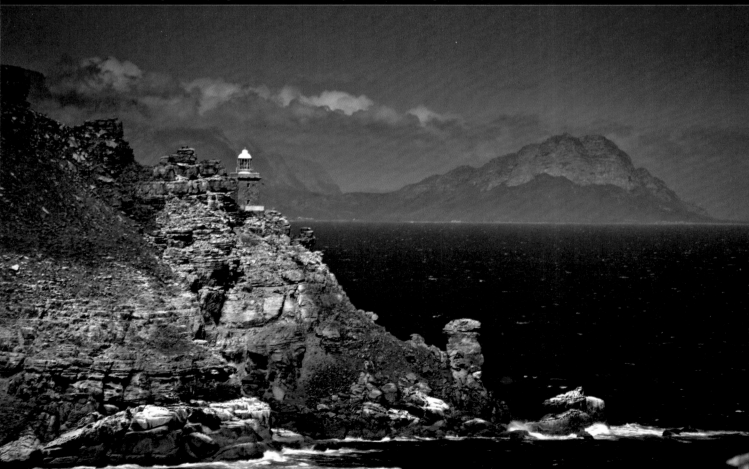

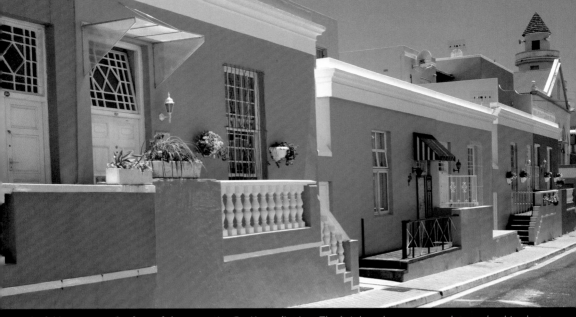

▲ *Colorful houses are the face of the attractive Bo-Kaap district · The bright colors are enough to make this photo work, but the orientation of the homes also adds a certain depth. 24 mm · ISO 100 · f/5.6 · 1/125 sec*

Children in a township on the outskirts of Cape Town · They both donned challenging poses as soon as they spotted me. The focus created by a wide aperture accentuates them. 119 mm · ISO 200 · f/2.8 · 1/5000 sec ▼

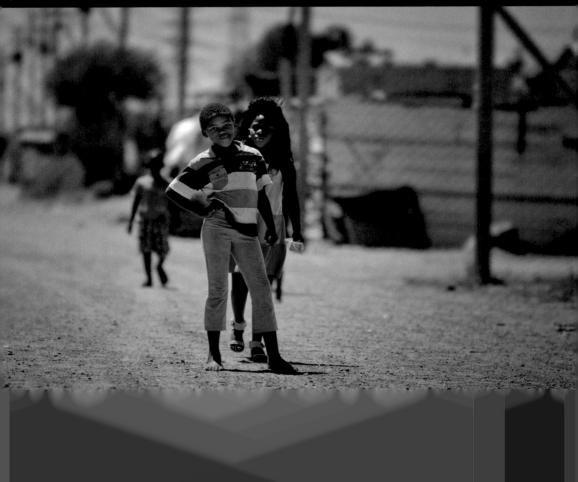

♠ Wine country: a scenic and culinary pleasure · The road guides the viewer's gaze through the photo. Landscape pictures tend to be more interesting when the horizon line doesn't pass directly through the center of the photograph. 24 mm · ISO 100 · f/6.3 · 1/125 sec

A view of Table Mountain from the Bloubergstrand · I used a gray gradient filter to darken the sky a bit. A slow shutter speed resulted in the blurred effect for the ocean and the playing children. 32 mm · ISO 100 · f/18 · 1.6 sec ♦

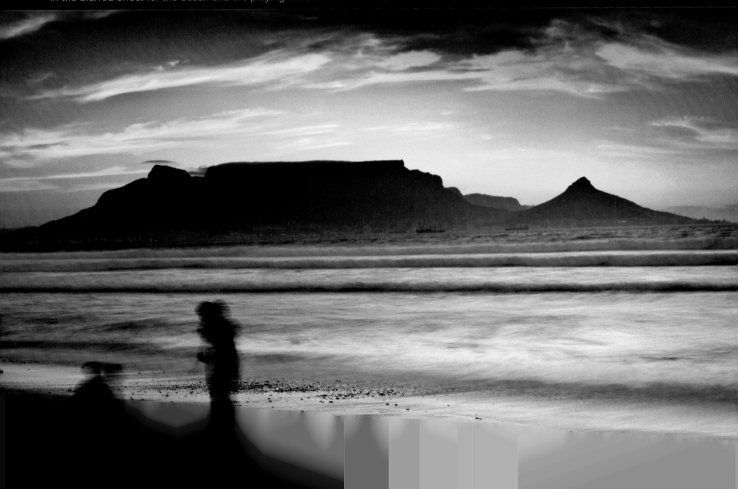

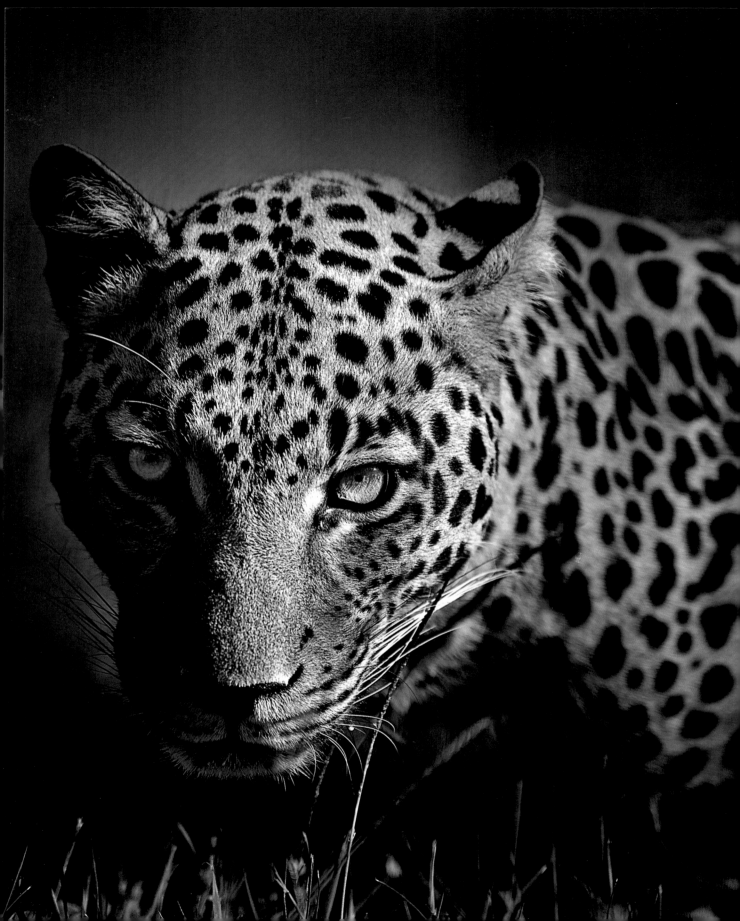

SOUTH AFRICA Garden Route

Humid air surrounds me and I hear a strange noise. There's a quick movement to my left, a shadow overhead, and something feels uncanny. Bright eyes watch our every move from the safety of a thicket. One moment of failing to be diligent and my neighbor's water bottle is gone in the blink of an eye. I had already learned that baboons are quick when I was in Cape Town. The monkeys that now circle our group with incredible speed are on an entirely different level.

The wildlife park I'm visiting on my tour is fascinating. There are several ape and monkey species that you can encounter in the wild. The small monkeys are the cutest—they remind me of Mr. Nilsson from Pippi Longstocking. Our guide tells us about the social behavior of the creatures, and I'm astonished to learn that apes have something akin to a nanny. I also didn't know until now that monkeys have tails and apes do not. It's incredibly fun observing how the animals interact.

When I come across a leopard sometime later I'm filled with reverent respect. He's still young and playful

so I'm not supposed to scream or he might jump up on me. "Don't run away from him, or you'll awaken his hunting instinct—and you won't stand a chance," our guide tells me. Not the most reassuring words. Nevertheless, it's amazing to encounter such an elegant animal with no fence between us. Because petting it is out of the question, I resign myself to taking a few photos.

Awestruck, I drive to my next destination. When I arrive at Tsitsikamma National Park, which is located on the coast, I'm a little confused. I wasn't expecting an enormous camping ground and it takes me some time to find my accommodations, which is something called an "oceanette." I discover what that means once I pull the curtains to the side and step out onto my balcony. I'm looking directly at the Indian Ocean and the view is simply fantastic.

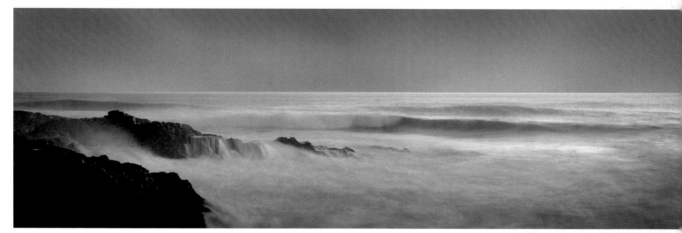

⬆ *Tsitsikamma Coastal National Park · The long exposure time makes the sea look like cotton. I decided in advance that I'd crop the photo into a panorama later, and I positioned the elements of the photo accordingly. 20 mm · ISO 200 · f/5.0 · 2 sec*

⬅ *Young leopard in the wildlife park · I opted for a portrait of the leopard's head and used a wide aperture to focus directly on its eyes. The viewer is involuntarily captured by the cat's direct gaze into the camera. 157 mm · ISO 100 · f/5.0 · 2 sec*

101

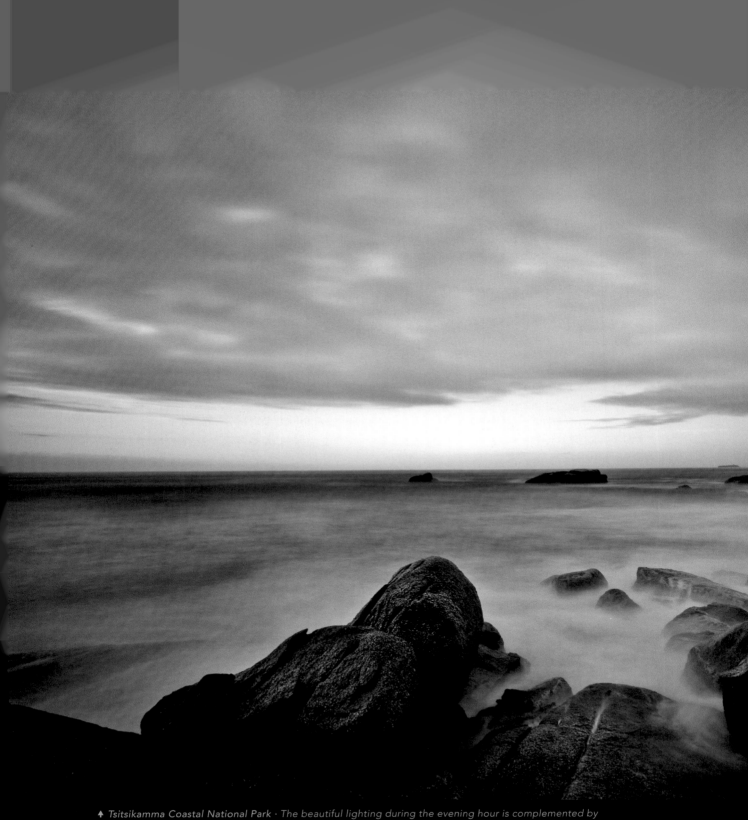

⬆ *Tsitsikamma Coastal National Park · The beautiful lighting during the evening hour is complemented by the calm, smooth water. I used a long exposure and a gray ND filter. 10 mm · ISO 100 · f/5.6 · 20 sec.*

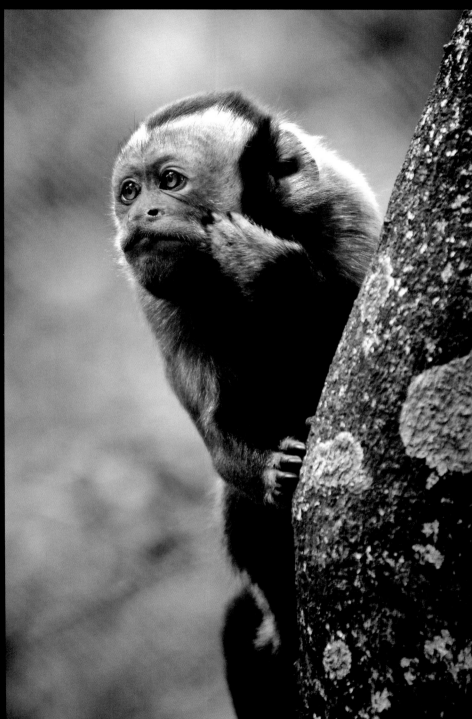

♠ *Monkey · The animal's pose makes it look reflective and almost human. Leaving some space in the image area where a subject's line of sight extends is usually advisable. 200 mm · ISO 400 · f/2.8 · 1/200 sec*

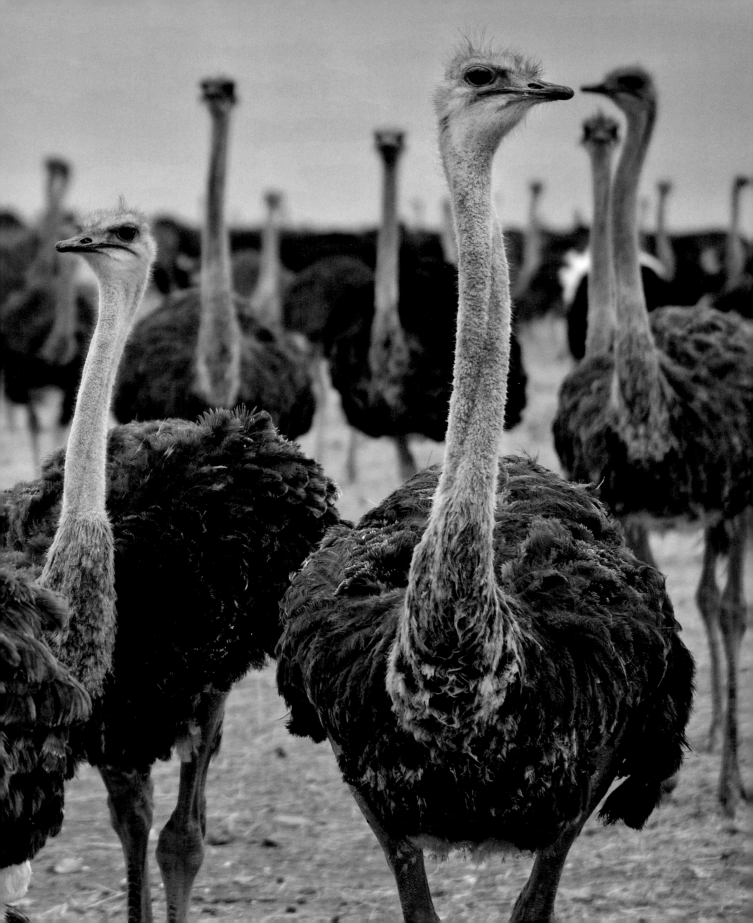

SOUTH AFRICA Oudtshoorn

The feathers are much softer than I expect. "Earlier, they were worth as much as gold," explains an employee. "Today they are exported to Rio for Carnival costumes or to Paris for the Moulin Rouge." I'm visiting an ostrich farm in Oudtshoorn, the center of the African ostrich industry, and I'm standing in front of hundreds of these running birds. They are looking at me with just as much interest as I have for them. "They can maul a person with their feet without any trouble at all." Hearing this makes me happy I survived my first encounter with an ostrich in Cape Town.

I learn many other interesting facts about this animal: The ostrich is the largest bird in the world but is unable to fly, primarily because it lacks breast muscles, can grow to over 9 feet tall, and may weigh as much as 320 pounds. An ostrich egg weighs 3 pounds, over 20 times the weight of a chicken egg. Ostriches have exceptionally long legs and a powerful musculature for running. They can reach top speeds of over 40 miles per hour.

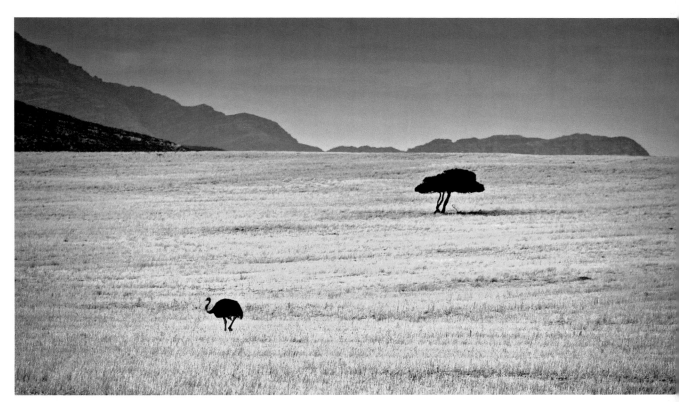

⬆ *Ostrich in the wild · Out on the steppe, the ostrich and the tree were natural subjects for a photo.*
200 mm · ISO 200 · f/5 · 1/2000 sec

⬅ *Ostrich farm in Oudtshoorn · This effectiveness of this picture relies on the repetition of the subject. The shallow depth of field establishes the bird in front as the main subject. 70 mm · ISO 200 · f/2.8 · 1/2000 sec*

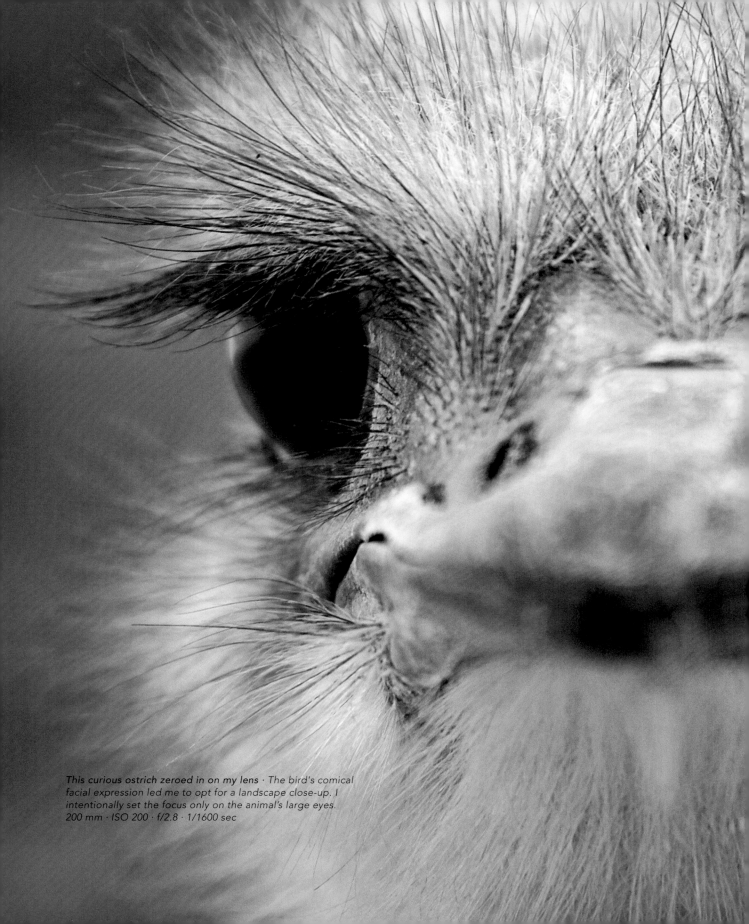

This curious ostrich zeroed in on my lens · The bird's comical facial expression led me to opt for a landscape close-up. I intentionally set the focus only on the animal's large eyes.
200 mm · ISO 200 · f/2.8 · 1/1600 sec

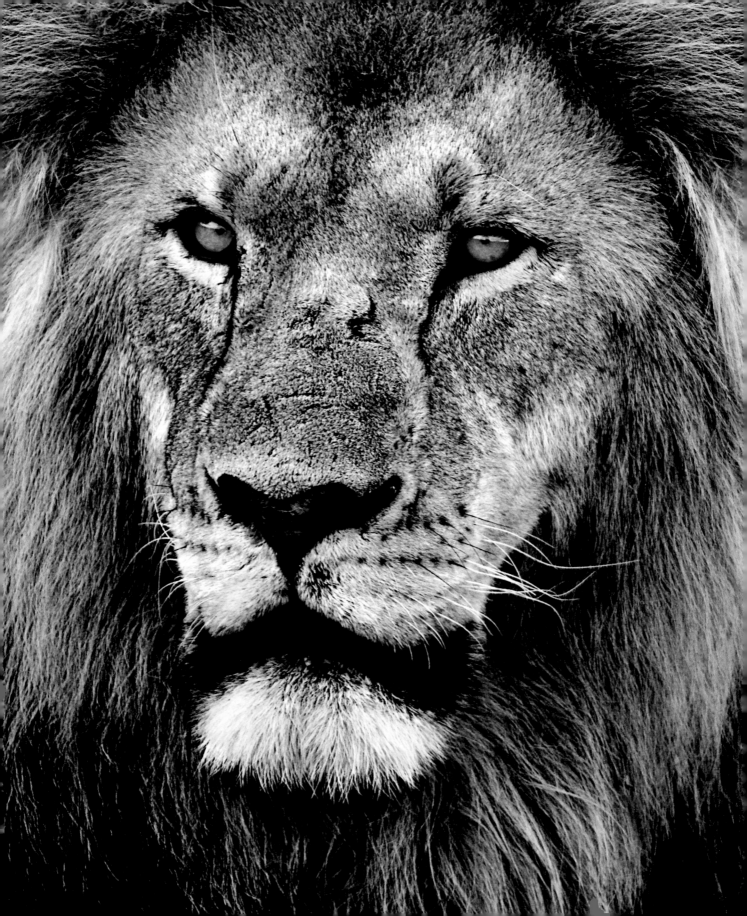

SOUTH AFRICA Port Elizabeth

(Addo Elephant Park / Schotia Safaris)

A friendly flight attendant told me, "If you go to Port Elizabeth, you absolutely have to do the Schotia and Addo safaris. It's indescribable." It's a tip I'm happy to follow. This is my first time on a safari and I'm excited. I'm sitting in a jeep with five other people and we're being jostled about as our vehicle rocks and bounces through the countryside. Our guide Malcolm discusses the various species of animals and plants we encounter until, suddenly, he goes quiet. Curious, we follow his gaze and spot African elephants. We see hundreds standing at a watering hole and there are more arriving. We slowly approach the herd. Once we're amidst the herd, I hold my breath because it's so incredible. I can barely take pictures fast enough, and have to work with a high level of concentration because there are just so many excellent opportunities. Suddenly, there's a loud trumpeting and the earth shakes when a roaring elephant stomps his feet. I have no idea how much this bull weighs, but his tusks are huge. He makes it immediately clear who the boss is around here.

I could stare at these gentle giants forever but we continue on with our tour. It isn't long before we come across a concentrated mass of muscles and a magnificent mane. He's the oldest lion in the pride; I spot the scars on his snout from many a turf war won. A certain reverence surrounds the king of beasts as he gracefully walks by our jeep, so closely that I could touch him.

Rhinos and a variety of other animals came before my lens today, but the lion and the elephants were unquestionably the highlights.

◄ The king of beasts · The lion's eyes are fixed on his next prey and his snout betrays a lifetime of bloody battles. The beast's mane makes an ideal frame for this portrait.
200 mm · ISO 400 · f/2.8 · 1/400 sec

Rhinos fighting at a waterhole · I took a series of photos just as this rhinoceros attacked his comrade out of the blue— the perfect moment to fire away.
200 mm · ISO 800 · f/2.8 · 1/640 sec ✈

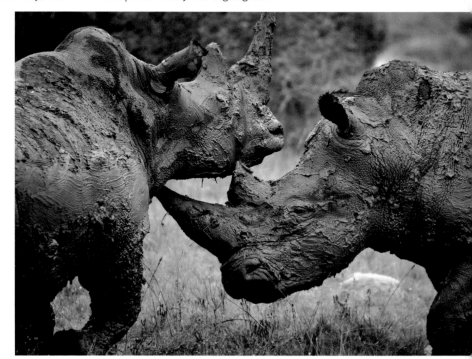

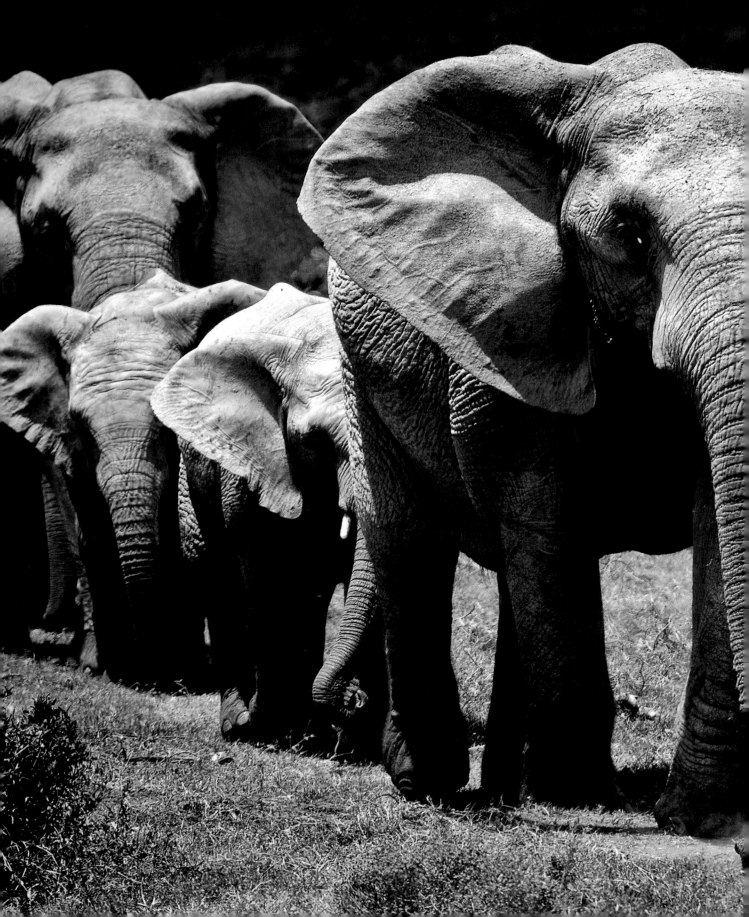

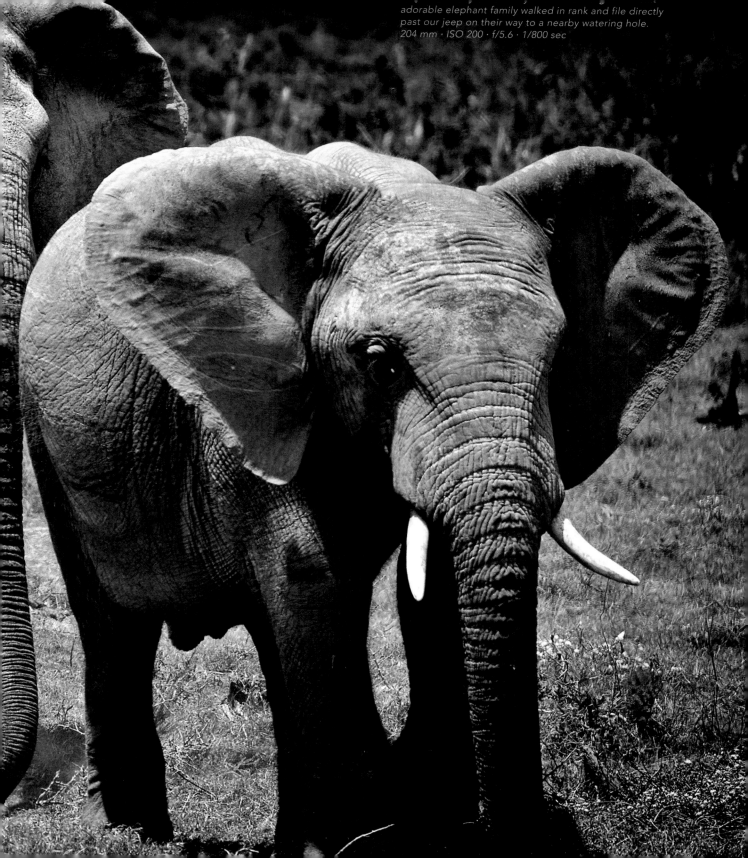

adorable elephant family walked in rank and file directly
past our jeep on their way to a nearby watering hole.
204 mm · ISO 200 · f/5.6 · 1/800 sec

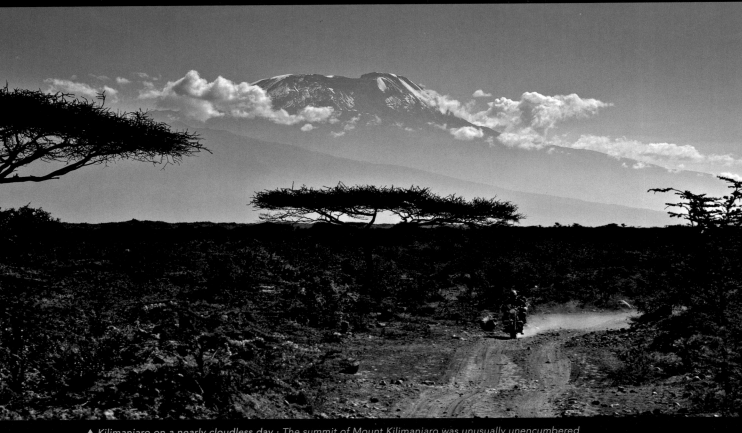

🔺 *Kilimanjaro on a nearly cloudless day · The summit of Mount Kilimanjaro was unusually unencumbered by clouds on this morning. While I was looking through the viewfinder to compose the photo I spotted the motorcyclist, whom I decided to include as a secondary subject. 70 mm · ISO 200 · f/5.6 · 1/500 sec*

TANZANIA Arusha

A disgruntled park ranger converses with my driver, prominently displaying his machine gun all the while. It's the middle of the night here in Tanzania, pitch black, and I'm standing at a gate to the national park. "There's a permission problem," my driver told me almost an hour ago. Naturally, I'm starting to get nervous. Then finally, the wait comes to an end, and I arrive tired and hungry at my next destination: the Hatari Lodge, named after the film *Hatari*, starring John Wayne and Hardy Krüger. After a warm reception and a delicious dinner, a Massai soldier leads me to my sleeping quarters. I am in the process of hanging my mosquito net when, all of a sudden, the lights go out. Shoot, I forgot that the diesel generator gets turned off at night here.

Chattering birds wake me up in the morning and when I look out my window, my jaw drops. Zebras and giraffes roam about in the lodge's front yard. Mount Kilimanjaro is in the background some 40 miles away. Someone tells me that it takes five or six days, favorable conditions, and lots of preparation and equipment to conquer the summit. Unfortunately, my stay here is too brief to give it a go, so I content myself with the excellent view, which normally isn't so clear because Kili is often shrouded in clouds.

Walking around the park on my own is not without dangers on account of the Cape buffalo, which are feisty and aggressive. A run-in with one of these 1,500-pound animals doesn't sound like a barrel of laughs, so I opt for the guided tour. First I learn about the great enemy of the elephants: ants. When ants bite the inside of an elephant's trunk, it causes the animal so much pain that it rubs its trunk against a tree until the tissues in the affected area die and the elephant's trunk eventually falls off. Then the elephant is left to starve or die of thirst in agony. We continue on through the wild with our guide and our jeep and we come across some bushbucks. A couple of children approach our jeep during a break and a married couple offers them a pair of pens. The children run away laughing and waving.

The next day, I turn my attention to the local culture. I drive for two-and-a-half hours over rough and rocky roads to visit a Massai village. The villagers welcome me with a loud song and a traditional greeting dance. The town consists of round, mud-plastered huts. Young Massai soldiers guide me through the landscape. They initiate me to the ways of the hunt and teach me how to use native plants as medicine. One soldier kindles a fire with a piece of wood and some cow dung, and I enjoy a delicious cup of tea offered to me with a smile by a tribal elder. Once again, I'm reminded of how little one needs to be happy.

Zebras · When taking pictures of moving subjects, such as these zebras, a fast shutter speed is needed to avoid motion blur. 200 mm · ISO 200 · f/4.0 · 1/2500 sec ➜

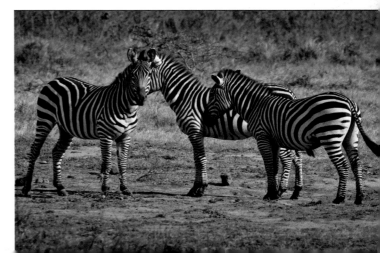

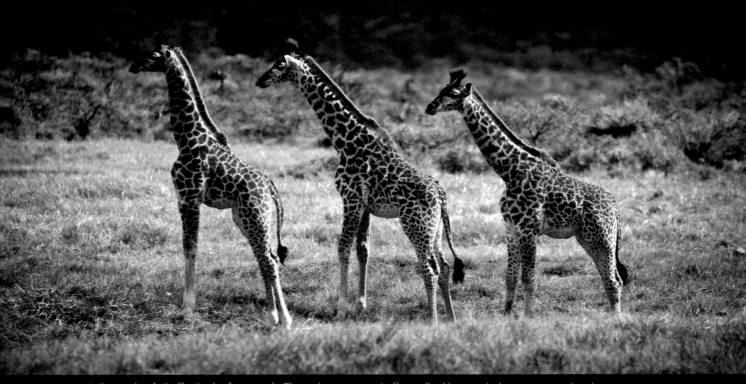

↟ *A parade of giraffes in the front yard · These three young giraffes walked by my window every morning. I waited for them to fall into line before snapping my photo. 200 mm · ISO 100 · f/2.8 · 1/1600 sec*

Cape buffalo · They are among the most dangerous animals in Africa—they're even referred to colloquially as "the black death." Some 200 people die every year from Cape buffalo attacks. 200 mm · ISO 400 · f/2.8 · 1/800 sec ↓

YOU ARE NOT ALLOWED TO WALK AROUND THE LAKE

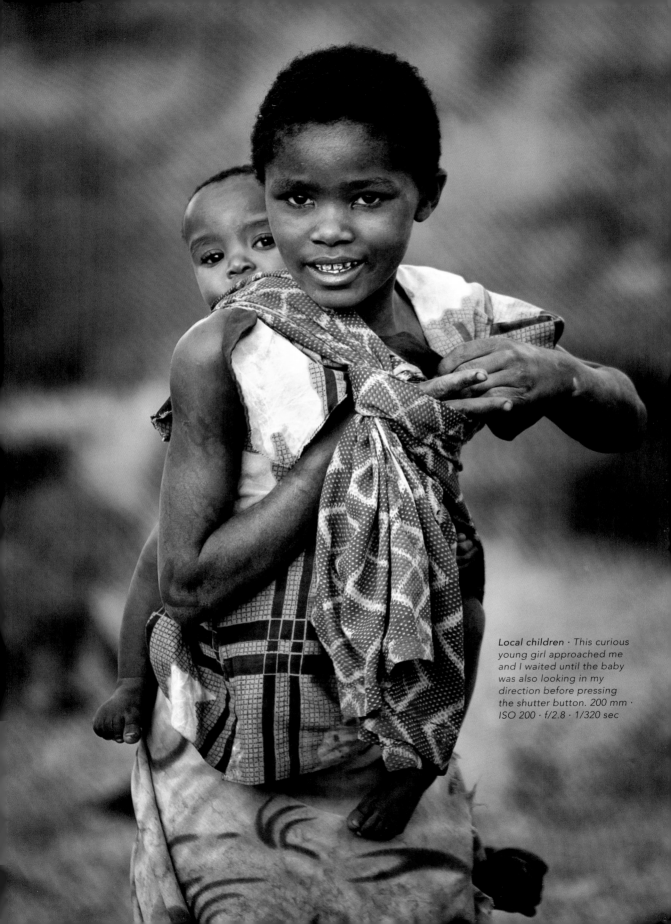

Local children · This curious young girl approached me and I waited until the baby was also looking in my direction before pressing the shutter button. 200 mm · ISO 200 · f/2.8 · 1/320 sec

Massai people wearing traditional, colorful dress · Members of the Massai tribe stand in their typical environs during a greeting dance. I kneeled down a bit to make the Massai, who are already tall people, look even more imposing. A polarizer accentuated the brightness of the scene's colors. 28 mm · ISO 200 · f/2.8 · 1/1000 sec

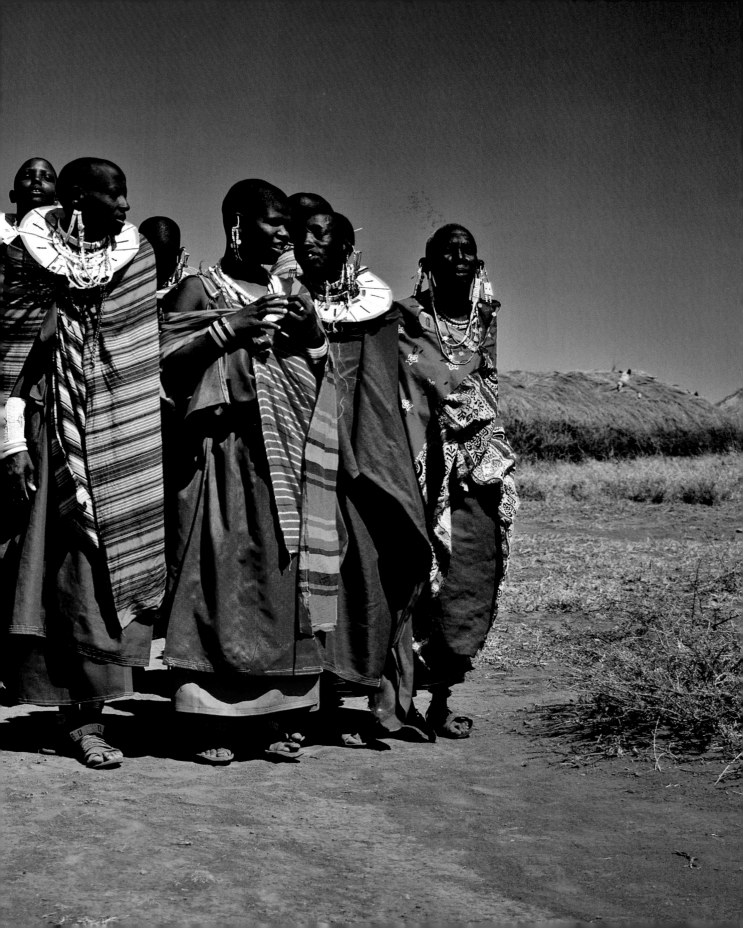

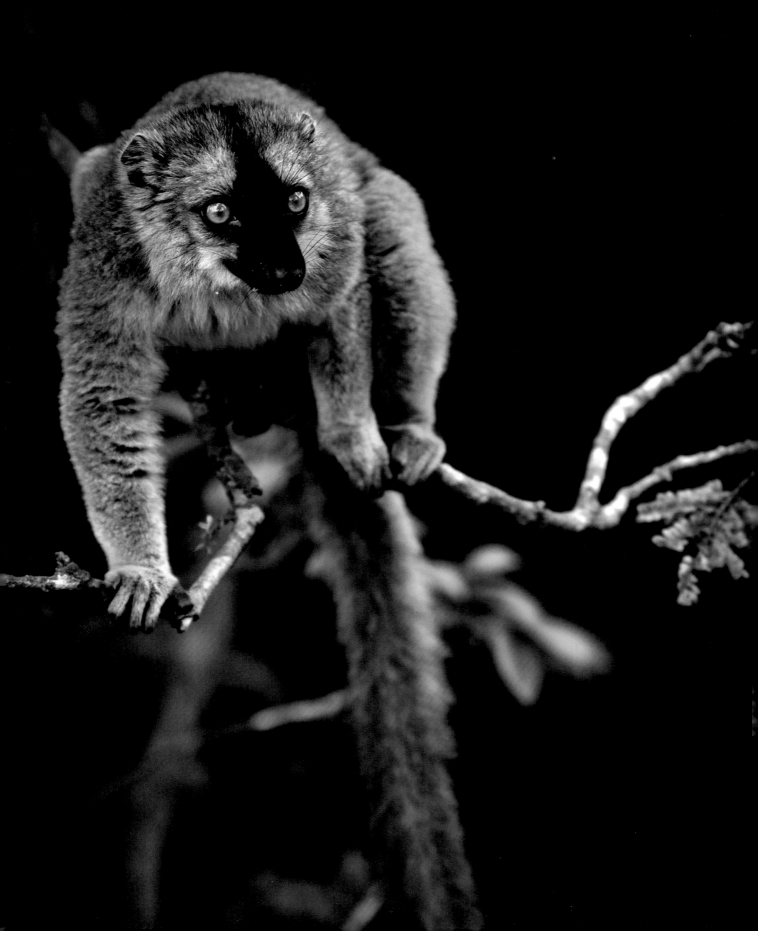

MADAGASCAR Madagascar

The high humidity is living up to its reputation. My clothes are glued to my body and my backpack gets heavier with every step. It's the rainy season, and despite using insect repellant, countless mosquitoes are feasting on me. I do my best to keep thoughts of malaria from entering my mind. I've been on the prowl in the rain forests of Madagascar for over an hour with my guide Josef and a tracker. All of a sudden, the tracker pauses, listens, and peers up toward the treetops. Finally: lemurs. I quickly forget my travails and pull out my camera. These animals with their bright eyes are truly delightful to observe. "They're endangered," Josef tells me. These are words I hear over and over again because Madagascar is an island with an incredible diversity of flora and fauna. In the umpteen-million years since the world's fourth-largest island split off from the mainland, so many plants and animals have evolved here that it makes my head spin just thinking about them. After stalking lemurs, we make a quick detour into the world of reptiles. I take photos of snakes and crocodiles, and also chameleons, of which Madagascar is home to many diverse species.

On our return trip to the capital city Antananarivo, we pass several small street stands where fruits and vegetables, crayfish, and fish are sold. As soon as I hop out to take some photos, curious children swarm me from all sides. They wear dirty, tattered clothing and are delighted as soon as I show them the pictures I've taken on my camera's display. "Madagascar is very poor and there are so many children," Josef explains to me. Now a bit disheartened, we drive farther to the huge market in Antananarivo. In addition to the obligatory fruits and vegetables,

meat is also sold here. I lose my appetite quickly as soon as I see what's on offer. The meat is completely spoiled because of the heat and is covered in blowflies. At times, the odor is unbearable.

Again and again I'm asked for money, and it really hurts that I actually don't have anything to give these people that can help them.

The island is a paradise for people who want to discover ancient plants and animals, but Madagascar is an impoverished land and crime is very high in some parts of the island. The infrastructure is poor, and the general lack of hygiene and health services creates a need for visitors to get preventative immunizations before traveling here. A rental car is also all but necessary, and cars are almost exclusively offered with a driver included. Making do on your own would otherwise be too difficult.

◄ Familiar from the animated Disney film Madagascar: a curious lemur · The jungle isn't a very bright place. A camera flash would have scared the animal, so a fast lens was needed to get adequate shutter speeds. 91 mm · ISO 200 · f/2.8 · 1/640 sec

▲ A lizard with fascinating eyes · A subject's eyes should be in focus for portraits. By using a wide aperture I was able to turn this animal's eyes into the main subject of the photo. 70 mm · ISO 200 · f/2.8 · 1/320 sec

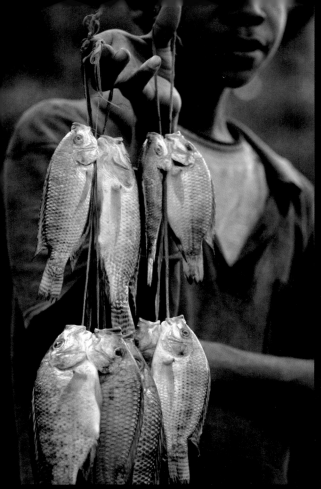

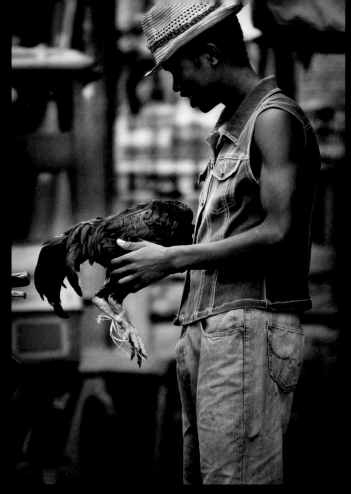

⬆ *Roadside fishmonger* · Consuming the day's catch would probably lead to stomach problems for me, so I stick with a photo. *85 mm · ISO 200 · f/2.8 · 1/800 sec*

⬆ *Lunch secured* · You won't find any frozen, ready-plucked chickens in the markets of Madagascar. *200 mm · ISO 200 · f/2.8 · 1/800 sec*

Colorful chameleon · The colors of this disgruntled-looking chameleon are strikingly beautiful. *51 mm · ISO 200 · f/2.8 · 1/100 sec* ⬇

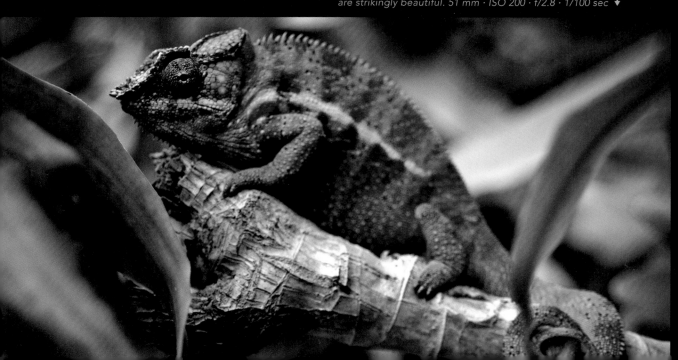

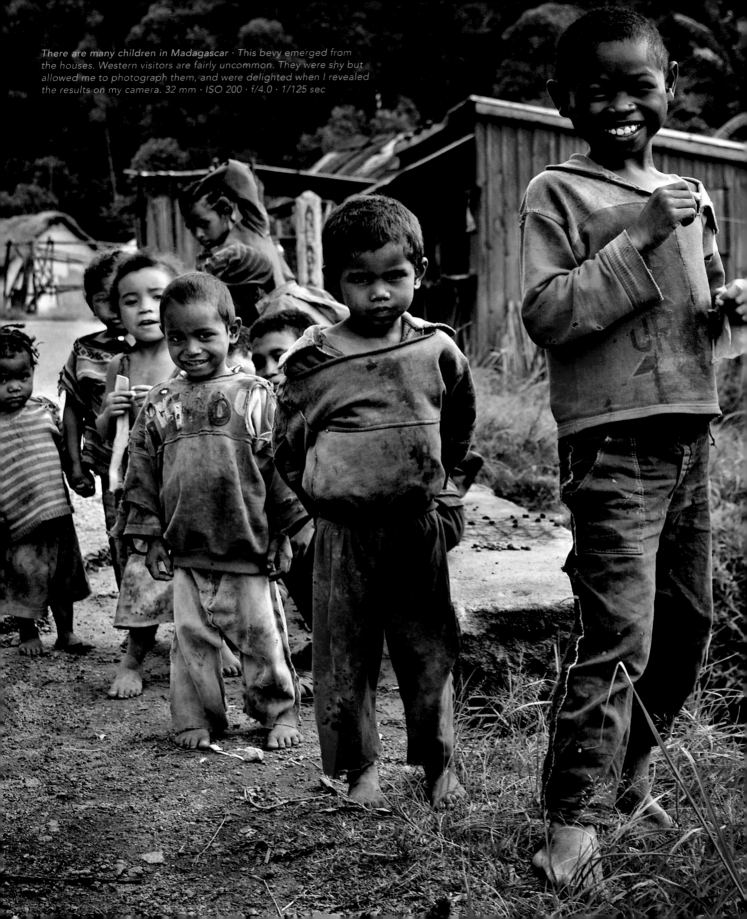

There are many children in Madagascar · This bevy emerged from
the houses. Western visitors are fairly uncommon. They were shy but
allowed me to photograph them, and were delighted when I revealed
the results on my camera. 32 mm · ISO 200 · f/4.0 · 1/125 sec

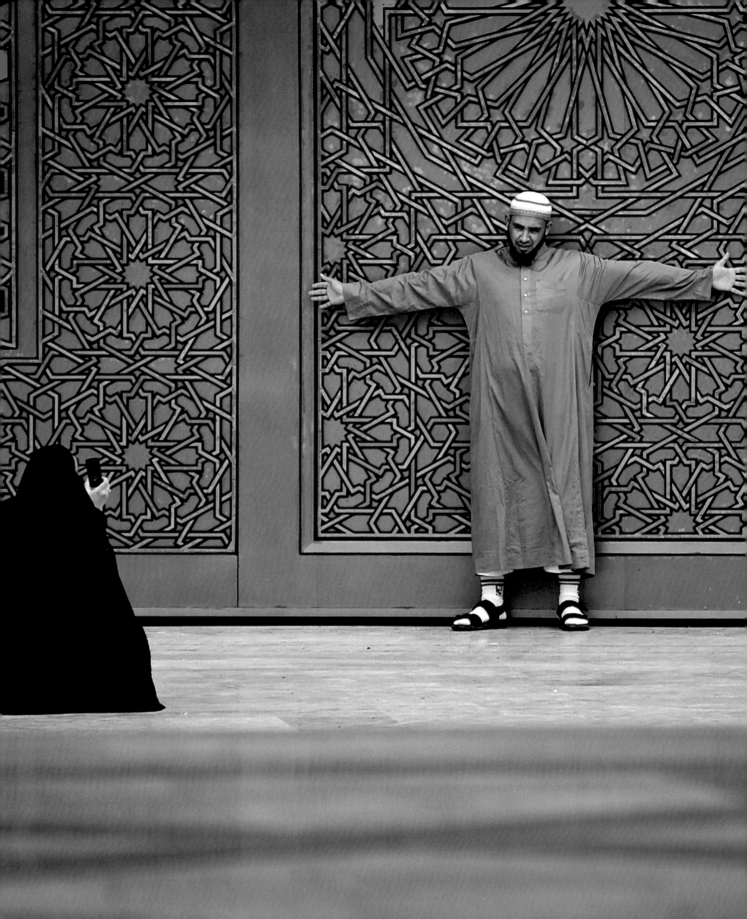

MOROCCO Casablanca

Until today, I knew of this city only through the eponymous Humphrey Bogart and Ingrid Bergmann film. When I actually arrive here, I head to the fascinating Old Medina. Here at the market I have any number of interesting subjects at my disposal. I zero in on a butcher selling live chickens. I watch a customer pick one out and take one last look at the helpless creature. "Here's lookin' at you, kid," pops into my head and seconds later I unwillingly witness the butcher behead, pluck, gut, and break down the bird with the efficiency of an expert. The sight causes my stomach to turn and I move along. In addition to the chickens, all of life's essentials are on hand, from tons of meat to fruit and vegetables to fish.

Casablanca is a photographer's paradise, but I only have a day of shooting to capture all of the subjects I want. In my zeal I end up sparking the anger of some people and the police. The locals are obviously not used to someone taking pictures at the market, so from now on I try to be a bit more empathetic.

Two hours later I follow a sound that has since become very familiar to me: the muezzin's call to prayer. I find myself standing in front of the Hassan II Mosque, the seventh largest mosque in the world. The construction of the immense building was scheduled to be completed in 1989 for King Hassan II's 60th birthday, but it was not finished until 1993. I watch as people flock to pray, and I capture a few scenes in the process.

◄ *Scene in front of the mosque · I always keep my camera where I can reach it quickly, and I keep its settings programmed so I can react at a moment's notice. Some scenes, like this one, last only for fractions of a second. 200 mm · ISO 200 · f/2.8 · 1/1600 sec*

The muezzin calls to prayer and the faithful heed him · Photographs of scenes like this one can be planned in advance. I saw this woman a long time before she actually walked through this arcade, and I positioned myself for the shot I wanted ahead of time. 76 mm · ISO 200 · f/2.8 · 1/800 sec ►

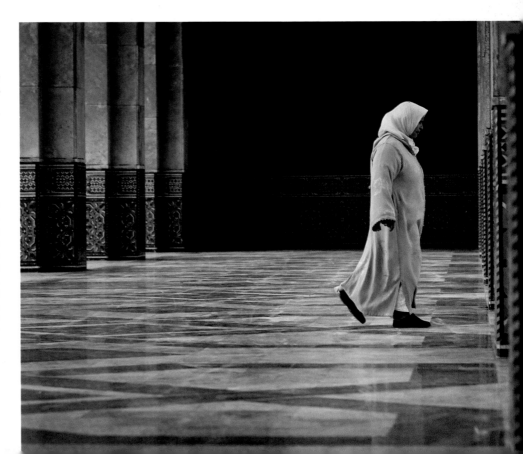

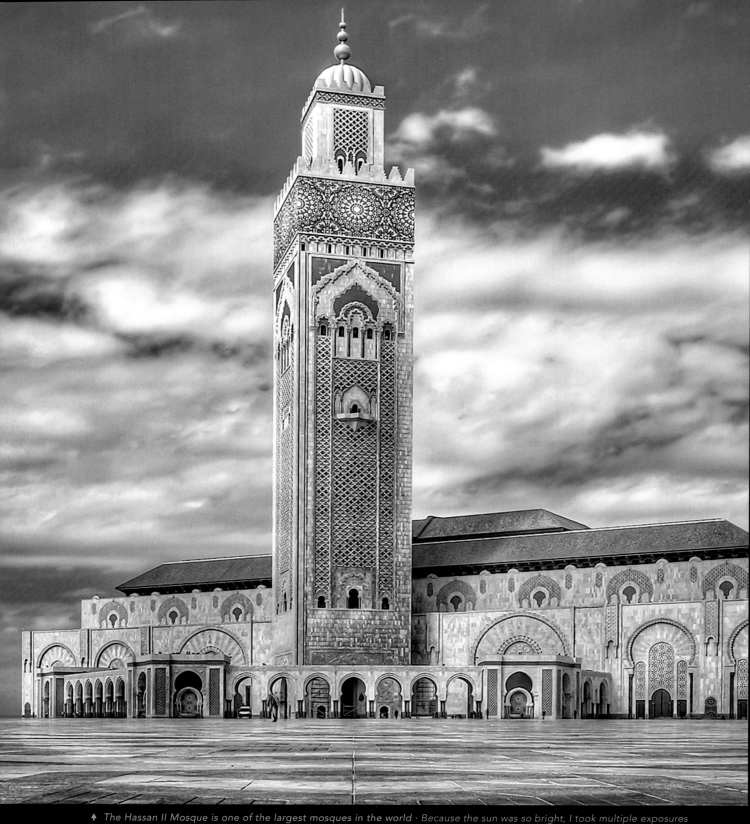

⬆ *The Hassan II Mosque is one of the largest mosques in the world · Because the sun was so bright, I took multiple exposures and created an HDR image later to minimize the appearance of the harsh shadows. 20 mm · ISO 200 · f/5.0 · 1/200 sec*

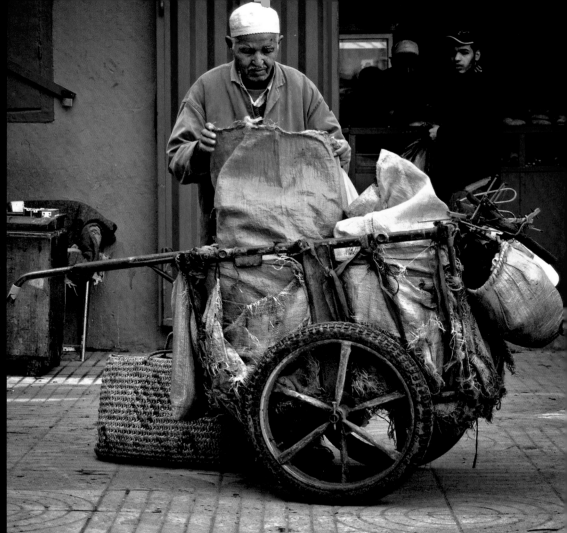

♠ *On the street* · I discovered this man with his cart full of rags in the back alleys of Casablanca. 45 mm · ISO 200 · f/2.8 · 1/500 sec

This chicken was in for it seconds after I shot this photo · It doesn't get any fresher than this. 70 mm · ISO 200 · f/2.8 · 1/100 sec ♦

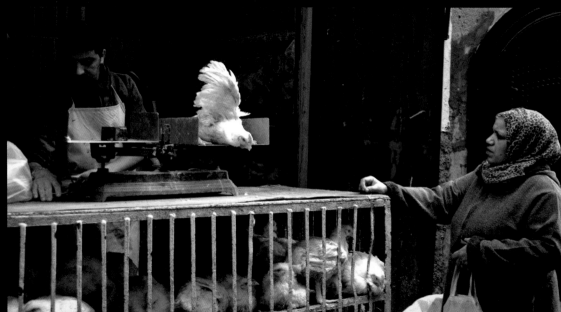

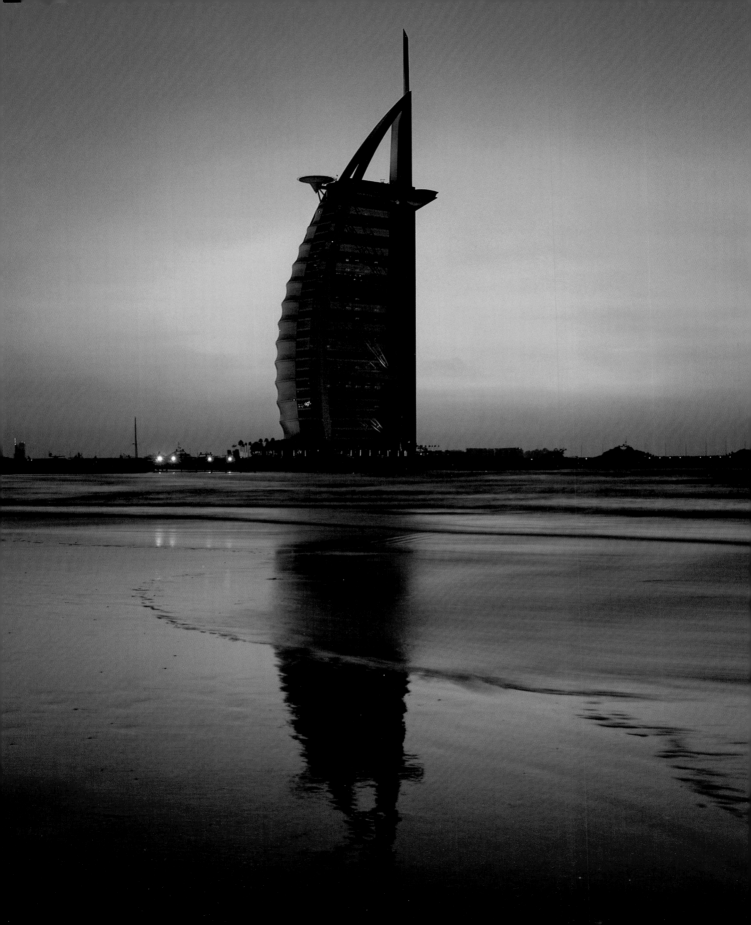

United Arab Emirates
UAE Dubai and Abu Dhabi

I'm sitting on the landing strip in Dubai and I can already see Burj Khalifa, the world's tallest building at 2,716.5 feet, from my airplane. One immediately senses that this city is different from others. There's a reason that it's earned the nickname "the city of superlatives." Dubai glistens with luxury hotels, massive shopping malls, islands shaped like palm trees, huge aquariums, horse races, expensive golf tournaments, and much more. And now I get to experience it all for myself. After my first day, which involved a host of overwhelming impressions, I need some peace and quiet, so I head out for an evening walk along the beach. With the sun slowly setting over the sea, I stroll toward the Burj Al Arab, the most expensive and only seven-star hotel in the world. A night here will set you back several thousand dollars.

The following day I turn to the nearby city Abu Dhabi, which is home to another of the world's largest mosques, the Sheikh Zayed Grand Mosque. It is as impressive from the outside as it is from the inside, and I feel as though I'm in a story from One Thousand and One Nights. Immediately after

entering the mosque, men and women have to go their separate ways. This is the first time that I encounter real problems trying to photograph people. I had hoped to get a couple of pictures of women wearing traditional burkas, but religious guidelines override even my best persuasions.

Afterward, I head back to Dubai and take a water taxi on Dubai Creek to the spice and gold markets. The wafting scent of cinnamon, coriander, roses, carnations, and incense hit me well before I actually arrive at the market. This side of Dubai is my personal favorite.

I sign up for a desert safari for my last day, imagining that I'll be photographing camels in front of sand dunes and a dreamy sunset. Unfortunately, it ends up being a disappointing tourist trap.

← *The seven-star luxury hotel Burj Al Arab at dusk · The warm evening light creates a reflection of the building on the sea. 26 mm · ISO 100 · f/7.1 · 2.5 sec*

Khussa shoes for sale at a bazaar · The shape, colors, and patterns of the shoes comprise the real subject here. 70 mm · ISO 200 · f/2.8 · 1/800 sec →

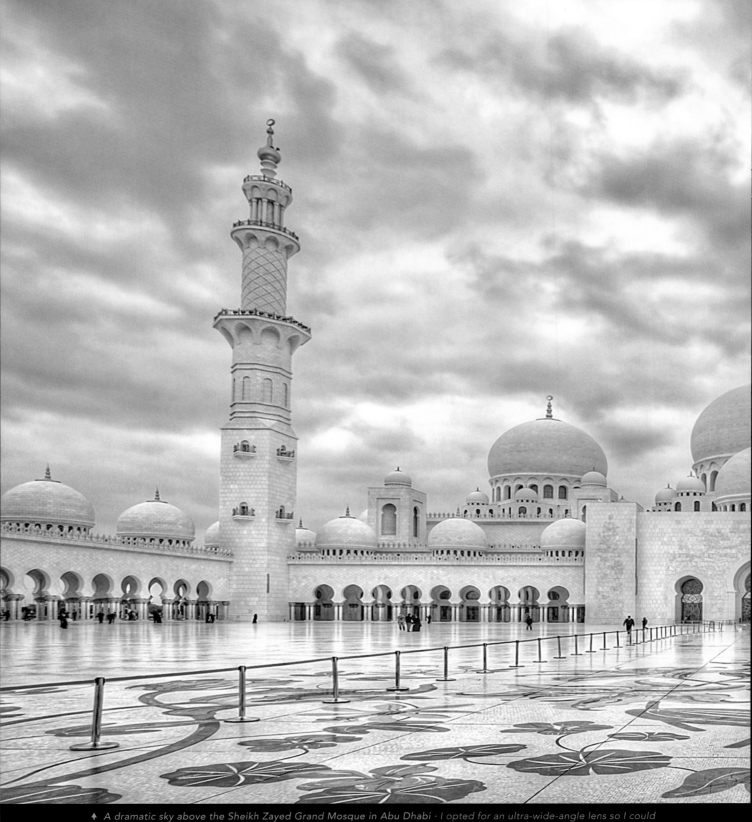

⬆ A dramatic sky above the Sheikh Zayed Grand Mosque in Abu Dhabi · I opted for an ultra-wide-angle lens so I could capture as much of the symmetrical building and ominous clouds as possible. The bright colors support the fairy tale look and feel of the photo. 10 mm · ISO 100 · f/7.1 · 1/1250 sec

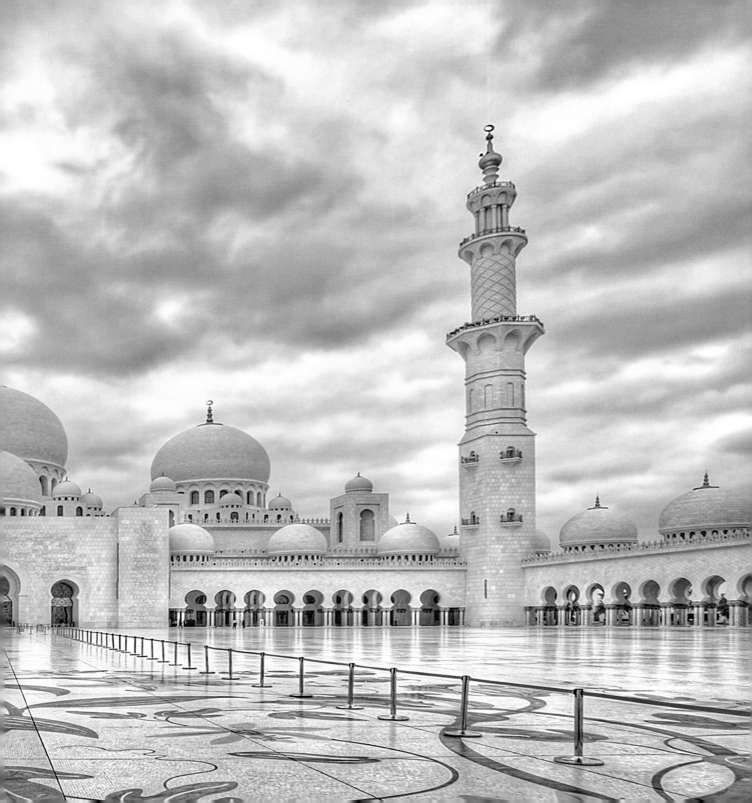

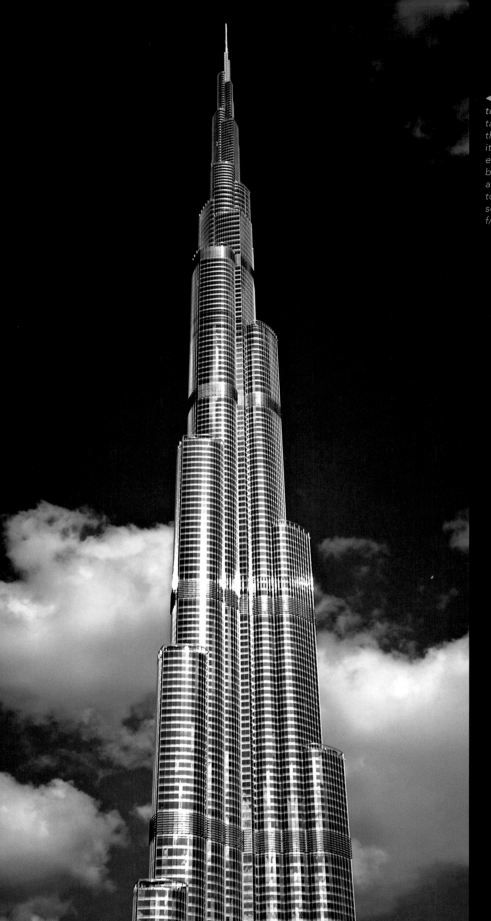

← The tallest building in the world today: the Burj Khalifa · I waited to take this picture until sunlight struck the building's facade directly, causing it to light up. A polarizer filter helped emphasize the contrast between the building and its blue background, and my point of view contributed to the impression that the building scrapes the sky. 24 mm · ISO 100 · f/5 · 1/1000 sec

Desert scenery on Dubai's doorstep · The angle of the late afternoon sunlight made the textures in the sand stand out. The complementary colors of the yellow sand and the blue sky contribute to the overall harmony of the picture. 10 mm · ISO 200 · f/5.6 · 1/250 sec →

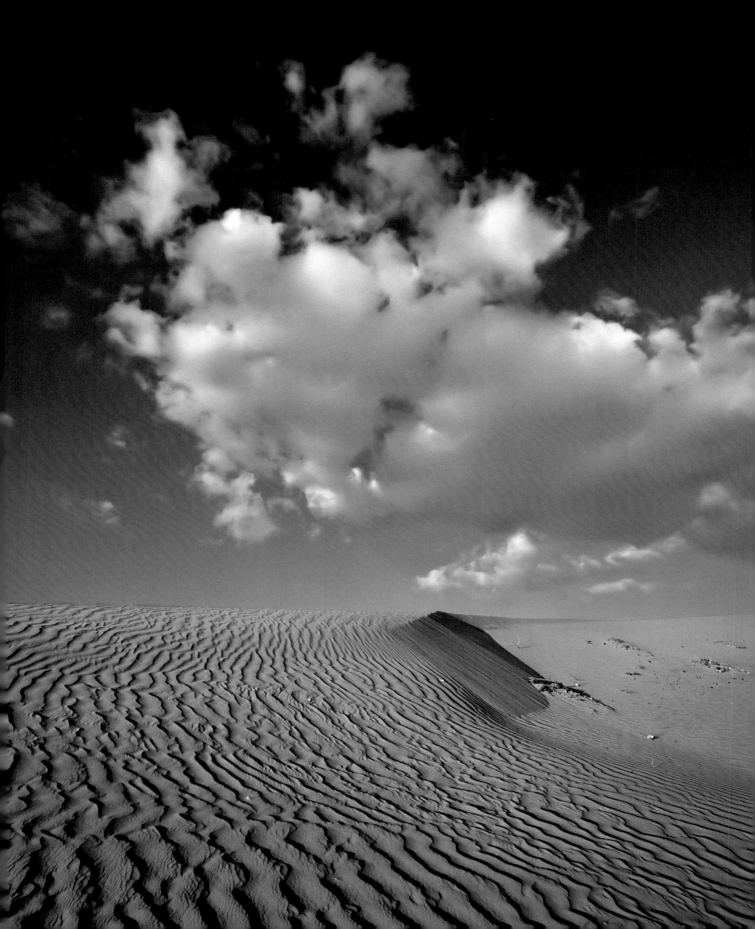

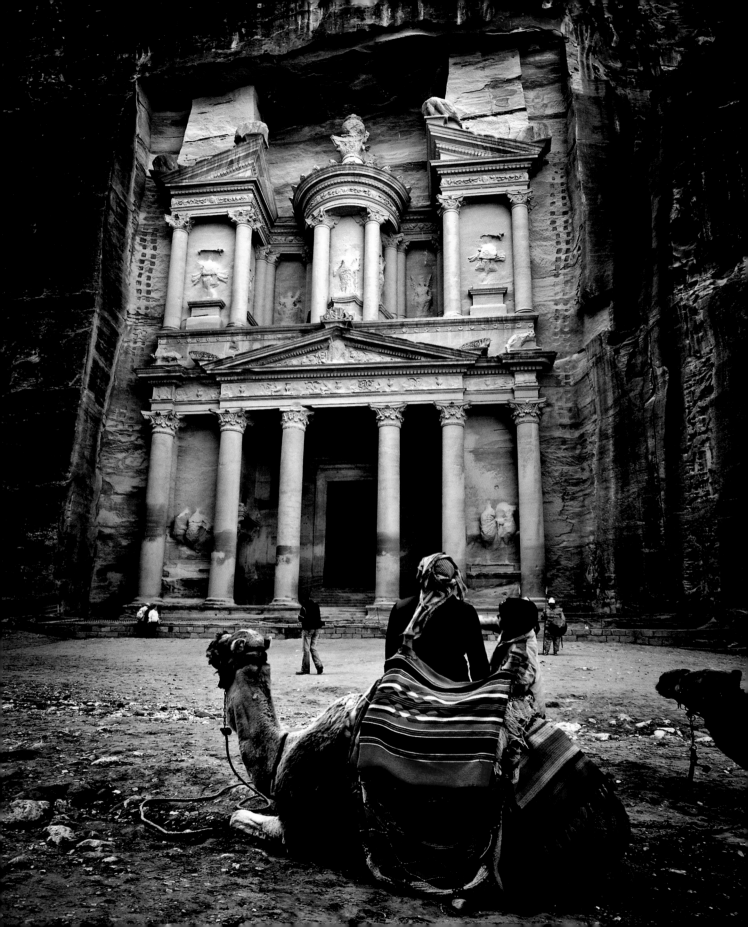

JORDAN Petra

The canyon walls—which are 600 feet tall in some places—are closing in on one another. The path is getting narrower and narrower and claustrophobia is setting in. After about a mile, and right before panic overcomes me, the canyon thankfully opens up. All of a sudden I'm standing across from the Treasury, which is carved into a rock wall. The 128-foot-tall facade is truly remarkable. I look around and find other carved tombs, caves, and columns. The information that I gathered about the fabled rock city of Petra before my visit was exciting on its own, but nothing prepared me for what I can see with my own eyes. Being here feels like I'm on a movie set, with camels, donkeys, and horses walking everywhere. It's no wonder that Steven Spielberg chose to film a portion of Indiana Jones here.

I decide to hike to the elevated rock monastery Ad Deir. The path there takes me by children selling postcards and women offering freshly brewed tea. After an hour, I reach the peak, where the view is almost as stellar as the monastery itself. I sit down on a ledge and spend some time up here soaking in the fantastic surroundings.

This trip was really worth it! Now I know why Petra is a UNESCO World Heritage site. The city also

has plenty of history to offer. One old legend says that Moses brought forth a spring of water nearby by striking the earth with his staff. The surrounding area is called Wadi Musa, which means "Valley of Moses" in Arabic.

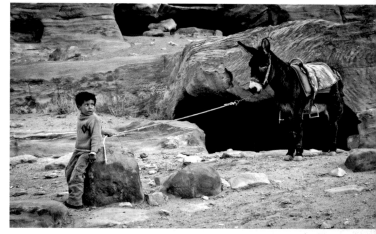

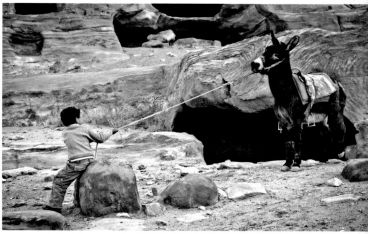

← Camel in front of the Treasury · I needed something in the foreground of the picture to support my main subject and to add some depth to this photo. The camel answered my call. 13 mm · ISO 400 · f/4.5 · 1/80 sec

These snapshots give credence to the claim that donkeys are stubborn · I could already see what was going to happen when I snapped the first photo (top). 45 mm · ISO 200 · f/2.8 · 1/400 sec →

Small children are dispatched by their mothers to sell postcards to tourists · I crouched down to photograph this girl at eye level. She thought my pose was funny and mimicked me. We repeated this game several times until I got the shot I wanted. 70 mm · ISO 200 · f/2.8 · 1/500 sec ➜

◄ Freshly brewed tea can be found at every rock corner in Petra · I had to adopt a very low perspective to include the water kettle and fire in this photo. I kept the emphasis on the woman's face by using a wide aperture to place the focus precisely. 32 mm · ISO 200 · f/2.8 · 1/100 sec

A common means of transportation · Panning the camera during the exposure window is a good way to bring dynamic motion into your photo, as I did here with this carriage. 24 mm · ISO 200 · f/11 · 1/15 sec ➘

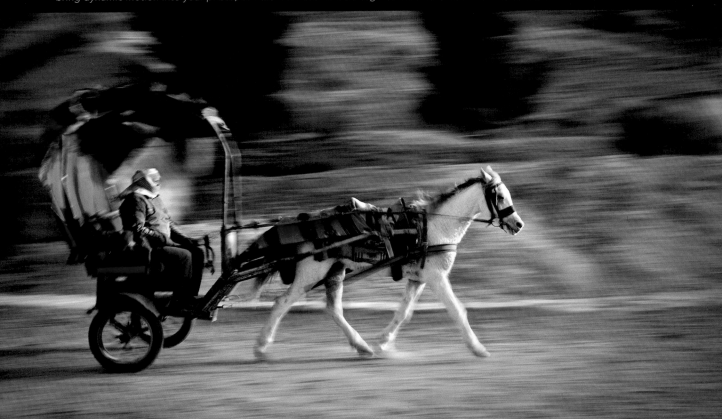

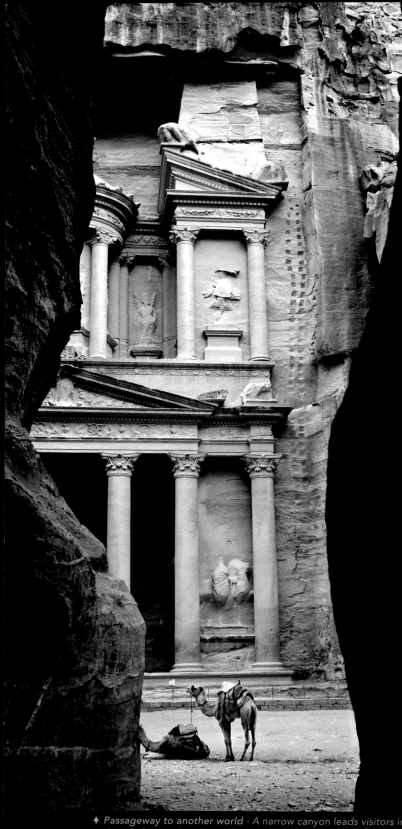
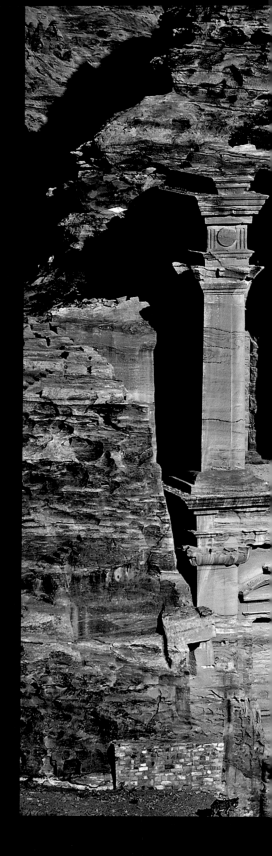

⬆ *Passageway to another world* · *A narrow canyon leads visitors into the rock city of Petra. 24 mm · ISO 200 · f/5.0 · 1/10 sec*

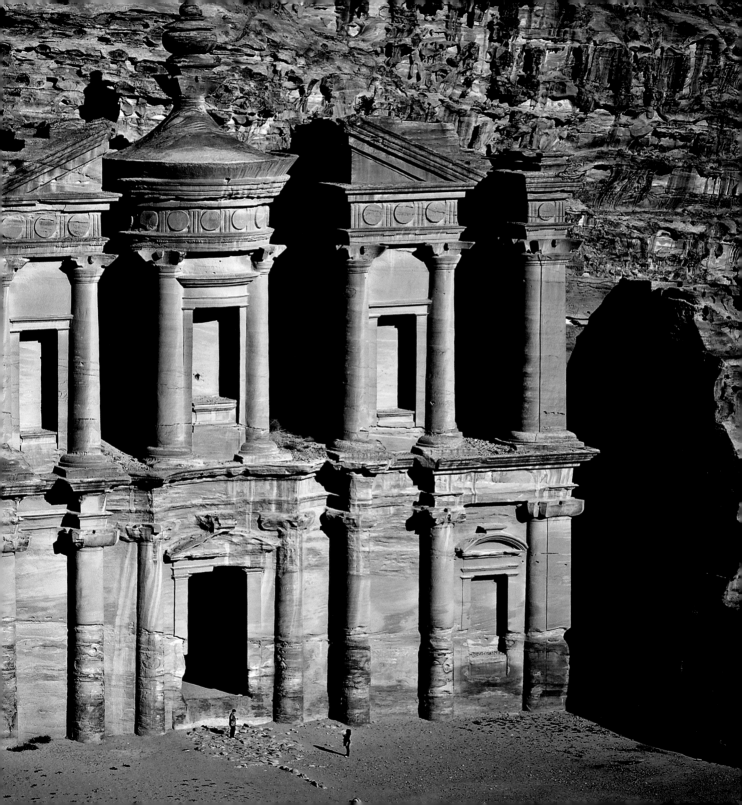

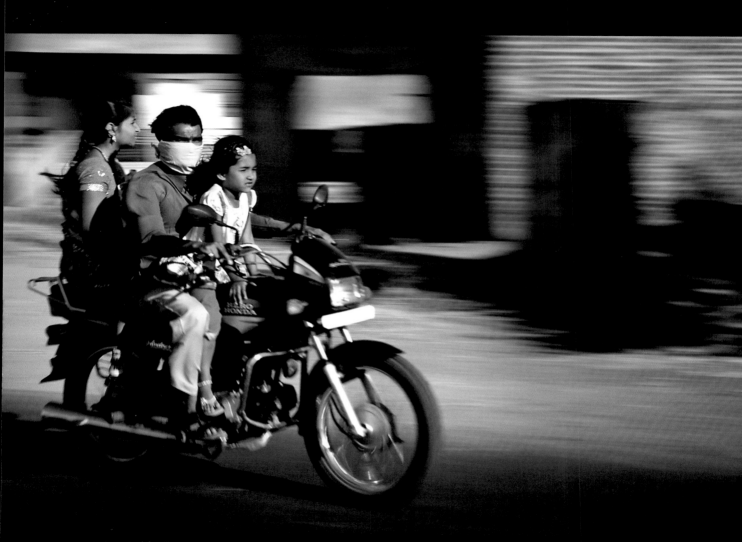

⬆ *A typical family outing on a motorcycle—without helmets, of course · I used the panning technique for this shot. The blurred lines don't attract the viewer's attention as much as the main subject. 50 mm · ISO 100 · f/10 · 1/60 sec*

INDIA Aurangabad

Frantic and covered in sweat, I dig my fingernails into the seat of my taxi. When I ask whether one needs a license to drive in this country, my Indian driver responds with a smile and an ambiguous shake of the head. I've just arrived in India and my car ride to the hotel is a harrowing experience. Apparently, you can drive however it pleases you here. Honking and passing other vehicles with lurching movements regardless of oncoming traffic are standard procedure. The many three-wheeled "tuk tuks" and motorcycles stand out. Anything can be transported on them, from semi transmissions to an entire family. This is my first time to India and I think it will take a few days for me to acclimate to life here.

In the first town I visit, Aurangabad, I participate in day tours that take me to the old Ajanta and Ellora cave temples. My head buzzes with all of the information from the tour guide about the various religions, architectural styles, paintings, carvings, and so on. To escape the endless stream of information, I duck into the next cave, armed with only my camera. Unfortunately, tripods and flash photography are not allowed and the light is much too dim to get a good exposure. Instead, I concentrate on the art that's outdoors. I'm particularly interested in the clothing that the women are wearing. Their dresses are bright and colorful, just like you see in Bollywood films.

Several interesting things catch my eye on the drive to and from the caves, including a group of partially torn, blue plastic tents out in a field. When the driver tells me field workers live there, I decide to take a closer look. As I walk about the tents women and children start to appear. I do my best to communicate through gestures with my hands that I'd like to take photographs of them. Western visitors are just as exciting to them as Indians are to us, so they ask to take pictures of me as well. In return, they usually grant me the chance to take portraits of them.

Ubiquitous in India: stone carvings of the Buddha ·
I converted the image to black-and-white because of the
subject's weak colors. 37 mm · ISO 200 · f/4 · 1/125 sec ✈

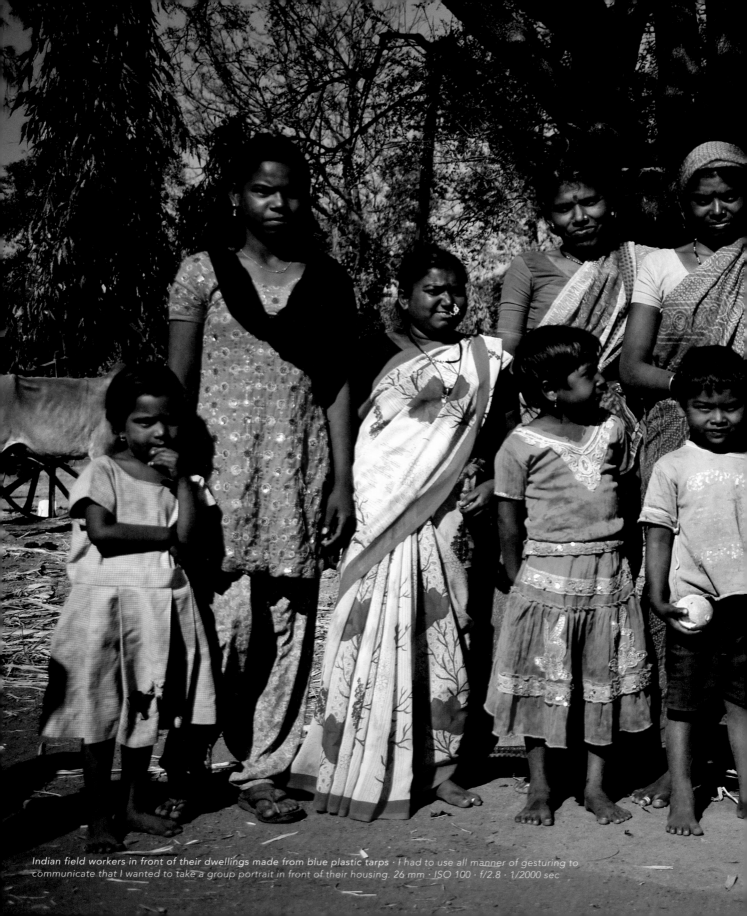

Indian field workers in front of their dwellings made from blue plastic tarps · I had to use all manner of gesturing to communicate that I wanted to take a group portrait in front of their housing. 26 mm · ISO 100 · f/2.8 · 1/2000 sec

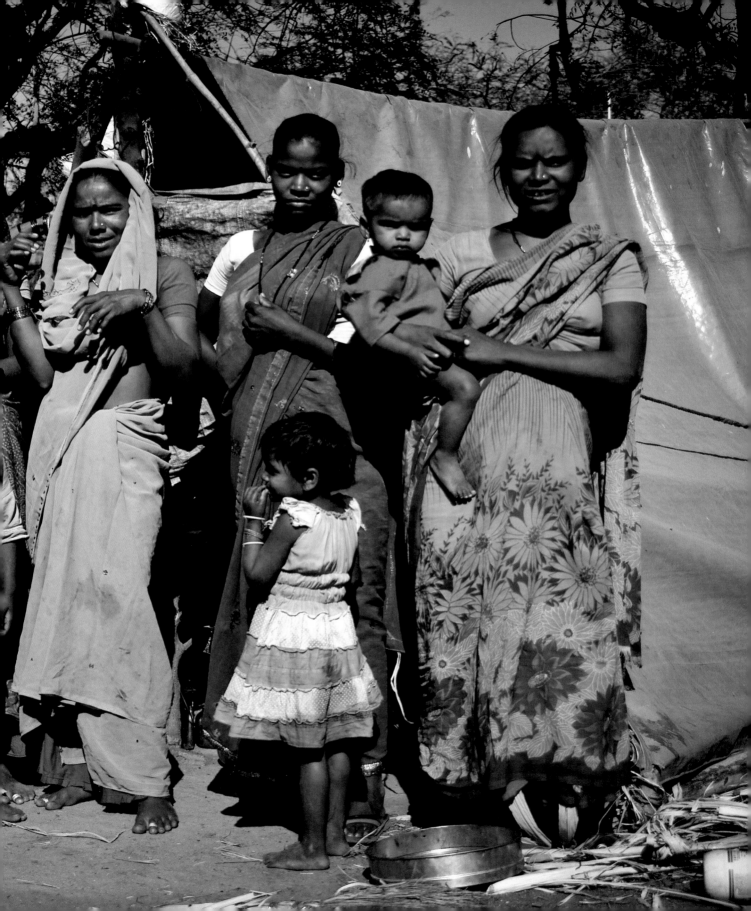

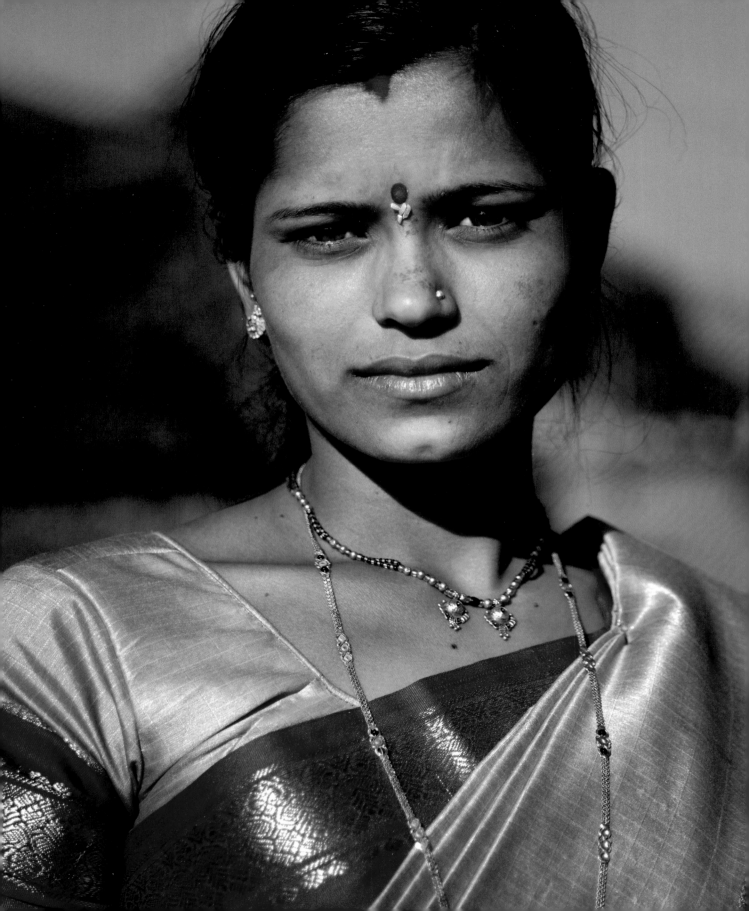

INDIA Mumbai (Bombay)

I arrive at the airport in Mumbai still dazed from my experiences over the past couple of days. At 12.5 million people, Mumbai is the most populous city in India. My flight continues on to Delhi in just a few hours so my stopover here is brief. I frantically look for a driver and a tour guide because there's so much to discover here. The traffic in Mumbai is chaotic and it's no surprise that this city is among the most populated in the entire world. The loud honking from cars, tuk tuks, and motorbikes assaults my eardrums with an enervating cacophony.

"The film *Slumdog Millionaire* was filmed here in Mumbai," explains my driver proudly. As I look around, I realize that it's the perfect setting for the film. The poverty in India is shocking. Neglected children in tattered clothing beg at our car windows at every stoplight. Their hair is filthy and their skin is covered in dirt. I look into their big, wide eyes and wish that I had food to offer them.

Our tour itinerary includes Mahatma Gandhi's one-time residence, the Prince of Wales Museum, and several other sights, which are all enticing, but I really want to see more of "authentic" Mumbai so we continue on. I take photos from our moving vehicle because the insane traffic makes it impossible to stop and get out for a minute. After three hours, the tour is over and I'm back on my way to the airport.

← *Indian woman in a traditional, colorful sari · This young Indian woman was wearing particularly beautiful clothing and jewelry. When I asked if I could take a photo of her, the woman's parents proudly said yes. I set the shot up so she wouldn't be totally blinded by the sun. A slight telephoto lens is ideal for an upper body portrait. 70 mm · ISO 100 · f/2.8 · 1/1600 sec*

Behind the scenes · Personal communication is the best way to achieve extraordinary, authentic portraits. 50 mm · ISO 100 · f/2.8 · 1/1000 sec →
Photo by Miriam Rass

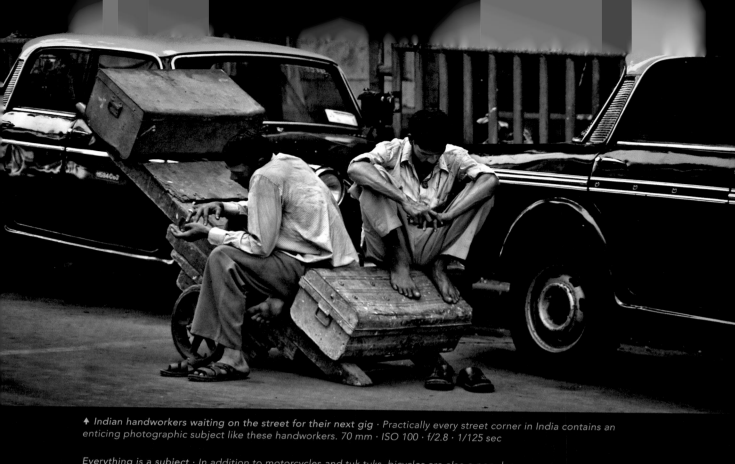

⬆ *Indian handworkers waiting on the street for their next gig* · Practically every street corner in India contains an enticing photographic subject like these handworkers. 70 mm · ISO 100 · f/2.8 · 1/125 sec

Everything is a subject · In addition to motorcycles and tuk tuks, bicycles are also a popular means of transporting people and cargo. 37 mm · ISO 200 · f/3.5 · 1/2000 sec ⬇

↟ *Indian street children · The ubiquitous poverty depresses me, but documentary photos like this one have their place. 70 mm · ISO 200 · f/3.5 · 1/320 sec*

Basket weaver on the road · Every family member tries to help earn a livelihood. 39 mm · ISO 200 · f/3.5 · 1/250 sec ↡

↑ *Typical street tableau in Delhi · Standing on the roof of a house, I was able to get a telling shot to document the busyness of the street in Delhi. 70 mm · ISO 200 · f/5.6 · 1/640 sec*

INDIA New Delhi

I hear a loud growl and then feel a sharp pain in my foot. In shock, I turn around and look behind me. A black dog with bloodshot eyes has latched onto my foot. A solid kick sends the perpetrator away howling. Rabies is my first thought, but there is no sign that the bite broke my skin. I'm thankful that I decided to put on tough hiking shoes today. I'm in the middle of chaotic Delhi. The traffic madness in the cities I visited most recently was enormous, but here in the capital of India, it's simply indescribable. With thousands of new residents arriving every day, it's no wonder this city is bursting at its seams.

I walk around the streets listening to the ceaseless honking of the traffic. "Your ear will get used to it after a little while," a local wearing a turban tells me. I don't believe him, but I ask if I can take a photo. He makes a hand gesture that can only mean he needs a few rupees, and we're in business. My wanderings through Delhi bring me to any number of fascinating scenes. Everything is exotic and exciting, but I can't stop thinking about the unfathomable poverty.

The next day I sign up for a city tour led by the non-profit Salaam Baalak Trust. This organization works to care for the many homeless street children in Delhi. My guide is Tarik. He is 18 years old, has lived on the street for years, and has a touching story. I'm surprised when he explains what the children do with the money that they beg for: drugs and Bollywood movies! Every kid on the street dreams of becoming a Bollywood star.

On the way back to the hotel I spot a crowd of people standing around one man. He works with various bottles and passes the mixture he creates to the people around him: a miracle healer. I also observe a so-called ear cleaner at work next to him. I had no idea that this occupation even existed.

My shrieking alarm clock rips me from sleep the next morning. It's 6:00 a.m. Time to grab a quick breakfast, pack up my photo bag, and head to the Taj Mahal. The chaotic traffic means I need to think of the drive there as a second trip around the world, even though it's only 140 miles away. All told, it will take 14 hours to get there and back.

We finally arrive and I stand in an impressively crowded security line. I have to leave my tripod behind, as my guide tells me it's "strictly prohibited." Despite the effort, the "short" excursion here is well worth it. The building is very impressive and the background story is romantic. I would have preferred to take pictures here at sunrise or sunset to take advantage of softer lighting and smaller crowds, but the guide keeps me moving along and the driver is waiting.

Street child at work · When I asked this boy in English if I could take a picture of him, he stared straight into the camera even though he didn't understand a word I said. 42 mm · ISO 200 · f/2.8 · 1/1250 sec ➜

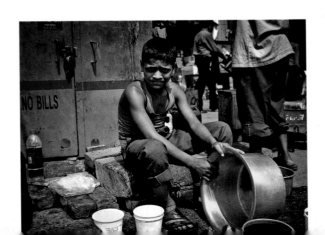

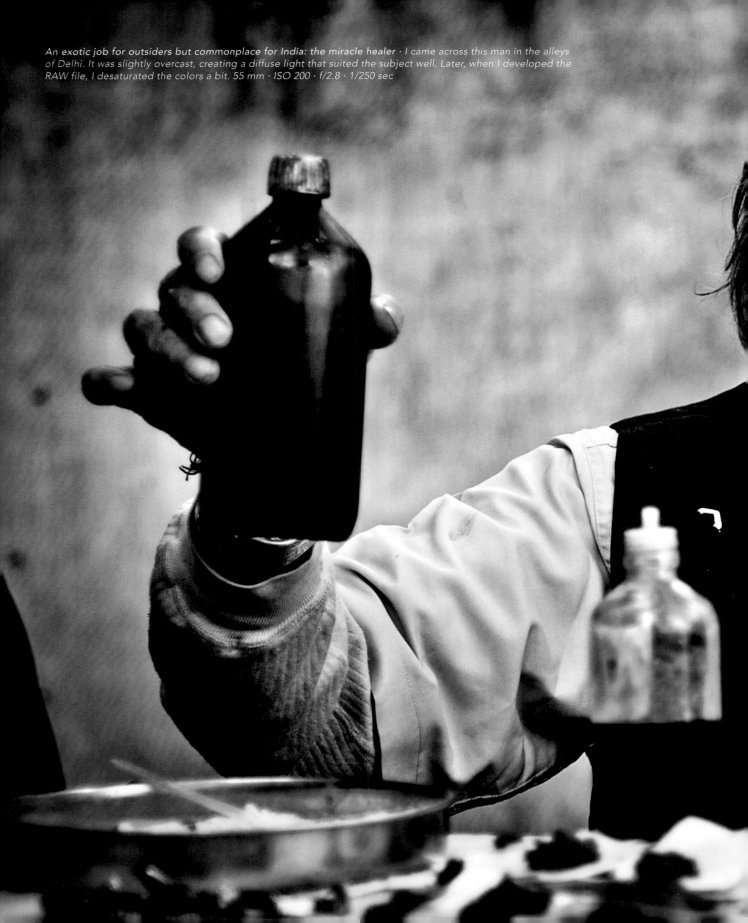

An *exotic* job for outsiders but *commonplace* for India: the miracle healer · I came across this man in the alleys of Delhi. It was slightly overcast, creating a diffuse light that suited the subject well. Later, when I developed the RAW file, I desaturated the colors a bit. 55 mm · ISO 200 · f/2.8 · 1/250 sec

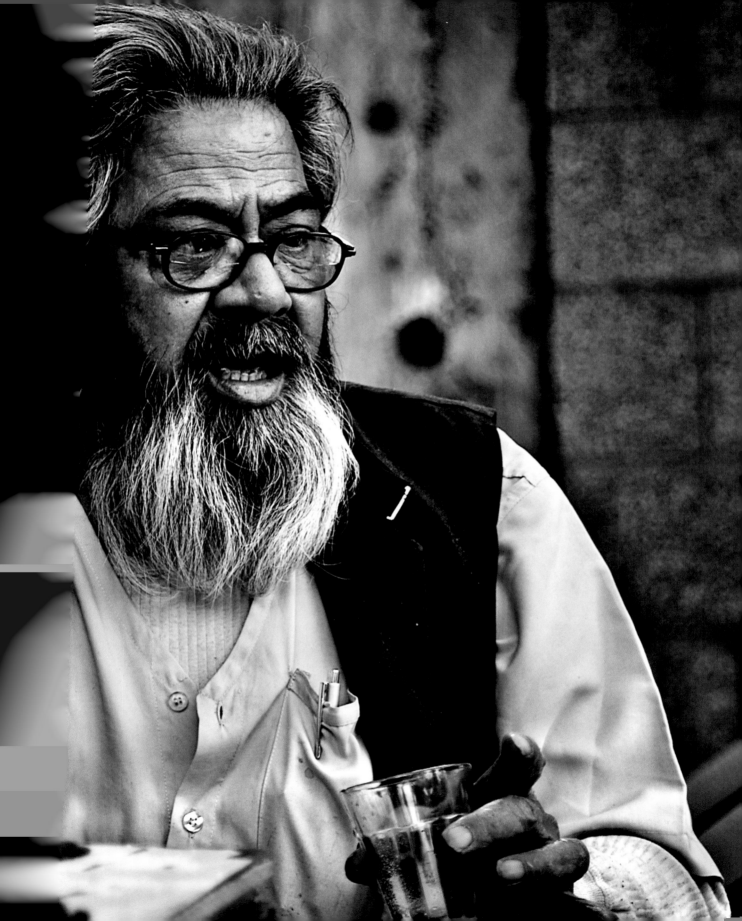

↟ *An Indian worker taking a midday nap · I shot this photo from an unconventional perspective to avoid disturbing the sleeping man. 26 mm · ISO 400 · f/2.8 · 1/125 sec*

← *Encounter with a Sikh on the way to the Taj Mahal · This man's face was exceptionally expressive, so I limited my portrait to only his head. 70 mm · ISO 100 · f/2.8 · 1/200 sec*

Devout Indian women in front of the Taj Mahal · The colorful, beautiful saris are simply attention grabbers. 70 mm · ISO 100 · f/5.6 · 1/125 sec →

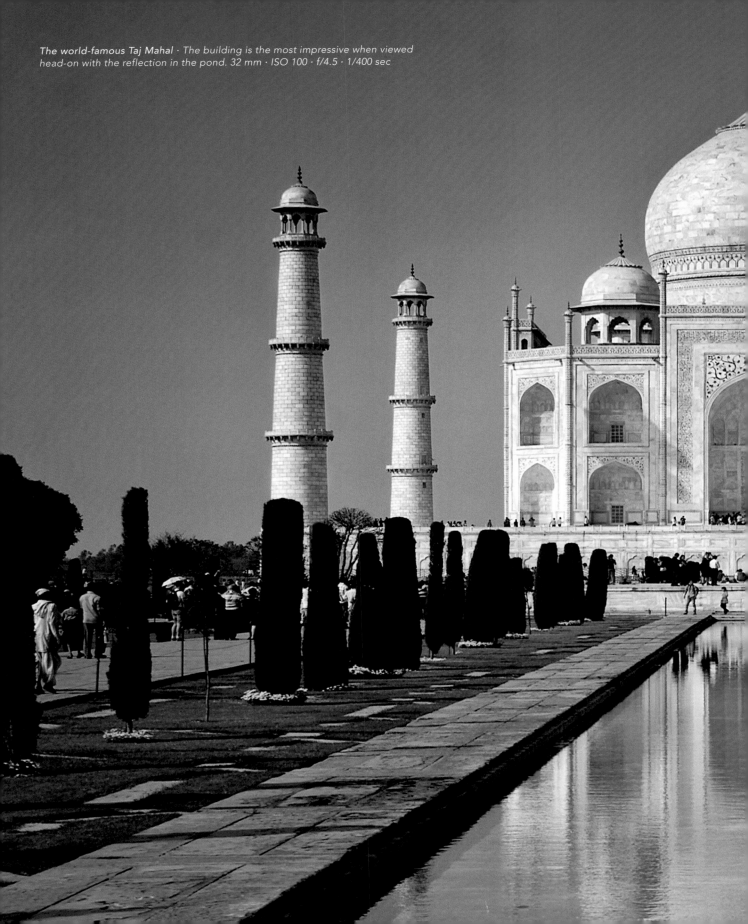

The world-famous Taj Mahal · The building is the most impressive when viewed head-on with the reflection in the pond. 32 mm · ISO 100 · f/4.5 · 1/400 sec

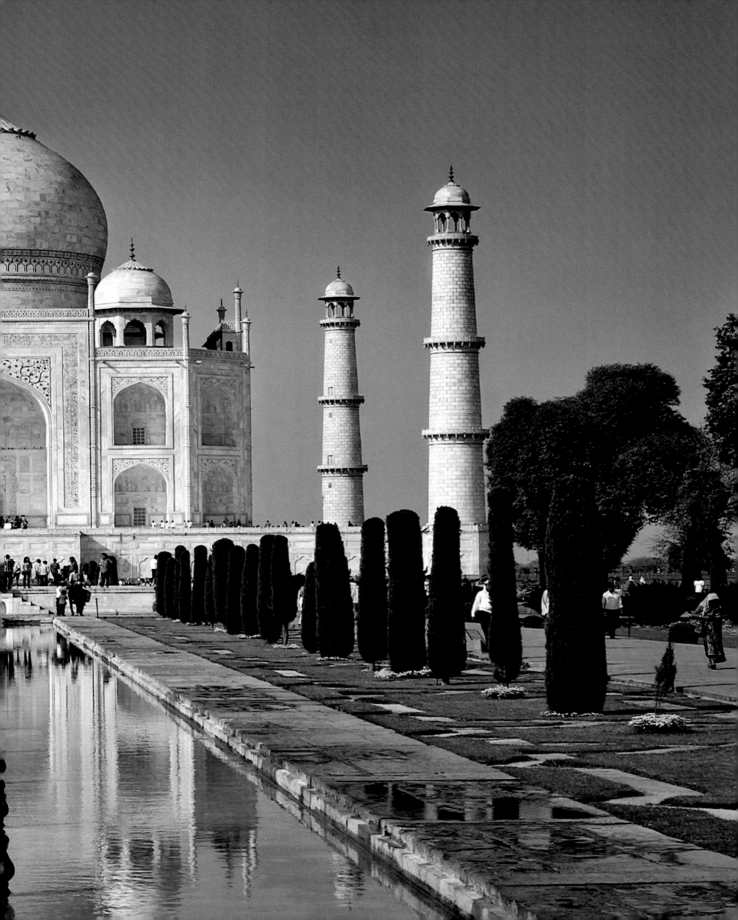

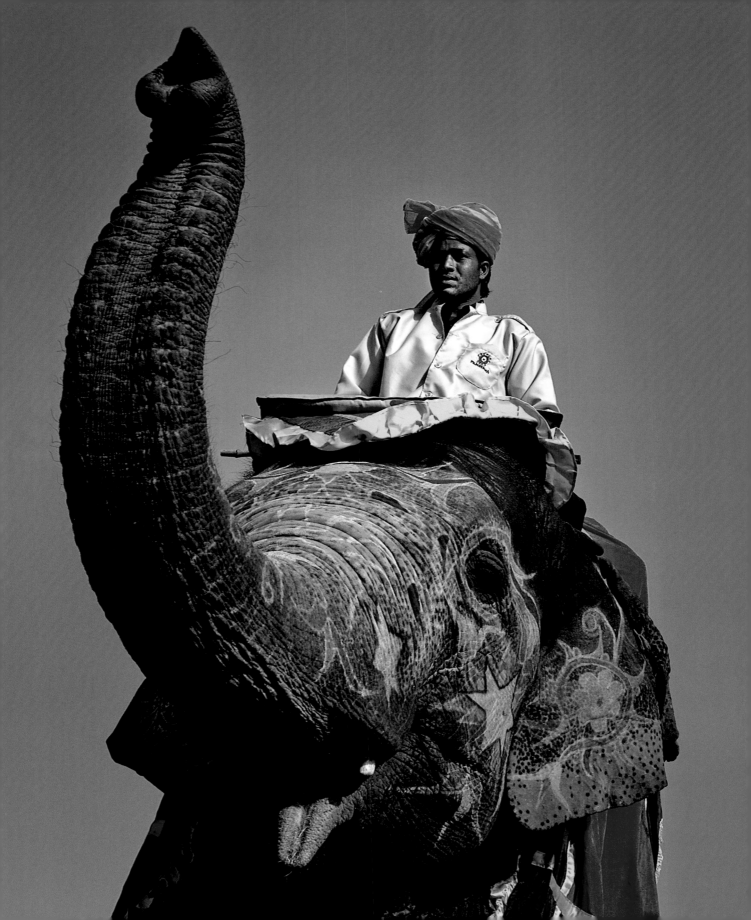

INDIA Jaipur

Thousands of people are gathered and enshrouded in an eerie silence. The air is charged with an electric excitement. I feel the earth start to vibrate beneath my feet. The vibrations become stronger and all of a sudden the source is visible. Accompanied by a loud trumpet concerto, they walk by the lofty crowds. Their skin is painted colorfully and their ears and heads are decorated with beautiful ornaments. I enjoy this experience that is at once impressive and overwhelming. No, I'm not at Rio for Carnival—I'm in Jaipur for the annual elephant festival.

The next morning I'm stopped as I try to exit my hotel. I had hoped to take a closer look at the city, but the travel director and hotel manager look at my camera equipment and shake their heads. They advise me strongly not to go out into the streets because today is Holi Festival. During this festival, it is tradition to welcome the spring by throwing large amounts of fine, colored powder and water balloons at each other. Because the locals also tend to drink a fair amount of alcohol, the fun sometimes gets out of hand. Tourists in particular are favorite targets for color attacks.

Instead, I jump ahead to the next event on my itinerary, one I'm particularly excited about: spending a few hours at sunrise up over the city in a hot air balloon. However, as soon as I climb into the basket my enthusiasm wanes. Instead of the eight-person maximum advertised in the brochure, there are nine people actually going up. This makes the basket quite crowded and I can barely move around. Swapping out my lens or changing my position is practically impossible. Scowls and curses come from the other passengers as I use some elbow tactics to force myself to the middle of the basket so I can take

a shot directly up into the balloon. But the crowdedness doesn't prevent me from thoroughly enjoying the grand view. The landing accidentally becomes something of a highlight of the trip. I can tell our pilot is getting nervous as he starts barking into his radio and splotches of sweat start to show through his shirt. The small meadow we are headed for is private property. The ground crew that normally secures the balloon at landing can't get to where they need to be. I look down as the pilot exasperatedly shouts, "jump over the fence" into his radio. This command seems to be just what the ground personnel is waiting for, and they negotiate a ten-foot tall barbed wire fence with a feline agility that makes my jaw drop. A few minutes later the suspense—and unfortunately the flight—is over.

My next sightseeing tours offer two real highlights. The first is my first-ever ride on an elephant. Being carried through countryside some ten feet off the ground is an incredible experience. The second highlight is the Galta Temple, which is often overlooked in most travel guides. Thousands of monkeys live in the abandoned temple. The fascinating photo opportunities keep me changing my lens like a thimblerigger. Distracted, I overlook the monkey who has been staring at me curiously and attempts to take off with my treasured telephoto lens. The lens is too heavy for him, though, and he drops it, leaving me one lens down for what's to come.

◀ *At the Elephant Festival · The animals were magnificently dressed, painted, and decorated. As I was still trying to work out exactly how to compose this picture, the elephant suddenly raised its trunk. The resulting photo is much more dramatic. 24 mm · ISO 200 · f/6.3 · 1/320 sec*

⬆ *The sale of colorful powders for the now world-famous Holi Festival · Not wanting my camera gear to be "decorated" with these colors, I opted to avoid the powder attacks in safety. 24 mm · ISO 200 · f/2.8 · 1/800 sec*

A proud elephant owner with his brightly decorated pachyderm · The deliberate crop of this photo brings the paint to the center of the viewer's attention. I tipped my camera to the left slightly to include the rider in the picture. 34 mm · ISO 200 · f/5.6 · 1/500 sec ⬇

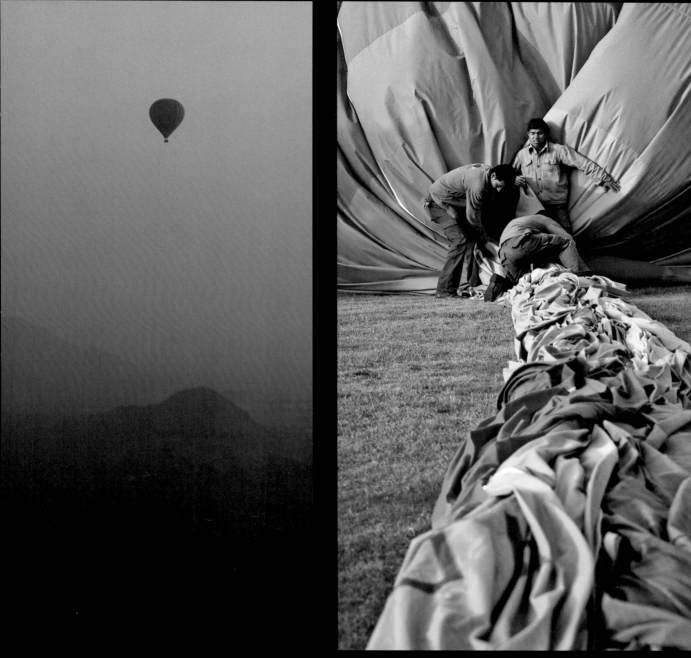

⬥ *A fantastic experience: a balloon ride at sunrise over Jaipur · The early fog, the soft light, and the positioning of the balloon combine beautifully to create the sense of distance and weightlessness.*

⬥ *The balloon is quickly secured after the spectacular landing · The part of the balloon that's folded together guides the viewer's gaze to the workers in the background. 70 mm · ISO 200 · f/5.6 · 1/200 sec*

← *Woman with a broom* · *I politely asked this woman to stand in the archway because it built a natural frame. The color of her sari matched the weathered background well. The midday sun created harsh shadows, but I lightened them up when digitally processing the photo later.*
30 mm · ISO 100 · f/2.8 · 1/2500 sec

↑ *Snake charmer in Fort Amber* · *I focused on the cobra by using a shallow depth of field. I also positioned myself on the ground so I could include the snake charmer in the background of the photo. 39 mm · ISO 200 · f/2.8 · 1/640 sec*

← *Female monkey in the Galta Temple* · *One of the last pictures I took of monkeys in India. A short time after capturing this image, one of these cute, little guys tried to take off with my telephoto lens, dropping and breaking it in the process. 200 mm · ISO 200 · f/2.8 · 1/160 sec*

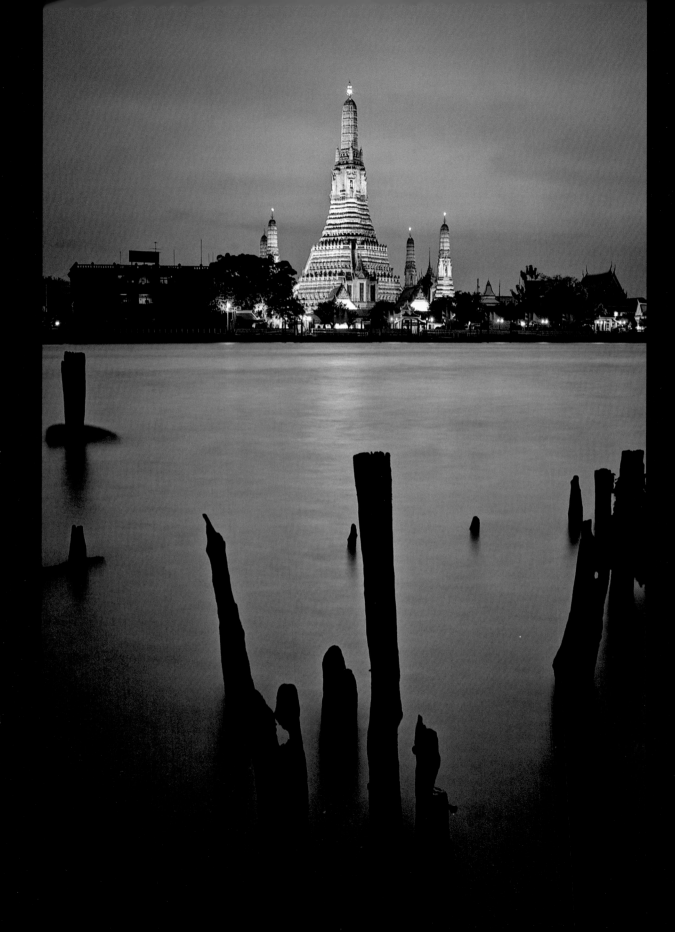

THAILAND Bangkok

The door opens and the hot, humid air envelops me immediately. It's 99°F and the humidity is at 75%. I can barely resist the temptation to run back into the air-conditioned airplane. I've arrived in Thailand's capital and am driven to my hotel as the sun sets. The skyscrapers fly by my car window as a catchy tune from the eighties, "One Night in Bangkok," floats through my head.

There are more than 400 Buddhist temples and monasteries in the "City of Angels," and I take a closer look at a few of them. Where there are temples, there are monks, and there are many in this fascinating city. Every time I meet one of these men wrapped in orange robes my interest is sparked anew. I continue onward to the bank of the Chao Phraya River, where I take in the Wat Arun Temple at sunset—a beautiful end to the day.

The last day in this city belongs under the motto "Good morning, Bangkok." Getting up early is a foregone conclusion because the hustle and bustle starts well before sunrise. My first journey takes me to the park, where "early morning exercise" takes on a new meaning for me. Groups and individuals alike practice their favorite sport, Tai Chi. The many old people participating are particularly interesting to me.

In earlier times, Bangkok didn't have many streets and instead had a network of canals, or khlongs. Traffic and markets took place on the water. Today, many of these canals are filled in, but you will still come across floating markets where women on narrow, long boats offer their wares. There is a broad selection of goods on sale, from vegetables to fruit to souvenirs. You can even find entire cookshops on these floating markets.

Bangkok is a city with many faces. It is both posh and dirty, beautiful and shabby. On one hand you have the impressive temples, monks, and lotus-decorated shrines, and on the other hand you have extreme air and land pollution, sex tourism, and much misery. All of these are facets of one of the most fascinating big cities in Southeast Asia.

✦ Wat Arun (Temple of Dawn) at sunset · The dark posts in the foreground aren't particularly attractive, but they make the picture interesting. 24 mm · ISO 100 · f/10 · 8 sec

Woman kneeling in prayer · Rituals are also an appropriate subject for documenting a country in photographs. I kneeled down to photograph at the same level as the subject. 70 mm · ISO 400 · f/2.8 · 1/60 sec ✦

♠ *Fresh fish for sale on a floating market · Repeating subjects often make interesting patterns, which is why I decided to shoot these fish from above. 42 mm · ISO 200 · f/2.8 · 1/320 sec*

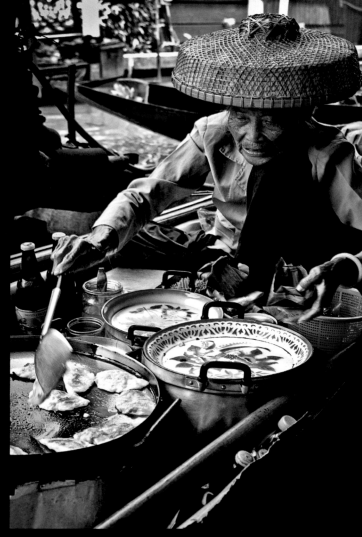

♠ *The famous floating markets and cookshop boats · This old woman fried fish directly in her boat. She was very quick at her task and it took me a while to snap a photo that's sufficiently sharp. 34 mm · ISO 200 · f/4.5 · 1/125 sec*

← *An elderly women engaged in early morning exercise · Her red fan caught my attention, and before I even took the photo, I knew I wanted to convert it to a colorkey image later. 85 mm · ISO 200 · f/1.4 · 1/250 sec*

A statue at the Grand Palace in Bangkok · I walked all the way around the statue and decided to use the temple, which has a similar color, as the background. The result is a calm, golden photograph. 86 mm · ISO 200 · f/5.6 · 1/500 sec →

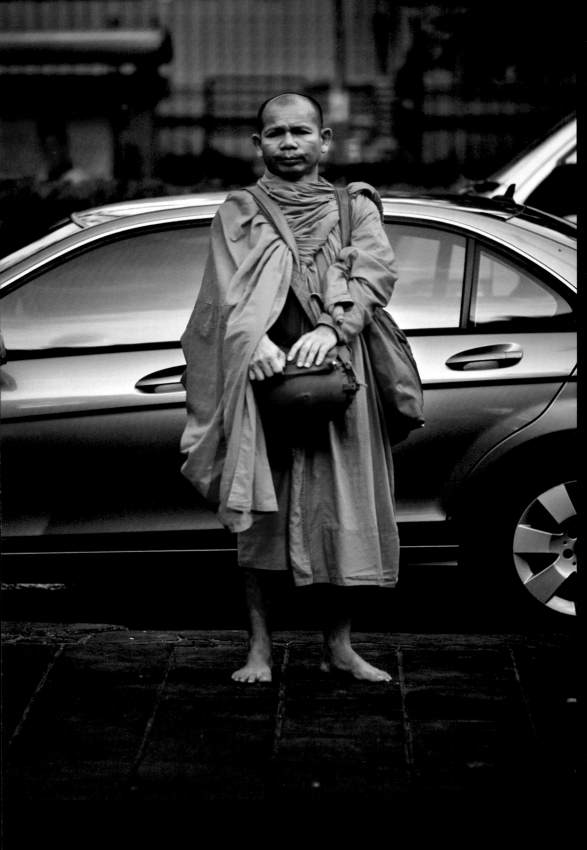

Bangkok's skyline · The blue hour always creates a special charm for me. 24 mm · ISO 100 · f/8 · 8 sec ↓

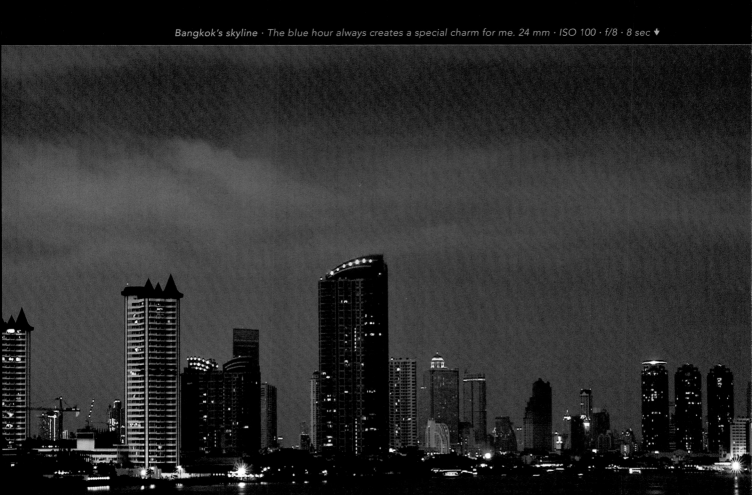

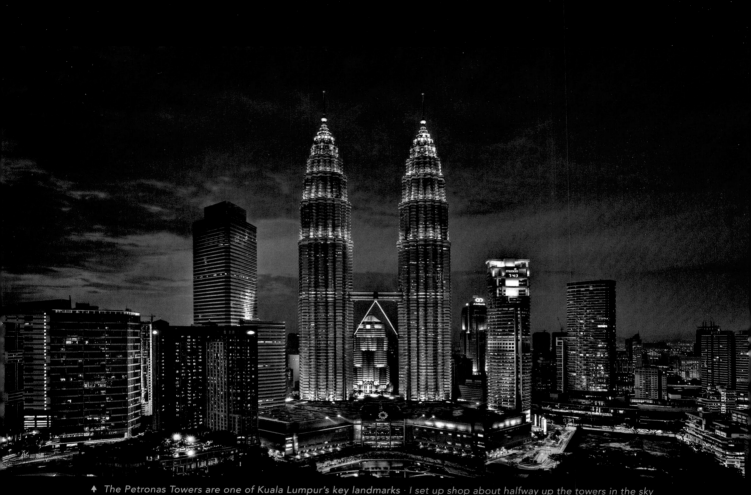

⬧ *The Petronas Towers are one of Kuala Lumpur's key landmarks · I set up shop about halfway up the towers in the sky bar of the nearby Traders Hotel to avoid distortions in my final image. 15 mm · ISO 100 · f/8 · 4 sec.*

MALAYSIA Kuala Lumpur

"This is the famous Chinese Thean Hou temple," my tour guide explains to me. I have been in Kuala Lumpur for a few hours with him already. I visited the national monument, the new royal palace, and more, but nothing has really jumped out at me as a great subject for a photograph. Unfortunately, the one subject that really caught my eye, the Sultan Abdul Samad Building, was obscured by scaffolding.

I had really looked forward to this city, but I'm having a hard time cracking it open. I'm standing in the middle of a skyscraper jungle and somehow can't see the forest for the trees.

The 1,483-foot Petronas Towers are the true hallmark of the city. I head in their direction with the hope of finding a good vantage point from which to photograph them in the evening. After an hour of scoping things out, I find my spot in the Traders Ho-

tel, which has a sky bar with a great view on the 33rd floor. I'll have to shoot through a pane of glass, but the view of the twin towers is really excellent. There's still a bit of time before the sun sets, and I strike up a conversation with a kind, elderly gentleman who turns out to be a well-known architect who designed several important buildings in Kuala Lumpur. He also likes to take photographs, so we talk shop for a bit and the time flies before the blue hour is at hand. Satisfied with the pictures I capture, I head back to my hotel in a good mood.

Orchids · I took this photo inside my hotel on a rainy day in Kuala Lumpur. The flower blossoms caught my attention and so I converted my bathroom into a makeshift photography studio. 105 mm · ISO 100 · f/5.6 · 3/5 sec →

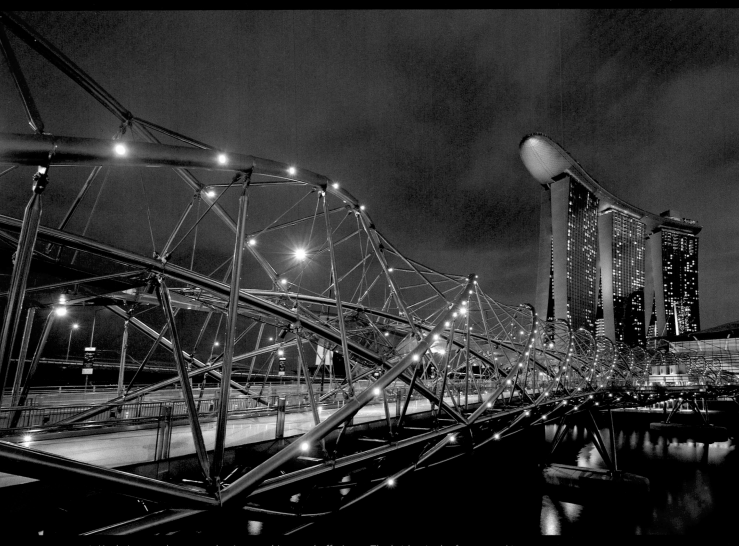

⬆ *Kuala Lumpur has several unique architectural offerings* · *The bridge in the foreground is modeled after the structure of human DNA. The Marina Bay Sands Hotel in the background has a rooftop swimming pool that sits 57 stories above ground. 10 mm · ISO 100 · f/8 · 6 sec*

SINGAPORE Singapore

It took fifteen minutes to get up here, but I'm finally looking down at the city of Singapore from the top of the largest Ferris wheel in the world, and I'm utterly filled with delight. This multicultural metropolis has won me over. It isn't as typically Asian as I had imagined; it has something of a European feel owing to the colonial era. Maybe that's why it appeals to me so much. After four weeks in Asia, this city almost gives me the feeling that I've come home. Right at sunset I walk along the water until I have an unobstructed view of this city that I've already grown to love.

A group tour the following afternoon turns into something of a rat race. About thirty other tourists and I are led quickly through a laundry list of attractions at a quick clip. We check off a museum, an aquarium, the botanical gardens, and so on. There's no time to find ideal perspectives, let alone consider image composition thoroughly or adjust camera settings. As it is, my brief stops to take photos are met with harsh glances. The comment, "Hurry—no

time!" is the straw that almost breaks the camel's back, but I'm still able to capture one or two subjects.

The city looks gorgeous during the day, but at night it turns into a spectacle of color. Some buildings are even illuminated attractively as part of an art project. There are also various light and sound installations that cast a spell over the eyes and ears.

Singapore is simply a fascinating city. It is modern, multicultural, and exceptionally clean, which has to do with the steep fines associated with minor breaches of the law. Tossed cigarette butts, for example, could set you back $675, and facial tissues and soda cans are double that. Until recently, you could even be fined for the possession of chewing gum!

Skyline with the highest Ferris wheel in the world · The Singapore Flyer is 541 feet tall. I walked to the other side of the river so that I could use the water's surface to reflect the beautiful lighting, quasi-doubling its significance in the photo. 13 mm · ISO 100 · f/10 · 3.2 sec ➤

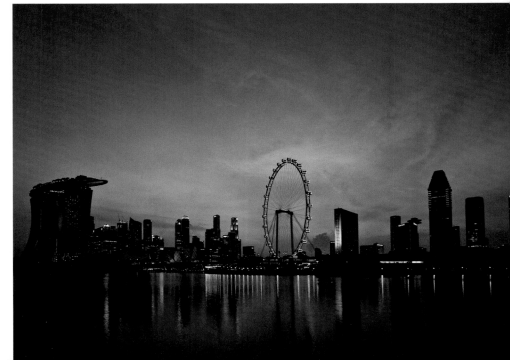

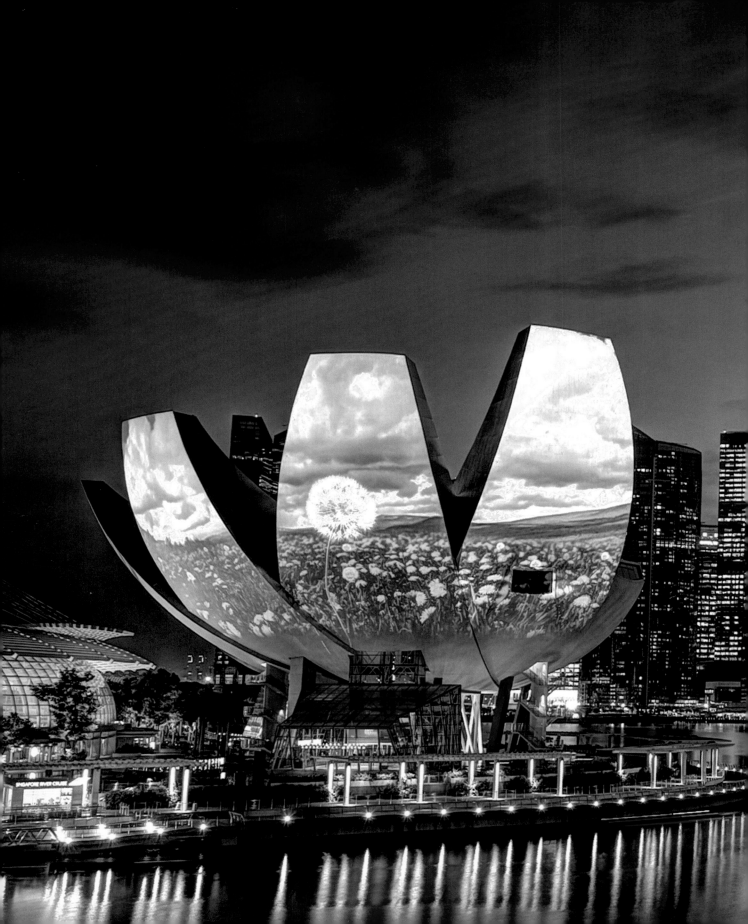

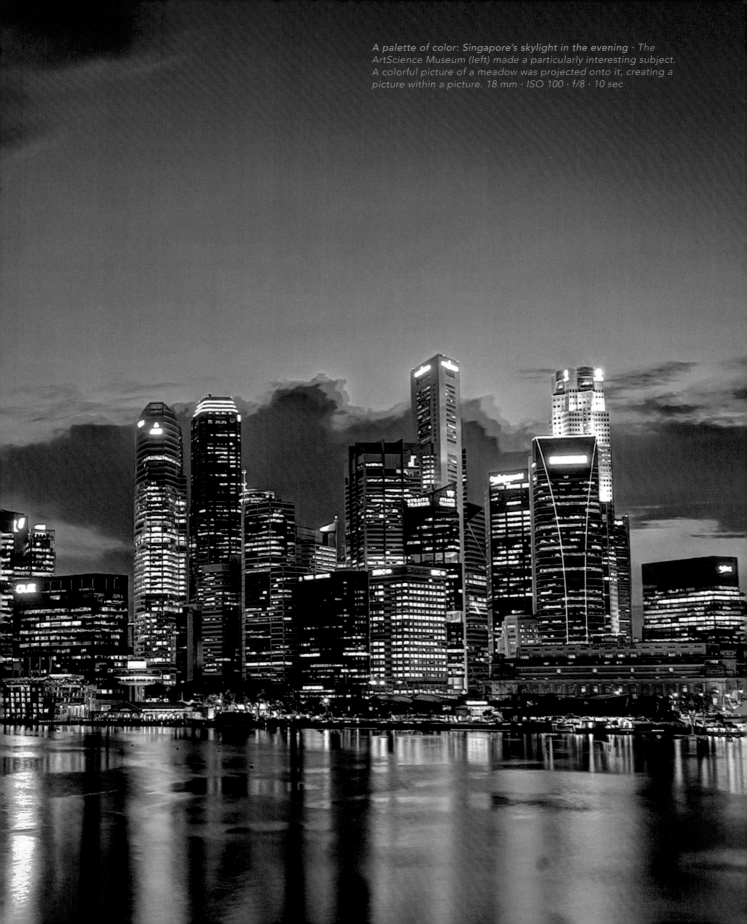

A palette of color: Singapore's skylight in the evening · The ArtScience Museum (left) made a particularly interesting subject. A colorful picture of a meadow was projected onto it, creating a picture within a picture. 18 mm · ISO 100 · f/8 · 10 sec

CHINA Hong Kong

I have a one-day stopover in Hong Kong, which was more or less gifted to me as a result of my around-the-world ticket schedule. My first walking excursion takes me to the port, where once again I'm rewarded with a fantastic skyline. Unfortunately, Hong Kong suffers from extreme smog, making it constantly hazy. The sky is a uniform gray and the visibility is limited, but I try my luck anyway.

The onset of darkness brings a big surprise with it: a light show involving large beams of light radiating outward from the city's skyscrapers combined with classical music. The light show lasts for ten minutes.

The next day, I walk through the city and end up being a photo subject for two students who take pictures of me with their cell phones. Shortly after that I spot a huge scaffolding site made out of bamboo. I watch the workers putting up the support beams—huge shoots of bamboo are tied together with

nothing other than hemp-like ropes. This seemingly dangerous construction method is even used for skyscrapers. I try to find an official construction permit on site but don't have any success.

In the meantime, I've managed to lose my sense of direction in this urban jungle. I wander aimlessly through the streets. The overwhelming Chinese signage isn't helping me much, either. My back is beginning to hurt and my legs are protesting each additional step. Exhausted, I flag down a taxi that takes me back to my hotel.

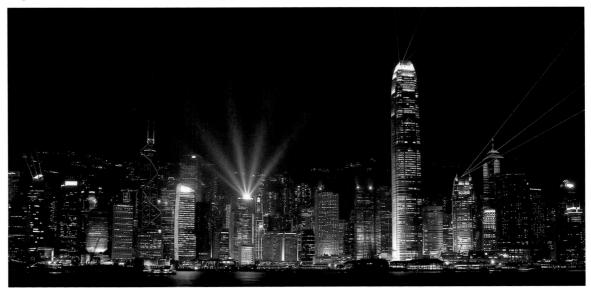

↟ *Hong Kong's skyline · Every day when it gets dark, the skyline of Hong Kong puts on a ten-minute laser show complete with accompanying music. 24 mm · ISO 100 · f/10 · 10 sec*

↞ *A forest of signs on the streets of Hong Kong · The abundant, colorful neon advertisements bearing Chinese characters made an interesting subject even during the day. 63 mm · ISO 200 · f/6.3 · 1/250 sec*

⬆ *Scaffolding workers · Bamboo is used in China to build huge scaffoldings. The shoots are tied together only with hemp ropes. Aluminum scaffolding, which is more common in Europe, is fairly rare here. 147 mm · ISO 400 · f/2.8 · 1/320 sec*

↟ *Exchanging portraits · I served as a subject for a snapshot that these two students took with their cell phones. Europeans are jokingly referred to as "long noses" in China. 42 mm · ISO 200 · f/2.8 · 1/60 sec*

One of the main means of transportation in Hong Kong: the taxi · The blurry Chinese signs in the background clue the viewer in to where the photo was taken. 112 mm · ISO 200 · f/2.8 · 1/2000 sec ↡

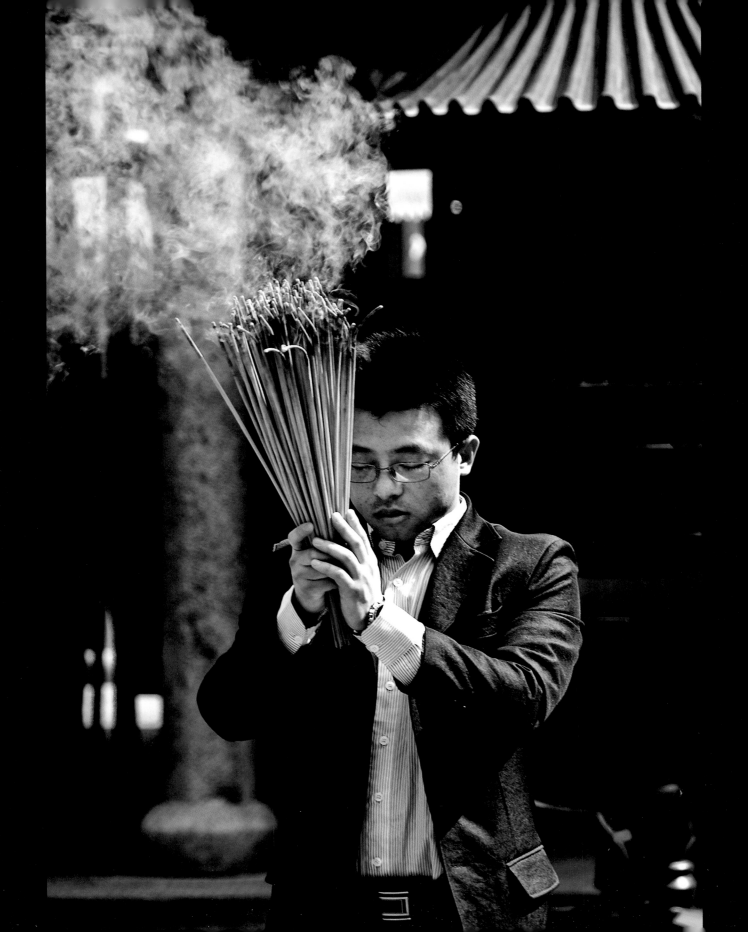

CHINA Shanghai

My eyes burn, my lungs fill with smoke, and ashes waft over my face. My tour guide Zoe has brought me to the most significant spiritual and cultural location in Shanghai, the Jade Buddha Temple. I find the chanting monks and praying believers who bow and waft smoking incense in all directions more exciting than the building itself. Even though I now smell like smoke, I can't tear myself away from the scene.

Only when my guide tells me that our next destination—the 1,614-foot Shanghai World Financial Center—is the tallest building in China am I finally ready to leave. (It has since been surpassed in height by its neighbor, the Shanghai Tower.) Once there, some kind Chinese ladies lead us to the elevator. Moving at an incredible speed of 22 miles-per-hour, we shoot up to the highest observation deck in the world. The view at 1,555 feet above the earth is breathtaking. Once my feet are back on solid ground, I take a stroll along the facing waterfront area called the Bund. The

pleasant view of the Huangpu River and Shanghai's skyline is arresting.

I venture out on my own the next morning but I have second thoughts at the first intersection I come across. I was able to get by with English in Hong Kong, but here it's another story. Nevertheless, I somehow make do and arrive at today's destination, the famous Hu Xin Ting Teahouse in Yu Garden. I enjoy a well-deserved cup of tea, take in the locals, and mentally prepare myself for the next stop on my journey.

← *A Chinese man with incense · This young man prays for his deceased ancestors. The dark background makes the smoke readily visible. 200 mm · ISO 100 · f/7.1 · 1/80 sec*

Praying monks · The success of this photo relies on the colors and the identical positioning of the monks and their cloaks. 34 mm · ISO 400 · f/2.8 · 1/200 sec →

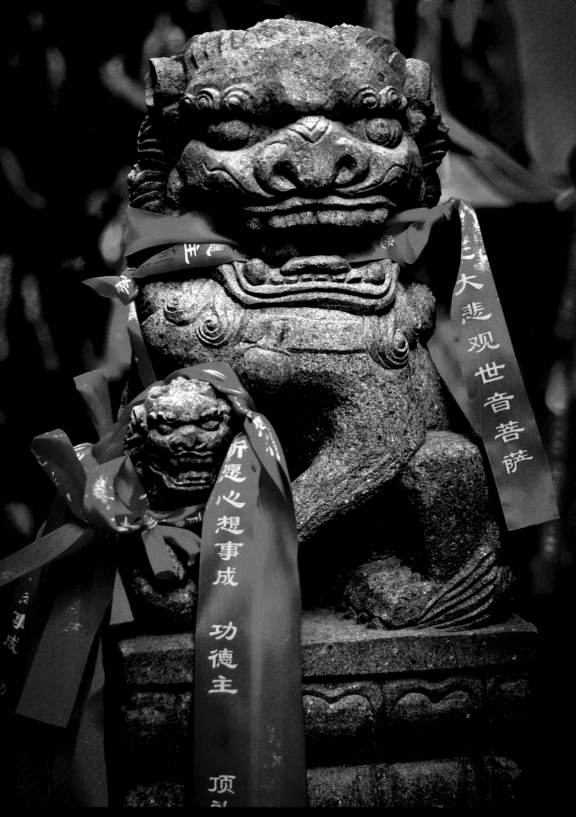

⬆ *A mother guardian lion with her cub · The red prayer flag makes this otherwise boring subject something special. 39 mm · ISO 400 · f/2.8 · 1/800 sec*

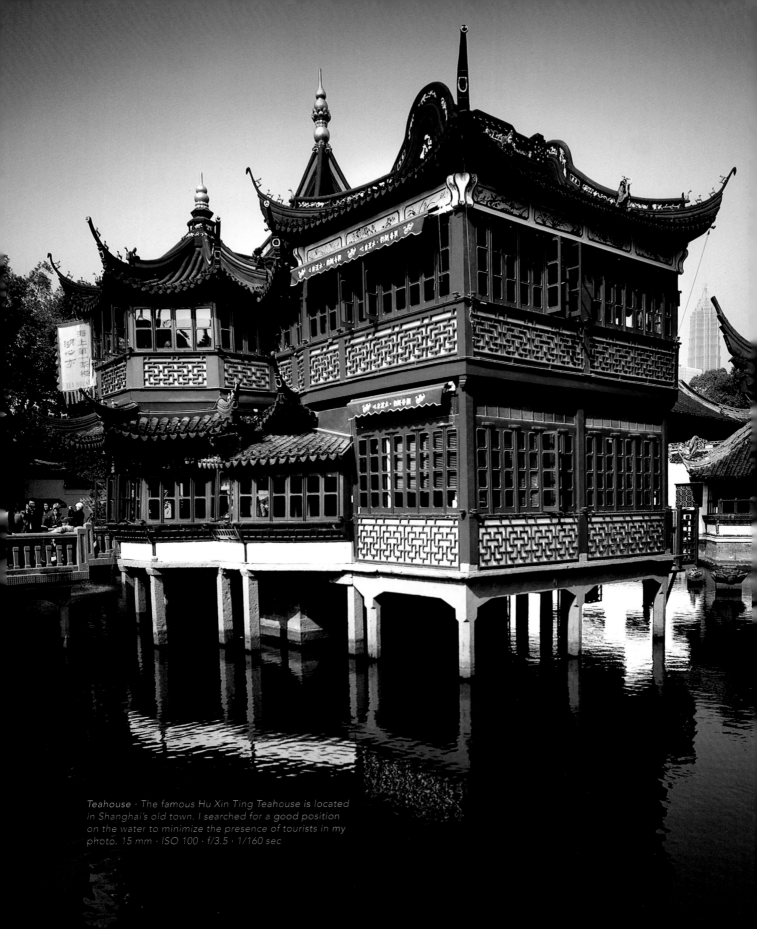

Teahouse · The famous Hu Xin Ting Teahouse is located in Shanghai's old town. I searched for a good position on the water to minimize the presence of tourists in my photo. 15 mm · ISO 100 · f/3.5 · 1/160 sec

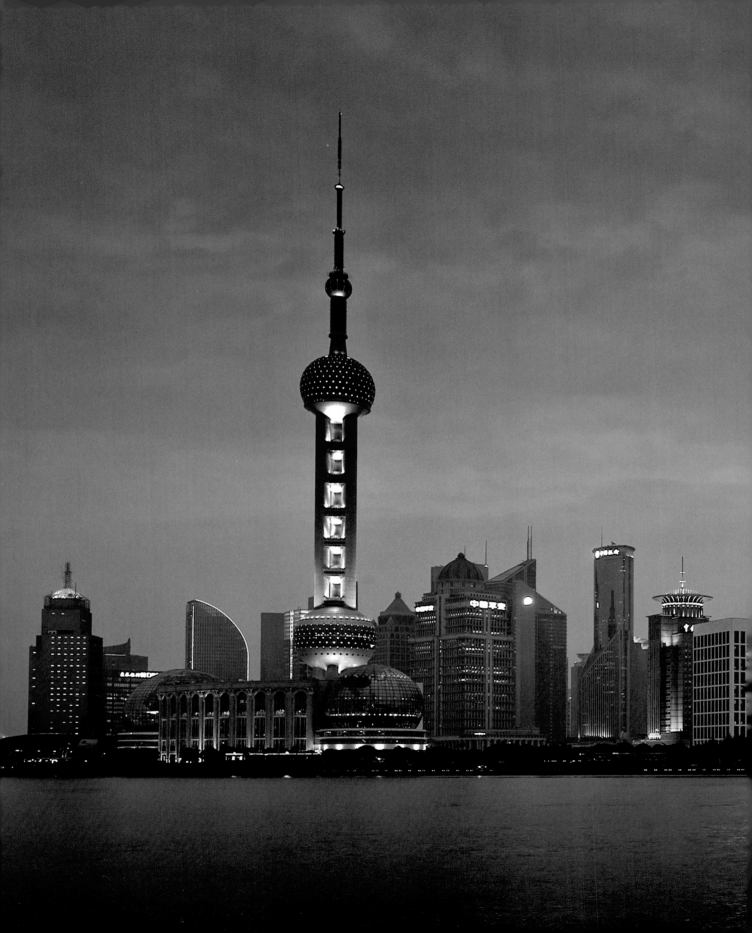

Shanghai's skyline during the blue hour · The Oriental Pearl Tower took on a particularly futuristic quality in this cold lighting. A small aperture kept everything sharply in focus, but a tripod was mandatory. 18 mm · ISO 100 · f/9.0 · 3/5 sec

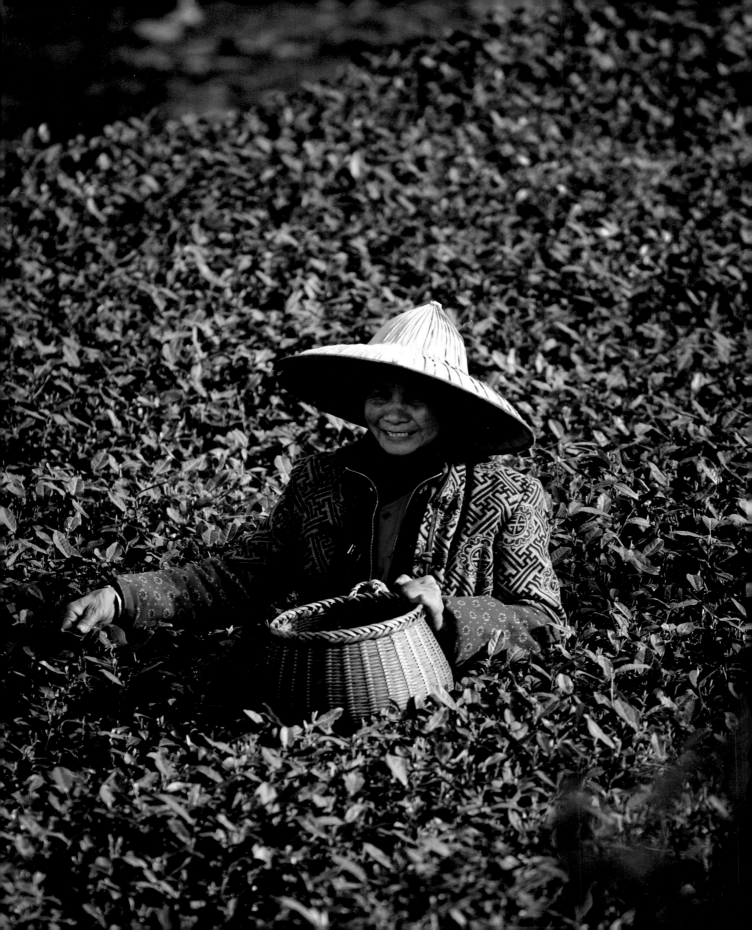

CHINA Hangzhou

"The heavens have paradise, but the earth has Hangzhou." This saying from my tour guide rattles around in my head as I take pictures of Hangzhou's famous West Lake. The relative desolation of my photo is actually a bit misleading. China's traditional Ghost Festival is currently underway and the entire country has three days off. Vacationers storm the city and lake by the hundreds of thousands. I have to fight with my whole body to keep my place on the waterfront. I hope paradise looks a bit different.

Hoping to avoid the masses the next morning, I decide to visit the Lingyin Temple, which is also called the Temple of Soul's Retreat. But thousands of visitors have arrived here as well, so it's time to grin and bear it. In addition to various Buddhist temples, there are also many sculptures that were carved in stone many years ago. The most famous is the smiling Buddha, which is revered as a god of luck.

At a loss for how to escape the throngs of people, I duck into a tea ceremony to relax. The minutia of tea production is explained—how green tea is harvested, why it's so healthy, and much more. The Chinese singsong relaxes me so much that I almost fall asleep. I quickly snap out of it when I pay the equivalent of 40 dollars for a tiny box of tea. This first-choice, hand-picked tea comprises the ultra young, tender tips of leaves. Interestingly, this tea is not available outside of China because China exports only its third-class tea to foreign countries. The premium product stays at home for locals to savor.

← Industrious tea picker · Premium green tea is picked by hand, and is accordingly very expensive. 128 mm · ISO 200 · f/2.8 · 1/640 sec

Chinese dragon boat · These large, ornately decorated boats are typical for the West Lake. 70 mm · ISO 100 · f/4.5 · 1/800 sec →

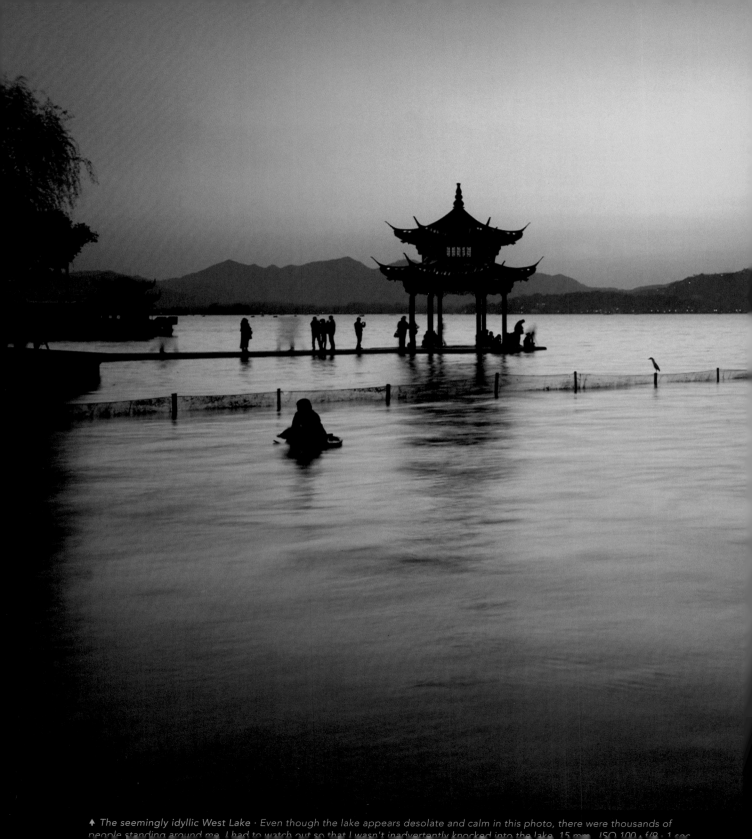

↑ *The seemingly idyllic West Lake · Even though the lake appears desolate and calm in this photo, there were thousands of people standing around me. I had to watch out so that I wasn't inadvertently knocked into the lake. 15 mm · ISO 100 · f/9 · 1 sec.*

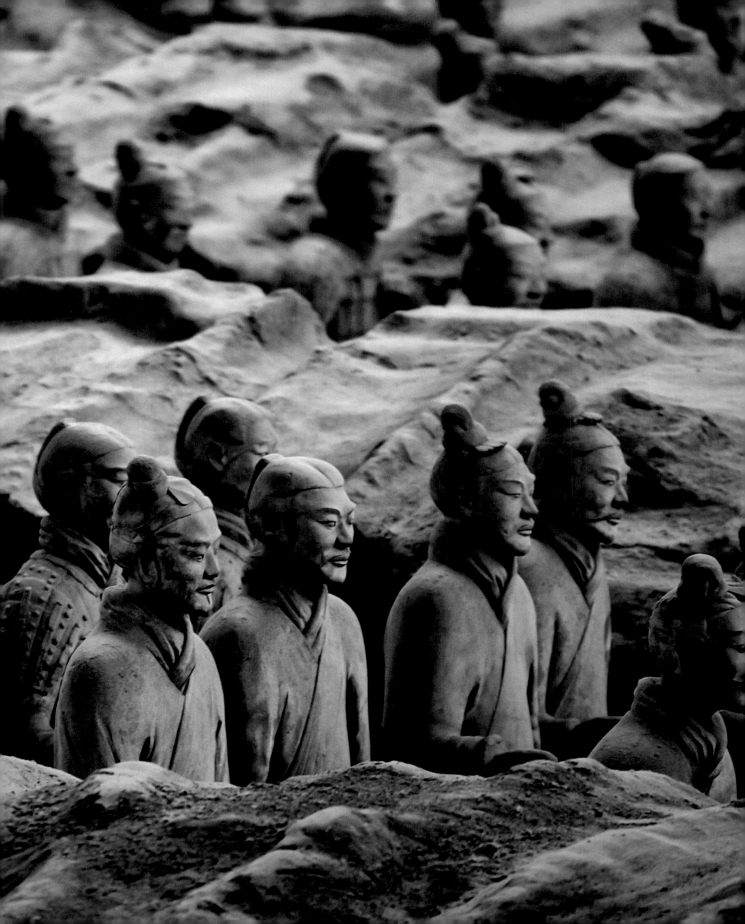

CHINA Xi'an

After a long drive, twenty minutes of hiking, and several drops of sweat, the soldiers of the Terracotta Army are finally standing across from me. They stare straight ahead and stand in formation, thousands strong, as though they are waiting for the attack signal. I've arrived in the Chinese city Xi'an, which was the seat of the emperor of China up until the beginning of the tenth century.

"The life-sized terracotta army guarded the grave of Emperor Qin Shi Huang for 2,000 years, until local farmers accidentally discovered the thousands of terracotta soldiers and horses when digging a well in 1974," explains my travel guide in broken German. I am fascinated by one of the world's most famous archeological discoveries, which is also sometimes referred to as the "eighth wonder of the world."

One highlight follows another, and next I jump ahead to the year 652 and the Giant Wild Goose Pagoda, Xi'an's most famous landmark. The monk sitting in front of the temple is the subject that catches my eye. He writes down the hopes of believers in elaborate calligraphy.

← *The eighth wonder of the world: the Terracotta Army · Thousands of these life-sized statues guarded the grave of the first emperor of China. 200 mm · ISO 400 · f/2.8 · 1/160 sec*

Dragon ornament with the Giant Wild Goose Pagoda, the city's landmark · For an unconventional look at the famous landmark, I decided to relegate it to a blurred secondary subject in my composition. 86 mm · ISO 100 · f/5.6 · 1/640 sec →

↟ *A monk writing calligraphy · This monk elaborately decorates a piece of paper with calligraphy. It's a conventional portrait, but one that has a definite charm to it on account of the uniqueness of Chinese culture. 120 mm · ISO 200 · f/5.6 · 1/640 sec*

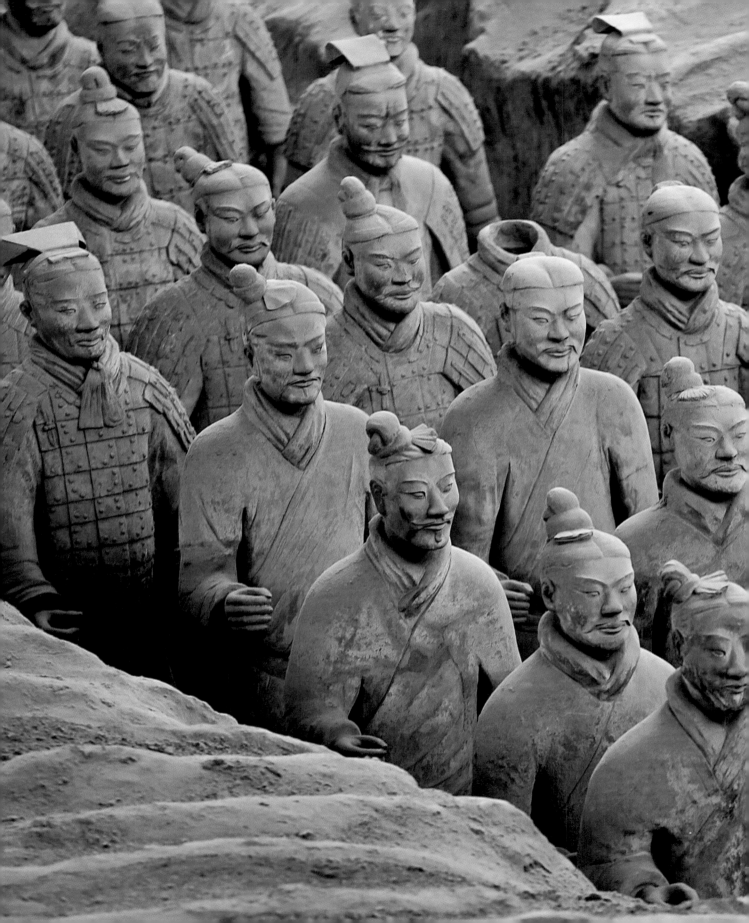

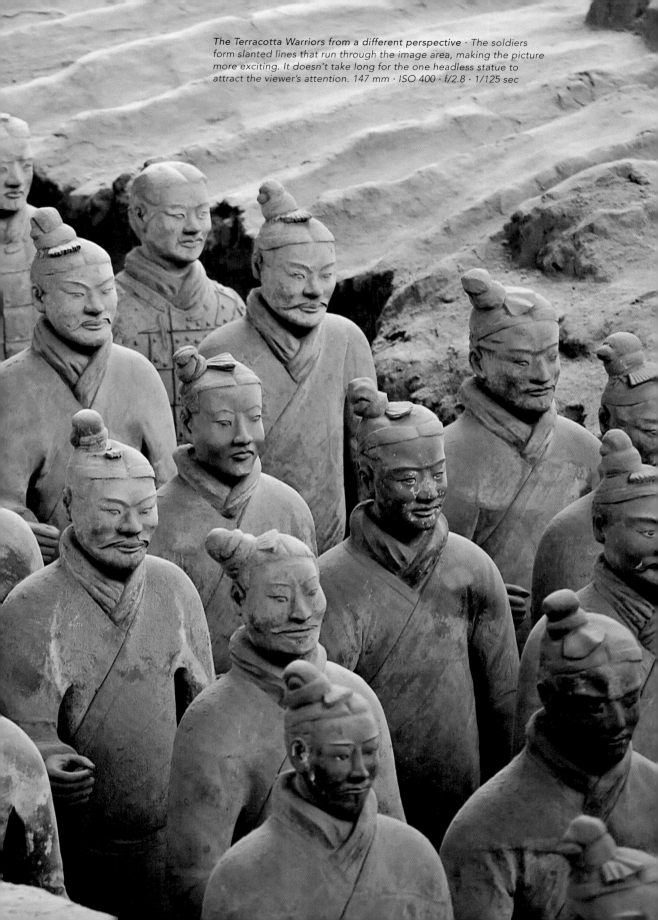

The Terracotta Warriors from a different perspective · The soldiers form slanted lines that run through the image area, making the picture more exciting. It doesn't take long for the one headless statue to attract the viewer's attention. 147 mm · ISO 400 · f/2.8 · 1/125 sec

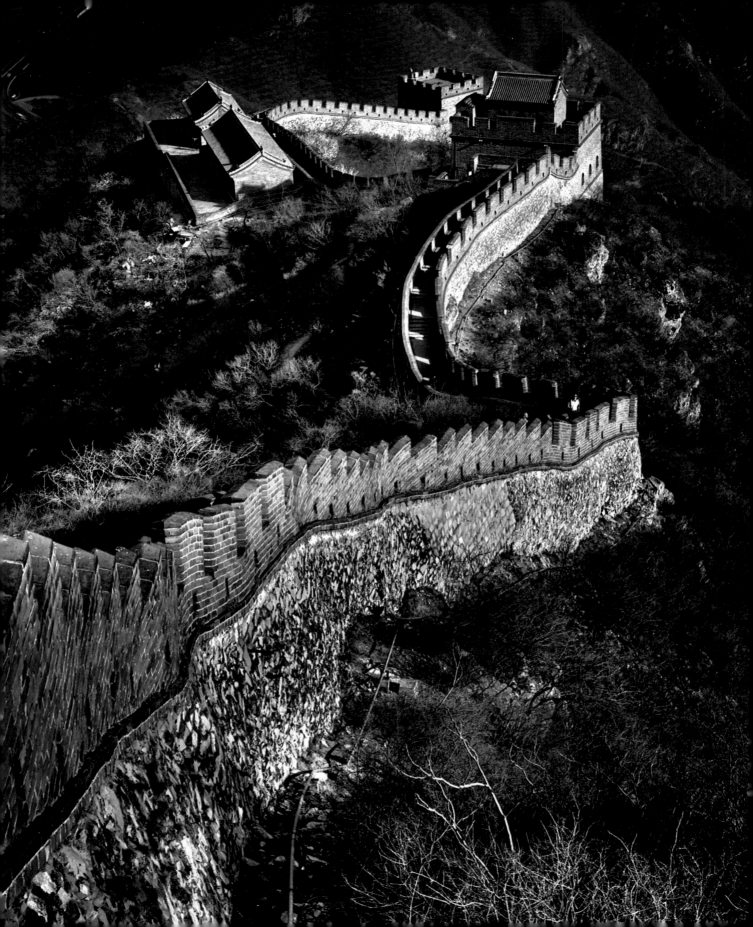

CHINA Beijing

I am on my last legs and my lungs are ready to burst. A feeling of joy rushes over me as I scale the last steps and start to take in the outstanding view. I have made it to the highest point of the Great Wall of China with my 45-pound backpack. I'm not the only one who has taken on this strenuous, hour-long march. Behind me, other tourists are panting toward their goal; their bright-red faces speak volumes. Who wouldn't make an effort to have an elevated view of a portion of the largest construction in the world?

I'm overtaken by hunger on my way back down into the valley and I head to one of Beijing's typical food halls. Meticulously skewered "delicacies" of all kinds wait to conquer my taste buds. The range is extensive—deep-fried cockroaches, grasshoppers, dried seahorses, and fried centipedes all cause my mouth to water. Ultimately, I decide on a real man's snack—scorpions on a stick. "And the poison?" I ask the vendor. He grins at me and picks up one of the wriggling wood skewers. "No poison," he says, as he sets a skewer with a live scorpion on it onto the grill and it begins to sizzle. They are crispy and quite spicy. The stinger is meant to be eaten too, by the way. I just have to hope that no symptoms of food poisoning emerge.

Now fortified, I head over to Tiananmen Square, which, at 100 acres, is one of the largest public squares in the world. Expressionless guards stand in front of the Tiananmen Gate, which has played a significant role in Chinese history. Built in the early 1400s, this is where the emperor's proclamations were read. This is also where Mau Zedong declared the founding of the People's Republic of China on October 1, 1949. A giant portrait hangs from the 110-foot gate in his memory. The Forbidden City, also known as the Imperial Palace, is located behind the gate. Up until 1911, this is where the Chinese emperors of the Ming and Qing dynasties lived and ruled. As the name suggests, it was off limits to the common folk.

The next stop is the Temple of Heaven, which is surrounded by a large park where locals rest and spend free time. Most of the visitors are retirees, in part because entrance is free for seniors. People play Mahjong, dance, and laugh. The most important building in the Temple of Heaven is the Hall of Prayer for Good Harvests. The hall, built in 1420, is one of Beijing's most famous landmarks and serves primarily as an altar to offer prayers for a bountiful harvest.

Beijing—also known as Peking—represents the past, future, and present of China in one city. The entire culture and history of the country is on display here. The city itself is constantly in transition and is on a mission to be better than other cities. Beijing was revitalized for the Olympic Games in 2008 when much of the city was torn down, renovated, and modernized. The city is an absolute must for anyone interested in China.

← *China's most famous landmark: the Great Wall · The position of the wall in this image is such that the viewer's eye is guided through the entire image area. 30 mm · ISO 100 · f/7.1 · 1/60 sec*

↟ A delectable treat: fried scorpions on a stick · This is probably
not an appetizing subject for most, but they actually don't taste
that bad. 55 mm · ISO 100 · f/2.8 · 1/125 sec

↟ Mahjong tiles · Mahjong is a beloved game, especially
by seniors who often play in public parks. 70 mm · ISO 200 ·
f/2.8 · 1/4000 sec

Entrance to the Forbidden City from Tiananmen Square · I opted for a classic central, head-on
perspective for this photo. 24 mm · ISO 100 · f/2.8 · 1/800 sec ↓

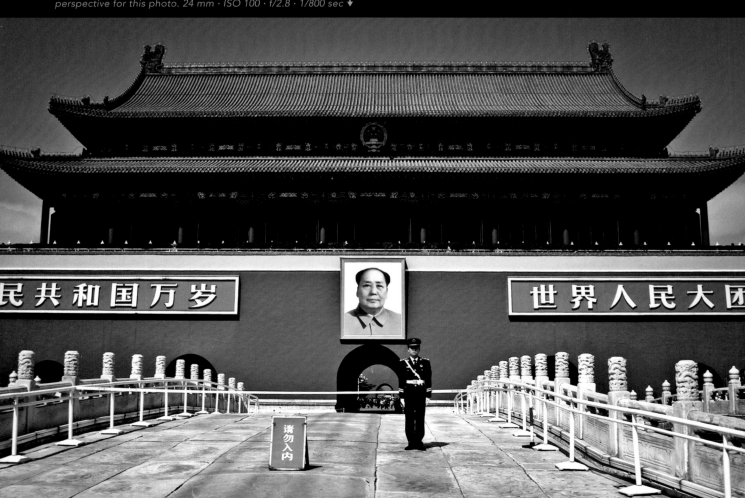

JAPAN Tokyo

"Guten Morgen Herr Dirks." Mr. Mori, the former managing director of SIGMA Germany, greets me very warmly in the lobby of my hotel. I'm in Tokyo and the SIGMA Corporation invited me to visit the headquarters of the company. Mr. Mori is kind enough to bring me there personally. I have prepared a presentation for the board for my visit, explaining some of the highlights of my trip and showing a selection of my photos. A pleasant surprise awaits me after my presentation: a replacement telephoto lens for the one that the monkey in Jaipur broke. After a tour through the various departments of the company, we take a group portrait and I happily accept an invitation to a typical Japanese meal and a tour of the city.

The next morning we visit the nearby volcano Mount Fuji. At 12,389 meters, it is Japan's tallest mountain. In the evening, I head to the World Trade Center. From the outside, you'd never suspect how great the 360-degree view of the city is from the 40th floor. It's quiet up here and I'm practically all by myself. After a delicious cup of green tea, I assemble my camera and attempt to capture the city at dusk. It might look like Paris at first glance, but that building that resembles the Eiffel Tower is actually the Tokyo Tower.

I devote my last day entirely to the beautiful cherry tree blossoms. I have the luck of being in Tokyo at just the right time to enjoy them. Various types of cherry trees bloom here for about two weeks in the middle of April. The Hanami Festival also occurs during this time of year. Blue plastic tarps are set out beneath the trees in the morning and the party starts in the afternoon after work. People talk, laugh, and drink a cup or two of sake. It's a delightful experience.

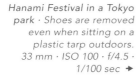

◆ *Cherry blossoms · The gentle pastel colors of the cherry blossoms awaken thoughts of spring. The shallow depth of field causes the petals in the background to melt into a sea of pink. 105 mm · ISO 100 · f/2.8 · 1/800 sec*

Hanami Festival in a Tokyo park · Shoes are removed even when sitting on a plastic tarp outdoors. 33 mm · ISO 100 · f/4.5 · 1/100 sec ➜

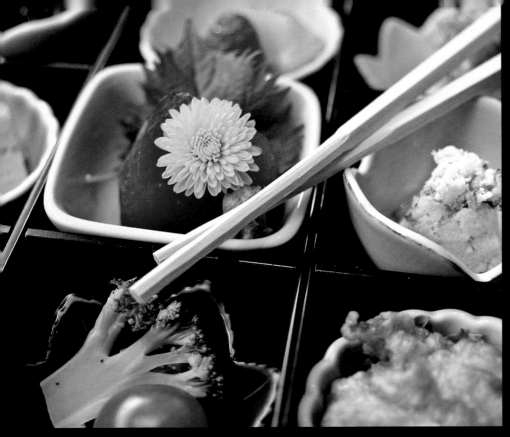

⬆ *A typical Japanese meal, with chopsticks, of course* · The various bright colors make this a pleasing picture of the everyday. 34 mm · ISO 200 · f/2.8 · 1/50 sec

⬆ *The Chinese Oracle* · At first, all of the drawers were closed, but I opened one to make the scene more interesting. 63 mm · ISO 200 · f/6.3 · 1/80 sec

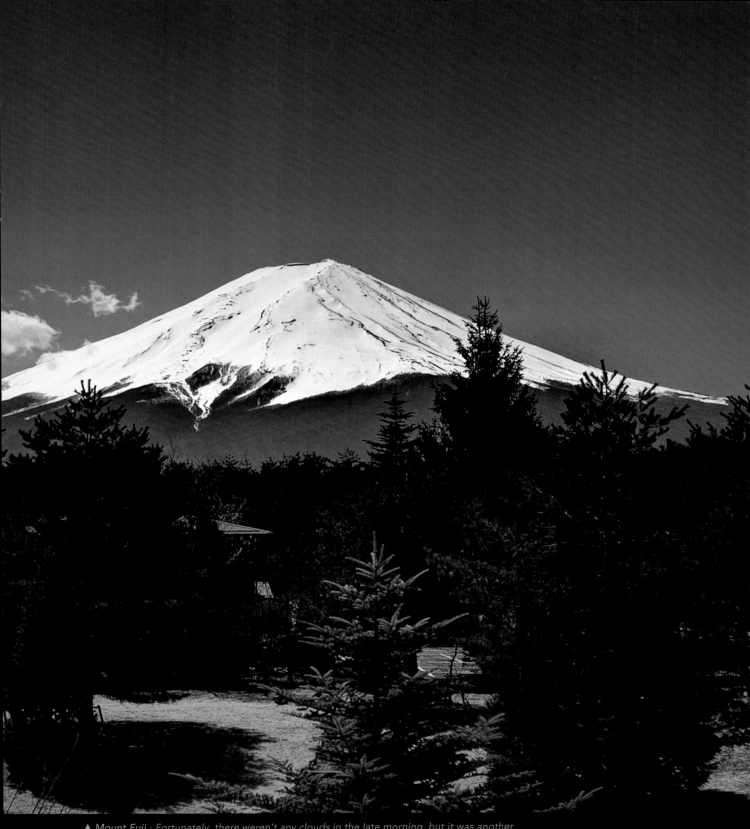

⬆ *Mount Fuji · Fortunately, there weren't any clouds in the late morning, but it was another story by afternoon. 30 mm · ISO 100 · f/8 · 1/200 sec*

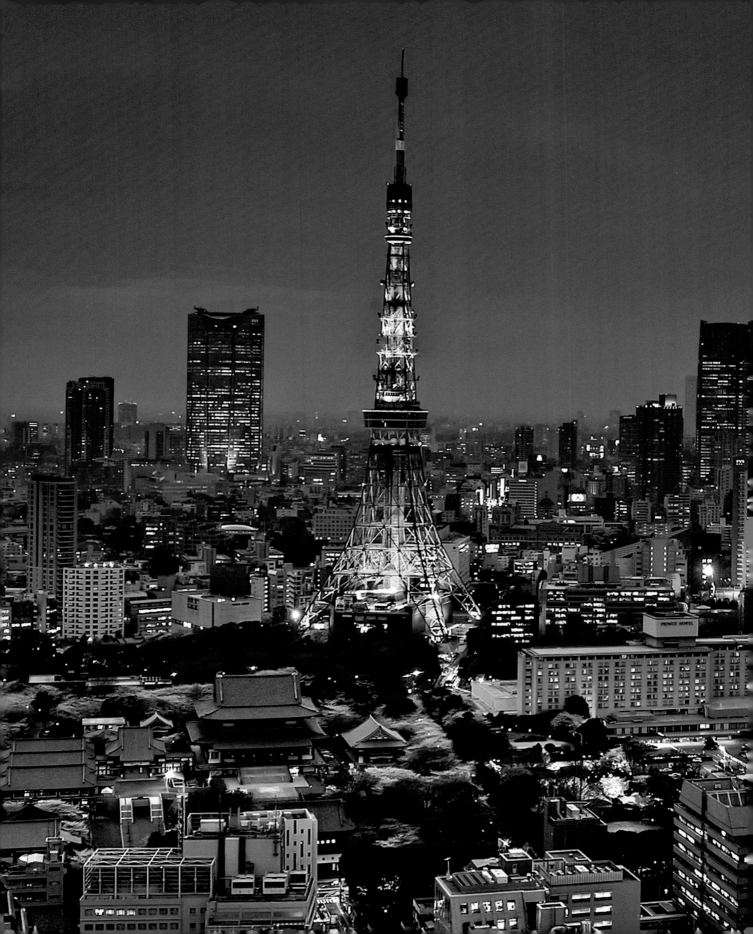

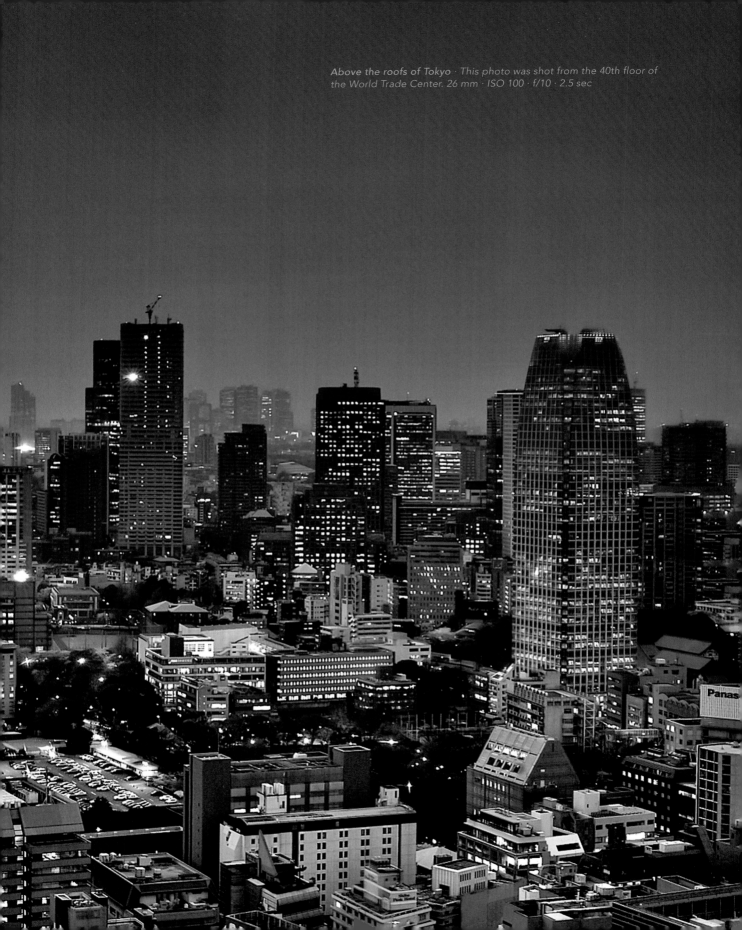

Above the roofs of Tokyo · This photo was shot from the 40th floor of the World Trade Center. 26 mm · ISO 100 · f/10 · 2.5 sec

Australia
and the Pacific Rim

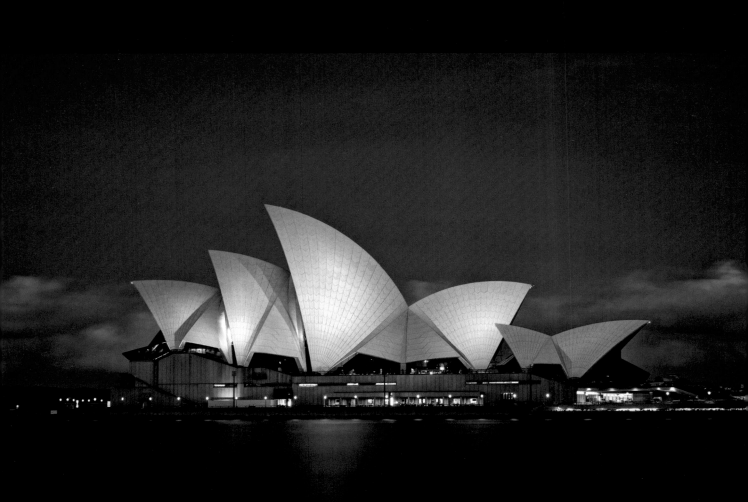

⬥ *Sydney Opera House during the blue hour · The shells that make the roof of the structure are illuminated brilliantly with spotlights at dusk. I set up my tripod on the opposite quay and used a relatively small aperture to capture the entire building in focus. 37 mm · ISO 100 · f/8 · 8 sec*

AUSTRALIA Sydney

Sydney ranks among the most beautiful cities in the world. Although this isn't my first time here, I'm delighted to have another chance to reacquaint myself with this city. It boasts a waterside location; fantastic beaches, including Manly and Bondi Beach where you can watch daredevil surfers and, with a little luck, run across celebrities; and many shops, boutiques, and restaurants.

My first outing takes me to the Circular Quay, where a relaxed atmosphere typical of Sydneysiders abounds. In addition to a wealth of cool bars, this part of town also features a great view of some of the city's best architectural gems, like the Sydney Opera House and the Harbour Bridge. The sun is setting, which means it's time for me to head over to my favorite spot on a nearby promenade near the St. George OpenAir Cinema. This spot offers a great view of the famous opera house with the Harbour Bridge behind it.

It turns out my spot is unavailable due to a concert. The fast-approaching twilight means I need to improvise. I run about searching for a different vantage point. Out of breath and soaking in sweat, I quickly screw my camera to my tripod and start shooting just to make it by the blue hour. With my first photos in the bag, I look forward to the upcoming days.

It's autumn in Australia right now and, unfortunately, the nice weather turned into a low-pressure system overnight. Intense, sustained rain is not exactly ideal for traveling photographers at work. Armed with an umbrella, I head over to Harbour Bridge, and I am glad that I do because a bridge climb is taking place. A guide, several brave tourists, and I attempt to climb the 440-foot bridge even though we're all soaked to the skin. If not for the carabineers securing us, a slipup could have fatal consequences. The view from up here is normally fantastic, but in this weather it's dull and gray. That just means that I don't need to pine about not being able to bring my camera equipment up with me on account of safety concerns.

The rain finally lets up for a moment after the climbing adventure and I make my way to an accessible support of the bridge. The view from this landing is great and, fortunately, cameras and tripods are allowed.

Even the upscale Darling Harbour should be a part of any visit to Sydney. On the way there, the rain drenches me one more time. In return, I'm compensated with a picture of the futuristic-looking monorail, which glides through the city a few meters above the ground.

The terrible weather forced me to explore the city armed with an umbrella · In extra strong rain, I often also use a small, clear plastic bag to wrap around my camera. The lens has to remain unobstructed, of course, and a rubber band wrapped around it makes for a good grip. 85 mm · ISO 200 · f/5.6 · 1/250 sec ➜ Photo by Miriam Rass

▲ The futuristic monorail glides through the city several yards above the ground · I won't be taking any more pictures of this train, however, because residents have been protesting its operation for years and it is scheduled to be shut down in the near future. 25 mm · ISO 100 · f/4 · 1/250 sec

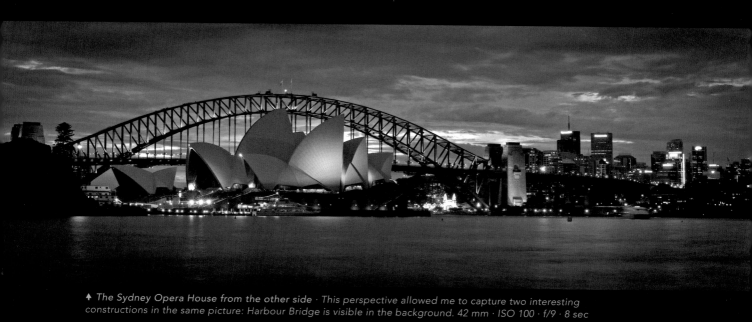

♠ *The Sydney Opera House from the other side · This perspective allowed me to capture two interesting constructions in the same picture: Harbour Bridge is visible in the background. 42 mm · ISO 100 · f/9 · 8 sec*

Sydney · I shot this panorama from the platform of a support beam of the Harbour Bridge. It's composed of six individual portrait-format photos. I opted for the black-and-white conversion because of the drab colors caused by the bad weather. 25 mm · ISO 100 · f/5.6 · 1/320 ♦

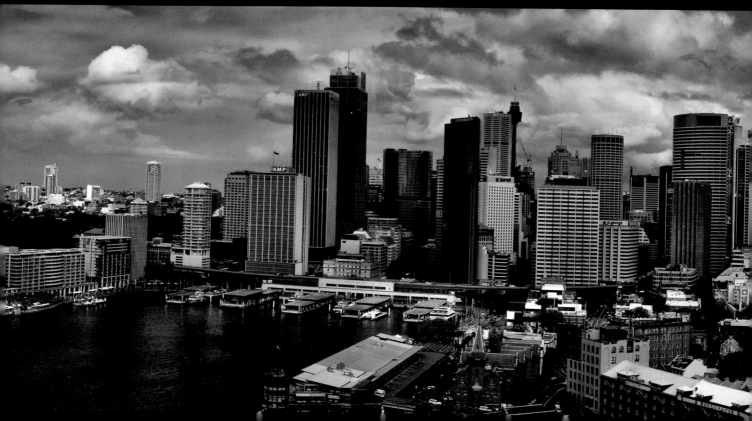

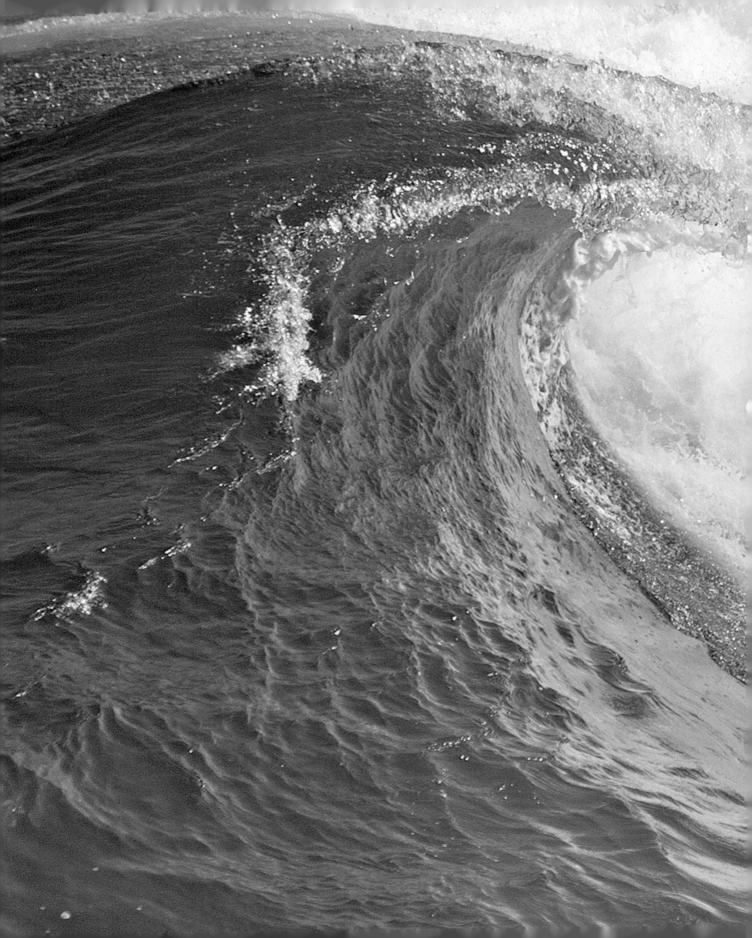

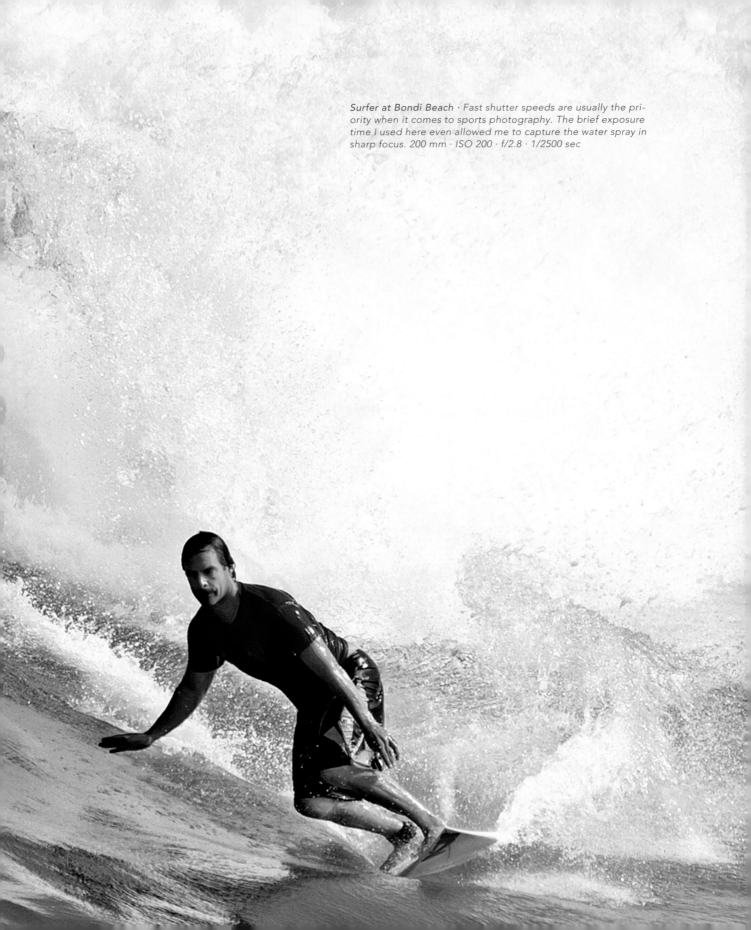

Surfer at Bondi Beach · Fast shutter speeds are usually the priority when it comes to sports photography. The brief exposure time I used here even allowed me to capture the water spray in sharp focus. 200 mm · ISO 200 · f/2.8 · 1/2500 sec

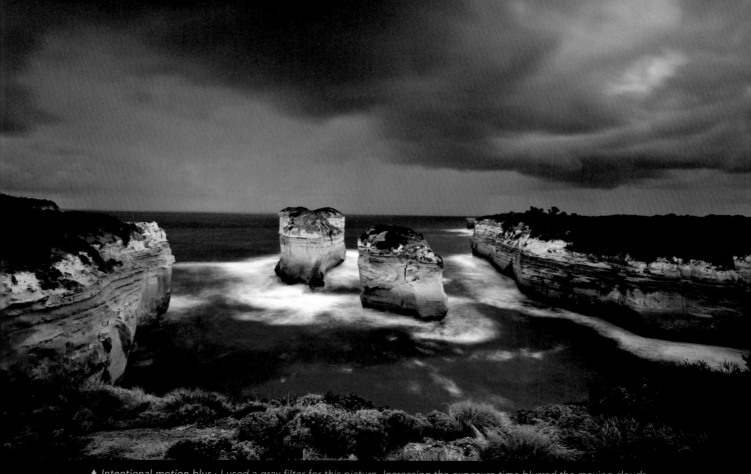

♠ Intentional motion blur · I used a gray filter for this picture. Increasing the exposure time blurred the moving clouds. The result is a photograph that looks like a painting. 15 mm · ISO 100 · f/6.3 · 10 sec.

AUSTRALIA Great Ocean Road

The patter quickly turns into drumfire. In shock, I stare out the window of my car while pea-sized hail covers the landscape with a white sheen in a matter of seconds. I hope my rental car is covered against natural disasters, I think to myself as I wait on the side of the road. My destination today isn't all that much farther away, so I'm glad when the hail turns into rain after a couple of minutes and I can continue on my way. After another half-hour of driving I reach the Twelve Apostles, lit up majestically in wonderful, soft light.

Coming from Melbourne, I drove here via the breathtaking Great Ocean Road, one of the most beautiful coastal highways in the world. The drive covered nearly 170 serpentine miles and took several hours. Despite the unpleasant weather, I made several stops along the way to photograph the stunning cliff formations.

I've arrived right in time for the warm light of evening to shoot a few pictures of these huge limestone pillars. I also decide to check-in to a nearby hotel so that I can return the following morning. It turns out that I made the right decision because the pillars present themselves in an entirely different light in the morning.

Tip: If you plan a trip to photograph the Twelve Apostles, it makes sense to find accommodations nearby. Doing so will give you the opportunity to capture the impressive structures in different lighting conditions.

Coastal landscape along the Great Ocean Road · I used a gray filter here to make the restless waves appear smoother. Using this tool allowed for a thousand-fold increase of the exposure time. Here I was able to shoot with an exposure window of 10 seconds. 10 mm · ISO 100 · f/8 · 10 sec ➔

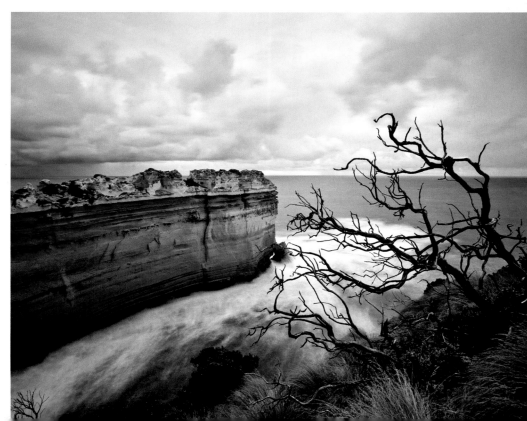

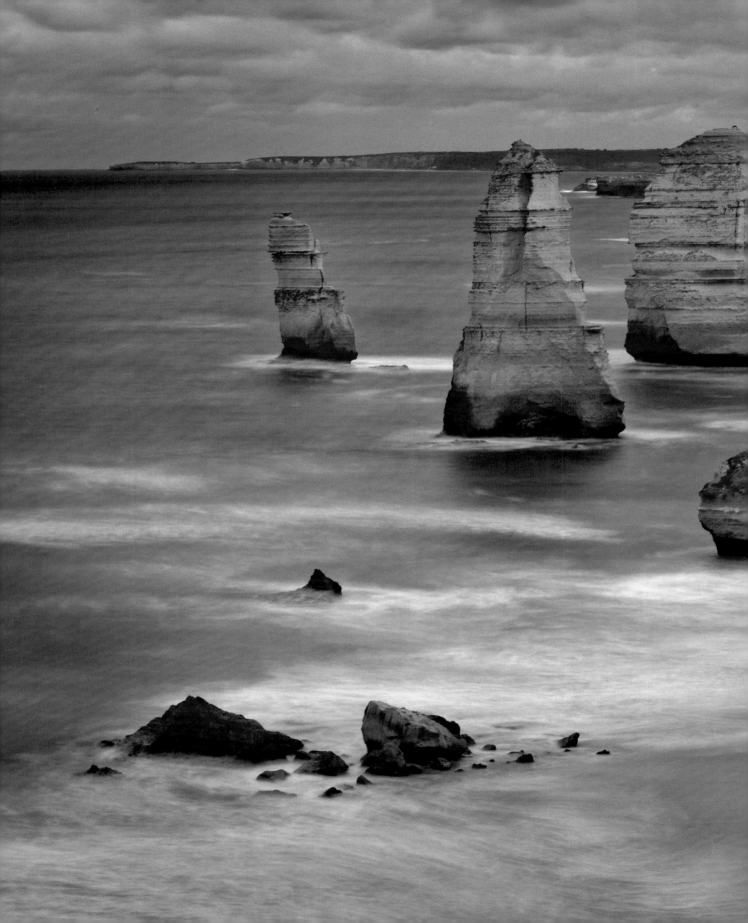

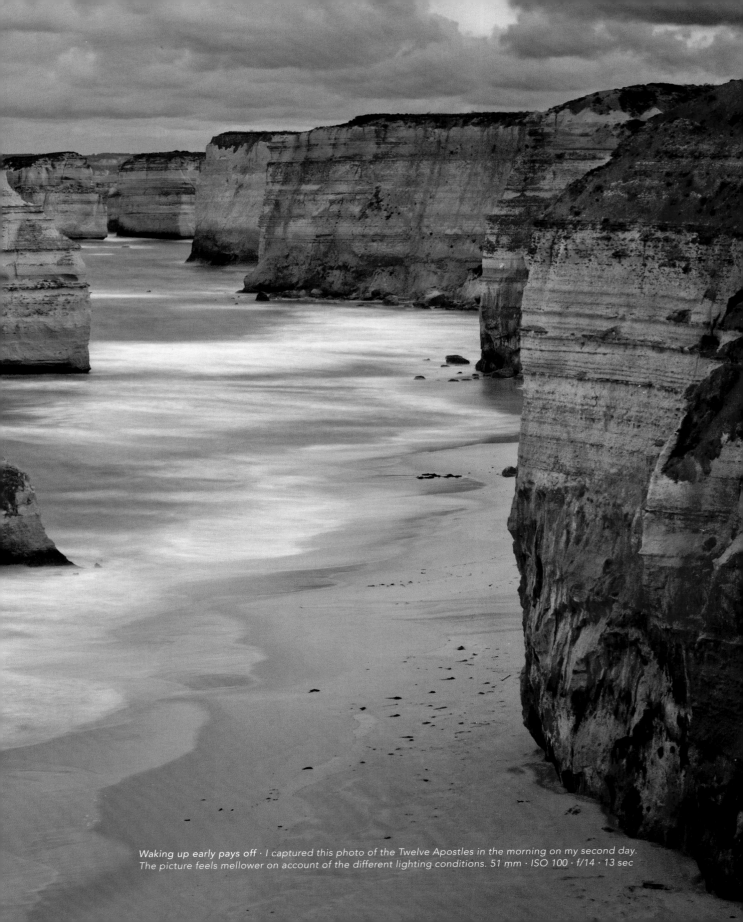

Waking up early pays off · I captured this photo of the Twelve Apostles in the morning on my second day. The picture feels mellower on account of the different lighting conditions. 51 mm · ISO 100 · f/14 · 13 sec

AUSTRALIA Melbourne

I stroll through Melbourne in bright autumn weather. It's the second largest city in Australia, after Sydney, and it offers diverse architecture and tons of cafés directly on the Yarra River where students meet and talk. It's a lovely city with flair and a relaxed atmosphere, but in comparison to Sydney, it's lacking something by way of photographic attractions. I take some pictures of the skyline in the evening and shoot the interesting Webb Bridge, but I haven't felt the spark of inspiration here, so I decide I'll check out the surrounding area tomorrow.

I wake up early the next morning and head out of town. While I'm exploring the area, I come across a sign warning of kangaroos—a common sight in Australia. It doesn't take long for me to spot some of the animals. One kangaroo after another crosses my path, from small wallabies to the giant red kangaroo and many others. They look so cute and comical that I can barely take my finger off the shutter button. The longer I stay at the site, the more trusting the animals become. This continues until finally one of them is so curious that it peeks over my shoulder while I'm working. A few hours later, and in a much better mood after my kangaroo photo shoot, I start to head back to my hotel. A glance up into the treetops brings another surge of joy. The dark areas that I first took for bird nests turn out to be adorable koalas.

Tip: Sometimes using a wide-angle lens to obtain unconventional animal portraits can pay off. Conversely, telephoto lenses and wide apertures help to isolate your subject by blurring any secondary elements that might otherwise distract from it. This effect helps guide the viewer's eye directly to your subject.

◄ Kangaroo portrait · I shot this humorous picture with a wide-angle lens. The lens's properties exaggerated the animal's head, making it appear inordinately large. I used a food bag to guide the animal until it was in just the right position and then I photographed it from above. 20 mm · ISO 200 · f/3.5 · 1/500 sec

Can you show me how to do that? · While I was taking pictures of his comrade, this kangaroo snuck up behind me and watched as I worked. I got quite a shock as soon as I turned around, but my fright quickly turned into laughter. I would have gladly taken the little fellow on as an apprentice. 50 mm · ISO 100 · f/3.5 · 1/400 sec ►

Photo by Miriam Rass

⬆ *Webb Bridge* · There are several architecturally interesting pedestrian bridges along the Southbank Promenade, and at night the city illuminates them nicely. The Webb Bridge appealed to me in particular. It's located at the very end of the promenade and its design is based on a fish trap. 13 mm · ISO 100 · f/3.5 · 3.2 sec

Melbourne's skyline · I took this photo in the light of the late evening hour. The lighting reflects attractively off the surface of the Yarra River. 24 mm · ISO 100 · f/4 · 2 sec ⬇

AUSTRALIA Ayers Rock

"No, no more tours are going out today. And besides, the weather isn't very good for taking pictures; it's overcast," the woman behind the information counter says with a shrug. If she only knew that this overcast sky would produce a dramatic depth in the photos that I would take later that day.

Red dust swirls about me as I rush toward my target. Two hours ago, I landed at the airport near Uluru-Kata Tjuta National Park and I'm now en route to Uluru, also known as Ayers Rock. I finally find a suitable location right as the sun is about to set. The light and the clouds are perfect—the stress was worth it. As the sun sinks below the horizon behind me, the rock, which has a reddish-brown hue during the day, glows red for a fleeting moment. This spectacle of color put on by the sunset is truly rewarding for visitors. I shoot many photos to make sure that I don't miss the moment. After the sun has set, I strike up a conversation with a local over a cold beer. He tells me that many tourists illegally take stones from Ayers Rock as souvenirs. If tragedies start to befall them, the regretful travelers end up sending the rocks back in the mail because they believe that the rocks cause bad luck. The address is simply Ayers Rock—Central Australia, and the sender's address is usually left blank.

The next day my alarm clock rings at four in the morning. I start out really early toward the red rock, which is approximately 600 million years old, with the goal of taking pictures from the other side—this time at sunrise. When I reach my targeted spot, the first rays of sun start to break through the black night. The dawn blossoms into a pastel red and a soft white light envelops Uluru.

It's fantastic. I wouldn't have thought that a large red rock, named Ayers Rock in 1873 by the adventurer William Goss, would have cast such a spell on me.

Tip: If you go to the trouble of traveling to Ayers Rock, it's worth spending at least two nights nearby. Having your own rental car affords flexibility, relieves any time pressures, and can help you experience this natural wonder more fully. One nuisance, which I wasn't aware of in advance, is that there are a lot of flies in the area. It's most annoying when they bother your face, so I recommend bringing a hat with a built-in mosquito net.

← Blood from a stone · I took this photo on my second evening at Ayers Rock. Its effect is calmer than the image on the next page, and it is generally less spectacular because the clouds are missing. I intentionally shot this photo in portrait format so that I could embed text in the sky later. 14 mm · ISO 100 · f/6.3 · 4 sec

Early morning · I shot this picture from the opposite side of Ayers Rock at sunrise. It looks stunning in this lighting too. 17 mm · ISO 100 · f/9 · 1.3 sec ➜

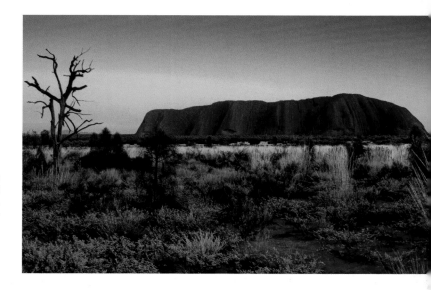

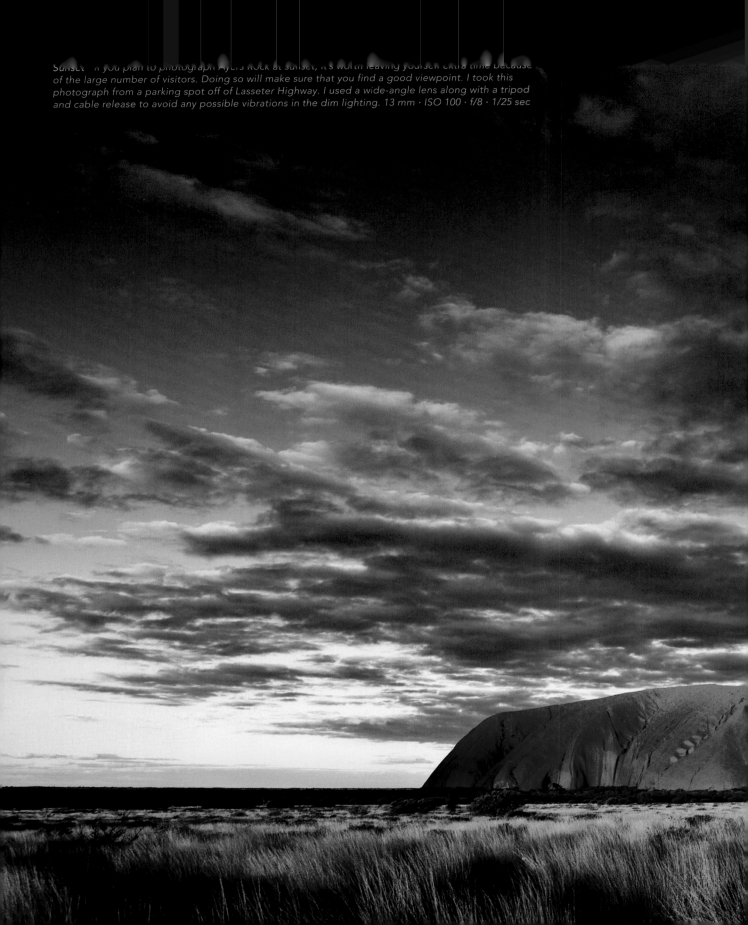

Sunset — If you plan to photograph Ayers Rock at sunset, it's worth leaving yourself extra time because of the large number of visitors. Doing so will make sure that you find a good viewpoint. I took this photograph from a parking spot off of Lasseter Highway. I used a wide-angle lens along with a tripod and cable release to avoid any possible vibrations in the dim lighting. 13 mm · ISO 100 · f/8 · 1/25 sec

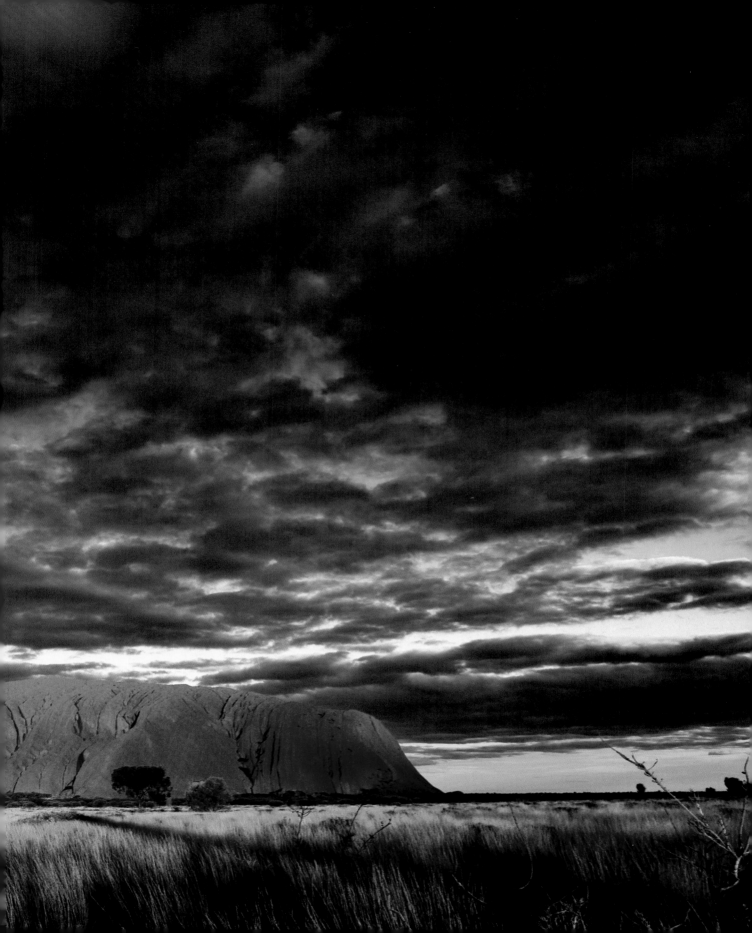

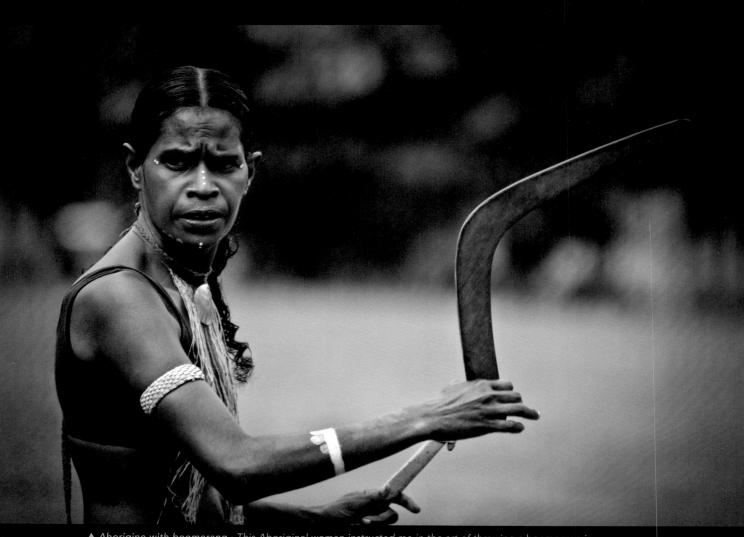

♠ *Aborigine with boomerang · This Aboriginal woman instructed me in the art of throwing a boomerang in the Tjapukai Aboriginal Cultural Park. My throwing technique failed miserably, so I reached for my camera equipment instead. 200 mm · ISO 200 · f/2.8 · 1/1000 sec*

AUSTRALIA Cairns

"We find ourselves in one of the rainiest places in the world, the wet tropics, which is why everything around you is so green," explains a tour guide. In fact, it's pouring rain. I'm in Cairns, hiking through one of the world's oldest jungles in Australia's Daintree National Park. We pass fan palms and many other plants that I've never heard of. It's relatively dark here beneath the tree canopy, which means I need to set up my tripod for every picture. I have to fumble around with my gear a bit because I'm using a clear plastic bag to protect my camera and lens—a delay that's starting to wear on the nerves of my tour group.

Cairns is known for more than it's unique rain forests. Other world-renowned attractions in this area include the Great Barrier Reef, which is the largest coral reef in the world, as well as the attractive-but-dangerous beaches. There are constant reminders that dangerous predators populate these waters. Sharks don't pose the danger here; it's crocodiles that are often spotted on nearby Trinity Beach, among other places.

The rain accompanies me for the next couple of days. My much-anticipated trip to the diver's paradise that is the Great Barrier Reef ends up being a big disappointment. The water is gray and dirty instead of clear and turquoise. My snorkeling trip doesn't even merit mentioning.

I try not to let the weather get the best of me, and I sign up for a crocodile tour. Cairns is supposedly teeming with these dangerous beasts. Back into the jungle I go, this time on a boat, but there are no crocodiles to be found anywhere. My guide tells me that the temperature of the water is warmer than the temperature of the air, which means the crocs have no reason to go on land. Frustrated, I pack my camera away, and then, of course, a specimen unexpectedly makes itself visible. It's a saltie, or a saltwater crocodile. These dangerous predators predate dinosaurs and can grow to be 17–23 feet in length and up to 2,200 pounds in weight. Their jaw is powerful enough to bite through the metal of a car body. They also have specialized eyes so that when submerged, they can still see what's going on above the water. "Don't ever go close to the rivers, lakes, or streams—they're everywhere," the park ranger warns us at the end of our tour.

On my last day in Cairns, I visit the Tjapukai Aboriginal Cultural Park, where an Aboriginal woman teaches me the art of chucking a boomerang. My attempts fail miserably, however, as do those of other visitors. My neighbor's stray boomerang lands in a group of spectators and elicits a scream or two. Deciding the activity is too dangerous, I opt to photograph an adorable wallaby that has hobbled up to me trustingly. "Earlier, the Aborigines would use boomerangs for hunting, especially little kangaroos," my local teacher whispers with a grin.

Tip: It's a good idea to dress in long sleeves and use a strong insect repellant if you're headed into the jungle. Also, never stray from the prescribed path because there are many extremely poisonous and dangerous plants and animals in the area.

223

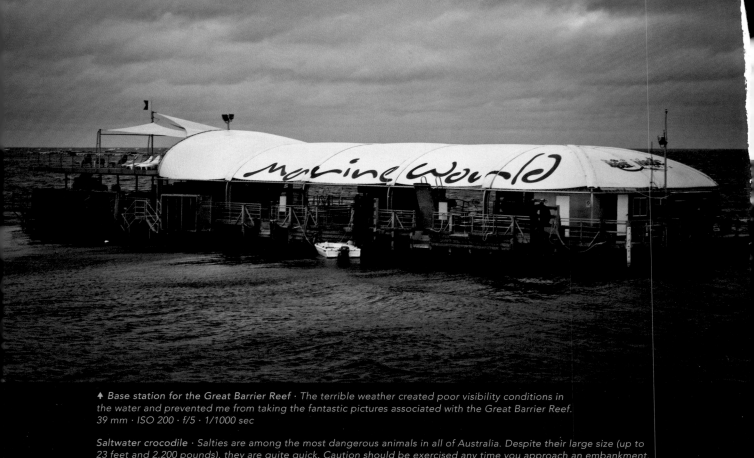

▲ *Base station for the Great Barrier Reef* · The terrible weather created poor visibility conditions in the water and prevented me from taking the fantastic pictures associated with the Great Barrier Reef.
39 mm · ISO 200 · f/5 · 1/1000 sec

Saltwater crocodile · Salties are among the most dangerous animals in all of Australia. Despite their large size (up to 23 feet and 2,200 pounds), they are quite quick. Caution should be exercised any time you approach an embankment.
200 mm · ISO 200 · f/2.8 · 1/400 sec ▼

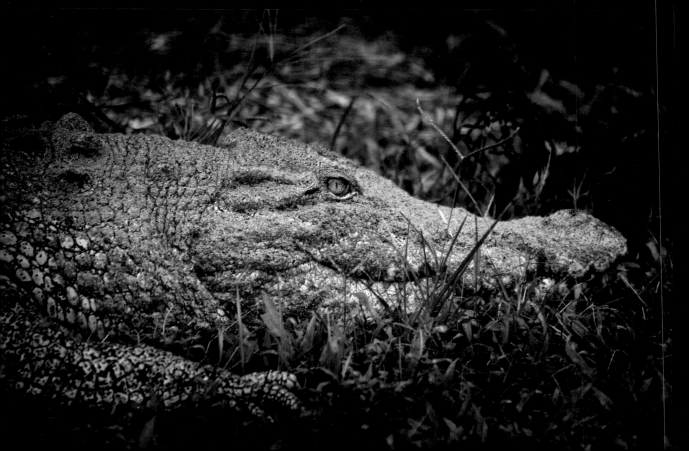

♠ *Stream through the rainforests of Daintree National Park · Using a slow shutter speed when photographing water makes it appear calmer. I had to stop down the aperture all the way here to expose this picture for 2.5 seconds. During the day an ND filter can make longer exposure times usable. 24 mm · ISO 100 · f/22 · 2.5 sec*

From above · I took this photograph in the middle of Daintree National Park as I was looking down from a suspension bridge. The photo looks as though it were shot from an enormous height because I used a wide-angle lens. 10 mm · ISO 200 · f/3.5 · 1/50 sec ♦

USA Hawaii

"Aloha! Welcome to Hawaii," I read as I exit my plane in Oahu. A warm breeze surrounds me and I immediately feel as though I'm on vacation. Unfortunately, the drive to Waikiki take a grueling three hours instead of the usual fifteen minutes due to traffic from a summit conference of the Pacific states.

My alarm clock rings at seven the next morning. The weather is spectacular and the "aloha" feeling all around Hawaii is something else. People greet each other with a "Hang loose!" and everything is very relaxed. No matter where you look, there are people young and old carrying surfboards through the streets. I'd love to surf, but I want to explore the east side of the island with my car. I simply can't get enough of the green volcano landscapes and the pristine beaches bordered by turquoise waters. From the 762-foot Diamond Head volcanic tuff cone, I go to Hanauma Bay, and then on to the North Shore. Many movies have been filmed at this famous surf spot and the waves are said to be gigantic in winter.

I spend the next day in upscale Waikiki, where a hula show by Polynesian natives is a must. It's incredibly beautiful here, but I can't neglect the neighboring islands, so it's on to Maui.

At 5:30 the next morning, I wake up shivering like a leaf at an elevation of close to 10,000 feet in Haleakala National Park. The temperature hovers around 37 degrees Fahrenheit. I'm not alone—around 150 other early birds have gathered here too. I can hear yawning and giggles but I can't see anything because it's pitch black. Hawaii's largest volcano crater is directly in front of me and as soon as the sun comes up, there's supposed to be an incredible light show. I set up my tripod and camera with frozen fingers, and then it happens: a small beam of light breaks over the horizon and I hear mystical Hawaiian chants behind me. It *is* something, but I end up missing the much-ballyhooed light spectacle because a wide wall of clouds floats in front of the sun. The photography continues on anyway. I take a few multiple-exposures that I'll turn into an HDR image later.

Once I'm back at sea level, I drive along the road to Hana, which is an obligatory part of any trip to Maui. First I arrive at Ho'okipa Beach, a well-known surf spot. Crosses on the cliffs stand in remembrance of surfers who tragically lost their lives here. Today the waves aren't particularly large, and ambitious youngsters and teenagers are in the water surfing. The road continues onward past steep cliffs and beautiful coves. On my way back I realize that this is my last evening in Hawaii. Drinking fresh coconut milk under a palm tree, I come to a decision: Hawaii, we'll meet again.

Koko Head · The Hawaiian islands formed from volcanoes. This picture shows the extinct Koko Crater, located on the southeastern side of Oahu. 20 mm · ISO 200 · f/7.1 · 1/200 sec ➜

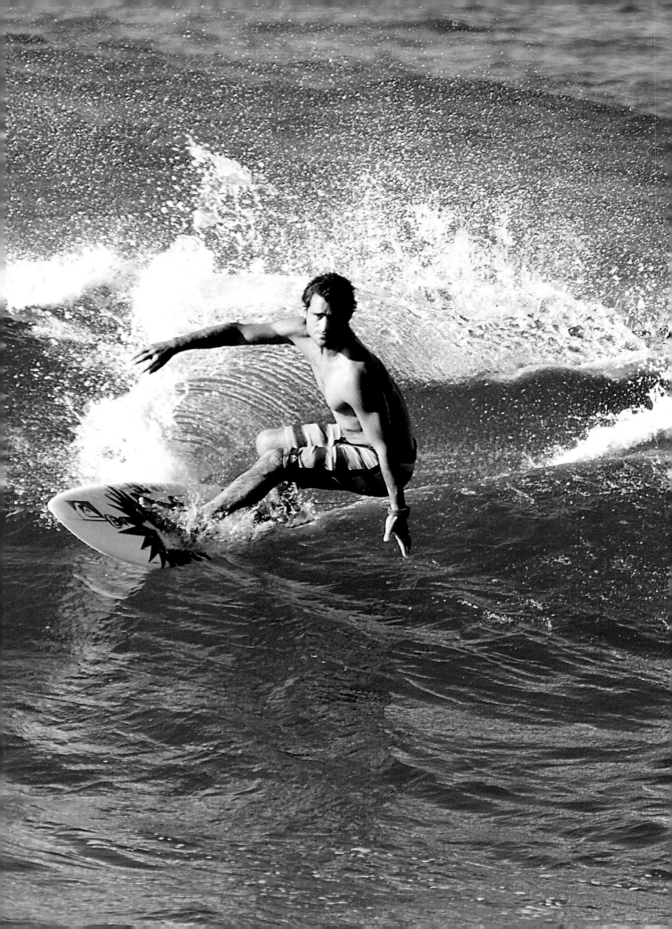

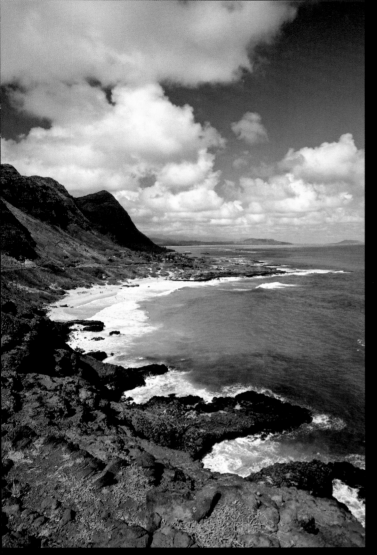

⬆ *Hawaii's beaches* · Some of Hawaii's coastline is formed by hardened black lava flows, as you can see in this picture, but there are also dreamlike sandy beaches and coves. 15 mm · ISO 200 · f/5.6 · 1/500 sec

⬅ *Surfer's paradise* · Having a really fast telephoto lens makes all the difference when shooting dynamic surfing pictures. Fast shutter speeds in tandem with image stabilization allow for crisp, sharp results. My largest lens has a maximum focal length of 200 mm with a maximum aperture of 2.8. To get even closer, I use a 2x teleconverter. The advantage: it saves space and weight. The disadvantage: a reduction of the lens speed by half (in this case, to an aperture of 5.6). 400 mm · ISO 200 · f/5.6 · 1/500 sec

⬆ *Natural attractions are in no short supply on the Road to Hana* · I discovered this imposing waterfall on a ten-minute walk near the side of the road. Normally you would want to use a tripod with a remote shutter release for long exposures like this one, but resting your camera on a stable rock will do in a pinch. The green moss is so brilliant thanks to a polarizer filter, which can both reduce and enhance reflections, as is the case in this photo.
70 mm · ISO 100 · f/22 · 5 sec

♠ *Cool dog* · I had heard that the surfers in Hawaii are serene and laid back. That their dogs are too was news to me. This pooch was relaxing in the bed of a pickup truck on a beach. *85 mm · ISO 100 · f/1.4 · 1/1000 sec*

A fence of surfboards · I found this subject on Maui, just before arriving at Ho'okipa beach. This picture says a lot about the favored sport of the locals and their attitude toward life. *20 mm · ISO 200 · f/4.5 · 1/500 sec* ✦

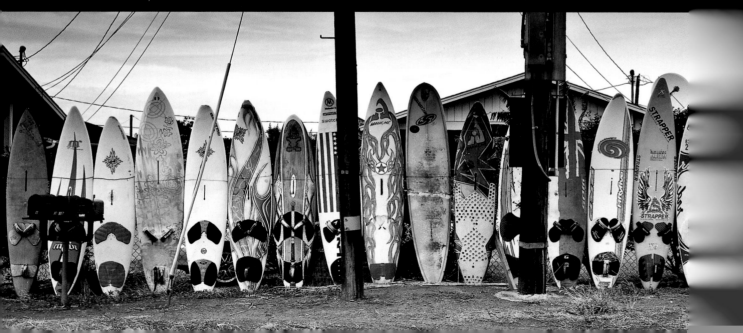

▲ *The power of waves is underestimated · Crosses on the cliffs memorialize surfers who have died. To isolate the cross, I used a long focal length and a wide aperture. 329 mm · ISO 200 · f/5.6 · 1/1250 sec*

▲ *A flavorful experience · Where there are lots of palm trees, there are also lots of fresh coconuts. I let a local man prepare one of these delectable fruits for me while I took a quick breather. 51 mm · ISO 200 · f/2.8 · 1/80 sec*

Haleakala National Park, Maui · I woke up in the middle of the night and made it to the peak of the 10,023-foot Haleakala volcano by sunrise to take this photo. It was freezing at the top and the clouds threw a wrench in my plans but the effort paid off in the end. 10 mm · ISO 100 · f/14 · 1/4 sec ↓

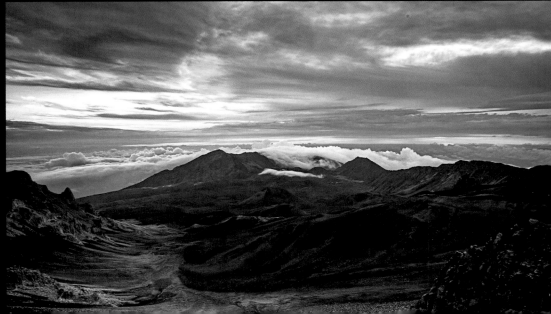

✦ *Beach on Kauai · These silhouettes emerged right before sunrise. The light had a beautiful color but it was still very weak, so I had to use a tripod. 20 mm · ISO 400 · f/7.1 · 10 sec*

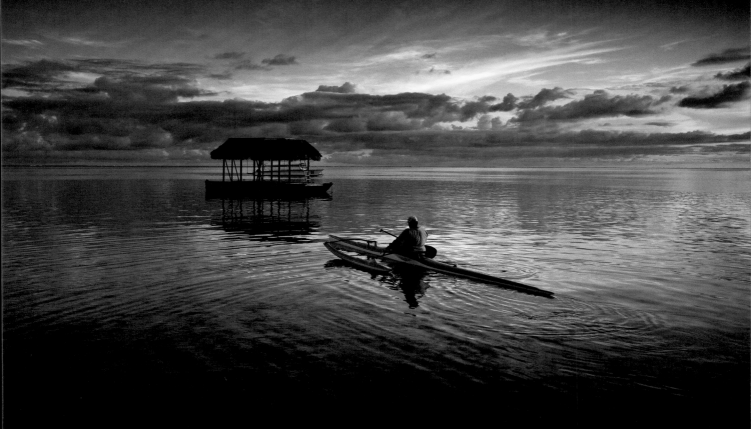

↟ *Into the sunset · After a day of illness-induced challenges and scant photographic results on Bora Bora, I discovered this local at sunset on a beach. A brief moment after I took this picture, he plunged his oar into the water and paddled away. The colors in this picture make it one of my favorite compositions. 20 mm · ISO 100 · f/6.3 · 1/60 sec*

POLYNESIA French Polynesia

The glasses in the minibar clank in time with the bass. It's the second night in a row that the loud music has gotten on my nerves and kept me from sleeping. At three in the morning, I can't take it anymore and I furiously rush down to the lobby, which is full of young, drunk, wild revelers. In response to my question about whether this is a hotel or a dance club, the woman at the reception desk smiles cheekily and answers, "It's a hotel AND a dance club." I'm in Papeete on Tahiti. Several people enviously told me, "Oh, how fantastic! You're in paradise!" But this is not how I imagined paradise by any stretch of the imagination. Even the surrounding areas and the beaches nearby are not what I associate with the South Pacific.

The next day, wiped out but happy to be leaving this hotel, I take a boat to the neighboring island Moorea. Even from a distance the difference between Moorea and Papeete is visible. The water is clearer and bluer, the sand on the beaches is whiter, and the beaches are lined with more palm trees. This is the South Pacific that I know from travel brochures. My accommodations make a pleasant impression. Small huts with roofs made out of palm fronds are situated just yards away from the gorgeous beach. I lie down in the sand and stare out at the turquoise waters blissfully.

This night has torments of a different kind: oppressive heat and a humidity of 90 percent. Instead of air conditioning, there's a decrepit ceiling fan, which isn't worthy of its name, given that it seems capable of rotating only five times per minute. Added to this are countless mosquitoes that munch on me mercilessly, not to mention crowing roosters and howling dogs that roam freely. The next day I move into a climate-controlled hotel with proper windows. This place also has a breathtaking beach, palms, and a wonderful sunset. I finally have the feeling that I've arrived in paradise.

The island hopping continues the next day as I head to Bora Bora, a truly dreamlike island with 8,927 inhabitants. Along with Tahiti and Moorea, Bora Bora is part of French Polynesia. From top to bottom, this island embodies the essence of a getaway vacation. I take a comedic boat tour; swim with stingrays, black fin reef sharks, and lemon sharks; and snorkel with all manner of colorful fishes and turtles in the coral reef.

At the end of the day, there's a delicious buffet featuring various fruits of the South Pacific. Delighted and lost in thought, I dig in. Big mistake! What started off as a string of bad luck has been elevated to a new level of misfortune—the following days are blighted by fevers and intestinal problems. Despite everything, I sincerely relished my time on the truly beautiful islands of Moorea and Bora Bora.

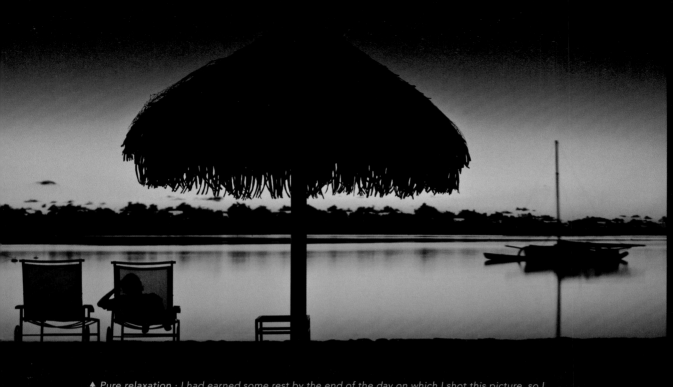

↟ *Pure relaxation* · *I had earned some rest by the end of the day on which I shot this picture, so I paused for a moment and enjoyed the view of the serene ocean. 32 mm · ISO 100 · f/3.2 · 8 sec*

Sunset on Tahiti · *The thr ee dugout canoes—recognizable only as silhouettes—in combination with the colors of the setting sun make an interesting subject. 30 mm · ISO 100 · f/4 · 1/200 sec* ↡

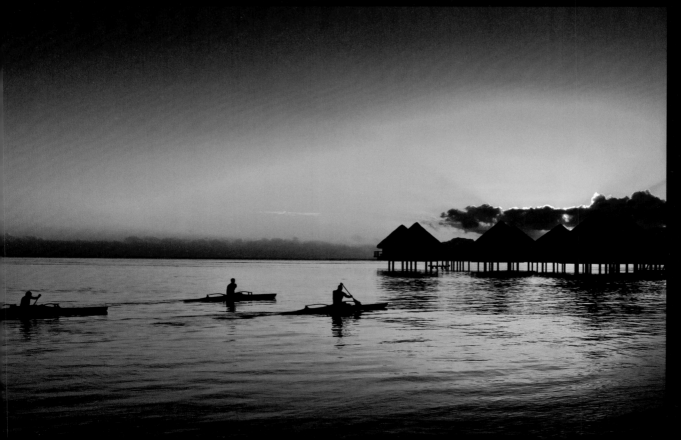

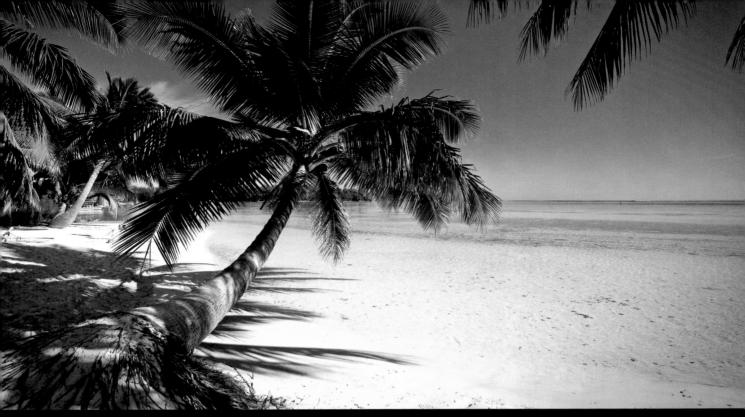

✦ *Bora Bora · Crystal clear, turquoise water; blue sky; and saturated colors. I used a polarizer filter to make these postcard images even clearer and more saturated. 10 mm · ISO 100 · f/8 · 1/100 sec*

Islet · I came across the smallest island I'd ever seen on my boat trip to Bora Bora. 24 mm · ISO 200 · f/4.5 · 1/640 sec ↓

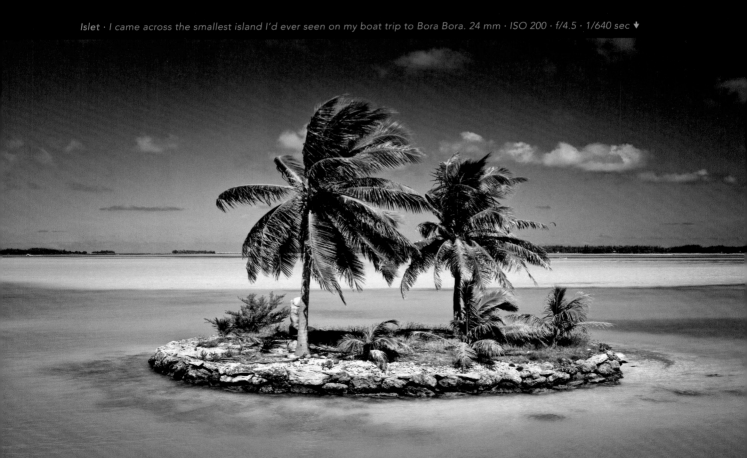

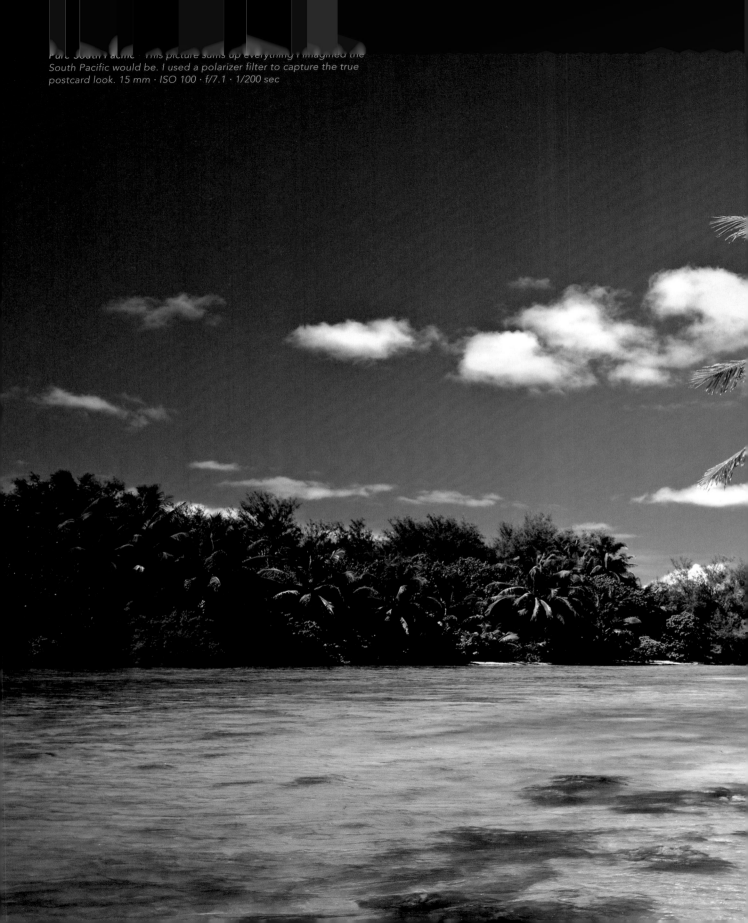

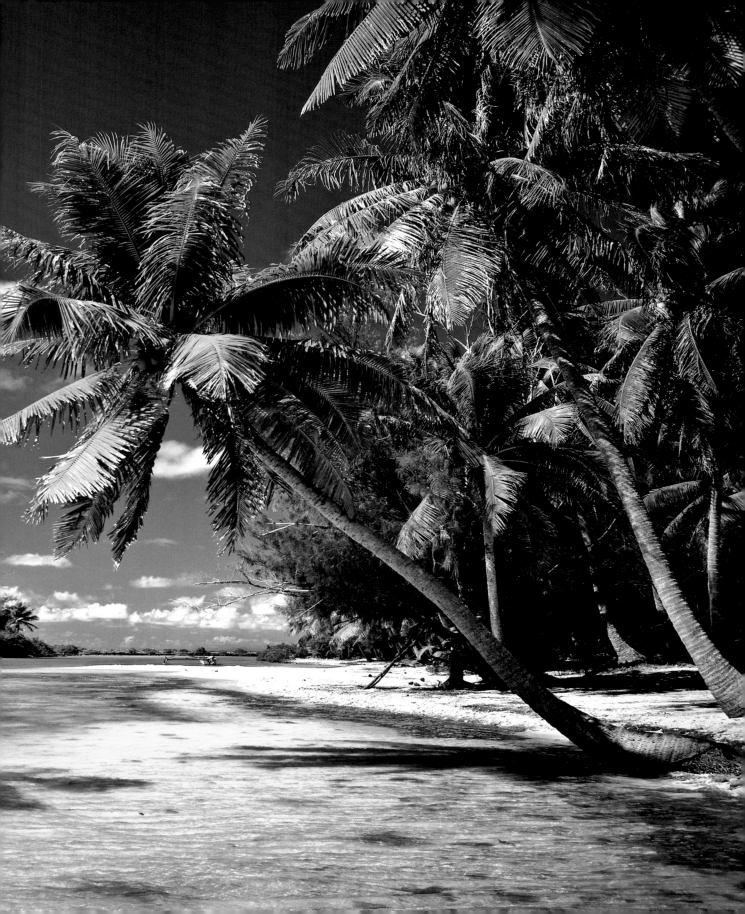

NEW ZEALAND North Island

With 1.4 million people, Auckland is the largest city in New Zealand. I've just landed and I'm already on the road in my rental car exploring the North Island. I have only a couple of days here. My first stop is Piha Beach, where scenes from the beautiful film *The Piano* were filmed. After a brief stroll on the beach, I head into the jungle. I amble past picturesque streams and desolate waterfalls, which would be tempting swimming holes in summer.

As I continue, now driving south, I come across a sign advertising a sheep show. These animals are an integral part of New Zealand, so I decide to check it out. I had no idea that there are so many different kinds of sheep in this country. One funny-looking sheep has dreadlocks, and it reminds me that I'm well overdue for a haircut. A bit later it's time for a merino sheep to be shorn. It's laid on a cross by a professional sheep shearer with a practiced hand, and some two minutes later, it's practically naked. With an efficient technique, a shearer can process 200 to 250 sheep in one day.

Next I visit an exhibition on the Maori to learn about the culture of the people native to this country. A warrior demonstrates battle technique and I also get a look into the traditional Maori art of wood-carving.

The city of Rotorua, known for its famous hot springs, is my next stop. Bubbling exhalations of smoke emerge everywhere. I cringe when a scalding hot fountain of water erupts into the air from the ground next to me. Then comes the sulfurous stink reminiscent of rotten eggs. All of this is great material for photography, even though it almost feels like I'm in hell. With my adventures on the North Island coming to a close, I now look forward to the South Island and wonder what photographic treasures I'll find there.

← *Rotorua, Geyser · This yards-high geyser shot into the air with a deafening noise. I nearly dropped my camera out of shock but managed to rally and release the shutter in time. The yellow colors stem from sulfur deposits. 10 mm · ISO 100 · f/5 · 1/640 sec*

Champagne Pool · This spring got its name from the rising bubbles of gas that resemble the pearls in a flute of champagne. I used a polarizer filter to accentuate the vivid colors that result from various mineral deposits. 11 mm · ISO 100 · f/5 · 1/500 sec →

Rotorua · The trio standing in front of the steam were reduced to a silhouette as a result of the backlighting. I liked the effect and included the people in my picture.
37 mm · ISO 100 · f/5.6 · 1/1000 sec

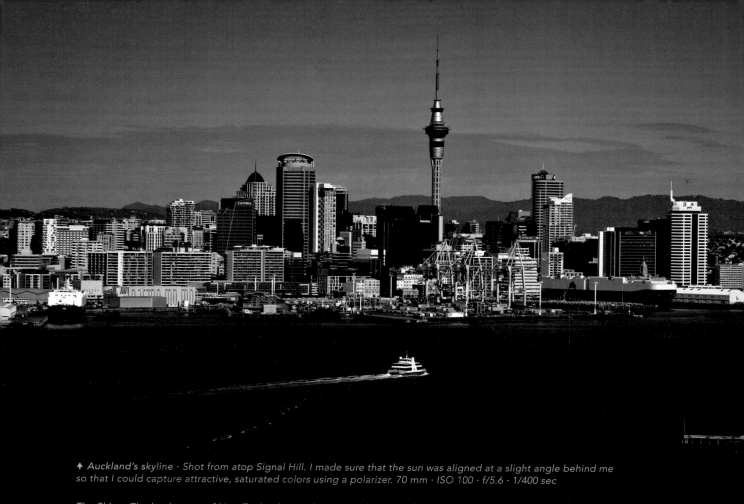

↟ *Auckland's skyline · Shot from atop Signal Hill. I made sure that the sun was aligned at a slight angle behind me so that I could capture attractive, saturated colors using a polarizer. 70 mm · ISO 100 · f/5.6 · 1/400 sec*

The Shire · The landscapes of New Zealand are a dream, which is one of the reasons that al l of the Lord of the Rings movies were filmed here I used a wide-angle lens, a polarizer, and, depending on the brightness of the sky, a gray gradient filter. 24 mm · ISO 100 · f/4 · 1/250 sec ↡

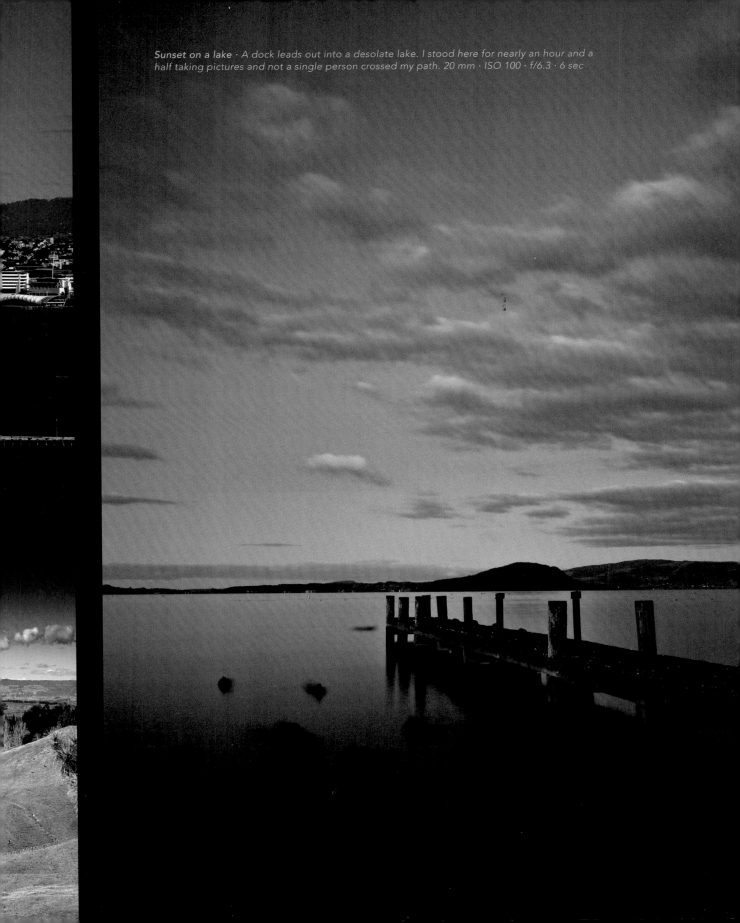

Sunset on a lake · A dock leads out into a desolate lake. I stood here for nearly an hour and a half taking pictures and not a single person crossed my path. 20 mm · ISO 100 · f/6.3 · 6 sec

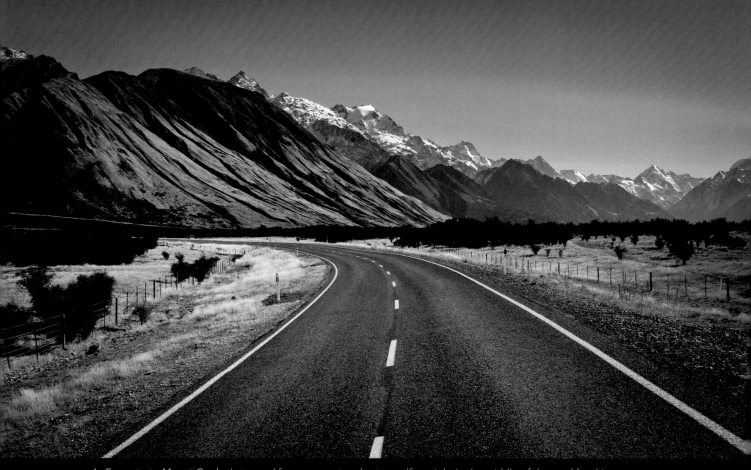

↑ En route to Mount Cook · I stopped for a moment and set myself up right in the middle of the road for this picture. The markings on the highway direct the viewer's gaze through the image. The foothills of Mount Cook are visible in the background. 24 mm · ISO 100 · f/5.6 · 1/125 sec.

NEW ZEALAND South Island

Sweat is dripping down my back but after two hours, I've finally made it. I've reached the peak and have a breathtaking view of New Zealand's landscape in front of me. The low autumn sun bathes the countryside in a golden light and the leaves on the trees contrast brilliantly with the blue sky.

Yesterday I landed in Christchurch to explore New Zealand's South Island by car. While driving, one dreamlike experience blended into the next. It's difficult to imagine that it's spring in Germany right now. Even the vineyards are a feast for the eyes at this time of year. The South Island is more diverse than the North Island. Here you can find everything from flat meadows to mighty glaciers, gently rolling inlands to precipitous cliffs, picturesque lakes and fjords to fantastic beaches.

My route out of Christchurch takes me inland to beautiful Lake Tekapo. From there I head over to Mount Cook National Park, where I hike for an entire day in the alpine landscape and see Mount Cook's 12,316-foot peak—New Zealand's tallest mountain.

I continue onward through the community of Wanaka to the island's west coast. Stunning photographic subjects await me along the magnificent coastal road, including the famous Pancake Rocks in Punakaiki. It doesn't take much imagination to see how these stacked rocks, which were formed more than 30 million years, earned their name.

Next I head up to the northern tip of the South Island, where Abel Tasman National Park is located. There is a really beautiful stretch of coast here that is renowned for its hiking trails, among other things. These trails lead into dense jungles, past romantic coves with crystal-clear, turquoise waters and pristine beaches. Unfortunately, this is exactly where my good luck with the weather runs out and I have to endure a steady downpour during my visits to Abel Tasman National Park and the Marlborough Sounds, and on the remaining drive back down the east coast to Christchurch.

My statistics for the past few days speak for themselves: 2,800 miles driven, 95 miles walked, and nine different hotel beds.

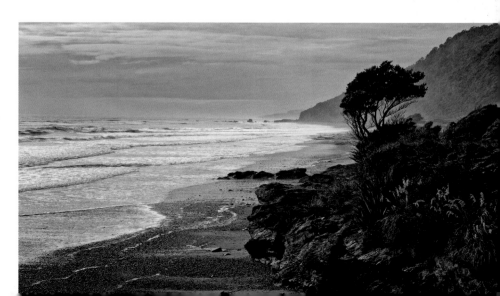

New Zealand is varied · Calm, sweeping landscapes morph into stormy, rugged coasts— enough to make any photographer's heart beat faster. 32 mm · ISO 100 · f/5 · 1/200 sec ➜

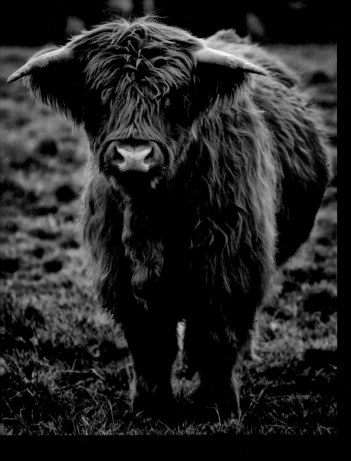

◀ *The lengths one goes to* · This cow cost me a 4.5-hour detour. After I shot the photo, I forgot my polarizer filter on a fence post and I didn't discover my mistake until I had already been driving for an hour and a half. I had no other choice but to drive back. 104 mm · ISO 200 · f/2.8 · 1/125 sec

New Zealand also has beautiful beaches · A slow shutter speed turned these rocks into an interesting subject. I had to stop down the aperture to achieve an exposure time long enough to cause the water to appear velvety around the rocks. 10 mm · ISO 100 · f/22 · 3/5 sec ▼

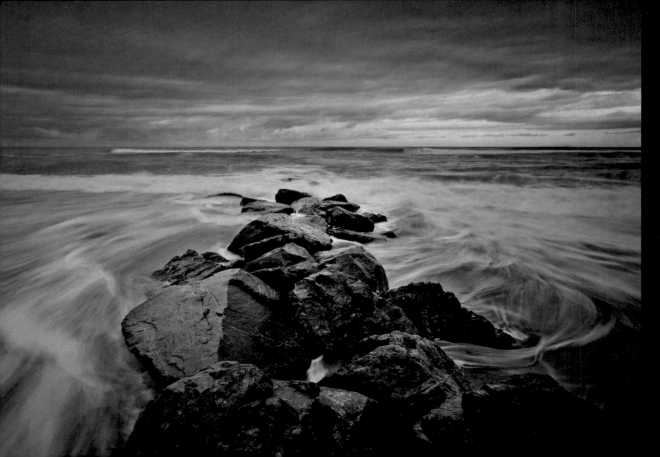

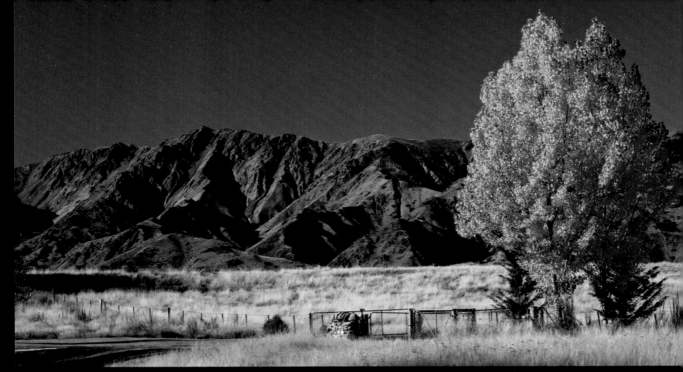

↟ **South Island** · My trip to New Zealand coincided with autumn. Here the colored leaves contrast beautifully with the blue sky. I used a polarizer to underscore this effect. 70 mm · ISO 100 · f/4.5 · 1/160 sec

Autumn in New Zealand · Composing landscape photos so that they have distinct foreground, middle, and background layers is an effective way to give otherwise two-dimensional subjects some depth. 34 mm · ISO 100 · f/4.5 · 1/250 sec ↡

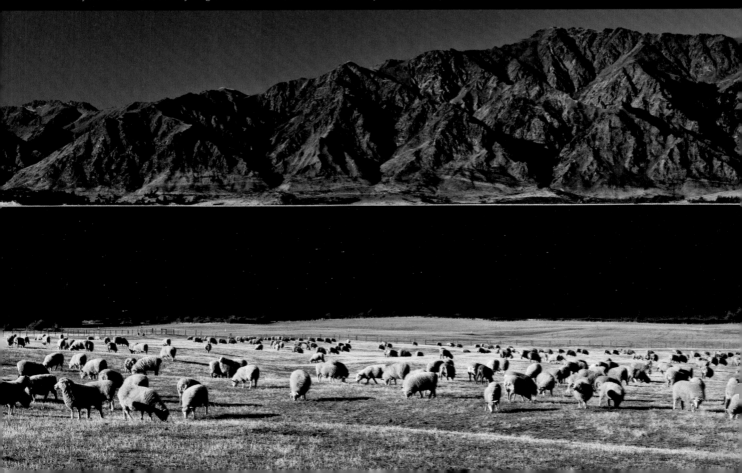

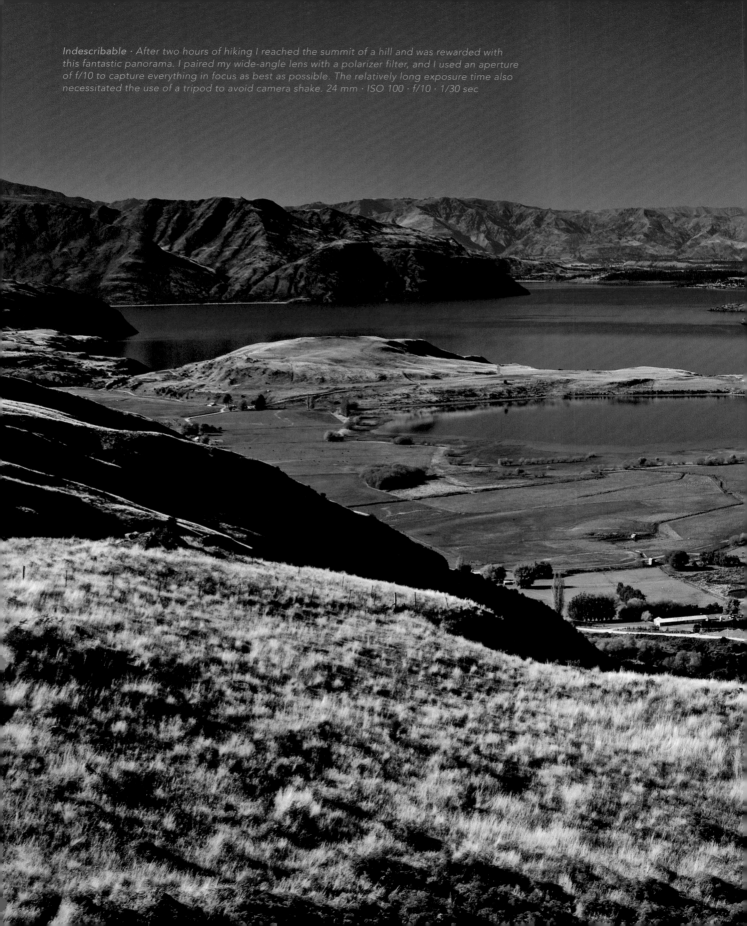

Indescribable · After two hours of hiking I reached the summit of a hill and was rewarded with this fantastic panorama. I paired my wide-angle lens with a polarizer filter, and I used an aperture of f/10 to capture everything in focus as best as possible. The relatively long exposure time also necessitated the use of a tripod to avoid camera shake. 24 mm · ISO 100 · f/10 · 1/30 sec

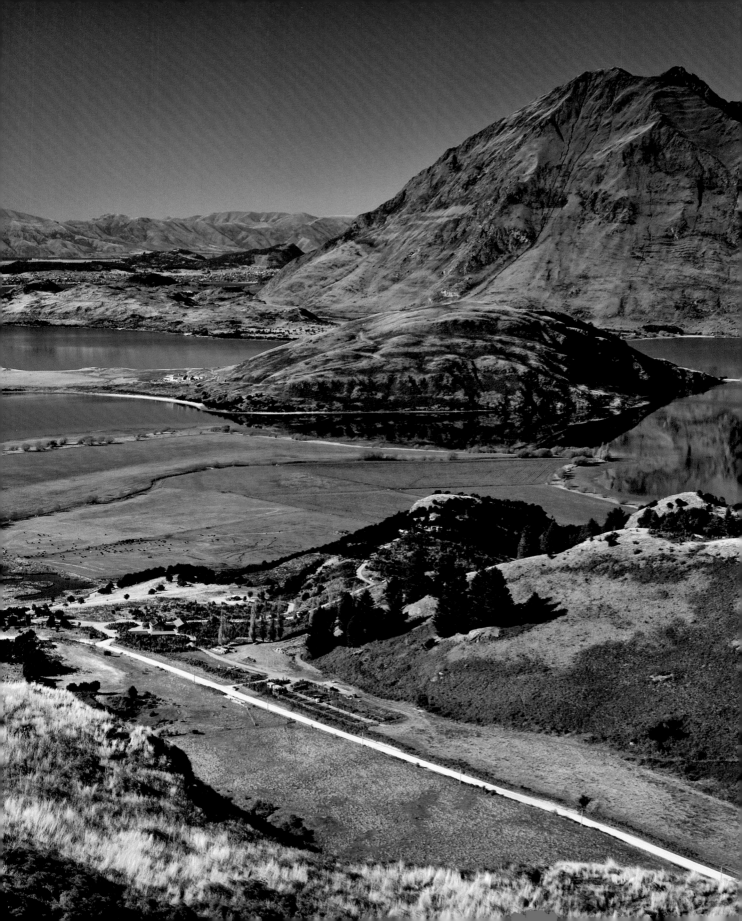

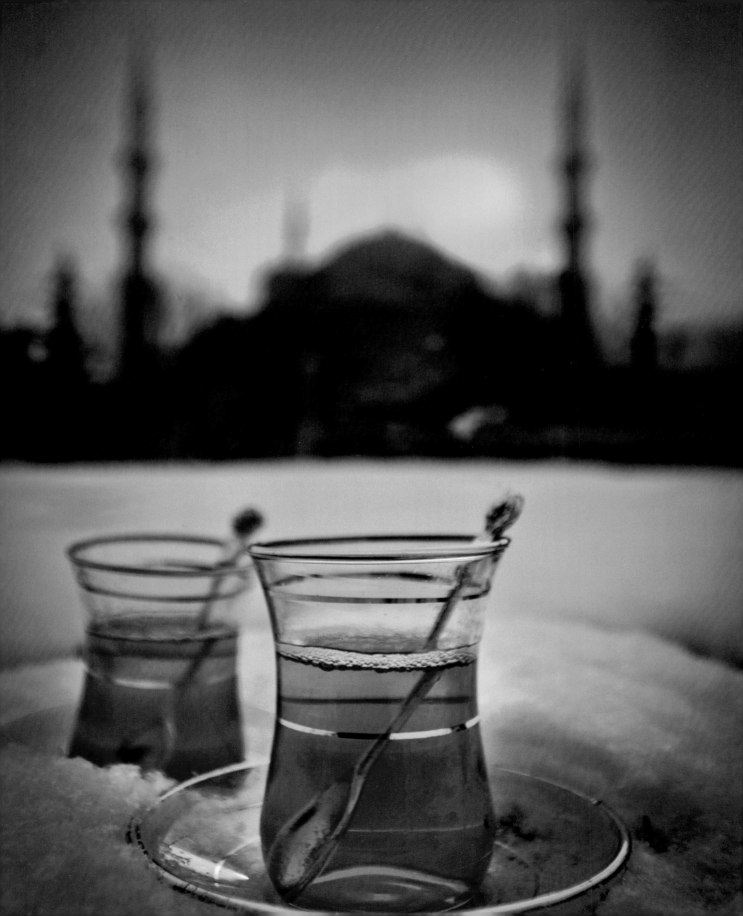

TURKEY Istanbul

It's snowing like crazy when the wheels of my airbus touch down in Istanbul. I realign my expectations for spring-like weather based on the frosty reality surrounding me, and I am relieved to arrive at my hotel despite the traffic nightmare I encounter on the way there.

The snowstorm thwarts my first attempts to photograph Istanbul's old town. Thick flakes assault my camera and lens, and my umbrella is utterly useless—the third gust of wind tears it to pieces. Okay, time to head underground.

I descend into the well-known Basilica Cistern (Yerebatan Sarnıcı), an underground water cistern, where scenes from the James Bond movie *From Russia with Love* were filmed. This respite from the storm can't last forever, though; I have to go back to the surface at some point.

As the next snow storm is getting started, I visit the Grand Bazaar, where anything you could ever need is for sale, from hookahs to sweet Turkish delicacies to magic lanterns.

The twilight hour is just getting started as I leave the market and I spot a lonely man selling chestnuts on the other side of the street. After buying some of his treats, he tips me off to my next subject as a way of saying thanks: the Hagia Sophia.

Last but not least, I take a ferry across the Bosphorus to Asia. Istanbul is the only city in the world that is located on two continents. Both sides of the city look more or less the same. I walk along the water toward Leander's Tower, a former lighthouse that now houses a restaurant.

The view of the straight and Istanbul's old town from the tower is excellent. As more flakes start to fall and I realize that I can no longer feel my fingers, I head back to my hotel.

← Hot and cold · Hot Turkish tea was just the ticket in Istanbul's frigid temperatures. The building in the background is the Blue Mosque. 16 mm · ISO 100 · f/3.5 · 1/2500 sec

Turkish gentleman · His colorful clothing made him jump out from the white snow around him. A photo was obligatory. 70 mm · ISO 100 · f/5 · 1/125 sec →

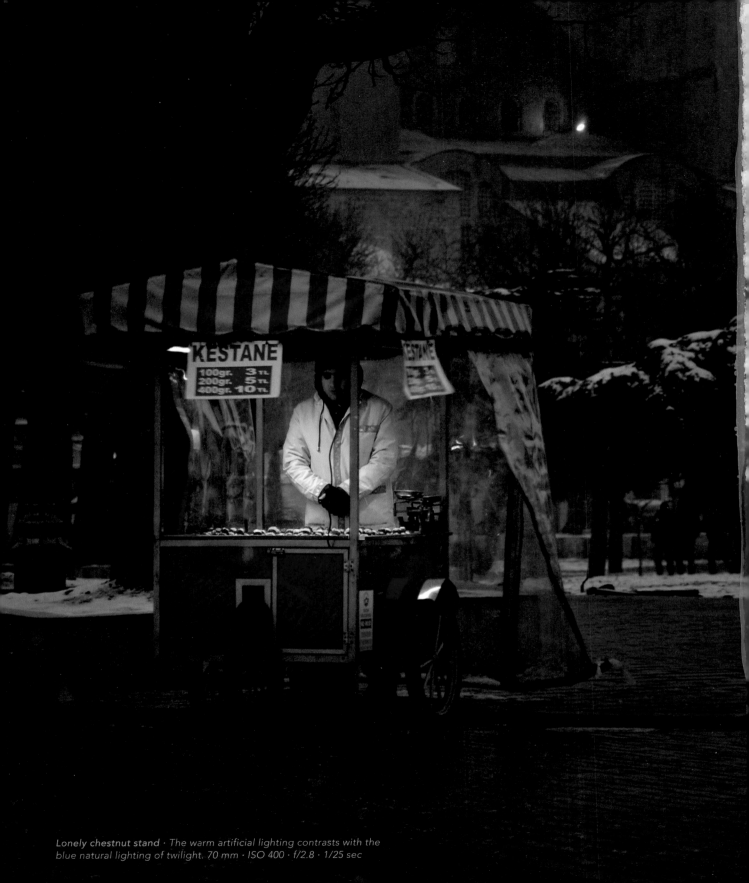

Lonely chestnut stand · The warm artificial lighting contrasts with the blue natural lighting of twilight. 70 mm · ISO 400 · f/2.8 · 1/25 sec

⤒ *The Basilica Cistern (Yerebatan Sarnıcı) and its minimal lighting · I used a wide aperture to keep the shutter speed and image noise within reason. 10 mm · ISO 200 · f/3.5 · 10 sec*

Leander's Tower right before a snowstorm · Located in Üsküdar, it is one of Istanbul's main landmarks. 30 mm · ISO 100 · f/8 · 2.5 sec ⤓

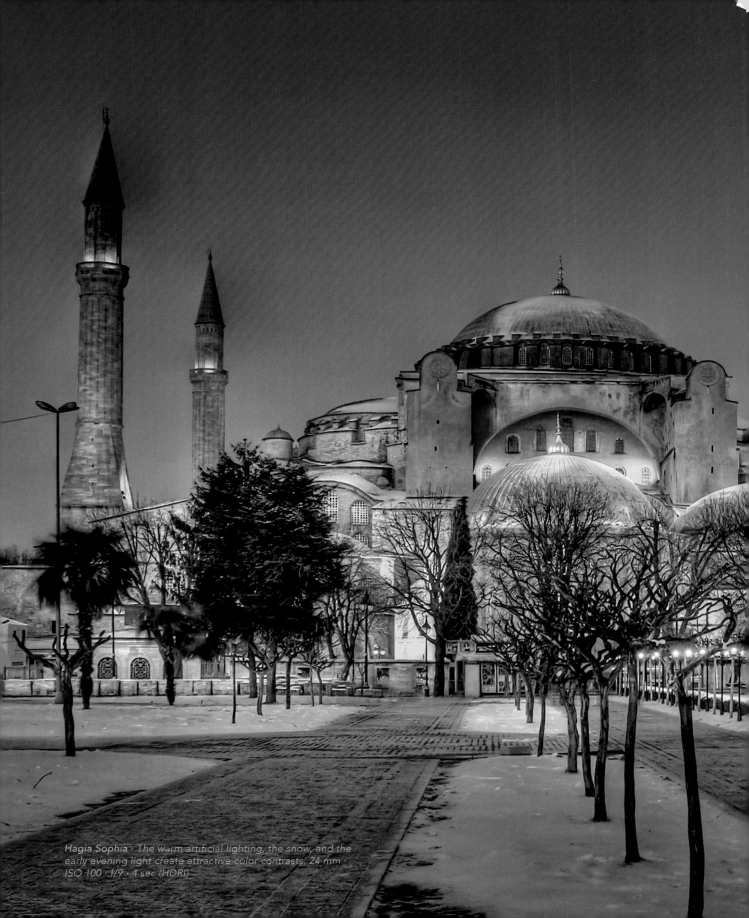

Hagia Sophia · The warm artificial lighting, the snow, and the early evening light create attractive color contrasts. 24 mm · ISO 100 · f/9 · 4 sec (HDRI)

⬥ *Metropolis Building in twilight · I set up my shot on this heavily trafficked street with an ultra-wide-angle lens and a long exposure time, which reduced the distracting cars to traces of light. 8 mm · ISO 100 · f/10 · 8 sec*

SPAIN Madrid

I walk along the Gran Vía, passing one impressive Baroque building after another. I am in Madrid. "It's a beautiful city," I think as I spot my first subject for a photo: an imposing building constructed between 1907 and 1910 with an angel on its dome and prominent lettering that spells out "Metropolis," which makes me think of Superman.

I walk to the Royal Palace the next day, but it's closed to the public for a ceremony. Instead of entering the building, I marvel at its exterior and witness the official changing of the royal guards.

On the way back to my hotel I come across two street performers who stand perfectly still despite the freezing temperatures. Even when examining them closely through my camera lens I can't deter-mine if they have simply frozen in place. Only after I deposit a euro do they spring to life; I'm glad that I don't have to call for a paramedic.

I take one final walk through the Parque del Buen Retiro. I'm sure it's delightful in summer, but it feels a little bleak now because the trees have lost their leaves. As soon as I spy the main monument and the dramatic clouds in the sky, however, my mood lifts and I pull out my camera in a flash.

Newspaper man · This street performer remained as still as stone for a long time, which allowed me to try out a number of different perspectives. I used my maximum aperture to isolate him from the background. 85 mm · ISO 100 · f/1.4 · 1/5000 sec ⬇

♠ *Parque del Buen Retiro* · *The park is located in the heart of Madrid and includes the magnificent mausoleum of King Alfonso XII. 34 mm · ISO 200 · f/5.6 · 1/320 sec*

♠ *Plaza de Cibeles* · *Once again I used a slow shutter speed for this photo to minimize the presence of the cars driving past on the street. 14 mm · ISO 100 · f/9 · 1.3 sec*

Change of watch · *The changing of the guards at the Royal Palace occurs on weekdays at noon and once every hour thereafter. 200 mm · ISO 100 · f/2.8 · 1/250 sec*

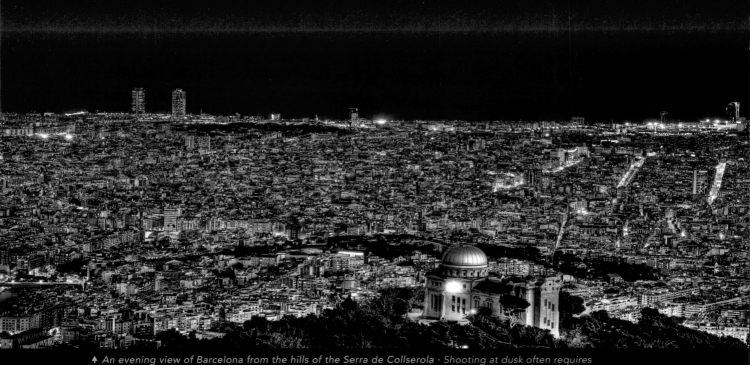

An evening view of Barcelona from the hills of the Serra de Collserola · Shooting at dusk often requires the use of a tripod to manage the longer exposure times. 63 mm · ISO 200 · f/5.6 · 6 sec

SPAIN Barcelona

The name of my hotel, Gaudi, says it all. I'm still in Spain, but I've moved on to Barcelona. This city is also often referred to as the city of Antoni Gaudí because it holds so many of his artworks and buildings, which represent the Catalan Modernism movement. There's Park Güell, Casa Batlló, Casa Milà, and on and on.

After I've walked through the city for a bit, I make my way to La Rambla, which is a very busy pedestrian zone packed with restaurants and artists of all kinds who compete for the favor of guests. But they're not the only ones after my pocket book—pickpockets are an everyday reality in this city. I follow the crowds for a bit until a local man gives me the tip that the best place to view the city at twilight is from up in hills of the Collserola. Because it's already getting late, I hail a cab to take me up into the mountains. I quickly forget about the added expense of the trip as soon as I take in the scene. The view of the city is simply stunning!

I pick up the Gaudí theme again the next day and visit the Sagrada Família. Antoni Gaudí was not able to complete this church during his lifetime, and its construction continues to this day, which means it's partially covered up.

In the evening I head to the Gothic Quarter, which is a beautiful area of the city with fantastic buildings. The small, narrow alleys with old lanterns make me feel as though I'm in the Middle Ages. Barcelona is amazing! I have a hard time concentrating on the "best" subjects because everything here makes a

photographer's heart race. What I don't care for, however, are the expensive Gaudí admission prices. And several buildings were being renovated during the off-season. Still, it's definitely worth visiting!

Out and about in the romantic alleys of the gothic old town · This alley was full of tourists, but a slow shutter speed enabled me to make them disappear. 34 mm · ISO 100 · f/13 · 4 sec (HDR) ➜

⬆ *La Rambla · A tree-lined mall in the heart of Barcelona. Artists and street performers line the walkway. The blurry passing tourists resulting from the slow shutter speed bring tension and excitement into the picture. 24 mm · ISO 200 · f/9 · 1.6 sec*

↟ *Jamón ibérico from Salamanca · National delicacies also belong in a travel photographer's repertoire. What would a trip to Spain be without some delicious ham?*
48 mm · ISO 400 · f/2.8 · 1/30 sec

↟ *Antoni Gaudí · Barcelona's cityscape is profoundly shaped by his ubiquitous works of art. 45 mm · ISO 100 · f/5 · 1/500 sec*

ITALY Rome

I'm a bundle of nerves as I slowly make my way through security. I just have to make it past one more round of guards. They'll want to see access credentials, which I, of course, don't have. I blend in with a large group of people in front of me. A guard sends us an inquisitive, troubling look and barks, "Halt!" Adrenaline shoots through my veins and drops of sweat collect on my brow, but my group is permitted access without any trouble. I never would have imagined it possible to gain access to this area without having to show access credentials or identification.

After an hour of waiting, it's finally time. The anticipation escalates and all of a sudden its deathly quiet. Then HE appears on the stage and all hell breaks loose. People cheer, scream, and wave national flags. The crowd goes wild. No, I'm not at a soccer match or a music concert. I'm in Rome, amid an audience of some 10,000 pilgrims from all around the world, to see Pope Benedict XVI. Despite my best efforts, I don't make it up into the VIP section. The lighting conditions are poor and the podium is fairly far away; in other words, the shooting conditions aren't ideal. Nevertheless I try my luck. Two hours later, this once-in-a-lifetime experience unfortunately comes to an end.

I still have one and a half days left to discover Rome. The sheer number of churches, museums, fountains, etc., makes my head spin, so I have to really force myself to focus on the most essential sights. St. Peter's Square is overflowing with people so I decide to come back later. I end up at the Ponte Sant'Angelo, where I admire the statues that line the bridge. An angel holding a cross catches my eye and matches my devotional mood perfectly.

I continue on to the Roman Forum, but there are thousands of tourists here too. It's seemingly impossible to get anywhere quickly and it's starting to get dark. I'm on my way back to my hotel when the outline of an imposing remnant of the Roman Empire becomes visible: the Colosseum.

The next day I visit the Spanish Steps, the Trevi Fountain, the Pantheon, the Piazza Navona, and more. At the day's end, I revisit where I started, the building of the Holy Father. I can finally take a picture that includes the imposing dome of St. Peter's Basilica. Unfortunately, the sight also reminds me that my journey must continue onward in the morning.

◄ Statue on the Ponte Sant'Angelo · The emphasis in this composition paired with the fitting sky create a nostalgic feeling. 45 mm · ISO 100 · f/2.8 · 1/250 sec

Look up · This is a fragment of a colossal statue of Constantine the Great, which I shot in Capitoline Hill. The hand alone is nearly six-and-a-half feet tall. 24 mm · ISO 100 · f/2.8 · 1/80 sec ✈

✦ St. Peter's Basilica, the center of the Catholic Church · I sought a central perspective for this photo to give the subject a degree of symmetry. The street lamps look like a landing path and direct the viewer's attention to the main subject. 55 mm · ISO 100 · f/8 · 1 sec

← To heaven · I zeroed in on a detail of this statue located on the Ponte Sant'Angelo. 37 mm · ISO 100 · f/6.3 · 1/160 sec

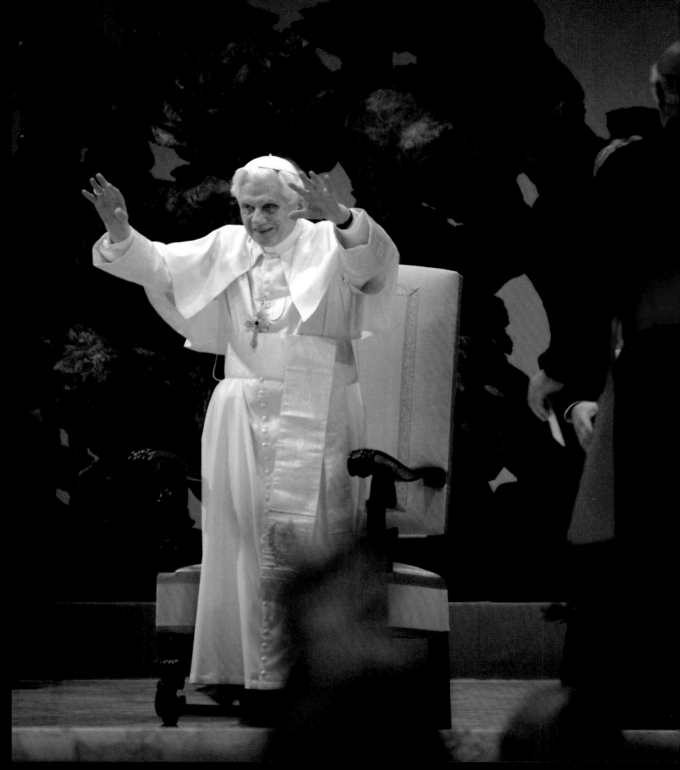

⬥ *Pope Benedict XVI in front of a General Audience in the papal Audience Hall · When shooting in cramped quarters and poor lighting, a monopod is a useful tool for avoiding camera shake. 200 mm · ISO 400 · f/2.8 · 1/100 sec*

The Colosseum · Executions, gladiator battles, and lion fights were among the bloody events conducted here. If these old, ailing walls could talk, they'd have gruesome stories to tell. 15 mm · ISO 100 · f/8 · 2 sec

ITALY Florence

As I walk through the streets of Florence, the weather is cheerless and the sky is overcast. I have one day to explore this wonderful city with my camera. First, I pay homage to the oldest bridge in Florence, the Ponte Vecchio over the Arno River. It was built in 1345 and is one of the oldest segmental arch bridges in the world. I came here wanting to photograph the bridge itself, but a painter is standing in my way. He interests me more than the bridge in a way, so I end up with a picture within a picture.

When it starts to drizzle, I step into the Galleria dell'Accademia, where what is perhaps the most famous statue in all of art history resides—Michelangelo's David. As is often the case, photography is strictly forbidden. I witness another visitor attempt to sneak a photo with his compact camera, but a watchful guard quickly puts an end to it with a reprimand.

I have to make do with the copy of the David, which stands in the Piazza della Signoria. It's not the same beautiful white as the original, and it's somewhat weathered, but it has a certain charm, perhaps for these very reasons. The other statues here are not nearly as famous but they are at least as worth checking out. I'm pleased with the dull soft light because it illuminates the beautiful figures around me so well. I take my time experimenting with different shooting perspectives.

At the end of my time in Florence, I visit the Piazzale Michelangelo. The view of the entire city is great from here. As the sun slowly sets, it bathes the Basilica di San Lorenzo and the bridges over the Arno in a beautiful warm light.

◄ *The pride of the city: Michelangelo's David · The original sculpture is located in a museum where photography is strictly forbidden. I had to be content with its copy, which lives on the Piazza della Signoria. I concentrated on David's dramatic facial expression in this photo. 400 mm · ISO 200 · f/5.6 · 1/125 sec*

Ponte Vecchio · When I arrived to photograph this bridge I found a painter in my way, so I improvised and integrated him into my composition—a picture in a picture. 51 mm · ISO 100 · f/2.8 · 1/250 sec ►

Basilica di San Lorenzo · This church is among the largest and oldest in all of Florence. 85 mm · ISO 100 · f/8 · 2 sec

ITALY Venice

I'm standing under one of the protective walkways along Piazza San Marco, which are densely packed with thousands of other visitors. Being in Venice for Carnival is the best thing that can happen to a photographer. But with only one day to shoot, it's a real challenge. And it would be an utter disaster if this one day were marked with torrential downpours that kept all of the mysterious masked partygoers from stepping out of doors for fear of ruining their expensive costumes. After two hours, the good Lord shows mercy and reduces the rain enough that I am only modestly soaked by the time I get back to my hotel. I take refuge in the hotel, waiting by the window for better weather and watching as the revelers defend themselves against wetness with umbrellas.

Late in the afternoon the rain slows to a light drizzle. I try my luck again and come across a few masks in the street. The sky is still overcast and the light is quite weak, but it's sufficient in most cases. This is my first time being in Venice for Carnival and it is tremen-

dously fun. Everywhere I look, I see stylishly dressed people in fantastic costumes practically waiting to be photographed. It's not surprising to find a number of amateur, hobbyist, and professional photographers, with two or more cameras around their necks, congregated here on the hunt for masks. Elbowroom is scarce when 30 photographers are crammed around a single model. It takes some jostling to get to the best position. I'm on the receiving end of an elbow strike or two as I work my way to the front.

Charm abounds in Venice, with its canals, gondoliers, antique buildings, and absent car traffic. You feel as though you've traveled back in time and there are attractive subjects everywhere.

◄ *Carnival of Venice, a photographer's dream · One of many beautiful, handcrafted masks. 48 mm · ISO 200 · f/2.8 · 1/60 sec*

Venice in the rain · Black-and-white conversions are often a natural choice for such sad weather. 58 mm · ISO 200 · f/3.2 · 1/1600 sec �']

♠ *Carnival of Venice · The beautifully dressed revelers love to strike poses. They are also delighted if you share a photo with them as a token of thanks. 30 mm ·*

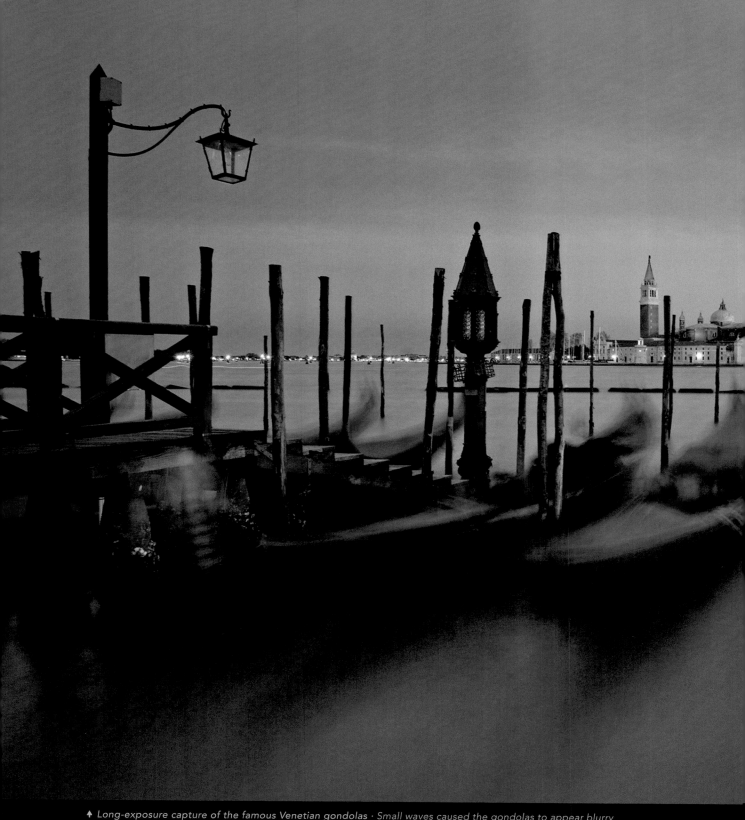

⬆ *Long-exposure capture of the famous Venetian gondolas · Small waves caused the gondolas to appear blurry in this long-exposure image. This quality makes the picture interesting.* 42 ISO 100 f/9 10

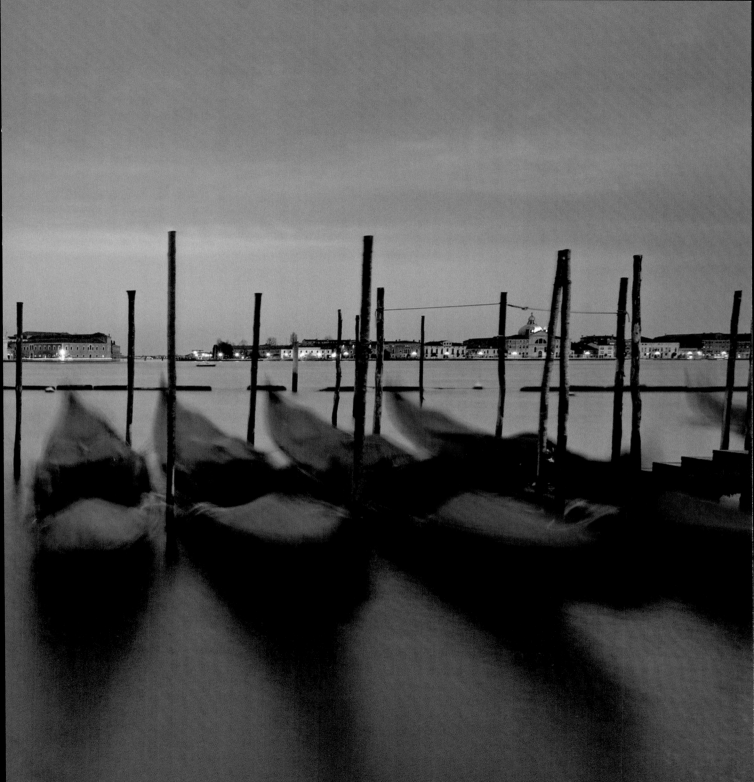

DENMARK Copenhagen

As he waves a bayonet around in front of my nose, the guard is trying to tell me something. Even though my knowledge of Danish doesn't extend much beyond "Smørrebrød," I can reasonably guess what he's getting at. So I fold up my tripod for what feels like the thousandth time and get ready to shoot by hand. I am in Denmark, standing with my photo equipment on the Palace Square in Copenhagen and watching the Royal Life Guards march.

I'm currently traveling by water to get to my destinations. Boats are a nice change of pace from the countless airplanes and rental cars that I've used over the previous months. I still have to make haste because I have only a couple of hours to track down all of the subjects that I've planned out. Accordingly, I walk quickly to Nyhavn, a famous branch canal that expanded the port of Copenhagen in the 17th century. Attractive boats line the water, and cafés and old, colorful houses along the waterfront compete for the attention of tourists.

The famous fairytale writer Hans Christian Andersen also lived in this part of town in the 19th century.

A handful of people may have heard his story about a little mermaid. This story was the inspiration for the statue sculpted by Edvard Eriksen in 1913. The statue was installed on a rock near the Langelinie promenade and has since become one of the most famous photographic subjects in all of Copenhagen. Every day, hundreds of tourists flock to the statue. The fanaticism surrounding her is so great that her head has even been sawed off and stolen on two separate occasions.

Time passes much too quickly here. I scamper over to the Parliament just as the sky darkens ominously. Right before I board my ship, I dash off a few postcards and drop them in the royal mailbox. And then once again it's "fare thee well, Copenhagen."

◆ The Little Mermaid, inspired by the eponymous fairytale by Hans Christian Andersen · She sits on a rock near the Langelinie promenade near Copenhagen's port. 137 mm · ISO 100 · f/2.8 · 1/1000 sec

Nyhavn · The beautiful ships and bright, colorful houses make Nyhavn one of Copenhagen's must-do attractions. The fairytale writer Hans Christian Andersen resided here. 20 mm · ISO 100 · f/8 · 1/40 sec ➤

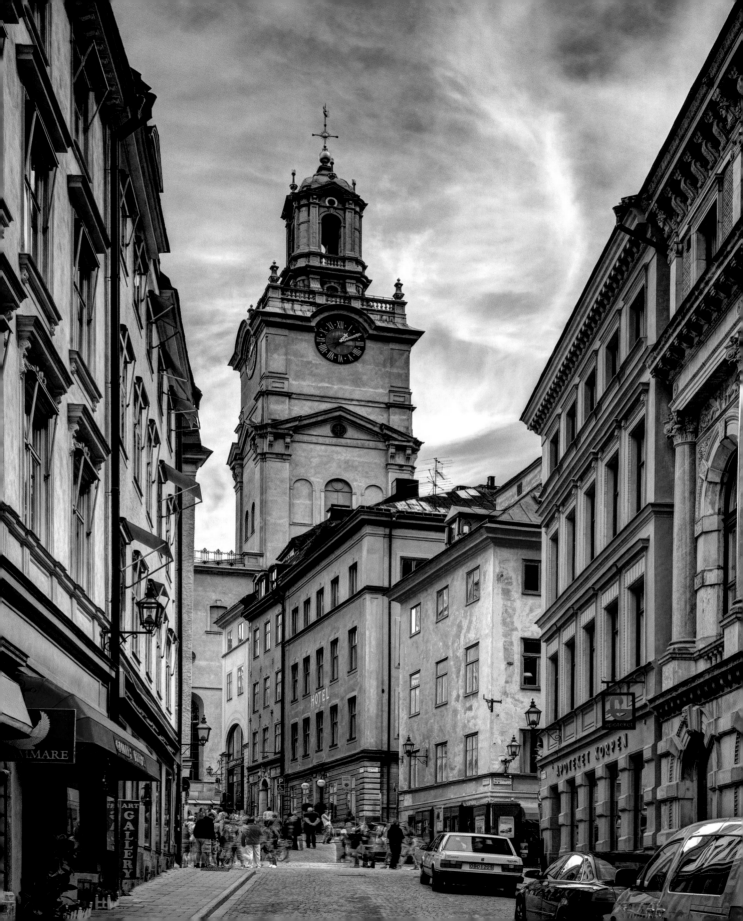

SWEDEN Stockholm

"Dear ladies and gentlemen…," the captain's voice blasts into my cabin and jolts me from sleep. I glance toward the clock in a daze and see that it's 7:00 a.m. The cruise ship is about to dock so I quickly get out of bed. I've arrived in Stockholm, the capital of Sweden. I've wanted to travel to Stockholm ever since I saw ABBA win the Eurovision Grand Prix for "Waterloo" when I was a kid. I had fallen madly in love with singer Agnetha Fältskog and had no idea that it would take 37 years for me to finally make my dream come true.

The weather is beautiful as I stroll through the city. I eventually arrive in Stockholm's old town with its colorful buildings. As soon as I get my tripod set up, the sky turns threateningly dark. I take a few pictures before a lightning bolt rips the sky apart. When the thunder claps, the floodgates open and it starts to pour rain right as I find some dry shelter. After an hour of pounding rain, I continue on with my tour of old town. The abundance of Pippi Longstocking dolls in the souvenir shops proves that this beloved character and her author, Astrid Lindgren, hailed from Stockholm. I head over to the German Church along beautiful alleys with unusual names like Humlegårdsgatan and Kungsgatan.

"You're a photographer? Then you have to visit the tower at city hall," explains a woman at a tourist center. "The view of the old town is magnificent from up there." I discover just how right she was as I reach the top, gasping for air. The strenuous, ten-minute stair climb was absolutely worth the effort!

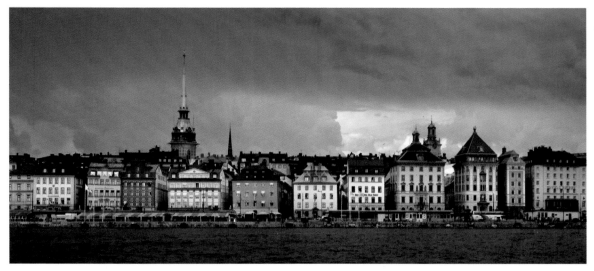

↑ *Cityscape · Stockholm is dominated by the beautiful facades of old buildings, which in this image are illuminated by a wonderfully dramatic light. 38 mm · ISO 100 · f/11 · 1/15 sec*

◄ *Stockholm's beautiful old town · The tower of the German Church is visible in the background. 26 mm · ISO 100 · f/10 · 1/25 sec*

SWEDEN Gothenburg

He is standing right in front of me: King Gustav Adolf II, the man who in 1619 founded Gothenburg, where I currently find myself. Pointing at the flag, he doesn't leave any doubt about the country to which his city belongs. I arrived half an hour ago. At four hours, my stopover here is the shortest of any of the destinations on my cruise. This means I need to hurry if I want to get to know this unfamiliar city.

My first stop is the Göteborg Opera, a modern and visually striking building. Aside from this structure, this city somehow lacks that certain photographic something for me. There are nice cafés and many students owing to the university here. Some try to earn some extra pocket money by performing music on the street. One flute and guitar combo is really good and I watch them for a while. I lose track of time while listening, so I have to hustle if I want to catch my boat. Walking will take too long, but fortunately I come across one of the blue-and-white streetcars that Gothenburg is known for. I make it back to the ship with just a few minutes to spare before the vessel shoves off.

▲ *Streetcar · Gothenburg is famous for its blue streetcars. They make for a colorful photo.*
17 mm · ISO 100 · f/2.8 · 1/50 sec

◀ *King Gustav II Adolf proudly points to his country's flag · I noticed this detail only after standing in front of the statue twice. It's all a matter of perspective. 73 mm · ISO 100 · f/6.3 · 1/1000 sec*

The opera · I shot this photo with a wide-angle lens and corrected the resulting distortions while editing the image later. 13 mm · ISO 100 · f/10 · 1/100 sec

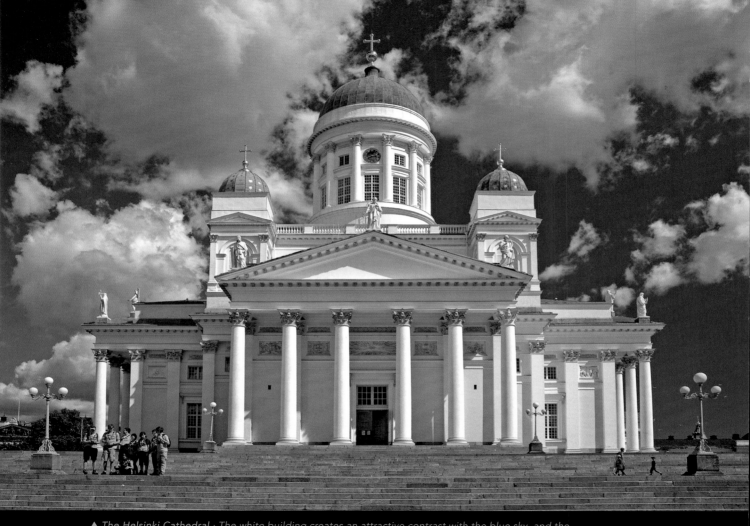

⬆ *The Helsinki Cathedral · The white building creates an attractive contrast with the blue sky, and the clouds are the icing on the cake. A great deal of patience was required to capture this photo because thousands of tourists were milling about. 18 mm · ISO 100 · f/7.1 · 1/100 sec*

FINLAND Helsinki

As soon as I leave the boat, I know that today is not going to be easy. Six different cruise ships are lined up at the harbor and between 12,000 and 18,000 visitors are already pouring into the city early in the morning. At least the weather and I are finally getting along—sunshine and blue skies—so I join the throngs in a good mood. I've made it to Helsinki, which is both the capital and largest city of Finland.

My first destination is the famous Helsinki Cathedral, which was built from 1830–1852. The classical white building contrasts sharply with the blue sky in a way that impresses me deeply. But I have to concentrate on the details of the beautiful cathedral for now because tour guides and groups of tourists are swirling about me and my camera.

Next I accidentally come across the Parliament House. Its many imposing, symmetrically arranged columns wake my interest. The architecture throughout Helsinki is strikingly diverse. The stylish Kiasma Museum of Contemporary Art is located across from the Parliament House, establishing a dramatic architectural contrast.

My shore leave here is slowly coming to an end. I walk past the National Theater on my way to the red Uspenski Cathedral, where I meet my dear fellow tourists from all over the world again. Despite my imposing tripod and my large collection of equipment, which makes me look like a professional photographer, the visitors stand directly in my way. The only thing left to do is tilt the camera.

I try my luck once again at the Cathedral on my way back to the ship. I have to stick it out for quite a while before most of the other tourists are also on their way back. Finally I succeed in capturing a photo of the beautiful building that isn't overflowing with tourists.

Pure form · I really liked the static, repeating columns of the Parliament House. A tight crop brings them to the foreground of this photo. 33 mm · ISO 100 · f/6.3 · 1/60 sec ➜

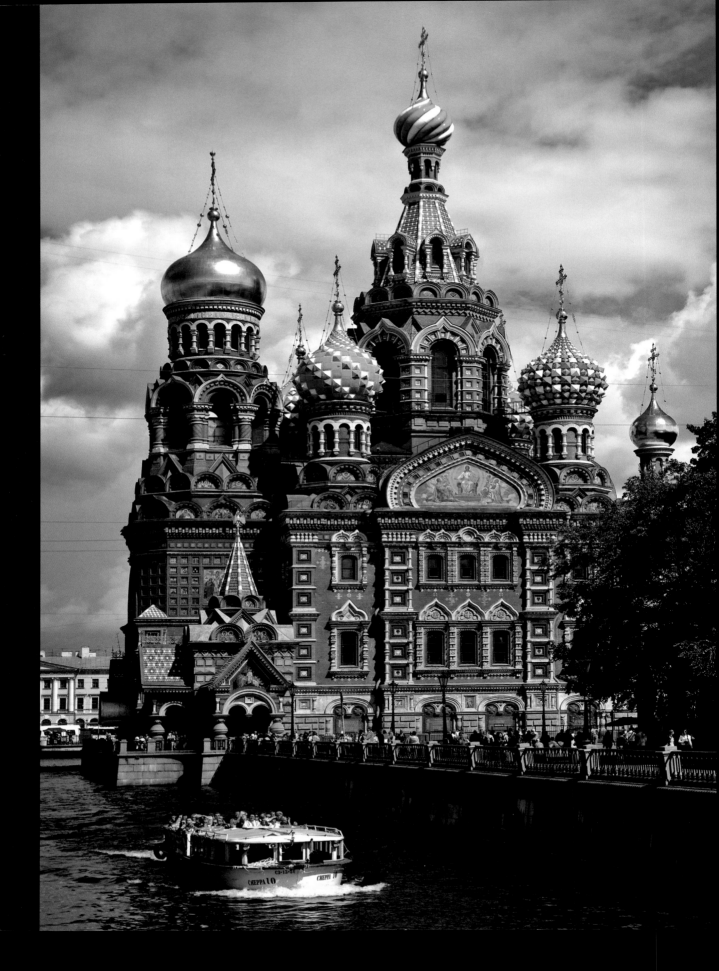

RUSSIA St. Petersburg

I'm soaked in sweat as the sun burns my skin here in St. Petersburg, the second-largest city in Russia. Some may still know it as Leningrad. The city is farther north than any other city in the world that has a population over one million people. I had no idea that temperatures could soar to over 85 degrees Fahrenheit here. I always associate Russia with frigid weather, but now I know better. I also underestimated the extreme geographical size of this city. What looks close on my map is miles away in reality.

I make my way along the Griboyedov Canal to the Cathedral of the Resurrection of Christ. The church was built between 1887 and 1907, and it features onion domes and a romantic nationalism style. It is the most famous and most colorful building in the city.

I happen across a small market a few streets over. In addition to vodka, all manner of souvenirs are for sale, including the traditional Russian nesting dolls. The highlight for me, however, are the giant fur hats. They're not likely to be purchased on a day like to-

day; just looking at them sends the sweat rolling down my back. The baroque Winter Palace, the onetime seat of the Tsar dynasty, is another architectural highlight.

The last building I want to shoot today is St. Isaac's Cathedral. Its gold dome is not to be missed, not least because it is the fourth largest in the world.

After so many exciting discoveries here, I'm ready to head back to the ship. But wait, how do I get there? This open-ended question becomes a major problem. I wasn't aware that hardly anyone in Russia understands, let alone speaks, English. So it takes me a good two hours before I finally make it back to the boat. Unfortunately, I didn't even try my German.

◂ *The Cathedral of the Resurrection of Christ · The onion domes make this church one of the most interesting buildings in the city. 23 mm · ISO 100 · f/4 · 1/320 sec*

Traditional Russian nesting dolls, or matryoshkas · You can find these dolls by the hundreds at markets on street corners. Often they are painted by hand beautifully. 50 mm · ISO 100 · f/2.8 · 1/400 sec ↠

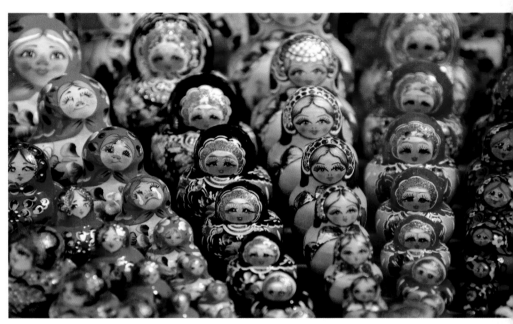

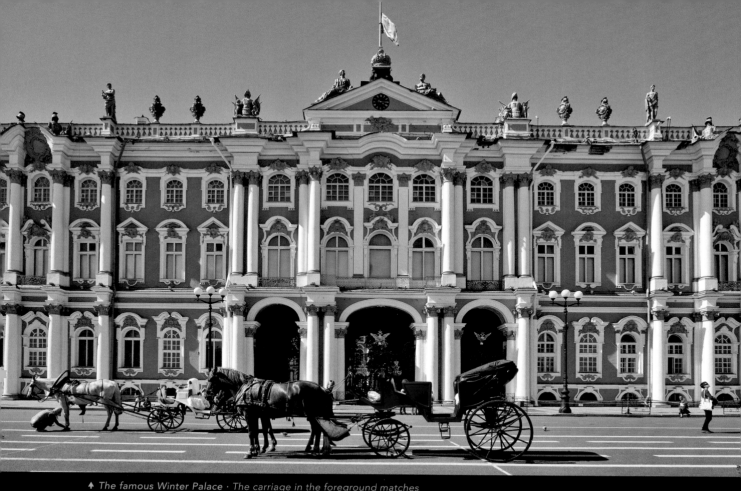

↟ *The famous Winter Palace* · *The carriage in the foreground matches the stunning, old facade perfectly. 13 mm · ISO 100 · f/11 · 1/50 sec*

The golden dome of St. Isaac's Cathedral glowing in the sun · *The bright lighting produces an interesting contrast between the dome and the blue sky. 23 mm · ISO 200 · f/11 · 1/40 sec* �ड

⬆ Striking towers with red tile roofs dominate Tallinn's cityscape · I used a wide-angle lens to capture as much of the city as possible here. 28 mm · ISO 100 · f/11 · 1/30 sec

ESTONIA Tallinn

I walk along rough cobblestone roads past suits of armor on my way to the market. It feels like I'm in the Middle Ages. No wonder—I'm in Tallinn, the capital of Estonia. This city is famous for its well-preserved medieval old town, which has been recognized as a UNESCO World Heritage Site since 1997. Opportunities for pictures abound here—old windows, carved and decorated doors, and market women dressed in historical garb hawking their wares.

I stroll around through the narrow alleys and soak up the medieval atmosphere. When I arrive at the Church of the Holy Ghost, I gladly stop to take a few pictures. I decide to climb a steep hill and when I arrive at the top, a sweeping view of the old town with its fortress walls and towers awaits me. I walk farther along wanting to discover more of this fascinating city and I find a painter who I thought had passed long ago. . . . With my time here drawing to a close, I rush over to one final attraction, the Alexander Nevsky Cathedral. It was built between 1894 and 1900 as a symbol of the Russification of Estonia and is a real feast for the eyes even today.

♠ *Picasso · I came across this famous painter while strolling through the city's alleys. I thought he had kicked the bucket long before. 38 mm · ISO 100 · f/2.8 · 1/100 sec*

SCOTLAND Edinburgh

The warm air that lifted my spirits seconds earlier quickly changes into storm gusts. A downpour immediately begins, turning what were content tourists into a group of less-than-happy travelers soaked to the bone. Now I understand why the hotel reception practically forced me to take an umbrella. I'm in Edinburgh, the capital of Scotland. My travel guide warned me that the weather conditions here were volatile, but I didn't want to believe it. As soon as the rain lets up a little, I sit down on a bench on Carlton Hill and take in the evening view of Edinburgh's old town. On my way back to the hotel I pass the famous Edinburgh Castle perched atop Castle Rock, an extinct volcano, and bathed in warm, evening light.

Edinburgh is definitely amazing, but I want to see more of Scotland than just its capital. I rent a car and head out for the Highlands. My drive takes me past unbelievable landscapes and lakes. I'd love to stop and photograph every single one, but each stop takes a good hour or two. First I have to find the right vantage point, then set up the tripod, then choose a lens, and then test out different filters. Then I have "only" to wait for the sky to open up and illuminate the otherwise dismal, gray landscape with rich, dramatic light.

The area's castles aren't the only highlights for me; the many rundown and often difficult-to-access ruins are also enticing. I am so enthralled by some subjects that I fail to take into account the typical Scottish moorland and sooner or later sink into the earth up to my knees. The many mosquitoes also make my life unpleasant and I decide that on my next trip I'll come prepared with rubber boots and bug repellant.

The weather changes for the worse when I get to the west coast. I'm a bit frustrated as I drive along the coastal highway in storms and heavy rain. After several miles, I spot a lighthouse on the horizon—a subject that is perfectly suited for such dramatic weather. The cold as well as my frustration and wet clothes are quickly forgotten.

◆ Bagpipes are just as essential a part of Scotland as Loch Ness in the background · I used my favorite prime lens with its maximum aperture here. 85 mm · ISO 100 · f/1.4 · 1/1600 sec

Iconic Edinburgh Castle on top of Castle Rock, an extinct volcano · The upward perspective makes it look large, powerful, and unreachable. 43 mm · ISO 100 · f/8 · 1/40 sec ➔

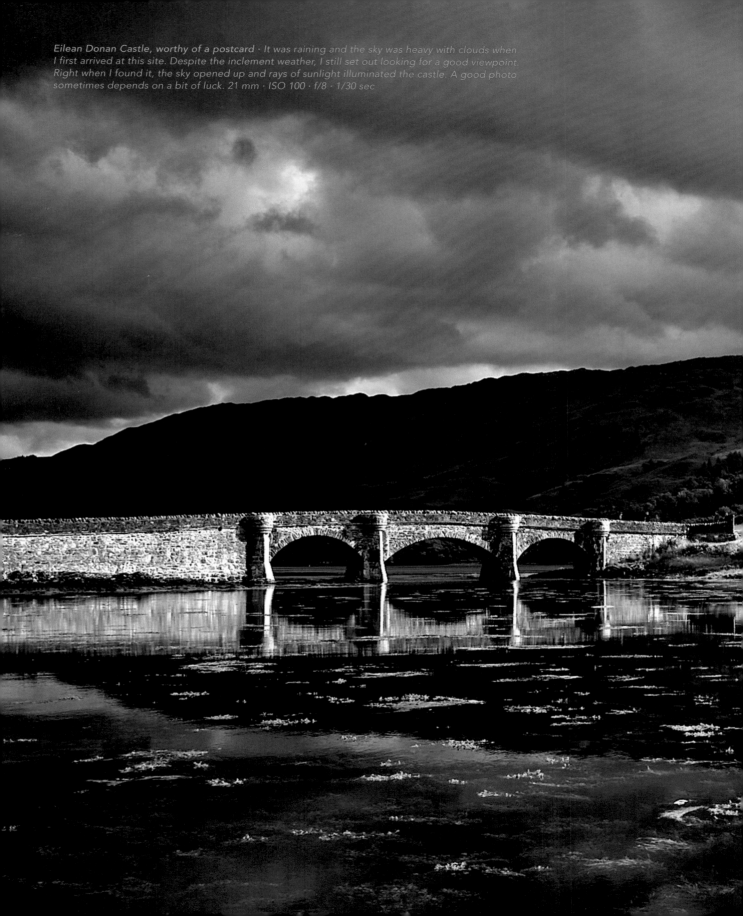

Eilean Donan Castle, worthy of a postcard · It was raining and the sky was heavy with clouds when I first arrived at this site. Despite the inclement weather, I still set out looking for a good viewpoint. Right when I found it, the sky opened up and rays of sunlight illuminated the castle. A good photo sometimes depends on a bit of luck. 21 mm · ISO 100 · f/8 · 1/30 sec

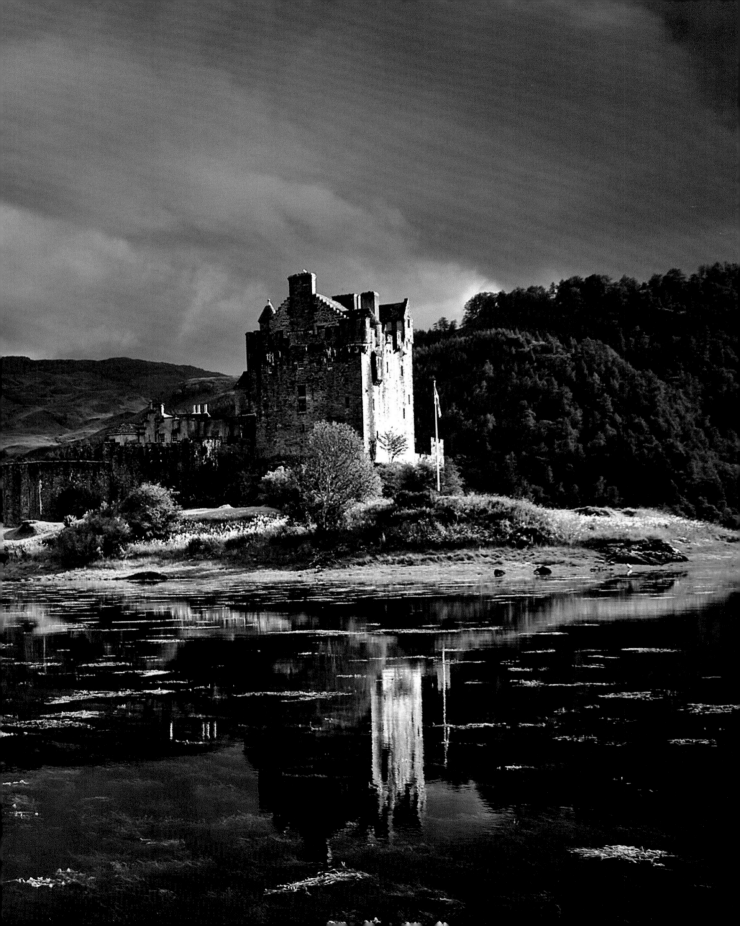

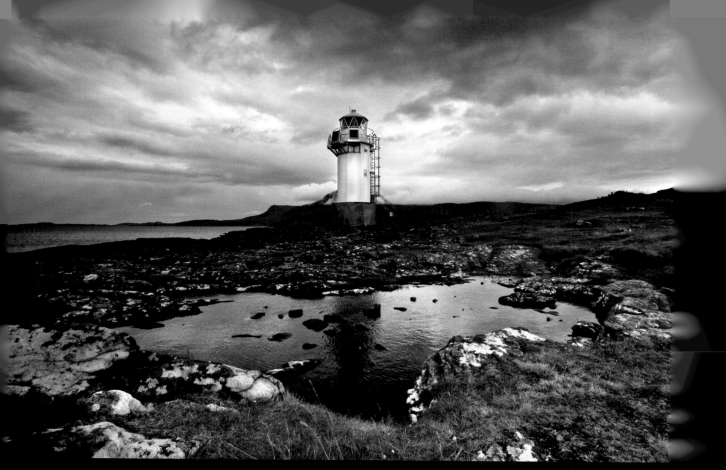

↟ *Scotland's rugged coastal landscape is rich with photographic subjects · I took some time trying out different angles fo this picture of a lighthouse. It would have been ideal if the water in the foreground was been smoother and reflected the lighthouse more clearly, but you can't have everything. 10 mm · ISO 100 · f/7.1 · 1/30 sec*

View of Edinburgh from Carlton Hill · As I was shooting this, the sun was already quite low in the sky, casting beautiful evening light over the city. Wanting to get as much as possible in focus, I used a small aperture. Accordingly, I had to use a tripod to manage the relatively long shutter speed. 26 mm · ISO 100 · f/10 · 1/13 sec ↓

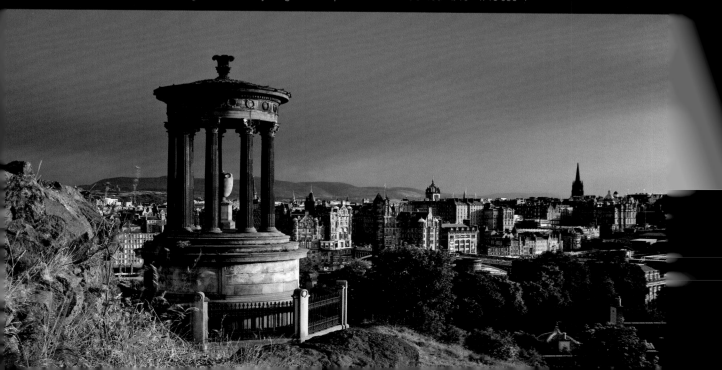

♠ *The illuminated Scottish National Gallery · I headed back out in the blue hour to shoot this building in my favorite lighting. 14 mm · ISO 100 · f/3.5 · 3/5 sec*

The Scottish countryside is extremely varied · A reflection of the clouds in this lake caught my eye. But by the time I had my tripod set up, the wind had thrown a wrench in my plans by stirring up the water. 10 mm · ISO 100 · f/10 · 1/80 sec ♦

IRELAND Dublin

The walk is long and my thirst is unbearable. With a dry mouth, I finally arrive at my destination only to discover that I'm too late, the black gate is already closed. I read the gold lettering on the gate, which spells out exactly why I've come here: GUINNESS. I'm in Dublin, Ireland's capital, and I'm standing outside of the locked brewery, which was founded in 1759. Determined to find a typically Irish end to the day, I set out for a pub. I finally choose Dublin's most famous watering hole, the Temple Bar. The next morning, I set out on a drive to explore Ireland's countryside.

Despite knowing in advance that Ireland's weather is variable, the perpetually clouded sky and rain drive me to the brink of insanity. Among other things, Ireland is known for its green landscapes, but without the sun, the scenery looks just as gray as the sky. My trip through the interior of the country brings me past dilapidated ruins and graveyards.

Poulnabrone Dolmen is the oldest and most famous of Ireland's "cemeteries." I can barely comprehend that this gravestone has withstood the Irish wind and weather for nearly 6,000 years.

A short time later, I reach the country's west coast, but I have no desire to even think about swimming in this weather, so I continue my drive. The road follows the coastline to the famous Cliffs of Moher. These steep cliffs are up to 702 feet high. Despite the vagaries of the weather, Ireland is a captivating country. Between the pubs, ruins, landscapes, and people, there's plenty to keep your camera busy.

◆ *The Irish countryside is dotted with ancient ruins and gravestones · I tried to get the most out of this picture with the right perspective, a wide-angle lens, and a polarizer filter. 10 mm · ISO 100 · f/4.5 · 1/320 sec*

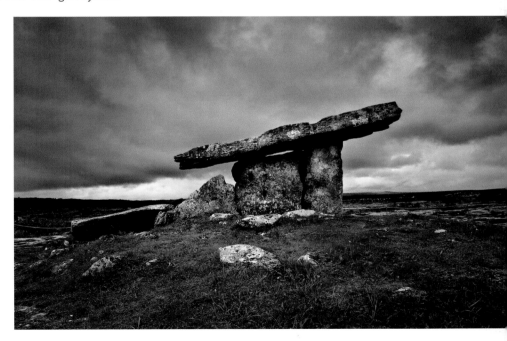

The famous Poulnabrone Dolmen · The site is more than 6,000 years old. The dramatic clouds pair with the weathered stones perfectly. 14 mm · ISO 100 · f/6.3 · 1/50 sec ➤

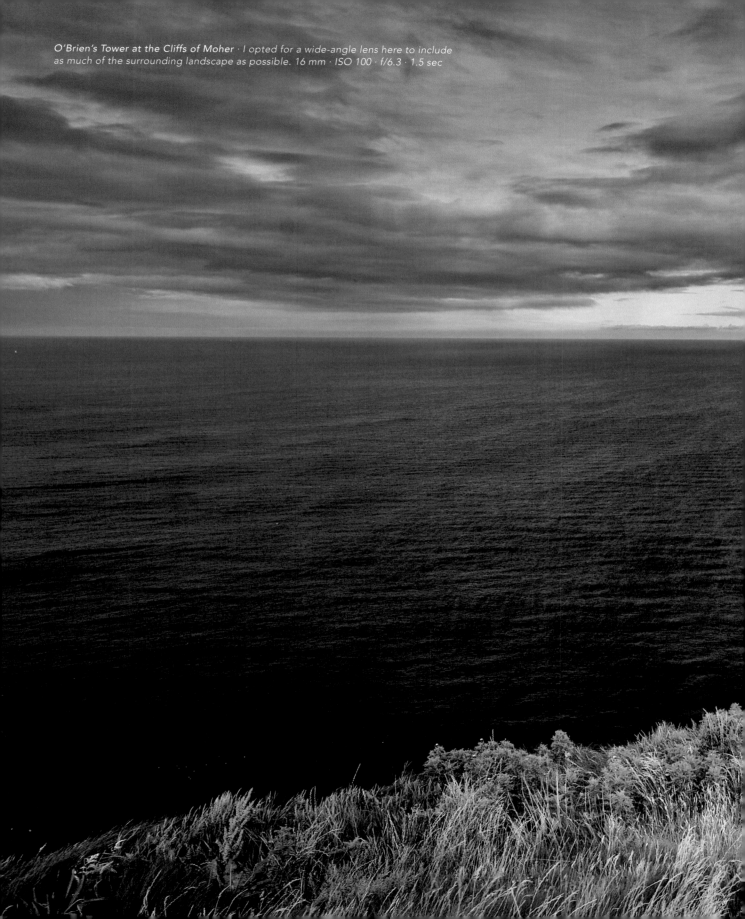

O'Brien's Tower at the Cliffs of Moher · I opted for a wide-angle lens here to include as much of the surrounding landscape as possible. 16 mm · ISO 100 · f/6.3 · 1.5 sec

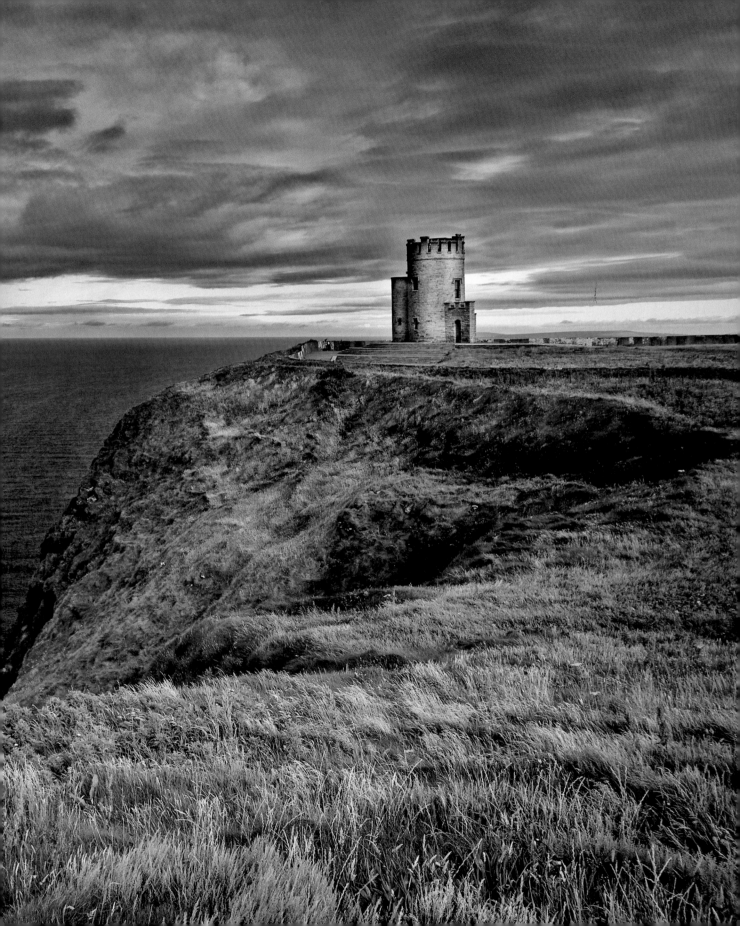

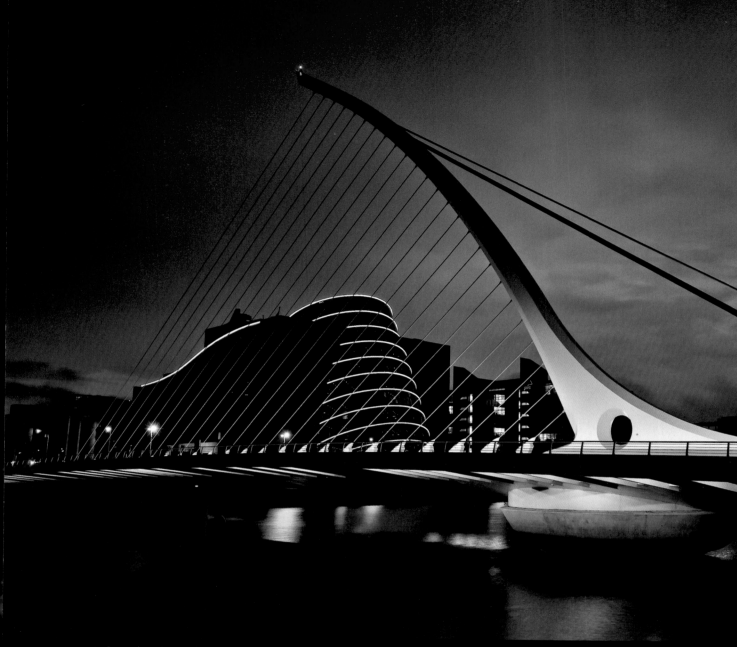

↑ *Samuel Beckett Bridge · This modern bridge is located in Dublin. It was inspired by an Irish emblem—the harp. 17 mm · ISO 100 · f/6.3 · 5 sec*

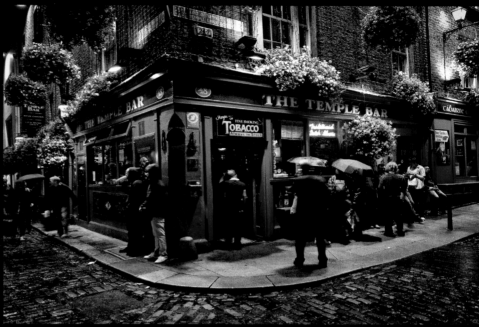

↟ *The Temple Bar* · *This is one of Dublin's must-sees. Here it takes on a certain charm in the light of the evening hour. 15 mm · ISO 100 · f/3.5 · 3/10 sec*

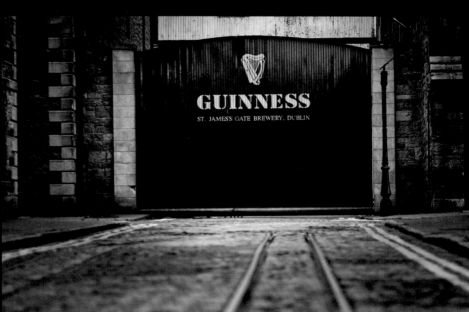

Guinness is Ireland's most famous beer · Unfortunately, the brewery was closed by the time I arrived, but the entrance gate and the cobblestones outside made for an interesting subject. 85 mm · ISO 100 · f/1.4 · 3/5 sec ➜

AMSTERDAM

NETHERLANDS Amsterdam

A sweet odor envelops me as people with dilated pupils and ear-to-ear grins exit the many "coffee shops" and walk past me. Amsterdam is known for many things, but its allowance of the sale and consumption of various intoxicants is certainly one of the reasons many tourists visit. This city is both the capital of and most populous city in the Netherlands. From cannabis lollipops to hash cookies to pipes, the city offers anything imaginable related to certain drugs. You can even find little do-it-yourself starter kits on nearly every street corner. It's almost a little irritating that I don't smoke.

Naturally, there are other attractions that make this port town beloved, including the many canals and the pleasant boats that cruise through them. In earlier times, the canal network, which is comprised of 65 miles of waterways, served as a key method for merchants to transport their wares. The city reminds me of Venice a little. Amsterdam is also known for its famous tulips. Unfortunately it's not springtime, so I have to content myself with the many colorful wooden tulips that are for sale everywhere I look.

Walking around this city is not without dangers. The main method of transportation in Amsterdam is via bicycle. Because the streets are mostly narrow, sometimes the only path to safety involves a quick jump to the side.

← *Letting the grass grow under one's feet · This little tongue-in-cheek Rasta gnome shows what is so happily smoked throughout Amsterdam. 200 mm · ISO 100 · f/2.8 · 1/400 sec*

Canals · Amsterdam isn't known only for its intoxicants—the canals that weave through the city are also a true hallmark of the area. 17 mm · ISO 100 · f/3.5 · 1/200 sec →

313

BELGIUM Brussels

A weight of 2,400 tons; a height of 335 feet; 9 spheres, each with a diameter of 59 feet; and escalators that are among the longest in all of Europe. All of these impressive facts describe a building designed to look like a unit cell of an iron crystal structure that has been enlarged by a factor of 165. Slack-jawed, I'm standing in front of the Atomium in Brussels, which was built in 1958 for the World's Fair as a symbol of the nuclear era and the peaceful use of nuclear energy.

Belgium's capital city has a wealth of landmarks to offer. Grand Place is lined with baroque facades and is among the most beautiful town squares in all of Europe. It has been recognized as a UNESCO World Heritage Site since 1998. Every two years, the city lays out a huge carpet of flowers here for a couple of days and people from all over the world come to visit. The unusually high heat over the past few days has caused most of the flowers to wilt by now.

On my walk through the city, I come across a crowd of excited people. I'm blinded by a barrage of flashes as I work my way to the front. Once I finally get there, I'm surprised to find out that the star of all of this attention is naked and only 24 inches tall—Manneken Pis.

Brussels holds its own in the department of sweets too. Aside from the famous Belgian waffles, the city is a veritable bastion of delicious chocolates and pralines.

◄ *The main hallmark and attraction of Brussels: Manneken Pis · Despite his diminutive stature of 24 inches, he is the city's most beloved target for photographers. 91 mm · ISO 100 · f/2.8 · 1/1000 sec*

Brussels is world famous for its delicious chocolates and pralines · I make a point of trying the goodies while also documenting how they are prepared. 50 mm · ISO 100 · f/2.8 · 1/60 sec ➤

↟ **Flower carpet** · Every two years a giant flower carpet is set up in the city for a few days. Visitors the world over flock to the city for this occasion. 8 mm · ISO 100 · f/9 · 1/200 sec

↞ **Saxophone player** · I met this musician on my wanderings through Brussels. He gave me permission to photograph him as soon as I promised him a few of the finished pictures. I wanted to isolate him in the foreground, so I chose a perspective that produced a dark, uniform backdrop. Using a long focal length and a wide aperture took care of the rest. 157 mm · ISO 100 · f/2.8 · 1/320 sec

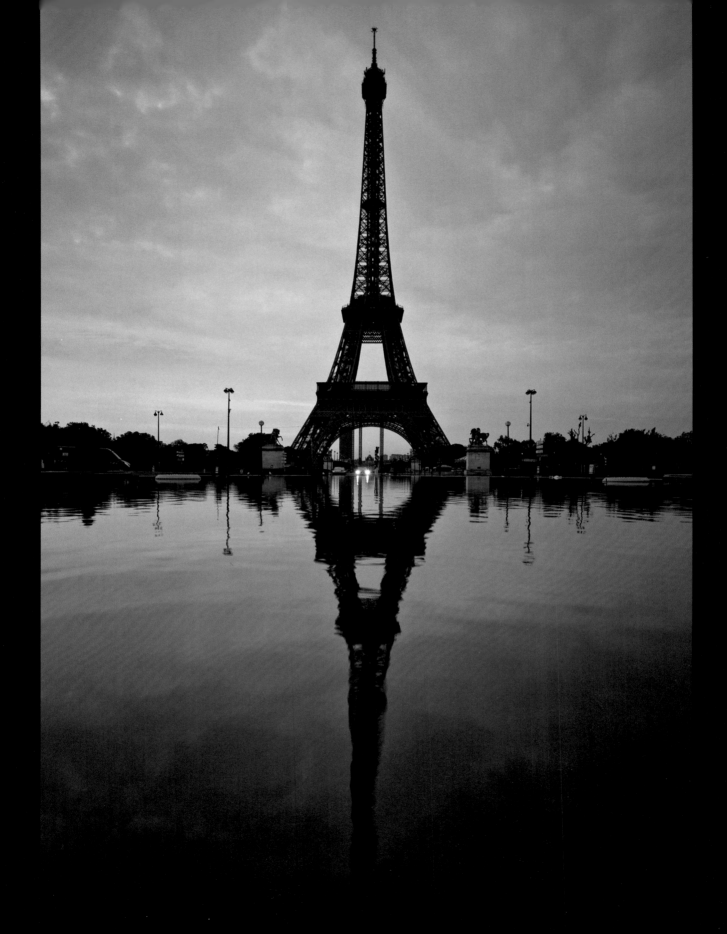

FRANCE Paris

It's six o' clock in the morning and I'm standing hip-deep in water all by myself. I have to concentrate very hard to use my shivering hands to set up my tripod and mount my camera and lens—just don't drop anything! I also have to work quickly or else security might throw a wrench in my plans, or worse yet, the huge pumps in this fountain might fire up and completely soak me and all of my equipment in a matter of seconds. I'm standing in the fountain in front of the Eiffel Tower in Paris, carrying out my wife's idea to capture a photo of the tower with no people visible and with a reflection of the structure in the surface of the water. The things one does to get the right picture! But this isn't the only way to make this 1,063-foot landmark look attractive. The tower has been photographed from every point of view imaginable, but nevertheless, I try my luck at finding an unusual one.

My time in the city of love sails by and my memory cards quickly overflow with countless photos of Parisian attractions. The Louvre, Notre Dame, the Arc de Triomphe, Sacré Cœur, and the Moulin Rouge are only a few of the sites I've checked off my list. The city's architecture is as interesting as its history. Paris is a paradise—and not just for photographers. I have no idea how many steps I scaled, miles I walked, or entrance fees I paid, but I do know that the effort was undoubtedly worth it.

Paris is turbulent, lively, and has a fascinating history. Gothic and baroque elements washed over with French flair make for an exciting visual and cultural backdrop. There's something to discover at every street corner. I will definitely be back soon.

◆ *Eiffel Tower · Early in the morning, I climbed into the fountain in front of this landmark to capture its reflection in the surface of the water. If the water pumps had turned on, all of my photography equipment would have become worthless in a single moment. 13 mm · ISO 100 · f/6.3 · 1/8 sec*

A visit to the Louvre was naturally on my to-do list · Here the pyramid is illuminated from within at twilight. 8 mm · ISO 100 · f/7.1 · 2 sec ➔

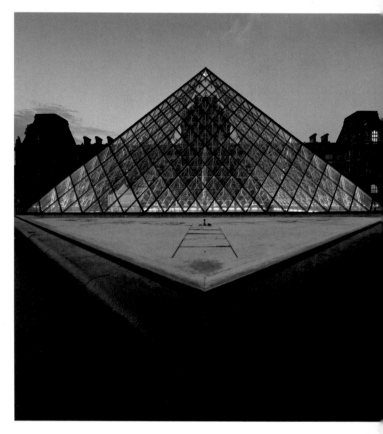

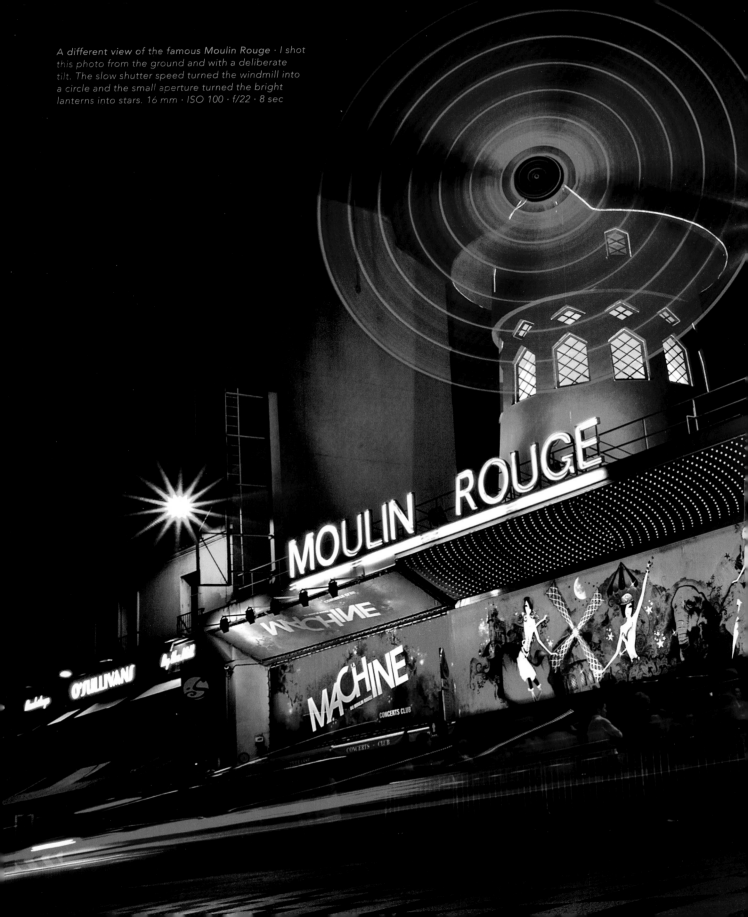

A different view of the famous Moulin Rouge · I shot this photo from the ground and with a deliberate tilt. The slow shutter speed turned the windmill into a circle and the small aperture turned the bright lanterns into stars. 16 mm · ISO 100 · f/22 · 8 sec

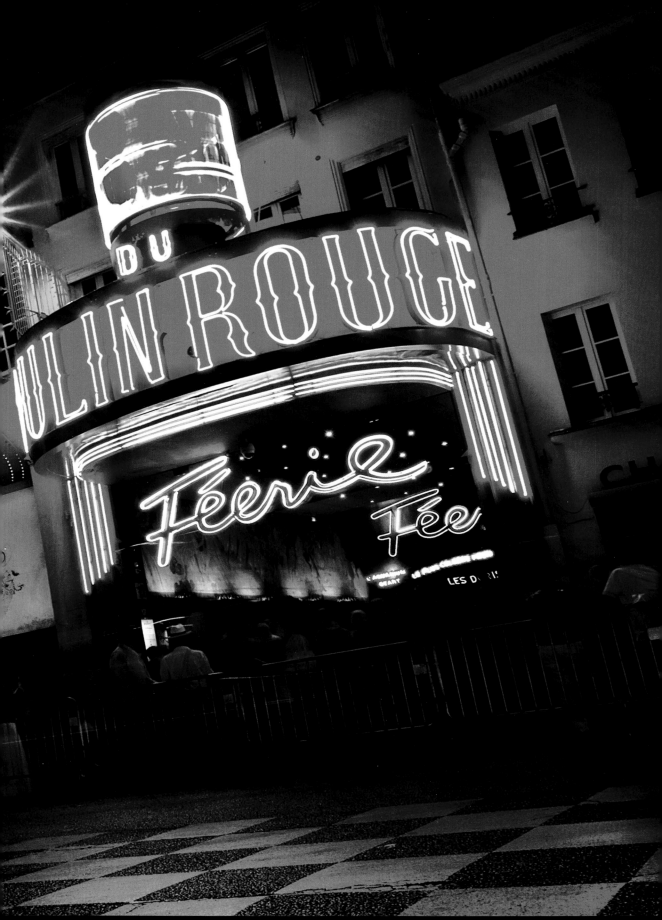

SWITZERLAND Zurich

My mouth starts to water as the snack vendor hands over my long-awaited curried sausage. After nearly a year of abstinence this treat is a truly special explosion of flavor. When the vendor rings up my total, though, my first bite practically sticks in my throat. "That will be eight francs, please," he says. I quickly do the math—nine dollars for a sausage? Of course, I'm in Zurich, the most expensive city in the world in 2012, according to Wikipedia. This is where the well-to-do go on vacation, which is easy to see based on the number of expensive hotels, including the Dolder Grand, which has a golf course directly outside its door. With 392,000 residents, Zurich is the largest city in Switzerland. Its luxuriousness is reflected in its elegant boutiques and shopping districts.

Early on I climb up the twin towers of the Grossmünster church to get a better overview of the city. The ascent is strenuous but the view of the old town and the Limmat are incredible up here. A walkabout in the city is definitely a must in Zurich. Above all, the Augustinergasse and its delightful, colorful facades are good for lovely stroll. Right as I arrive, however, a rain starts that continues for the next several days.

I keep my spirits up and make my way onward to the old Polybahn. This funicular railway travels up a stretch of the Zürichberg hill. It makes for a truly bizarre sight when it suddenly emerges right in the middle of a house's wall. I spend the next few rainy hours recovering in my hotel room with some delicious Swiss chocolate made by Lindt & Sprüngli.

↟ *Every corner of the city features classy boutiques* · *The elegant black-and-white appearance and the well-dressed woman in the foreground suit the setting. 45 mm · ISO 100 · f/5.6 · 1/200 sec*

↞ *Augustinergasse* · *As soon as the bicyclist came up wearing a Swiss rain poncho, I simply had to release the shutter. 73 mm · ISO 200 · f/5.6 · 1/250 sec*

↟ *The Dolder Grand · This luxury hotel high above the rooftops of Zurich looks like a fortress and makes for an interesting subject. 14 mm · ISO 100 · f/8 · 1/100 sec*

The Polybahn, built in 1886, is a protected landmark in Zurich · The tram makes for a bizarre scene when it emerges suddenly from the side of a house. I converted this photo to a colorkey image when editing it later. 39 mm · ISO 200 · f/4.5 · 1/320 sec ↓

AUSTRIA Vienna

The chocolate slowly melts on my tongue as a small wave of euphoria overcomes me, but only once the apricot jam hits my taste buds does the culinary experience reach perfection. I'm sitting in Café Sacher in Vienna, savoring the original, world-famous Sacher cake.

After this delicious little break, it's time to pick up where I left off exploring the capital of Austria. I spot a few carriages, and what would a trip to Vienna be without a city tour in one of these horse-drawn cabs? The ride takes me past several attractions including the Hofburg Palace, the Court Theater, and the Pallas Athena fountain. After 45 minutes, the pleasant ride is up and it's time to go back to walking. Statues and busts of famous personalities are all over the place. In addition to Mozart, many other notables have lived and worked here, including Johann Strauss.

At Schönbrunn Palace I walk in Sissi's footsteps while remembering the film starring Romy Schneider and Karlheinz Böhm. What is more romantic than taking wedding pictures in front of such a majestic palace? After I've had my fill of nobility, I head over to St. Charles's Church. The cornerstone for this Roman Catholic parish church was laid in 1716. The position of the pond here allows me to capture an image of the building and its reflection. As dusk slowly settles in, I make my way to the Prater, Vienna's famous public park and my last destination for today.

✦ *My itinerary included a visit to the Prater · The illuminated Ferris wheel caught my attention immediately. 26 mm · ISO 100 · f/7.1 · 6 sec*

✦ *Anyone unfamiliar with the world-famous Sacher cake is missing out · Whipped cream makes the experience complete. I draped the napkin in the foreground so that the lettering was readily legible. 51 mm · ISO 200 · f/5 · 1/50 sec*

327

↟ *The Vienna State Opera at night* · *It was rainy and wet when I took this picture. The reflections on the wet pavement contribute to the photo, as do the traces of light from the passing vehicles. 16 mm · ISO 100 · f/9 · 2.5 sec*

The Hofburg Palace · *I cropped this photo into a panorama. I also converted it to black-and-white to give the photograph a nostalgic look and feel. 18 mm · ISO 100 · f/6.3 · 1/250 sec* ↡

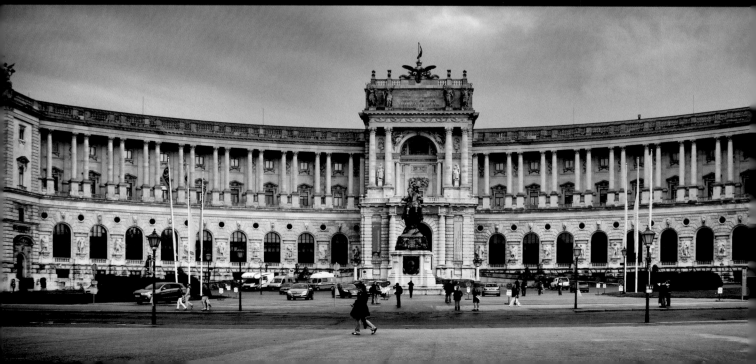

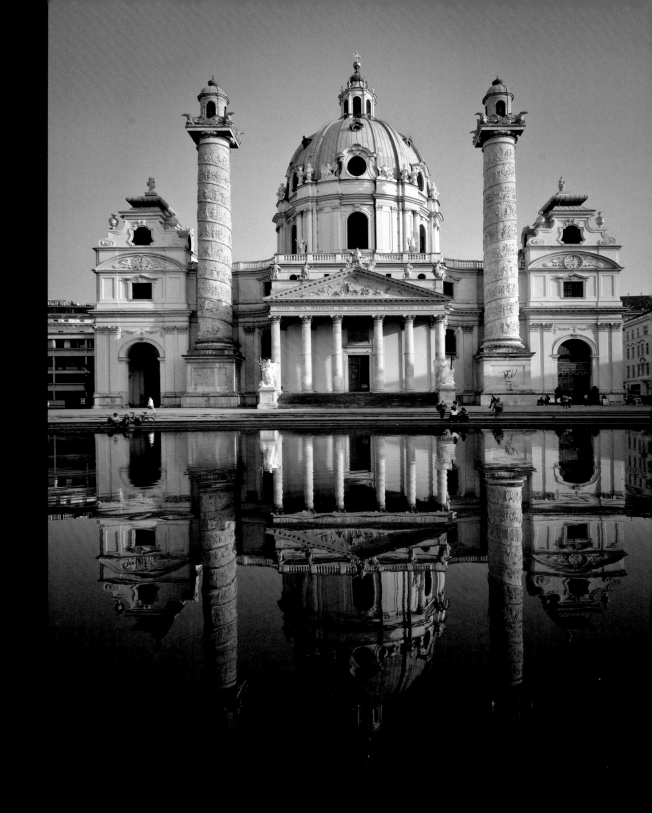

⬆ *The reflection of St. Charles Church doubles its splendor · I used a polarizing filter for this photograph. These tools can help you intensify or eliminate reflections depending on how they are used. 13 mm · ISO 100 · f/8 · 1/50 sec*

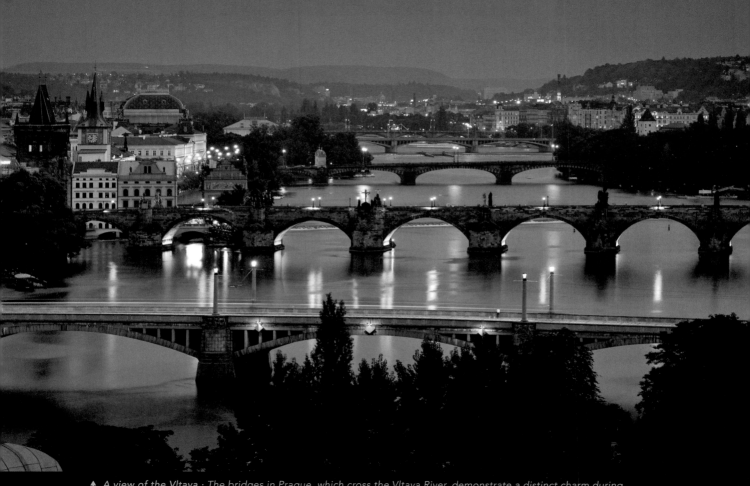

⬆ *A view of the Vltava · The bridges in Prague, which cross the Vltava River, demonstrate a distinct charm during the evening hours. They remind me a little of the bridges in Florence · 86 mm · ISO 100 · f/5 · 5 sec*

CZECH REPUBLIC Prague

I'm utterly exhausted as I reach the top of the hill and start to take in my surroundings. I look around as day slowly turns to night and suddenly it hits me that this beautiful view reminds me of someplace else—Florence! Italy isn't the only place where one can find such breathtaking vistas; Prague, the capital of the Czech Republic, offers some stiff competition.

The next day, I concentrate on the highlights that Prague has to offer. As someone interested in technology, I decide to visit the astronomical clock at City Hall first. Some parts of this clock—the movement, for example—date back to the 14th century. It is a true masterwork of gothic science and technology as well as a cultural landmark. Unable to pass up another vantage point, I also climb the tower at city hall, which affords yet another stunning view of the city.

Prague wins visitors over through its architecture above all else, with both old and modern designs. Architects Vlado Milunić and Frank Gehry collaborated to produce a stunning example with their modern-looking Dancing House. Natives to Prague also affectionately refer to the building as Fred and Ginger (after dancers Fred Astaire and Ginger Rogers) because it resembles a dancer wearing a glass pleated dress gracefully leaning in to a gentleman wearing a hat. A stroll across the Charles Bridge is an obligatory part of any visit to Prague. Over the centuries, the bridge has been decorated with various baroque statues.

Prague abounds with charm and flair. When you think about the old architecture, the Vltava River, the picturesque bridges, the beautiful old town with its pedestrian zones, and the countless charming cafés, there's really no other choice but to fall in love with this Czech city.

This vintage car fits in perfectly with the Old Town setting and the cobblestone streets · My low perspective clearly brings the vehicle to the front of the picture. 31 mm · ISO 100 · f/5 · 1/50 sec ➜

♠ *The astronomical clock at City Hall · Certain parts of the clock are as old as the 14th century. It is a masterwork of gothic science and technology. The ornamental figures caught my attention so I decided for a tight crop here. 212 mm · ISO 100 · f/6.3 · 1/500 sec*

Prague Castle · Located atop a hill in Hradčany, the Prague Castle is the largest enclosed castle complex in the world. The Vltava River and its beautiful bridges are visible in the foreground. 73 mm · ISO 100 · f/8 · 8 sec ♦

The Dancing House · This building is an architectural wonder and a beloved subject for photographers. It is also affectionately known as Fred and Ginger. 22 mm · ISO 100 · f/8 · 1/200 sec

GERMANY Berlin

The sun breaks through the clouds and light floods the building. My gaze wanders upward to the interesting structures above. Some 11,500 square feet of safety glass, 16 mm thick and weighing in at 105 tons, seems to hover over me. The Teflon-coated fabric panels give this architectural highlight a decidedly futuristic look. I'm standing in the Sony Center in Berlin. A city steeped in history and home to 3.5 million people, Germany's capital is a world-renowned hub of history, nightlife, architecture, politics, and multiculturalism. The history of this city interests me in particular because I can still remember November 9, 1989, very well—the day the borders opened.

Only remnants of the Wall remain in the city. The East Side Gallery is the longest and most famous piece of the Berlin Wall still standing. At 4,317 feet long, this stretch of the Wall has been the longest open-air gallery in the world since its inception in 1990. Through hundreds of paintings on the former east side of the Wall, artists use diverse materials to comment on the political changes that occurred in 1989 and 1990.

Wandering through the city, I arrive at Checkpoint Charlie, which was one of the most notorious border crossings of the Berlin Wall, connecting the Soviet and US sectors of the city. The control point was also the scene of spectacular escapes from former East Berlin.

Berlin has no shortage of monuments. The Holocaust Memorial, which opened in 2005 and comprises 2,711 concrete blocks, was built in remembrance of the Jewish people who were murdered under the regime of the National Socialists. And what would a trip to Berlin be without a visit to the Brandenburg Gate? This monument is not only the best-known hallmark of the city, but it also indicates where the border between East and West Berlin stood before the Wall fell. The Gate has been a symbol of German reunification since 1990 and is one of the most photographed landmarks in all of Germany. The juxtaposition of the Reichstag building and the modern architecture along the Spree River make for a successful symbiosis of old and new.

← The Victory Column in the middle of the Tiergarten · The golden statue of Victoria was recently restored and she shines with a redoubled brilliance today. 155 mm · ISO 100 · f/8 · 1/500 sec

The Sony Center's ceiling structures · This photo relies on the pleasant color contrast and symmetrical designs. 26 mm · ISO 100 · f/6.3 · 1/250 sec →

◄ *Checkpoint Charlie, the former Berlin Wall crossing point · I opted for a frontal point of view to avoid distortions. 183 mm · ISO 200 · f/6.3 · 1/125 sec*

The Wall · Only fragments of the Wall remain, the most famous of which is the East Side Gallery. Artists have made statements with paintings and graffiti on this stretch of the Wall ever since it fell. 26 mm · ISO 100 · f/8 · 1/8 sec ▼

↟ *This memorial was built to commemorate European Jews who were killed · The monument was constructed in 2005 and consists of 2711 concrete blocks. It creates a very graphic photo. 87 mm · ISO 100 · f/5.6 · 1/50 sec*

The Brandenburg Gate · This structure marked the border between East and West Berlin up until the Wall's collapse. It is Berlin's hallmark. The quadriga is a compelling subject on its own. 51 mm · ISO 100 · f/8 · 3.2 sec ↡

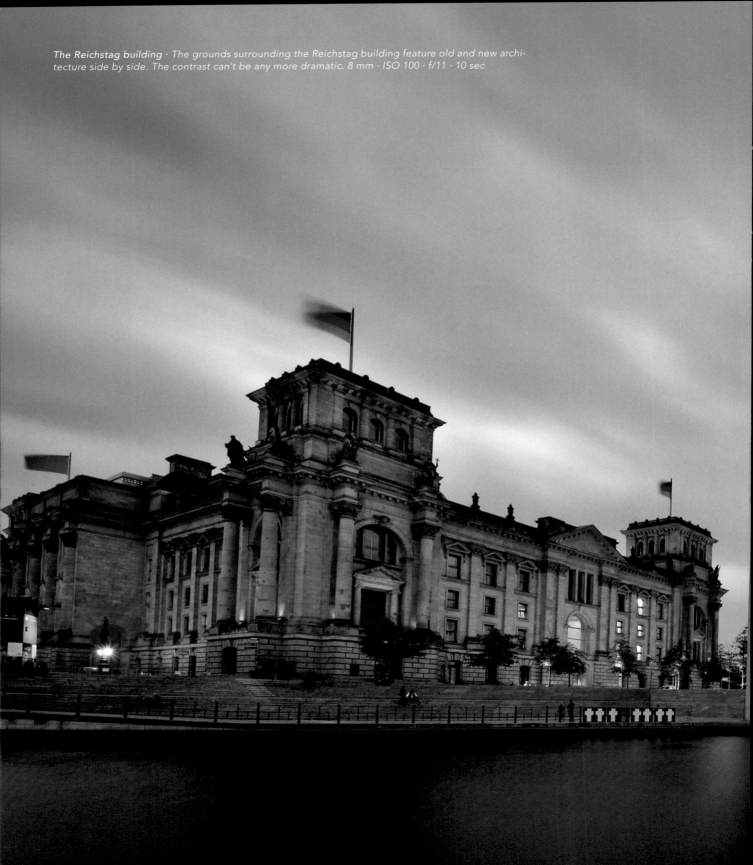

The Reichstag building · The grounds surrounding the Reichstag building feature old and new architecture side by side. The contrast can't be any more dramatic. 8 mm · ISO 100 · f/11 · 10 sec

Himmel der Bayern

Frauenkirche

Hacker Festzelt

Marienplatz

Pschorr Bräurosl

Der Pschorr

Wiesn

Donisl

Odeonsplatz

Stachus

Hackerbrücke

Altes Hackerhaus

♠ *The Bavarian sky · I discovered this huge, painted tarpaulin while strolling through the city of Munich. The crop intentionally obscures the subject, though, making it a comical backdrop for this photo. I used a long expo-*

GERMANY Munich

Backside turn, frontside turn… and then a splash. I jealously watch the hip surfer negotiate the waves with obvious skill. Many professionals have surfed here, including Kelly Slater, who's been world champion countless times. No, I'm not in Hawaii; I'm in Bavaria. More specifically, I'm in Munich, where a standing wave in the Eisbach attracts surfers from all over the world.

Several of Munich's attractions are grouped together at St. Mary's Square. Here I find City Hall, the Munich Toy Museum, and the Church of Our Lady, which is partially obscured by scaffolding. The weather hasn't cooperated much over the past few days, so I look underground for some shelter from the heavy rain. Even Munich's subway offers several interesting subjects.

With the weather still dismal, I head out to the Bavarian countryside around Munich in hopes of finding sunshine. I'm surprised by how beautiful the scenery is and how many striking subjects I find. The most famous by far is Neuschwanstein Castle, which sits high above the rushing Pöllat River. King Ludwig II oversaw the creation of this work of art from 1869 until his death in 1886. Today it wins over the hearts of tourists from around the globe. Unfortunately, the castle looks as though Christo beat me here because it's covered with scaffolding. I had planned to shoot from a specific spot, but the only plausible remaining viewpoint is from Mary's Bridge.

Subway station · The lighting in some stations is particularly modern. Here, I opted for a highly symmetrical image composition and a slow shutter speed to capture the motion of the subway cars. They guide the viewer's attention into the photo. 10 mm · ISO 100 · f/20 · 2 sec ✦

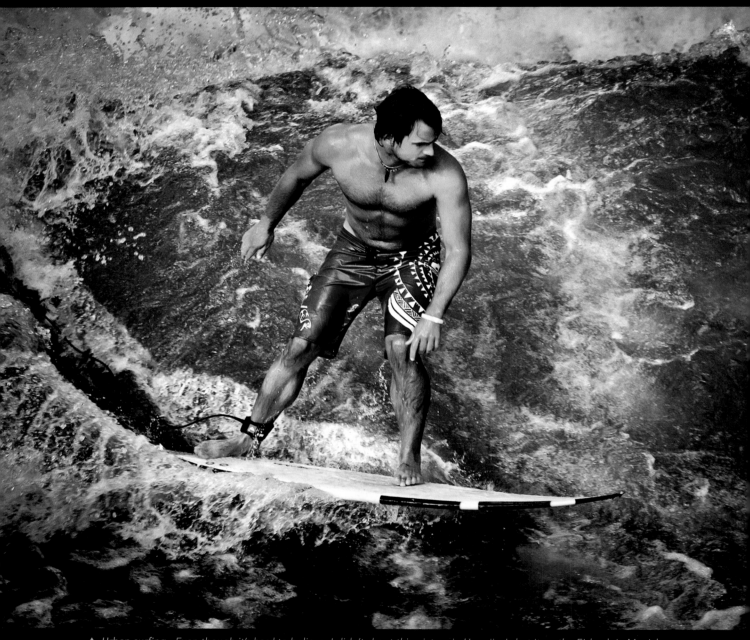

♠ *Urban surfing · Even though it's hard to believe, I didn't shoot this picture in Hawaii—I shot it on the Eisbach in Munich. A standing wave forms in this river and it has become famous to surfers all over. 70 mm · ISO 200 · f/2.8 · 1/400 sec*

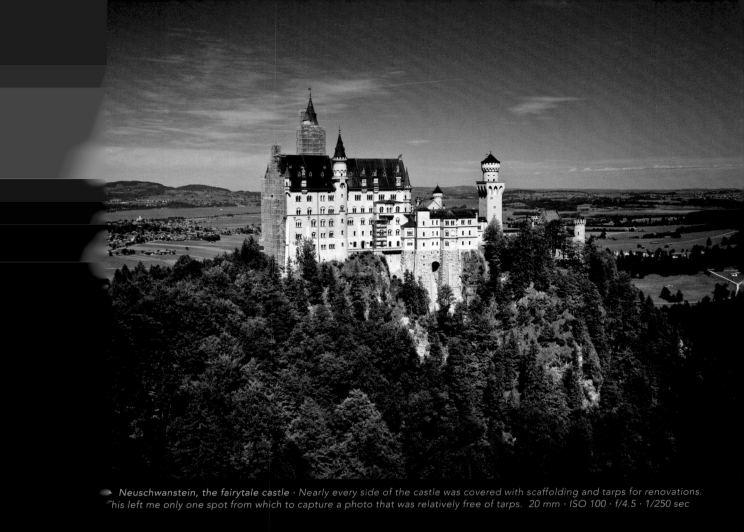

Neuschwanstein, the fairytale castle · Nearly every side of the castle was covered with scaffolding and tarps for renovations. This left me only one spot from which to capture a photo that was relatively free of tarps. 20 mm · ISO 100 · f/4.5 · 1/250 sec

St. Coloman · I drove past St. Coloman on the way to Newschwanstein Castle. This church is also a beloved subject for photographers. The peak of Säuling is visible in the background. 31 mm · ISO 100 · f/8 · 1/200 sec ♦

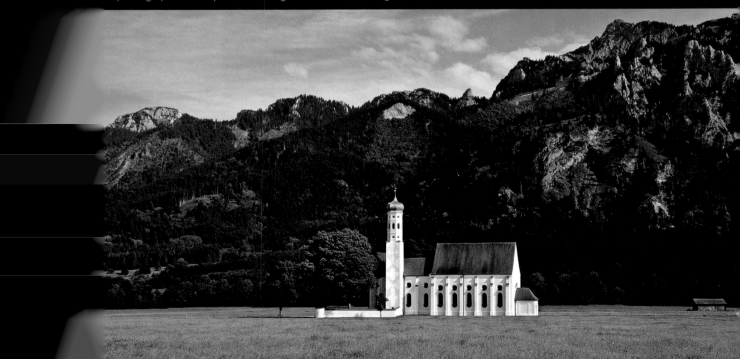

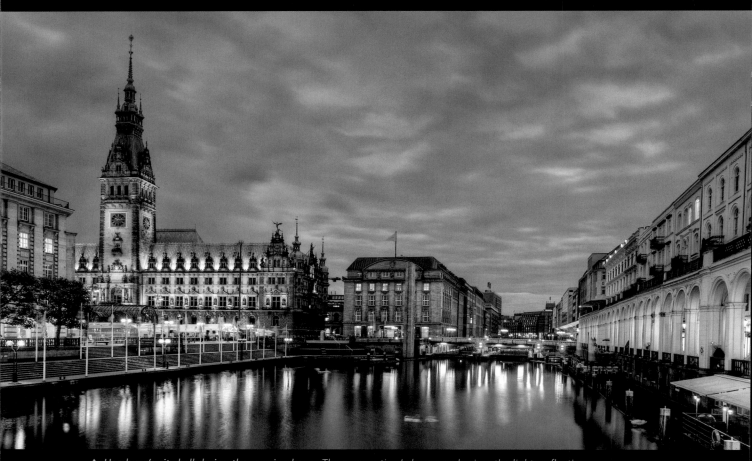

↥ *Hamburg's city hall during the evening hour · The perspective I chose emphasizes the lights reflecting off the surface of the Elbe. These reflections along with the overcast sky are key parts of this photo and its overall effect. 16 mm · ISO 100 · f/8 · 4 sec*

GERMANY Hamburg

"Let's meet at the Harbor Piers," Sven said on the telephone. I have arrived in Hamburg and am delighted to have the chance to meet up with my photography colleague again. He and his girlfriend Inge have lived here for more than a year and know their way around this port city. The three of us set out to see the sights and take some pictures. Our first stop is the Old Elbe Tunnel, where old lifts bring cars down to an underground passageway. Hamburg offers a slew of interesting subjects for photographers, including the clock tower with the dock of the shipbuilding company Blohm + Voss in the background. As the sky grows dark, we finish off the evening with a fitting beverage known as alsterwasser, which is a beer and soft drink blend.

The weather the next day is a mixed bag—perfect for black-and-white photography, especially in Speicherstadt, Hamburg's warehouse district. At one point, however, the rain gets so heavy that I have to interrupt my work. Right around evening, the rain starts to let up in time for me to take my last picture in Hamburg: city hall during the blue hour.

⬥ *St. Michael's Church · The light of the blue hour illuminates the clock tower as well as the dock and cranes of Blohm + Voss. 51 mm · ISO 100 · f/9 · 4 sec*

⬥ *The warehouse district · The small castles along the loading canals in Speicherstadt are one of my favorite subjects in Hamburg. The diffuse light resulting from the overcast sky led me to convert the image to black-and-white without any reservations. 20 mm · ISO 100 · f/9 · 1/25 sec*

GERMANY Norderney

The sound of the sea reaches my ears as I walk along my home island Norderney, one of my final objectives for this photographic journey. I pass by "Kap," an ancient structure used for fires that used to lead ships to safety along the coastline. It has become a landmark for Norderney since those days.

From Januskopf, the view of the waves and the sea is magnificent. I watch surfers as they gather near the water. The beach at the White Dunes is one of the best on the island, offering fine, white sand as far as the eye can see. Quaint bathing machines that serve as changing rooms provide a glimpse of what swimming was like in earlier times. I ride a bicycle up to the lighthouse. This nearly 200-foot tall structure in the interior of the island extinguished Kap for good in 1874. Climbing exactly 253 steps brings you to a platform that affords a pleasant view of neighboring islands.

A gentle breeze stirs up at the end of the day as the sun slowly sinks into the sea. I listen to the sounds of the waves and make myself comfortable in a beach chair to reflect on the previous year. It was an exhilarating and simultaneously stressful chapter of my life, filled with so many extraordinary experiences that it makes my head swim just thinking about in. In the last 50 weeks, I visited 6 continents, 48 countries, and 77 cities. To get to those places I took 101 flights on 56 different airlines and logged 264 hours in the air. On the ground, I trudged almost 2,500 miles by foot. And I still haven't been able to calculate the miles traveled by car, the number of hotel rooms slept in, and the terabytes of image data produced.

It definitely feels good to be back with family, friends, and acquaintances, but it is also somehow difficult to acclimate to the ins-and-outs of everyday life after having spent so long amid foreign lands and cultures.

It will take some time to adjust to being at home again and to sort through all of my experiences from the previous year, but one thing is for certain, the next journey will start soon!

⬆ *The swimming zone at Norderney's north beach · The long-exposure capture causes the ocean to look calm, almost as though it were painted. The posts invite the viewer's attention into the picture. 40 mm · ISO 100 · f/22 · 6 sec*

⬅ *Kap, which stands on top of a dune, is the landmark of the island · This structure provided guidance for ships up until the construction of a lighthouse. 23 mm · ISO 100 · f/7.1 · 1/125 sec*

Acknowledgments

Thanks to SIGMA Germany Corp., Mr. Hahn, Mrs. Reußwig, and Mrs. Keller for the amazing idea for this extraordinary project and the realization of Our World Tour. Thanks also, of course, to SIGMA headquarters in Tokyo, Japan, and to CEO Kazuto Yamaki. I'd like to thank all of my friends, acquaintances, relations, and fans who believed in me and motivated me with emails, texts, and phone calls.

Many thanks to Mr. Rossbach and dpunkt.verlag, to my editor Barbara Lauer, and to Cora Banek for the great layout! To Frank Schmidt, who stood in for me during my tour at the Oldenburg State Theater. To Jens Saathoff for helping with my video application. To Katharina, Ole, and Dieter, who trembled with me in the final round. To the Stern Agency. To Anne Eversbusch for the preparations, Ralf Bielefeld for the writing coaching, Antke Akkermann for the travel assistance, Andreas Etter for the tips about Frankfurt, to Paul and Irene Rass, Georg Banek, Peter Geller, and Ulli Götze, to my family, and everyone who contributed to this book! Please forgive me if I have left anyone out.

I dedicate this book to my wife Miriam. Without her support, this journey, this book, and all of the making-of pictures and videos would not exist. She supported me tremendously during the journey and the time when I was writing this book. This experience was not always easy, but together we made it through the highs and the lows and overcame every obstacle.

Thanks, my love!